Photography

The Concise Guide

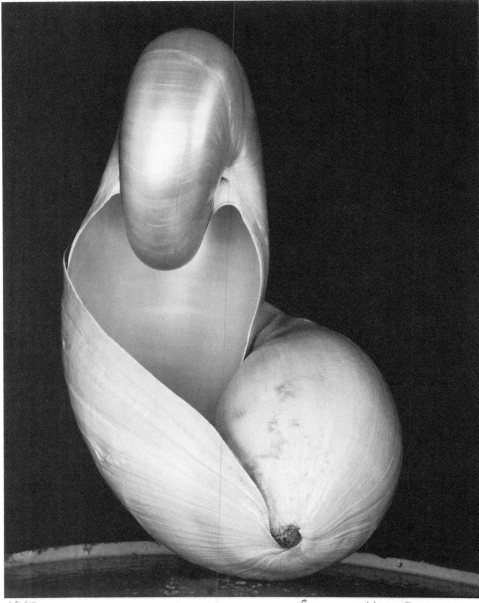

Edward Weston, *Two Shells, 1927.*

PHOTOGRAPHY
THE CONCISE GUIDE

BRUCE WARREN

DELMAR

THOMSON LEARNING™

Australia Canada Mexico Singapore Spain United Kingdom United States

DELMAR

THOMSON LEARNING

Photography
The Concise Guide
Bruce Warren

Business Unit Director:
Alar Elken

Executive Editor:
Sandy Clark

Acquisitions Editor:
James Gish

Editorial Assistant:
Jaimie Wetzel

Executive Marketing Manager:
Maura Theriault

Channel Manager:
Fair Huntoon

Marketing Coordinator:
Sarena Douglas

Executive Production Manager:
Mary Ellen Black

Production Manager:
Larry Main

Art/Design Coordinator:
Rachel Baker

Cover Image:
Bruce Warren

Page Design:
Bruce Warren

ISBN: 1-4018-8745-7

NOTICE TO THE READER

Contents

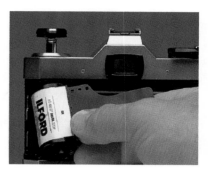

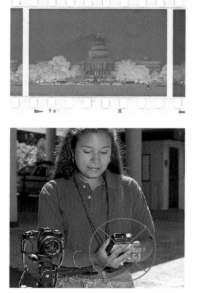

NASA

© Ralph Gibson

© Bognovitz

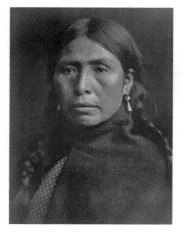

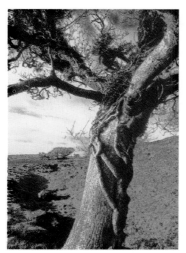

© Bruce Warren

Preface

Introduction

Photography: The Concise Guide is an introductory photography book that covers basic and intermediate materials, techniques, and concepts. Based on Bruce Warren's widely used and highly respected *Photography 2E*, *Photography: The Concise Guide* is a compact but thorough text designed to serve as a textbook for one- and two-semester photography courses. It can also be used by the individual reader, making it an appropriate reference for all photographers. The text's hands-on approach emphasizes the experience of making photographs as a tool for learning. Black and white and color techniques are covered in the text. A complete chapter on digital photography and one on special techniques expands the scope of the book. There is also a Web site associated with the book at:

http://www.delmar.com/photography/warren.

Over 700 illustrations in full color and black-and-white duotone reinforce points made in the text and serve as inspiration. Exemplary photographs by well-known photographers, both contemporary and historical, demonstration photographs showing step-by-step procedures, and a wealth of drawings, charts, graphs, and tables help the reader to understand both the technical and aesthetic aspects of photography.

Coverage

The reader who is new to photography should begin making photographs immediately. Producing photographic images builds enthusiasm and provides examples of levels of technical control, aesthetics, and use of light.

■ **Chapter 1: Getting Started.** Chapter 1 provides just enough technical and aesthetic information to allow the reader to operate a camera and a light meter.

■ **Chapters 2–5: Mastering Skills.** Because mastery of the technical aspects of photography is necessary for success in all aspects of the art, the early chapters introduce readers to the tools and techniques of photography.

■ **Chapter 6: Troubleshooting.** Chapter 6 is dedicated entirely to solving technical problems; clearly organized and illustrated troubleshooting charts help readers solve common problems. A section on testing equipment helps to pinpoint problems.

■ **Chapter 7: Working with Light.** Chapter 7 discusses the interaction of light and subject and introduces basic lighting techniques, including flash.

■ **Chapter 8: Seeing Better Photographs.** The aesthetic aspects of photography are touched on throughout the early chapters, culminating in a detailed treatment of design and aesthetics in chapter 8.

■ **Chapter 9: History of Photography.** With the technical and aesthetic information provided in the first chapters, the reader can more fully appreciate the history of photography, presented in chapter 9.

■ **Chapters 10: Special Techniques.** Chapter 10 explains special effects that can be produced in the camera or in the darkroom, including filters, photomacrography and special effects.

■ **Chapters 11: Digital Photography.** Chapter 11 provides an introduction to the equipment and techniques of digital photography, including a tutorial on image editing.

Using This Book

Organization: An important feature of *Photography: The Concise Guide* is its conception of photography as an integrated system of equipment, materials, and procedures, that leads from the original idea to the completed photograph. The book is organized according to this systematic approach, so that the reader always knows how a particular piece of information fits into the overall process. Topic headings are clearly organized. The table of contents is graphically designed to make finding any major topic or section simple. A thorough index strengthens the book's value as a photographic resource.

Integrated Illustrations: Photographs and illustrations (numbering over 700) are essential components of *Photography: The Concise Guide*, and their captions are an integral part of the text, with clear caption headings to indicate their place in the flow of information.

Cross References: Because many topics in photography appear in more than one context, both forward and backward cross-references are included in the text or in margin notes to connect the topics.

Glossary: Within the chapters, the first appearance of important photographic terms is in boldface type. These terms are formally defined in the glossary.

Notices: Warnings and cautions, including health and environmental notices, are bulleted to reinforce their importance.

Web Site: *http://www.delmar.com/photography/warren.* The Web site provides a valuable resource for students and instructors of photography. On the Web site you will find technical materials for ready reference when you are on

the Web, handy links to valuable Web resources such as manufacturers of photographic products and photographers' Web sites, an extensive glossary of photographic terms, additional information about photography not to be found in this text, and galleries of photographic images for inspiration.

Instructor's Manual: An instructor's manual is available to adopters of this book. It includes chapter overviews, outlines, learning objectives, recommended supplementary materials, and chapter tests.

Acknowledgments

A project of this complexity could not be completed without the help of many dedicated people. I would like to thank the professionals at Delmar Learning for their work on this text, especially James Gish, Acquisitions Editor; Rachel Baker, Art and Design Coordinator; and Larry Main, Production Manager. A number of others also offered their time, support, and encouragement. Murray Bognovitz deserves special mention; he not only produced the commissioned photographs, but also invested endless hours of his own time in consultation and discussion and offered suggestions that made this book the best it could be. Others who contributed special effort include

Joe Chiancone and Merle Tabor Stern. This book owes a great deal to the professionals at West Publishing responsible for the first edition of *Photography*, including Clark Baxter, Nancy Crochiere, Jeff Carpenter, Chris Hurney, and Kara ZumBahlen. A large number of photographers, corporations, and individuals gave time and expertise to the creation of the illustrations. They are listed in the photo credit lines and the "Special Contributors" box.

The approach to teaching photography presented here owes a great deal to my experience as a faculty member in the photography program at Montgomery College, Rockville, Maryland. Many ideas came from countless meetings and discussions with my fellow faculty members, Tom Logan and Woods Price. The photography students who have passed through my classes also deserve thanks for their hard work and dedication, serving as inspiration and proving ground for my theories.

The author and Delmar Learning would also like to extend our heartfelt thanks to those who reviewed the text for this edition. This reviewer panel provided invaluable comments and suggestions. Our thanks to:

Robert Crites, Art Institute of Philadelphia.
Jonathan Goell, Montgomery College.
Bernard Krule, Oakton Community College.
Travis Ueoka, Brookhaven College.

Special Contributors

Several corporations and their representatives were particularly helpful in the creation of the commissioned photographs.

- **Abbey Camera, Silver Spring, MD:** Robert C. Becker and David Brown
- **Fuji Photo Film U.S.A., Inc.:** Harry Markel
- **Ilford Photo Corporation:** R. Paul Woofter and Wendy Erickson
- **Ken Hansen Photographic, New York:** Ken Hansen.
- **Photo Habitat, New York:** Walter Lew and Ray NG

- **Canon, U.S.A., Inc.:** Michael Sheras and Jim Rose
- **Chrome, Inc., Washington, D.C.:** Theodore Adamstein
- **Bogen Photo Corp.:** Lydia S. Thomas
- **R & R Lighting, Silver Spring, MD:** Mary Ann Robertson
- **Knoxville Museum of Art:** Stephen Wicks
- **Distinctive Bookbinding, Inc., Washington, D.C. and New York**
- **Seawood Photo, San Anselmo, CA:** Graham Law
- **Phase One, Northport, NY:** Lisa Struckman
- **Alfa Color, Gardena, CA:** Steve Trerotola

C H A P T E R 1

Getting Started

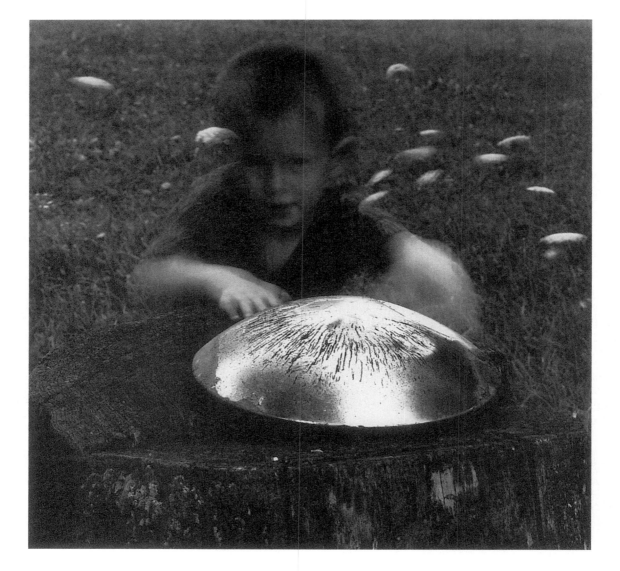

Ralph Eugene Meatyard, *Boy with Hubcap.*

© Ralph Eugene Meatyard, Courtesy of Christopher Meatyard.

It is not difficult to take photographs. Billions of photographs are made by the public every year with successful results for their purposes. However, photography is a bit like sailing. With a little instruction it is not too hard to figure out how to get the boat to move, but it can take a lifetime to master all the intricacies. This chapter will give you just enough information to get moving. Once you have started producing photographs, you will probably want more information so that you can get even better results. Use the chapter and page references to locate more in-depth discussion of the steps covered in this chapter.

If things do not turn out as well as you expected, chapter 6 can help you with some possible cures for your problems. Mastering the technical details that make up the craft of photography is only the beginning. To make photographs that communicate your ideas or feelings, you will also have to learn the differences between human visual perception and the way photographs represent reality. The best way to do this is to start making photographs, but you will find some helpful suggestions for improving your photographic seeing in chapter 8.

■ Equipment and Materials

To begin making photographs you will need film, a camera, and a light meter, either the one built into your camera or a separate meter.

Film

Photographic **film** is a material that is sensitive to light. When a pattern of light falls on film, an image is produced. Chemical processing makes this image visible and useful for producing photographs. Any of the many types of film available, black and white or color, may be used for getting started. If you plan to process your own film, black and white is simpler to process.

On the film box you will see a number labeled ISO. The higher this number is, the more sensitive the film is to light. A good starting film is one with an ISO between 100/21° and 400/27°. Several black-and-white films are available in this range:

See chapter 2 for complete film information.

ISO 100/21°	Kodak T-Max 100, Agfapan 100 Professional, Ilford Delta 100
ISO 125/22°	Kodak Plus-X, Ilford FP4
ISO 400/27°	Kodak Tri-X, Kodak T-Max 400, Agfapan 400 Professional, Ilford HP5, Ilford Delta 400, Ilford XP2 Super, Kodak Black and White +400

See pages 12 and 23 for more on film sensitivity.

Color films for prints in this range are offered by Kodak, Konica, Agfa, and Fuji, all available in ISO 100, 200, and 400.

Ilford XP2 Super and Kodak Black and White +400 are black-and-white films designed to be processed in color print film developer (C-41).

Camera

A camera is basically a light-tight box that holds the film and has a lens that gathers light from the subject, forming an image of the subject on the film. Many different types, brands, and models of cameras are available. For the purpose of discussing operation of the camera, we will use a basic 35mm camera, shown on page 5. This is a manual camera, meaning that you have complete control over all the settings. Other cameras may control some settings automatically.

See chapter 3 for information on camera types.

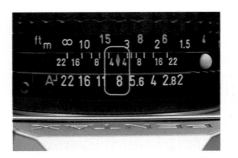

Aperture Control Ring Set at f/8.

For more on aperture see pages 20, 54, and 57.

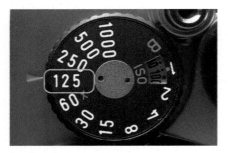

Shutter Speed Dial Set for 1/125 Second.

For more on shutters see pages 20 and 43–47.

See pages 24–37 for complete information on light meter types and their uses.

Camera Exposure Controls

To produce high-quality images the film must receive the proper amount of light, called the correct **exposure**. Two controls on the camera alter film exposure: the **aperture** and the **shutter speed**.

Aperture The aperture is a variable-size opening in the lens, much like the iris in the eye. It is adjusted with the aperture ring. The numbers on the ring are an indication of the size of the opening and are called f-stop numbers. A standard series of f-stop numbers has been established:

$$1.4 \quad 2 \quad 2.8 \quad 4 \quad 5.6 \quad 8 \quad 11 \quad 16 \quad 22$$
More Exposure ← → Less Exposure

Contrary to what you might expect, larger f-stop numbers indicate smaller apertures, which admit less light. Setting the aperture at f/8 will give *less* exposure than setting it at f/4.

Shutter Speed The **shutter** shields the film from the image formed by the lens until you are ready to take a photograph. When the shutter release (see "Locating Camera Parts," page 5) is depressed, the shutter opens for the amount of time indicated on the shutter speed control dial, which is marked with a set of standard shutter speeds in seconds:

$$1 \quad 1/2 \quad 1/4 \quad 1/8 \quad 1/15 \quad 1/30 \quad 1/60 \quad 1/125 \quad 1/250 \quad 1/500 \quad 1/1000$$
More Exposure (Slower Speeds) ← → Less Exposure (Faster Speeds)

On the shutter speed dial these are indicated as whole numbers, but the actual shutter speeds are fractions of a second. The longer shutter speeds give more exposure to the film: 1/30 second will give *more* exposure than 1/125 second. Some cameras may have longer or shorter shutter speeds in addition to the ones given on this scale.

Light Meter

A reflective-type photographic **light meter** measures the amount of light coming from a subject and gives settings for the aperture and shutter speed to insure proper film exposure. Most small cameras made today have a light meter built into them. Separate light meters in their own housings—hand-held light meters—are also available.

■ A Procedure for Taking Photographs

The following procedure explains how to make photographs with both manual and automatic cameras. All cameras utilize the same controls, but the location and operation of those controls will vary, especially on cameras with automatic controls. If your camera is not like the one discussed, refer to your operator's manual to see how the controls on your camera correspond to the ones shown here. Chapters 2 and 3 also help explain the operation of different types of light meters and cameras. Some automatic cameras can be set to manual metering mode. If your camera can be set to completely manual operation, follow the procedures given for manual metering. Refer to the illustration on the following page to locate controls on a typical manual camera.

Locating Camera Parts

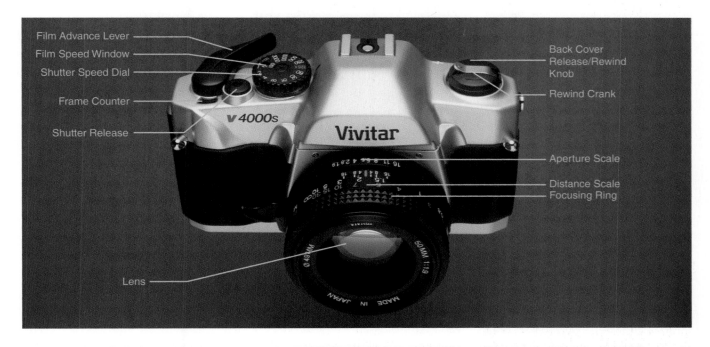

Film Advance Lever

Film Speed Window

Shutter Speed Dial

Frame Counter

Shutter Release

Back Cover Release/Rewind Knob

Rewind Crank

Aperture Scale

Distance Scale
Focusing Ring

Lens

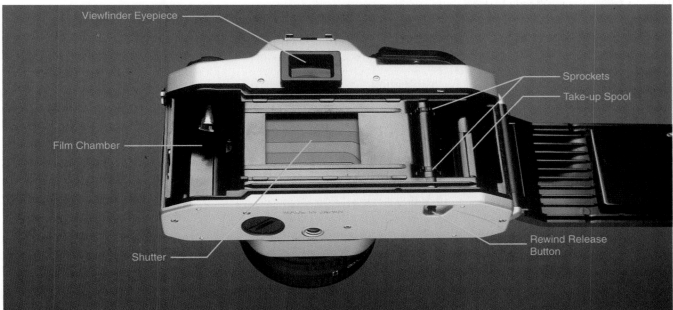

Viewfinder Eyepiece

Sprockets

Take-up Spool

Film Chamber

Shutter

Rewind Release Button

Vivitar V4000s 35mm Camera.

Loading the Film into the Camera
A. Pull up on the back cover release–rewind knob until the camera back pops open.

B. Leave the knob pulled up and insert the film cassette into the camera. The end with the spindle projecting should be toward the bottom of the camera. Do not expose the film cassette to direct sunlight.

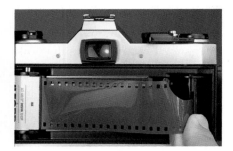

C. Push the back cover release–rewind knob all the way in, rotating it slightly if necessary. Insert the end of the narrow film leader firmly into one of the slots on the take-up spool. In auto-load cameras, the film is not inserted into a slot, but is instead placed at an index mark.

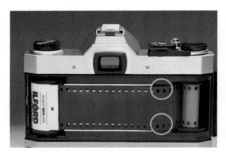

D. Operate the film-advance lever until the film is securely wrapped around the take-up spool and both edges of the film are engaged with the sprockets. If the film-advance lever will not move at any time during this procedure, press the shutter release and continue. (Skip this step for auto-load cameras).

E. Close the camera back and press gently until it latches. Repeatedly press the shutter release and operate the film-advance lever until the frame counter reads 1. Auto-load cameras require only one press of the shutter release to advance to frame 1.

Setting the Film Speed (ISO)
A. Set the number before the slash of the ISO into the film speed window labeled ISO by lifting up on the outer rim of the shutter speed ring and rotating it. On some cameras the film speed window may be labeled ASA, but the procedures are the same.

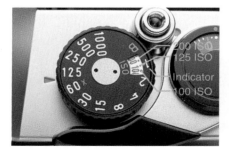

B. This dial is set for film labeled ISO 125/22°. Note that not all numbers are marked on the scale. The two dots between the 100 ISO mark and the 200 ISO mark correspond to ISO 125 and ISO 160. (See page 23 for a list of ISO numbers.) Some cameras automatically set the ISO if DX coding is indicated in the film labeling.

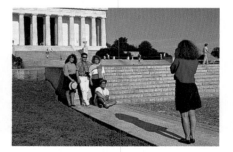

Ideas for Photographs
Most photographs are taken as a record of people, places, things, or events. Many other reasons for making photographs exist, some of which are discussed in chapters 8 and 9. For now, photograph anything that interests you.

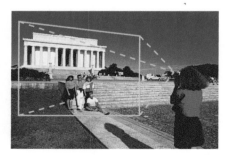

Framing and Composing Your Photograph
A. When you take a photograph, only part of what you see of the subject with your eyes will be included within the borders—the "frame"—of the photograph. To see what you will get in your photograph, look through the viewfinder of the camera.

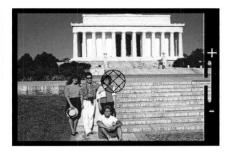

B. If you have one central subject, move backward or forward until you have it framed as you want it. Make sure that other objects appearing in the viewfinder do not distract from the main subject. Unattractive backgrounds or strong shapes or patterns may draw attention from the subject. Move the subject to a better place if possible, or change your position for a different point of view.

C. Most cameras take a rectangular picture, so you can turn the camera on end to get a different framing. This view shows the subject closer up with vertical framing.

Evaluating the Light on Your Subject
A. Think about how the light falls on your subject, the quality of the light, the direction the light comes from, and the resulting pattern of light and shade on your subject.

B. The easiest way to control the light on your subject is to simply move the subject so that the light strikes it in a more desirable way. Other ways of controlling light are discussed in chapter 7.

Metering and Setting Camera Controls.
Manual In-Camera Meter *A. Taking the Meter Reading.* Point the camera just as you will when you take the photograph. In this view through the viewfinder, the needle on the right indicates the amount of light coming from the subject. It will rise with increasing light and fall with decreasing light. The meter needle also moves as the aperture ring and the shutter speed dial are changed.

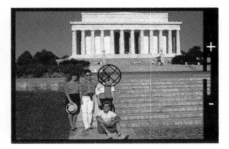

B. Setting the Camera Controls. Keeping the camera pointed at the subject, change the shutter speed or the aperture settings or both until the needle is centered between the + and − signs. You will discover that several shutter speed and f-stop pairs will center the needle. All of these pairs give the same exposure to the film.

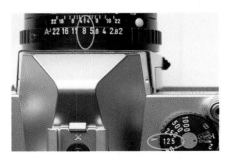

C. Choosing Camera Settings. The controls are now set for an f-stop and shutter speed pair of f/8 at 1/125 second. Reasons for choosing one pair over another are discussed in later chapters. For now stay with shutter speeds of 1/60 second or faster—for example, 1/125, 1/250, and so on—to reduce the possibility of image blurring due to camera movement. **NOTE:** You can set the aperture ring between f-stops to make the meter balance, but the shutter operates only at the marked speeds.

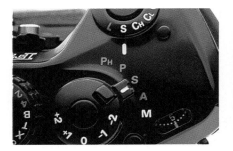

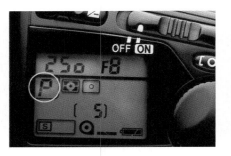

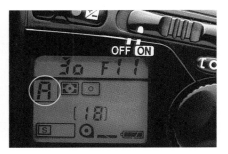

Metering and Setting Camera Controls: Automatic Cameras A. *Metering Mode:* Automatic cameras may offer several metering modes, providing differing control over the camera settings. Manual mode (M) is discussed on page 7. The automatic modes are discussed here. This camera has two Program modes, one for general use (P) and another that favors higher shutter speeds (Ph).

B. *Program mode (P)* automatically sets both aperture and shutter speed, giving less control but more ease and speed in shooting. To shoot in program mode, simply focus as shown below and release the shutter. This camera displays the aperture and shutter speed it has set, in this case f8 at 1/250 second.

C. *Aperture-priority mode (A or Av)* gives another level of control. You choose an aperture, and the shutter speed is set automatically. Choice of aperture controls depth of field (see pages 54–55). Here f11 was chosen for more depth of field, giving a shutter speed of 1/30 second.

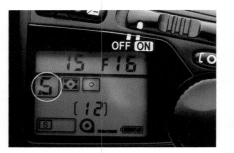

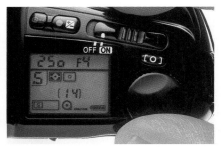

To shoot in aperture-priority mode, select the aperture you desire Most cameras will display the shutter speed being set. If it is too slow, move the aperture to a smaller number. Here the aperture was changed to f2.8 giving a fast shutter speed of 1/500 second. Focus as shown below and release the shutter.

D. *Shutter-priority mode (S or Tv)* allows you to choose a shutter speed. The aperture is set automatically. Choice of shutter speed controls the amount of blur caused by subject or camera movement (see pages 44–47). Here a slow shutter speed of 1/15 second was chosen, giving an aperture of f16.

To shoot in shutter priority mode, select a shutter speed. Most cameras will display the aperture being set. If the combination is not acceptable, choose a different shutter speed. Here the shutter speed was changed to1/250 second, giving an aperture of f4. Focus as shown below and release the shutter.

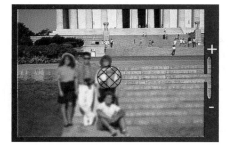

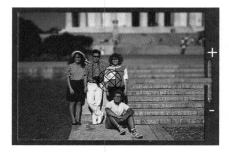

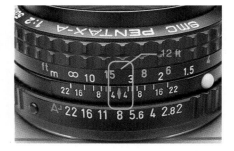

Focusing the Camera

A. In the viewfinder, parts of the subject look sharp and clear, while other parts look blurred or fuzzy. This effect depends on the distance of the objects from the camera. The part of the subject that is sharp and clear is said to be in focus. Here the background is in focus and the people are not.

B. The distance at which the subject is in focus can be changed by turning the focus ring. You will be able to see the focus change if you watch through the viewfinder. Turn the focus ring until the part of the subject you think is most important looks sharp and clear in the viewfinder. Now the people are in focus and the background is not. (See chapter 3 for focusing methods on other camera types.)

C. The focus ring has a distance scale with a pointer to tell you what distance will be in focus. Most cameras give this distance in both feet and meters, so be sure to read the correct scale. This camera is focused on 12 feet—a little less than 4 meters. To focus with an autofocus lens, place the focusing spot (usually the center of the frame) on the subject and partially depress the shutter release.

Exposing the Photograph

Check the focus and the framing of the subject. When you feel the moment is right, gently squeeze down on the shutter release to make the exposure on the film. To avoid blurring the image, steady the camera by holding your arms against your body and the camera against your face. After taking the photo, advance the film to the next frame with the film-advance lever. Many cameras have auto-advance.

Rewinding the Film

A. The number of exposures available on each roll of film is listed on its box. The film counter indicates the number of exposures you have made. After you have taken the last frame on a roll, you will be unable to advance the film. Do not force the film-advance lever. Auto-advance cameras will stop automatically.

■ **CAUTION** Do not open the back of the camera until the film has been rewound.

B. Turn the camera over and press the rewind release button on the bottom. If it does not stay in, hold it in with one finger while you perform the next steps. (Skip this step for auto-advance cameras.)

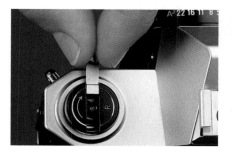

C. Flip open the small crank on the back cover release–rewind knob.

■ **CAUTION** Do not pull up on the back cover release–rewind knob.

Slowly wind in the direction of the arrow until you feel the film release from the take-up spindle. If you listen carefully you can also hear the end of the film as it releases and winds into the cassette. For auto-advance cameras, there will be a button or buttons to activate automatic rewind.

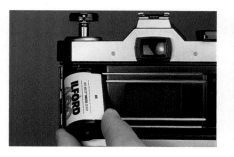

Removing the Film from the Camera

Pull up on the back cover release–rewind knob until the back pops open and remove the film cassette from the camera. Protect the film cassette from direct sunlight, heat, and moisture until you have it processed. On many cameras, especially auto-advance models, the back cover release is a slide latch on the side of the camera.

Processing and Printing the Exposed Film

You can take your exposed film to a commercial photo finisher for processing and printing, or you can process and print the film yourself. If you plan to do your own processing and printing with black-and-white film, the procedures are explained in detail in chapters 4 and 5. If you take the film to a photo finisher, it is more convenient to work with color film, since black-and-white processing and printing services are difficult to find.

Evaluating Your First Results

If you have been careful in following directions, your first roll of film should give you good results. Look for technical quality in the prints: Are they sharp and clear? Do the tones or colors look as you expected? Now look for aesthetic qualities of each photograph: Is the subject framed in a way you like? Do extraneous distracting details appear in the print? Are the expressions of people in the photograph interesting or attractive? Do you like the way light illuminates the subject? Have you recorded an interesting moment of time? What kind of feelings or ideas do you get from the photograph? You will probably also like to find out what other people think of your images. The remaining chapters in this text will help guide you through the process of learning to make more interesting and exciting photographs.

C H A P T E R 2

Film and Exposure

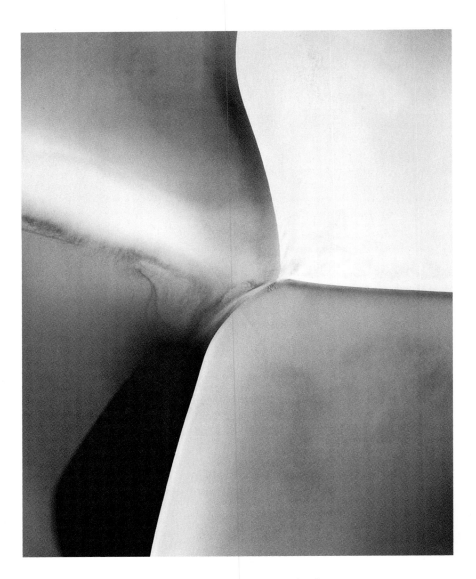

William A. Garnett, *Four-Sided Dune, Death Valley, CA, #2.*
© 1954 William A. Garnett.

■ Light-Sensitive Materials

It was the discovery that certain materials changed when struck by light that made photography possible. Silver salts—usually **silver-halide crystals**, which are metallic silver in chemical compound with iodine, chlorine, or bromine— are the most commonly used **photosensitive** (light-sensitive) **materials**. When light strikes these silver salts, it reduces some of the salts to their components, giving metallic silver. Since silver in this form normally appears black, the light darkens the silver salt.

It takes a large amount of light to directly create a visible darkening of silver salts. For photographic purposes, this would mean a long exposure to the image formed by the lens on the film. Luckily, even small amounts of light create tiny specks of silver, which are not visible to the naked eye. The pattern of these invisible silver specks is called the **latent image.** The developing process causes more silver to be deposited around these latent image specks, creating a visible image composed of silver. The accumulated silver in the image is called **density.** The greater the amount of silver present in the image, the higher the density and the darker the appearance of that area of the image. The chemical development of the latent image gives usable photographic images with small amounts of exposure to light.

Since the effect of light is to turn the silver salts dark, the resultant pattern produced on the light-sensitive material is normally reversed from the **tonal values (tones)** of the subject. The result is a **negative image.** Through special development techniques—as with color slides—the silver image can be reversed again, resulting in a **positive image**, with the same tonal relationships as the subject.

The support that carries the silver salts is called the **base** of the light-sensitive material. Two general types of base are used: photographic films use a transparent base; photographic prints use an opaque base, usually paper.

For more information on photographic print materials, see chapter 5.

Negative-to-Positive Photographic Reproduction. Note that the lighter parts of the subject are represented in the negative as dark tones, and the darker subject areas are represented as light tones.

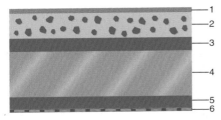

Enlarged Cross-Section of Black-and-White Film.

1. *Scratch-resistant Coating.* Helps protect the emulsion from damage.
2. *Emulsion.* Silver halide crystals and sensitivity dyes suspended in gelatin.
3. *Adhesive.* Insures attachment of the emulsion to the base.
4. *Base.* Transparent, flexible cellulose acetate or polyester.
5. *Adhesive.* Attaches the antihalation backing.
6. *Antihalation Backing.* Contains absorbing dyes to reduce reflections from the back of the base that would create unwanted exposure on the film, called **halation.**

See pages 18–19 for information on film storage.

ISO	ASA	DIN
25/15°	25	15°
32/16°	32	16°
40/17°	40	17°
50/18°	50	18°
64/19°	64	19°
80/20°	80	20°
100/21°	100	21°
125/22°	125	22°
160/23°	160	23°
200/24°	200	24°
250/25°	250	25°
320/26°	320	26°
400/27°	400	27°

Black-and-White Films

A simple photosensitive silver salt material will not show the colors of the original subject, only the shades of light and dark. These images are called **monochrome images,** or, more commonly, black-and-white images.

Structure of Black-and-White Films

Silver salts will not adhere to a film base without a carrier, so the silver halide salts are mixed with gelatin to form an **emulsion,** which can then be coated onto the base. The gelatin also makes the silver salts more sensitive to the action of light. Certain dyes, called **sensitivity dyes,** are mixed with the emulsion to improve the film's response to some colors of light. Though only a few thousandths of an inch thick, the film contains several layers.

The manufacture of photographic film is a highly complex process. Many additional ingredients are used by manufacturers to improve the quality of the films. The process of mixing and coating the emulsions is especially sensitive to contamination and environmental conditions. The emulsions are manufactured in large batches, which are generally consistent in quality, but small variations from batch to batch are unavoidable. Manufacturers identify each batch with an emulsion batch number, which is printed on each box of film. For critical work requiring strict film consistency from roll to roll, make sure all rolls are from the same emulsion batch and have been stored under the same conditions.

Characteristics of Black-and-White Films

A number of characteristics of a film, such as **sensitivity** to light, **grain** structure, **color sensitivity, contrast,** and **exposure latitude** are determined in the manufacture of the film. Choice of film depends on how well these characteristics match the intended use of the film.

Sensitivity to Light Film sensitivity, also called film speed, indicates the amount of exposure required to produce a given amount of density in an image. More sensitive (faster) films require less exposure than less sensitive (slower) films to produce the same amount of density.

Various systems have been devised for measuring the sensitivity of film to light and assigning a number indicating the speed of the film. This film speed number is called the **exposure index.** In the United States, American Standards Association (ASA) numbers are most widely used. In Europe, Deutches Industrie Norm (DIN) numbers are used. The International Standards Organization (ISO) number combines the two systems. The number before the slash of the ISO number is the ASA. The number following the slash is the DIN. In all systems, the higher the exposure index number, the more sensitive the film is to light. Films are generally categorized by speed:

Slow	About ISO 50/18° or lower
Medium	About ISO 100/21°
Fast	ISO 200/24° to ISO 400/27°
Ultrafast	Higher than ISO 400/27°

Grain Structure The silver particles resulting from exposure and development in the film do not collect in a perfectly smooth fashion, but tend to gather in clumps. In the film this clumping is not visible to the naked eye, but when the image is magnified, as in printing, a granular texture called **grain** is seen. The size and appearance of this grain depend on a number of factors, including amount of exposure and amount and type of development, but the major influence on grain structure is the film itself. In general, faster films exhibit coarser grain. The T-grain emulsions—used in T-Max films—introduced by Kodak achieve higher sensitivity with finer grain by using a silver halide crystal that is flatter and more tabular in structure, exposing more of the crystal surface to light.

Color Sensitivity Light is a form of energy, and our perception of its color depends on the particular wavelengths in the light (see the illustration at lower right). The sensitivity of photosensitive materials to various colors of light may vary from the sensitivity of the human eye. Several categories of films with different color sensitivities are available:

Panchromatic. **Panchromatic emulsions** are sensitive to all the colors visible to the human eye, but their sensitivity to individual colors varies somewhat from the response of the eye. Panchromatic films are usually more sensitive to blue than to red, causing blues to reproduce somewhat lighter and reds darker than expected in the print. Panchromatic films also show some sensitivity to ultraviolet rays, which are invisible to the eye. Most general-purpose black-and-white films are panchromatic. Panchromatic films must be handled and processed in total darkness.

Orthochromatic. Orthochromatic films are sensitive to all colors except red, making them useful in graphic arts darkrooms where they may be used under red lights.

Blue sensitive. Blue-sensitive films are sensitive only to blue light and are safe to handle under yellow or amber light, making them useful in black-and-white copy work and lithographic work (making plates for printing).

Infrared. Infrared films are sensitive to infrared radiation near the visible spectrum. They are also sensitive to some visible light and must be used with special filters if only the effect of infrared is desired. Since infrared films are not sensitive to the long-wavelength infrared associated with heat, special imaging techniques must be used to record heat radiation. Infrared films are discussed in more detail on pages 206–07.

Exposure Latitude Exposure latitude is the ability of a film to withstand overexposure or underexposure and still produce a usable image. The latitude for overexposure is usually greater than that for underexposure. In general, slow-speed films have less exposure latitude than fast films.

Contrast The contrast of a film is the amount of density difference obtained for a given change in exposure on the film. Films that produce little density difference for relatively large changes of exposure are low in contrast. Since contrast may also be changed by altering the amount of development, films with inherently low contrast can produce images of normal contrast by being given more development. In general, slow-speed films have more inherent contrast than fast films and therefore usually require less development. High-contrast films are designed to produce only two tones, black and white,

Grain Structure.
Top: Full-Frame Image.
Bottom left: ISO 50/18° Film Image at 40X magnification.
Bottom Right: ISO 400/27° Film Image at 40X magnification.

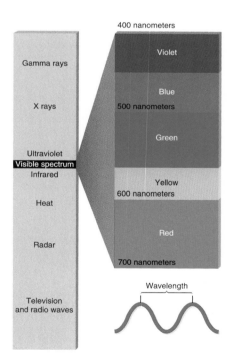

Electromagnetic Spectrum. Visible light is a tiny part of the spectrum of electromagnetic waves. The **wavelengths** of visible light are from 400 nanometers to 700 nanometers (a nanometer is one-billionth of a meter).

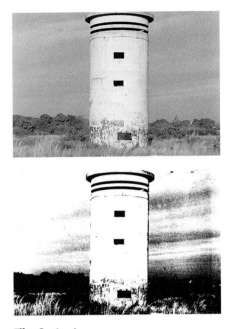

Film Contrast.
Top: Print Made from Negative on Normal-Contrast Film.
Bottom: Same Subject Photographed with High-Contrast Film.

© Bognovitz.

eliminating the intermediate tones of gray. These are used in graphic arts or for special creative effect.

■ Special Films

Chromogenic films are monochromatic—black-and-white—films designed to be processed with standard color print film chemistry, called C-41. Since C-41 processing is widely available at photofinishing labs, chromogenic films offer a black-and-white negative without the need to process it yourself. The most commonly available chromogenic films are Ilford XP2 Super and Kodak Black and White +400. Chromogenic negatives may be printed on black-and-white papers as described in chapter 5.

Instant-print films give a finished print on the spot. Polaroid pioneered these materials, and they are now available in black and white or color and in several different formats. Some instant-prints develop right before your eyes. One type of professional black-and-white Polaroid produces both a positive print and a negative that can then be printed by standard enlarging techniques. Polachrome is an instant color slide film that can be exposed in a normal 35mm camera and then processed on the spot.

The advantages of having the results in a few seconds or minutes are obvious. Photographers use Polaroid materials to check lighting setups for subjects that they then photograph using regular films. Polaroids are also useful as proofs to show a photographer's client how the finished photograph will look. A number of photographers are also using instant-print materials as the finished photographic product.

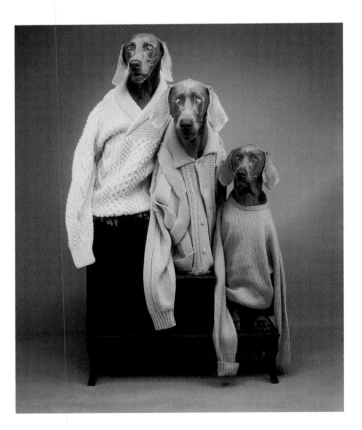

Use of Intant-Print Film. William Wegman, *Sweatered Trio,* 1990, from "Kibbles 'n Knits," 20" × 24" Polaroid.

© 1990 William Wegman. Courtesy of Pace/MacGill Gallery, New York.

■ Color Films

Color films are also based upon the use of silver halide emulsions, but since the silver itself does not have any color, dyes must be introduced into the film to reproduce the color we see in the subject. The following information is enough to allow you to choose and use color films.

Positive and Negative Color Film

Two basic types of color film are available. **Color negative film,** or color film for prints, produces an image on the film that is reversed in both tone and color. When a color negative is printed directly onto color printing paper, a color positive print is obtained. **Color positive film,** or color film for slides or transparencies, produces a positive transparency suitable for projection. Using special processes, color prints can be made from transparencies, but they are more expensive than those made from color negatives.

Color Balance

The light from various light sources does not always contain the same mix of colors as the white light from the sun. Even sunlight can vary in color, depending on the time of day or year and the weather conditions. The brain adjusts for the color of the illumination so that the colors of objects look normal to our eye. Color films do not have this ability, so films must be manufactured for a specific color of light. This is called the **color balance** of a film.

Most color films are **daylight balance,** designed for use with daylight illumination—average direct sunlight in the middle of the day. If daylight balance film is used with illumination of a different color, that color will show in the resulting image, as seen in the illustrations to the right. If warned, some processing labs can correct somewhat for these problems when printing color negatives, but the color balance of slides cannot be corrected in processing.

Tungsten balance films are designed to give correct color rendition with the tungsten light used in professional photography studios. Tungsten films will also give better results than daylight films with household tungsten lights. It is also possible to correct the color of the illuminating light with filters (see pages 202–03 for information on filters for use with color film).

Characteristics of Color Film

Sensitivity Color film sensitivity or speed is rated using ISO numbers, just as with black-and-white film.

Grain As in black-and-white film, increasing film speed means coarser grain. Color positive films generally have finer grain than color negative films of the same speed.

Exposure Latitude Color negative films can withstand some underexposure or considerable overexposure and still produce usable images. Color positive materials have little exposure latitude—sometimes as little as one-half stop each way—and require extremely accurate exposure to achieve good results.

Color Balance of Film

Daylight Film with Daylight Illumination.

Daylight Film with Tungsten Illumination. Light from household tungsten bulbs has a higher percentage of yellow or orange light than daylight, producing orange-tinted prints or slides with daylight films.

Daylight Film with Fluorescent Illumination. Fluorescent lights usually have more green than daylight and will produce green prints or slides.

■ Film Formats and Packaging

The size of the image produced on a film, called the **format size**, varies from just a few millimeters to 4 × 5 inches and larger. Format size is determined by the camera design. The same film size may be used by cameras of different image formats, but the size of the film obviously limits the maximum format size possible.

The film packaging protects it from light and usually holds the film for use in the camera. Strips of film allow-

ing several exposures are packaged in light-tight metal or plastic cartridges or cassettes or they are wrapped together with opaque paper backing on spools. Manufacturers have standardized on a few combinations of film sizes and packaging, specified by a code number, name, or actual size. Some of these are shown below. The negatives are shown life size. See pages 39–40 for more information on film formats.

Advanced Photo System (APS) Film.

Advanced Photo System (APS) film is packaged in a self-contained cartridge. **Cartridges** are inserted directly into the camera and require no handling of the film itself. After processing, APS films are returned to the consumer still in the self-contained cartridge, so the film is never handled directly. APS films also incorporate special features, such as a choice of formats (including panoramic) and a magnetic strip for data recording.

135 Film.

Commonly called 35mm film, 135 film is 35mm in width with sprocket holes on both sides, packaged in cassettes for twelve, twenty-four, or thirty-six exposures. **Cassettes** require a take-up spool in the camera. The film must be rewound into the cassette after use. 35mm film is also available in long rolls—**bulk film**—which can be cut into strips and loaded into reusable cassettes. Bulk loading reduces film costs, but the extra handling required gives a higher risk of scratches or damage to the film.

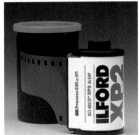

120 and 220 Films.

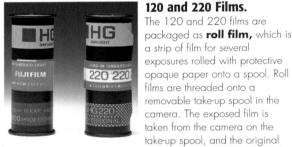

The 120 and 220 films are packaged as **roll film,** which is a strip of film for several exposures rolled with protective opaque paper backing onto a spool. Roll films are threaded onto a removable take-up spool in the camera. The exposed film is taken from the camera on the take-up spool, and the original spool then becomes the take-up spool for the next roll of film. The film—60mm in width with no sprocket holes—and spool are identical for 120 and 220, the difference being that the opaque backing continues throughout the roll for 120 but consists only of leader and trailer taped to the 220 film, allowing twice as many exposures on 220.

Sheet Film.

Film sizes 4 × 5 inches and larger are commonly available only as sheet film. **Sheet film** comes as individual sheets, one for each exposure, packed in a light-tight box. It must be loaded into light-tight film holders or magazines for use. Unprocessed film must be handled in total darkness.

■ Film Selection

A great variety of brands, types, sizes, and packaging of films is available, with new films being introduced regularly. No single film will serve for all purposes, so the type of photography you do will govern your choice of film. Subtle differences in the tonal or color qualities of a film may also determine a choice for aesthetic reasons. Preliminary choices can be made on the basis of the manufacturer's description of the film's qualities or by referring to film tests periodically published in photography magazines. To decide which film is best for you, test different films yourself under the conditions you plan for use.

Color versus Black-and-White

Black-and-white photographs are more of an abstraction of a subject than are color photographs; some photographers feel they more readily convey drama or allow for creative interpretation of the subject. Color, on the other hand, gives more information about the subject and can carry its own aesthetic messages. A photojournalist who is photographing for black-and-white reproduction in a daily newspaper may choose a black-and-white film, whereas a photojournalist who may be published in either black and white or color may choose color film, converting the color photograph to black and white through darkroom techniques when necessary. The demand in portrait or wedding photography is predominantly for color photographs, with only a few photographers offering black-and-white prints.

Color Negative versus Color Positive

The desired final image presentation is usually the determinant in a choice between positive or negative color. If the end result is to be a color print, either material can be used. Prints from color negatives are cheaper. Prints from slides have better sharpness, more brilliant color, more resistance to fading, and generally longer print life, though in recent tests one negative print material (Fuji Crystal Archive) showed better permanence than any other traditional print material, negative or positive. Slide films have finer grain for equivalent film speed.

A great deal of color reproduction in magazines for advertising and editorial work is done from color transparencies, so photographers doing advertising, fashion, travel, and similar work normally use color positive films. Photojournalists who work under difficult conditions may prefer color negative films for their greater exposure latitude. Wedding photographers prefer color negative films for the lower print costs and greater exposure latitude.

If the end result is to be a projected image, as in slide shows, then a color positive film should be used. Films that provide both slides and prints—actually designed for movies—are color negative films, with the slides produced from the negatives. As a result, these slides cannot match the quality of original slides from a color positive film.

Film Speed

Choice of film speed depends upon the amount of light illuminating the subject, the desired camera settings (shutter speed and aperture), and the desired fineness of grain. Although faster film speeds give faster shutter speeds or smaller apertures, they also produce coarser grain. The general rule is to use the slowest possible film that will give the needed shutter speed and f-stop settings for the available illumination.

Murray Bognovitz. This image was photographed on color negative film.

© Murray Bognovitz.

■ Film Care and Handling

Photographic films are relatively fragile and require care in handling and storage. The proper techniques are the same for unexposed and exposed films. For best results, exposed films should be processed as soon as possible, but if they must be held for some time before processing, the tips for longer storage given below will help preserve the latent image. In general, color films are more sensitive to storage conditions than are black-and-white films.

Film Storage

Several environmental conditions can affect film quality:

Humidity Exposure to high relative humidity or liquids is damaging to film. The moisture-proof packaging should not be opened until a film is loaded into the camera. After exposure, the film should be stored in a moisture-proof container. Usually 35mm film comes in a small plastic can, which can be reused for moisture protection. Zippered plastic bags can be used to protect films whose foil packets are destroyed by opening.

Temperature Higher temperatures cause deterioration of film; lower temperatures—the lower the better—maintain the condition of film. Do not leave film or loaded cameras in automobiles, where in the summer temperatures can soar. Films can be frozen in home freezers or kept in refrigerators to extend their useful life. Films labeled Professional require refrigerated storage to maintain optimum quality.

■ **CAUTION** Refrigerators and freezers contain high humidity, so films *must* be placed in moisture-proof packages before they are refrigerated or frozen. Allow films to warm up to room temperature before opening to prevent condensation of moisture on them.

Warm-up Times for Refrigerated Photographic Film (in Hours)

	FROM 35°F TO 70°F	FROM 0°F TO 70°F
One roll (35mm, 120, 220)	1	1½
Bulk roll (35mm, 100 ft)	3	4
Sheet film (10-sheet box)	1	1½
Sheet film (100-sheet box)	3	4

Accidental Exposure to Light Accidental exposure of unprocessed film to light causes **fogging** of a film, giving undesirable streaks and ruining images. Be careful not to disturb the light-tight packaging of the film. Although a film may be packaged for "daylight" loading, cassettes, cartridges, roll film, and sheet film holders should not be exposed to the direct rays of the sun but should be handled in subdued light. If forced to load film into a camera in direct sunlight, do so in the shadow of your body if no other shade is available.

■ **CAUTION** General-usage films removed from their light-tight containers for processing or other purposes must be handled in total darkness.

Exposure to X rays The use of X-ray devices at airports and other high-security locations puts film at risk. Even though security personnel may claim that the machines are safe, all photographic films are sensitive to X rays and can be fogged, especially with repeated exposure. Fast films are particularly susceptible to X-ray damage. Hand inspection is the best protection for your film. Most U.S. airports will hand inspect on request, but many areas in the world with high security risks will not. An alternative is to place your films and loaded cameras in lead-foil bags—available at camera stores—which offer some protection from X-ray exposure. Checked baggage is also often subjected to X-ray inspection.

Age Although proper storage extends film life, over time a film will deteriorate. Manufacturers stamp an expiration date on the film package. This is an estimated date for which the film retains optimum quality with average storage conditions. For consumer films, this means storage in the original packaging at normal room temperatures. For professional films, it means refrigerated storage according to the directions. Storage of any film in a freezer at 0°F can extend the usable life well past the expiration date.

Film Handling

Photographic films are sensitive to scratching and fingerprints. Take care that the image-bearing surfaces of a film are not touched or rubbed against abrasive surfaces. This caution applies before and after processing of the film. Film can also be scratched by dust or dirt inside the camera. Keep the camera clean, as instructed in chapter 3.

When advancing or rewinding film, use a slow, steady motion to prevent static electricity discharge from marking the film. Dry weather increases the possibility of static discharge.

■ Film Exposure

A major factor in making photographic images of good technical quality is the amount of **exposure** to light the film receives. The definition of exposure can be given as a formula:

Film exposure = Illuminance of image on film × Time

"**Time**" is the length of time the image is allowed to fall on the film, normally equal to the time the shutter is open (the shutter speed).

"**Illuminance**" is the amount of light falling on a surface, in this case the image formed on the film from light coming from the subject. Any factors that change the amount of light coming from the subject will also change the film exposure. The amount of light reflected from the surface of the subject is called the **luminance** and is affected by two variables:

1. The **illumination,** which is the amount of light falling on the subject
2. The **reflectance,** which is the ability of the surface to reflect light

The amount of light reaching the film is also altered by passage through the lens, particularly by the size of the aperture. A simple statement summarizes this information: *Film exposure depends upon* subject luminance (*illumination and reflectance*) *and* camera settings (*f-stop and shutter speed*). If we wish to get correct exposure we must be able to measure or control all of these factors.

Camera Settings and Exposure

Film exposure can easily be controlled by adjusting the shutter speed and f-stop settings on the camera.

Shutter Speed Shutter speed dials are marked with standard shutter speeds in seconds:

1 1/2 1/4 1/8 1/15 1/30 1/60 1/125 1/250 1/500 1/1000
More Exposure ← → Less Exposure
(Slower Speeds) (Faster Speeds)

Some cameras may have additional speeds at either end of this scale. Most cameras also have a B setting. When the shutter speed control is set on B, the shutter remains open as long as the shutter release is held down, allowing times longer than those marked on the scale.

A simple mathematical relationship exists between numbers of this scale: Each shutter speed is half the preceding one. Since film exposure depends directly on the time the shutter is open, we alter the film exposure by a factor of two each time we move the shutter speed dial one step: 1/125 second gives half as much film exposure as 1/60 second and 1/8 second gives twice as much film exposure as 1/15 second. NOTE: Some of the speeds have been rounded off to give neat-looking numbers— 1/15 second should technically be 1/16 second and so on—but for practical purposes we can say that each shutter speed is half the one before it. The faster speeds give less film exposure, each step dividing the exposure by a factor of two. The slower speeds give more film exposure, each step multiplying the exposure by a factor of two. More about shutter types and the effects of changing shutter speed can be found on pages 43–47.

Aperture The aperture is a variable opening in the lens consisting of an iris-type diaphragm. The size of the aperture is controlled by a ring with **f-stop numbers,** also called f-numbers, marked on it.

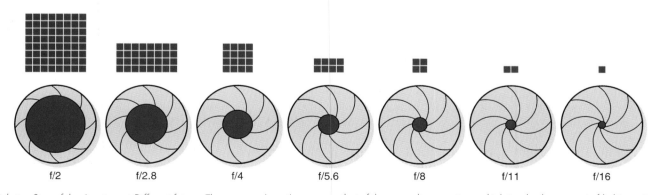

f/2 f/2.8 f/4 f/5.6 f/8 f/11 f/16

Relative Size of the Aperture at Different f-stops. The squares show the relative area of the aperture. Note that the area of each aperture is half that of the preceding aperture, which is why the amount of light passing through the aperture is reduced by half for each step on the scale.

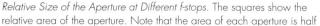

A standard scale of f-stop numbers is used (see page 54 for the origin of these f-stop numbers):

1 1.4 2 2.8 4 5.6 8 11 16 22 32
More Exposure ← → Less Exposure
(Opening Up) (Closing Down)

The smaller f-stop numbers give *more* exposure because they actually represent *larger* apertures. The f-stop numbers have been chosen so that changing one step on the scale changes the film exposure by a factor of two, just as it does on the shutter speed scale: f/8 gives twice as much film exposure as f/11 and f/5.6 gives half as much film exposure as f/4. **NOTE:** Some lenses have click stops between the numbers to allow half-f-stop settings.

The Stop as a Measurement of Exposure

When the aperture scale is moved one step, the exposure is changed by a factor of two. This is called a change of one **stop** in exposure. The terminology used by photographers is this:

Doubling the exposure = **Opening up** one stop

Halving the exposure = **Closing,** or **stopping, down** one stop

The exposure can be doubled in two ways:

1. Move the aperture ring to the next-larger aperture (next-smaller f-stop number)—for example, from f/8 to f/5.6.
2. Move the shutter speed dial to the next-slower shutter speed—for example, from 1/250 second to 1/125 second.

Likewise, the exposure can be halved by either moving to the next-smaller aperture (next-larger f-stop number) or moving to the next-faster shutter speed. The effect on the film exposure is the same, and although technically the term *stop* applies only to the aperture, it is commonly used to describe exposure changes made with the shutter speed as well. **NOTE:** Some lenses have f-stop numbers that do not appear on the standard scale, such as f/1.2, f/1.7, f/1.8, f/3.5, and f/4.5. These f-stop numbers represent fractional stops of exposure change. Moving the aperture ring from f/2.8 to f/1.8 increases the exposure 1–1/3 stops, not one stop.

Since the change in exposure for each stop is a multiple of two, the exposure increases or decreases as a power of two. For example, opening up one stop gives 2 times as much exposure; opening up two stops gives $2 \times 2 = 4 \times$ as much; opening up three stops gives $2 \times 2 \times 2 = 8 \times$ as much, and so on. Closing down one stop gives half as much exposure; closing down two stops gives one-fourth as much; closing down three stops gives one-eighth as much.

Shutter Speed and F-Stop Combinations

Since both shutter speed and f-stop scales are based on factors of two, the same film exposure can be achieved with a number of different shutter speed and f-stop pairs. A camera setting of f/8 at 1/60 second produces the same exposure on the film as a camera setting of f/5.6 at 1/125 second because f/5.6 gives twice as much exposure as f/8 but 1/125 second gives half as much exposure as 1/60 second. The end result is the same. This procedure can be continued to give a set of pairs of shutter speed and f-stop settings, known as **equivalent exposure settings,** any one of which will produce the same film exposure. Achieving correct exposure on the film can be compared to filling a bucket with water, as seen below..

Normally the different shutter speed and f-stop pairs that produce equivalent film exposure also produce the same density on the film, a fact known as the **reciprocity law,** which states: *The effect of exposure on the film—that is, the density—is the same, regardless of the rate at which the exposure is given.* In other words, the density due to a particular image illuminance and time will be the same as the density due to that image illuminance halved and that time doubled. The use of equivalent exposure settings depends upon the reciprocity law. However, the reciprocity law fails at long or very short exposure times, giving less density than expected. Reciprocity failure may be corrected by increasing the exposure time or aperture. See pages 36–37 for reciprocity failure corrections.

	Controls flow rate	Aperture
		Shutter speed
	2 gallons	Correct film exposure

Flow rate	Time to fill 2-gallon bucket	
2 gal./min.	1 minute	f/4 at 1/125 second
1 gal./min.	2 minutes	f/5.6 at 1/60 second
1/2 gal./min.	4 minutes	f/8 at 1/30 second

Equivalent Exposure Settings. The amount of water in the bucket (the amount of film exposure) can be controlled in two ways: the flow rate can be controlled with the faucet (the aperture), and the time the faucet is left on (the shutter speed) can be varied. If the bucket holds 2 gallons, we can fill it just to the top in many different ways. With a flow rate of 2 gallons per minute, it will take 1 minute to fill the bucket. At 1 gallon per minute, it will take 2 minutes to fill the bucket. You can continue halving the flow rate if you remember to double the time. All the combinations in the chart give the same result—a full bucket—just as all the equivalent exposure settings give the same amount of exposure on the film.

Effects of Film Exposure Changes

The negatives below show effects of changing the film exposure. The overall density, or darkness, of the negative increases as the exposure increases. Negatives of low density are said to be **thin.** A more important change can be seen in the areas of the negative representing the dark tones of the subject—often called the **shadow** areas—which are the less dense, or lighter, areas in the negative. As exposure is decreased, these areas begin to lose **detail**, or tonal **separation** which is the visible evidence of texture or pattern.

The "best" or **optimum exposure** is the least exposure that retains detail in the areas representing the dark tones of the subject. Negatives receiving less than this optimum exposure are **underexposed** and show loss of de-

tail in the dark subject tone areas. Prints made from underexposed negatives will also show a reduction of contrast, which is the difference between the dark and light tones of a print.

An **overexposed** negative, one that received more than the optimum exposure, shows good detail in the dark tone areas but has unnecessarily high overall density. This produces coarser grain in the image and longer printing times when prints are made from the negatives. If the film is overexposed enough, detail will be lost in the areas representing the light tones of the subject—often called the **highlights**—and sharpness of the image will deteriorate. Loss of detail in the light subject tone areas of the negative due to overexposure is called **blocking up of highlights.**

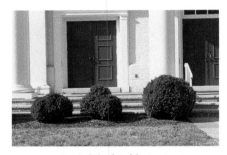

Original Subject.

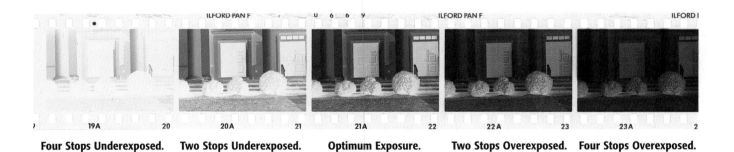

| Four Stops Underexposed. | Two Stops Underexposed. | Optimum Exposure. | Two Stops Overexposed. | Four Stops Overexposed. |

Underexposure:
- Low overall density of the negative (thin)
- Loss of detail in dark subject tone areas
- Reduction of contrast in negative and final print

Optimum exposure:
- Proper detail in dark subject tone areas
- Reasonable printing times
- Finer grain than with overexposed negatives

Overexposure:
- High overall density
- Coarse grain
- Long printing times
- With extreme overexposure, blocked-up highlights and reduced sharpness

Film Sensitivity and Exposure

An ISO film speed index is derived from actual tests performed on a film by the manufacturer. The ISO number is calculated from the amount of exposure needed to produce a standard density on the film. Films with lower ISO numbers are less sensitive to light, requiring more exposure to achieve the same density. Here is a partial list of the standard scale of ISO numbers, which are a combination of the ASA and DIN numbers:

ASA **25** 32 40 **50** 64 80 **100** 125 160 **200** 250 320 **400** 500 640 **800**
DIN **15** 16 17 **18** 19 20 **21** 22 23 **24** 25 26 **27** 28 29 **30**

NOTE: Some numbers are rounded off in this scale: Two times 64 should give 128, but 125 is used, and so on. Doubling the ASA, or adding three to the DIN, indicates that one stop less exposure is required. If ISO 100/21° film requires a camera setting of f/8 at 1/60 second for correct exposure, then an ISO 200/24° film will require one stop less exposure, or f/11 at 1/60 second, assuming the same subject and lighting. The ASA doubles every third number, each number on the scale representing a one-third stop change in the necessary exposure. An ISO 160/23° film requires one-third stop more exposure than an ISO 200/24° film.

The ISO number a manufacturer gives a film should be thought of only as a guide or starting point. Your personal equipment—camera, lens, and meter—and your techniques may vary from those used in the manufacturer's film speed tests. Film speed may also vary slightly depending on the emulsion batch of the film. See page 12 for a discussion of emulsion batch.

Start by using the ISO provided by the manufacturer. If that does not give the desired results, the amount of exposure supplied to the film can be altered by manipulating the ISO (ASA/DIN) scale on the light meter, or on the camera if you are using a built-in meter. Setting a higher ISO into the meter will give less film exposure, as demanded by more sensitive films. Setting a lower ISO will give more film exposure.

Knowledge about the available films and the effects of exposure on the film will allow you to express yourself through photographs under nearly any lighting conditions. An important tool for controlling film exposure is the photographic light meter. The following sections give an in-depth treatment of light meters and their use for controlling the quality and appearance of photographs.

© Bruce Warren

■ Light Meters

To achieve correct film exposure, we must measure the amount of light coming from the subject into the camera lens. The tool used for measuring amounts of light in photography is the photographic **exposure meter,** usually called a **light meter.** Light meters may be incorporated in the camera body (**in-camera light meters**) or contained in a separate housing (**hand-held meters**). Photographic light meters are also divided into two categories by the way they measure light: the **reflected-light meter** and the **incident-light meter.**

In-Camera and Hand-Held Light Meters

In-camera meters have become so common that many people do not realize that the meter is not an integral part of the camera. Meter and camera are two distinct pieces of equipment, even when combined in one body. The design and use of in-camera meters are governed by the same principles as those governing hand-held meters, with the major distinction being that in-camera meters can be coupled to the controls of the camera to allow direct transference of meter readings, either automatically or manually.

Through-the-lens (TTL) in-camera meters measure the light after it has passed through the camera lens and will sense any alterations in exposure due to lens changes, filters, or close-up attachments, providing corrected camera settings. Some TTL meters, called **off-the-film (OTF)** meters, measure the light reflected from the film during exposure. These are useful when light may change during the exposure or when the camera meter is capable of metering and controlling flash exposure.

In-camera meters without TTL metering have the light meter receptor placed on the exterior of the body. Non-TTL and hand-held meters will not adjust for lens attachments or procedures that might change the amount of light reaching the film. One exception is a non-TTL meter with the sensor located above the lens in such a way that filters placed on the lens cover the sensor as well. In that case, the effect of the filter on exposure is sensed by the meter.

Incident- and Reflected-Light Meters

The incident-light meter gives no information about the effect of the subject on the light, which means that the photographer must be familiar with the interaction of subject and light. The major strength of the incident-light meter is its ability to measure evenness and balance of light sources, which is useful when exercising control over the lighting. Photographers working in situations where lighting is not under their control or where it is inconvenient to make meter readings at the subject most often use reflected-light meters.

All in-camera meters are of the reflected-light type. Hand-held meters can be purchased in either reflected or incident types. The identifying feature of an incident-light meter is the translucent plastic dome—sometimes a disc—covering the receptor, whereas a reflected-light meter will have a lens to collect light. Many hand-held meters in use today are convertible from reflected mode to incident mode.

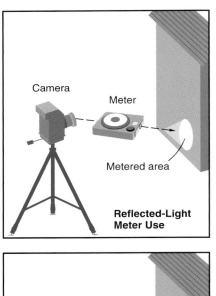

Reflected-Light Meter Use. Top: Reflected-light meters (also known as luminance meters) measure the amount of light emitted or reflected by the subject (the luminance). Since the light of interest to the photographer is that which enters the camera lens, these meters are normally pointed at the subject either from the position of the camera or along a line from the camera lens to the part of the subject being metered.

Incident-Light Meter Use. Bottom: Incident-light meters (also called illuminance meters) are designed to measure the amount of light falling on the subject (the illuminance). For that reason they are normally placed at the position of the subject and pointed back toward the camera.

Angle of View

The **angle of view** is a measurement of how much of a subject a meter "sees." Any light coming from the part of the subject within the angle of view is sensed by the meter and included in the meter reading. Angle of view strictly applies only to reflected-light meters, since incident-light meters are generally designed to accept light coming from anywhere in a 180° hemisphere.

The shape of the area sensed by the meter, called the metering pattern, varies from meter to meter. A meter with a circular metering pattern includes any subject matter inside a conical shape extending from the meter. The angle of view for this type of meter is the angle across the cone. A meter with a rectangular metering pattern includes any subject matter within a pyramidal shape, the angle of view being measured across the diagonal of the pyramid.

Hand-Held Metering Patterns Hand-held meters are designed with various angles of view. **Averaging meters** have an angle of view of 30°–45°, covering about the same subject area as a camera equipped with a normal lens. They are called averaging meters because when used from camera position they integrate all the different luminances in a subject—due to differing subject tones or illumination—into one reading. **Restricted-angle meters** have angles of view of 5°–20°, allowing smaller areas of a subject to be read from camera position. **Spot meters** have an angle of view of only 1° or 2°, allowing very small areas of a subject to be read, and are useful for metering small subjects or if a subject cannot be approached for close-up readings.

If meter readings are to be accurate, it is important to know what is included in a meter's angle of view. Most hand-held averaging meters do not include a viewing system, so the subject inclusion must be estimated. The chart in the illustration (top right) gives the diameter of the circle seen at different distances by a 30° meter. Hand-held meters with restricted angles of view normally have a viewing system to show subject inclusion.

In-Camera Metering Patterns The angle of view of a TTL meter depends on the metering pattern and the lens being used on the camera. If you know the metering pattern for your TTL meter, you can see visually through the viewfinder what is being metered. Matrix metering complicates this by simultaneously taking several meter readings at different points or areas in the image and then calculating a camera setting on the basis of a built-in computer program. It is difficult to predict what results such meters will give. The choices of exposure made by the designers of the program may or may not coincide with your desires. Some cameras offer a selection of more than one metering pattern, allowing the possibility of switching from center-weighted to matrix or spot readings. Refer to your operator's manual for your camera.

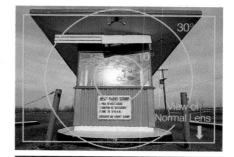

DISTANCE FROM METER	DIAMETER OF CIRCLE SEEN BY METER	
	30° Meter	1° Meter
1 ft	6.4 in.	0.2 in.
3 ft	1.6 ft	0.6 in.
10 ft	5.4 ft	2.1 in.
30 ft	16 ft	6.3 in.

Subject Inclusion for Different Angles of View Metered from Camera Position.

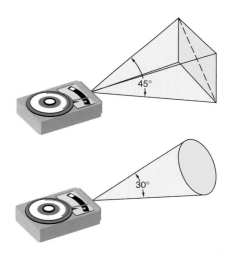

Hand-Held Metering Patterns
Top: Angle of view for a meter with a rectangular metering pattern. Bottom: Angle of view for a meter with a circular metering pattern.

In-Camera Metering Patterns
Left: *Center Weighted.* The entire field of view is metered, but more value is given to the center of the field. Right: *Matrix Metering.* Readings from each of the zones are analyzed by an in-camera computer to produce a single reading.

All photos this page © Bognovitz.

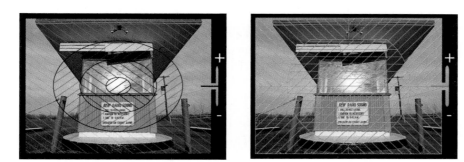

Match-Needle Transfer. One needle is connected to the metering mechanism and gives an indication of the amount of light. The second is connected to the outer calculator dial. Superimposing the two needles transfers the light meter reading into the calculator.

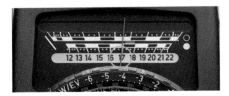

Number Transfer. The number indicated by the needle is a measure of the amount of light. This number is set into the meter number window on the calculator by rotating the outer calculator dial.

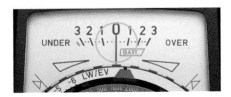

Null System Transfer. One needle moves with both the amount of light and the outer calculator dial. Rotate the dial until the needle is balanced in the center—the zero point—of the meter. This method is also called the centering or zero method.

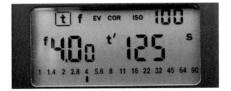

Electronic Transfer. The meter reading is transferred electronically into the calculator, giving a direct readout of a suggested shutter speed and f-stop pair in digital form using LCDs. Although this type of transfer requires less manipulation to get a camera setting, it only displays one shutter speed and f-stop pair at a time. If other equivalent pairs are desired, they may usually be scrolled through on the display.

Light Meter Design

Many different light meter designs have been developed over the years. Each design does some metering jobs better than others. Several light meter design aspects have been discussed already—in-camera versus hand-held, reflected versus incident, angle of view—but other design features affect meter operation as well.

A light meter has two major components with different functions:

Metering mechanism. The metering mechanism is the part of the meter that senses and measures the amount of light. It consists of a light-sensitive cell and the necessary electronic circuitry to give an indication of the amount of light striking the cell.

Calculator. The reading of the amount of light is transferred from the metering mechanism into the calculator, which reads out suggested camera settings, taking into account the film speed. Calculators may be mechanical—usually a device like a circular slide rule—or electronic.

Much of the variation in design of meters has to do with the type of light-sensitive elements used in the metering mechanism and the way the metering information is transferred into the calculator.

Light-Sensitive Elements Three major categories of light-sensitive elements are used in meter construction: selenium cells, cadmium sulfide cells, and photodiode cells.

The **selenium cell** is the oldest type and has the advantages of low cost and not requiring a battery, but it is less sensitive, bulky, and slow in response.

The **cadmium sulfide (CdS) cell** is a more recent type that is intermediate in cost, compact, and sensitive. It requires a battery, is slow in response, and exhibits a memory of bright light sources, which means that after exposure to higher levels of light, falsely high readings may be obtained at lower light levels. This is a temporary effect and normally takes a few minutes or less to disappear. Users of cadmium sulfide meters should try to avoid prolonged exposure of the cell to intense sources of illumination such as the sun.

Photodiode cells are the latest type. Photodiode meters either use silicon and are called silicon blue cell (Sbc) or silicon photodiode (SPD) meters or they use gallium arsenide and are called gallium arsenide photodiode (GPD or GAP) meters. The main difference is that silicon cells are sensitive to infrared and gallium arsenide cells are not—a problem eliminated by internal filtering in the meter. A major distinguishing feature of the photodiode meters is that their response to changes in light is so fast that with the proper circuitry attached, electronic flash can be read. They are also sensitive and compact, but more expensive than other types and require a battery.

Modern in-camera meters make use of either CdS or photodiode sensing cells, because of their compact size. Cameras with flash-metering capability use photodiode cells.

Hand-Held Reading Transfer Several systems are used to transfer the meter reading into the calculator so that camera settings can be chosen. Meter readings may be indicated by a needle, by liquid crystal display (LCD), or by a series of light-emitting diodes (LEDs). The illustrations to the left show four different hand-held reading transfer methods.

In-Camera Reading Transfer Most in-camera meters are coupled mechanically or electronically to the shutter speed or the aperture or both, with metering information shown in the viewfinder. Transfer of the metering information to the camera controls may be done manually or automatically.

Manual Operation In manual operation, the readout of the in-camera meter—usually seen in the viewfinder—is manually transferred to the camera settings by the photographer. Transfer methods are the same as with hand-held meters. The meter readout may be coupled to one or both of the camera controls, so the effect of manipulating the controls can be monitored in the viewfinder.

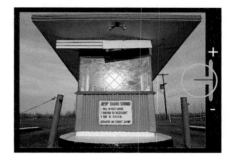

In-Camera Null System Transfer. Center the needle by manipulating the shutter speed and aperture controls.

Automatic Operation In automatic operation, the photographer sets one control manually and the meter automatically adjusts the other according to the meter reading. **Aperture priority** means that the aperture is set manually and the meter sets the shutter speed automatically. **Shutter priority** means that the shutter speed is set manually and the meter sets the aperture automatically. In **program operation,** the meter sets both the shutter speed and the aperture automatically, based on the amount of light. The photographer has no control over either camera setting. The choice of shutter speed and aperture for each light level is preselected and programmed into the meter. The programs vary from camera to camera. Some owner's manuals will give a chart outlining the shutter speed and f-stop pairs chosen for each light level.

Many of today's sophisticated cameras offer a selection of operating modes for the meter. Some cameras can be operated in manual, shutter-priority automatic, aperture-priority automatic, or program automatic by a flick of a switch. Many cameras even offer more than one program mode, one favoring faster shutter speeds—often called an action program—another favoring smaller apertures.

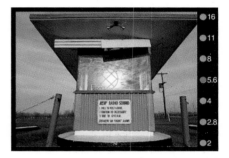

In-Camera Number Transfer. The lit LED indicates an f-stop, which is then manually set on the aperture control ring.

Photos © Bognovitz.

Readout of Camera Settings Hand-held meters using circular calculator dials display all the possible equivalent camera exposure settings at one glance. In-camera meters and hand-held meters with digital readout, on the other hand, provide only one equivalent exposure setting at a time. The other equivalent settings can be seen only by manipulating the controls of the camera or meter so that each is displayed in turn.

Most hand-held meters have a scale labeled EV, which stands for **exposure value.** Exposure values are often used for comparison of light meter readings. A change of one in the EV indicates a change of one stop in the meter reading. A meter reading of EV 13 is one stop higher than a reading of EV 12; twice as much light is coming from the subject. It is possible to have negative exposure values for very low light levels. **IMPORTANT:** The EV changes with the ISO, so comparison readings must be done with the meter set for the same ISO.

EVs are widely used to describe light meter sensitivity, usually at ISO 100/21°, which should be specified in the manufacturer's literature. The EV is meaningless without the ISO. EV 15 at ISO 100/21° is a typical daylight reading, giving a camera setting of f/16 at 1/125 second. An indoor exposure might yield EV 6 at ISO 100/21°, giving a camera setting of f/2 at 1/15 second. EV 0 at ISO 100/21° is a very low reading, requiring a camera setting of f/2 at 4 seconds.

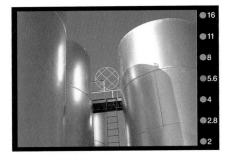

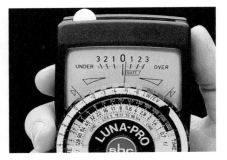

LED Readout. No fractional f-stop readings are possible on this scale, since only the full f-stops are indicated.

© Bruce Warren.

LED Readout. On some cameras, two LEDs light when the reading is between f-stops, giving readings to the nearest half-stop.

© Bruce Warren.

Needle Readout. A reading can be estimated to a fraction of a stop. Here the reading is one-third-stop higher than f/5.6 at 1/125 sec.

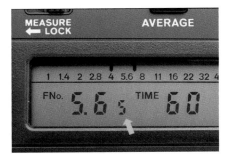

LCD Readout. The small number (arrow) indicates tenths of a stop.

Reading Discrimination Meter readout indicated by needle mechanisms (**analog readout**) has largely been replaced by electronic readout in numerals (**digital readout**) or a scale of flashing light-emitting diodes (LED readout). Although the new readout techniques give some convenience, they often sacrifice one strength of analog readout, the ability to estimate readings of fractional f-stops. The movement of even the cheapest needle mechanism will indicate an exposure change—a **reading discrimination**—of one-third stop or less; the reading discrimination of digital and LED readouts is limited by their design. Many LED readouts, even in the most expensive in-camera meters, will give readings only to the nearest half-stop or sometimes only to the nearest stop. Digital readouts can be designed to give readings to the nearest tenth of a stop. If you intend to do work requiring accurate meter readings—for example, color transparencies—this should be taken into account. In automatic metering mode, most cameras using LEDs control the exposure more accurately than is indicated by the readout. The problem is using these in-camera meters in manual mode, where accurate meter readings are desired.

Reading discrimination should not be confused with the accuracy of a meter. Just because a meter gives readings to a tenth of a stop does not guarantee that it is accurate to a tenth of a stop. On the other hand, a meter that reads only to the nearest half-stop can never give accuracy better than one half-stop. The accuracy of a meter can only be determined by comparing its readings to a known standard.

Choosing a Light Meter

As with any piece of equipment, choice of type, brand, or model depends largely on the intended use. Many photographers will find no need for a meter beyond the one built into their camera. Working photographers usually have more than one meter—hand-held or in-camera—as backup or for specialized purposes.

The convenience and, with TTL types, the ability to account for exposure-modifying accessories and techniques are obvious advantages of in-camera meters. Modern cameras offer a wide selection of metering features, including various metering patterns (see page 25), that strongly influences the purchase of a camera.

The advantages of automatic in-camera metering are the speed and ease of operation. The disadvantage is the loss of control over the metering process. Many photographers do not feel the need for manual operation of the meter.

Hand-held Meter System with Accessories.

However, as you progress in photography, you will find situations where manual control of metering is useful. For this reason, it may be wise to choose a camera that offers both manual and automatic modes or at least exposure override of the automatic metering process. In some cameras, switching to manual mode shuts off the meter. If you wish to meter while in manual mode, this is an obvious disadvantage.

Hand-held meters offer advantages as well. They can be used independently of the camera, which is convenient if the camera is mounted on a tripod. Some models of hand-held meters offer far more sensitivity to low light levels or a wider flexibility of use through modes or accessories than do in-camera meters.

The usual first choice for a hand-held meter is a 30°–45° averaging meter. Although the ability of a spot meter to measure very small areas of a subject might seem like a powerful advantage, evaluation of spot meter readings requires considerable experience and knowledge. The choice of sensing cell, reading transfer method, and readout discrimination depends on your personal use of the meter.

Whether you are purchasing a hand-held meter or a camera with built-in meter, the best way to determine its feel and see if its features match your needs is to go to a well-equipped camera store and experiment with as many different models as possible.

Care and Handling of Meters

Light meters are very fragile, so the main consideration is to protect them from shock or rough handling. Allowing a hand-held meter to dangle or swing on its cord exposes it to possible damage. Meters placed in a shirt or blouse pocket may easily fall out. When placing a meter or camera on a surface, make sure it is not close to the edge. Meters should also be protected from dirt and moisture.

If treated carefully, meters do not require extensive maintenance. If your meter has a battery, change it according to the manufacturer's directions. Most batteries have a life of about a year, although some newer types will last several years. Many meters have a battery check procedure, which will indicate when the battery needs replacing. If the meter is stored for any length of time, remove the battery. If the meter quits working or you have reason to believe it is not giving proper results, test it.

See page 121 for some simple testing techniques for light meters.

Reflected-Light Meter Operation
An averaging meter mixes all the tones within
the metered area and produces a reading as if
they were all one tone.

© Bognovitz.

■ Operation of Reflected-Light Meters

Since reflected-light meters are the most widely used, only their operation is
discussed here.

Meter Response to Subject Tone

The subject being photographed usually contains many different tones (re-
flectances), each providing a different luminance. The reading given by the light
meter consists of an averaging of all the luminances within the metering area.

Subject as 18 Percent Gray When a meter calculates camera settings, it must
take into account the reflectance of the area metered to achieve correct film
exposure. Because of the wide variety of tonal distribution in different sub-
jects, meter manufacturers must make an assumption about the average sub-
ject reflectance. They assume that all the tones in a typical subject average
out to a gray of 18 percent reflectance—an area reflecting 18 percent of the
light falling on it. To the eye this looks like a tone midway between black
and white, so 18 percent gray is also called **middle gray.** *Light meters will give
camera settings for correct film exposure only if the average tone of the subject area
metered is 18 percent gray.* Because of this design feature, it is often said, *"Light
meters read everything as 18 percent gray."*

Correcting for Other Subject Tones Many subjects do not average 18 percent
gray and will cause problems with metering. The illustrations show what hap-
pens when subjects of three different tones are metered. In each case they re-
produce as 18 percent gray, because the light meter is designed to produce

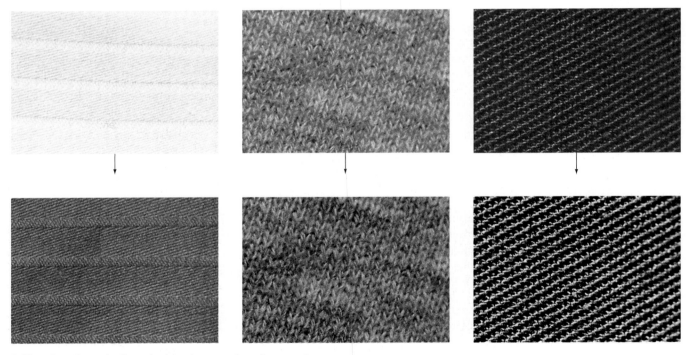

Subject Tone Reproduction. The first subject is white, the second gray,
and the third black. When the meter reading from each is used for the
camera settings, middle gray will be reproduced in the print.

proper exposure only for an average tone of 18 percent gray. If a subject contains predominantly light tones, the meter sees it as a middle gray subject with brighter illumination and gives camera settings so that the film exposure is reduced for proper 18 percent gray reproduction. In other words, the film exposure is too low for proper reproduction of the light tones. Using the suggested camera settings for a meter reading off light tones thus produces underexposure. Conversely, metering dark tones produces overexposure.

It is up to the photographer to modify the camera settings suggested by the meter to insure the proper exposure for tones other than middle gray. Opening up from the camera settings suggested by the meter produces a tone lighter than 18 percent gray in the finished positive image, and stopping down produces a darker tone. The illustration below shows the results of these exposure changes on the tones in the print. The material on these two pages is the basis for methods of exposure and development called **tone control**. The best known tone control system is the **Zone System**, devised by Ansel Adams. Refer to the bibliography at the back of the book for references dealing with tone control.

Relationship of Print Tones to Exposure. The scale of grays shows the print tones resulting from opening up or closing down from the camera settings suggested by the meter.

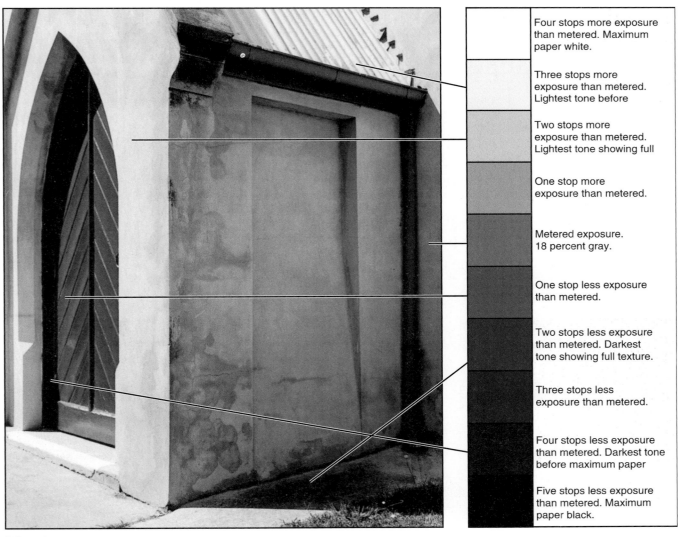

Four stops more exposure than metered. Maximum paper white.

Three stops more exposure than metered. Lightest tone before

Two stops more exposure than metered. Lightest tone showing full

One stop more exposure than metered.

Metered exposure. 18 percent gray.

One stop less exposure than metered.

Two stops less exposure than metered. Darkest tone showing full texture.

Three stops less exposure than metered.

Four stops less exposure than metered. Darkest tone before maximum paper

Five stops less exposure than metered. Maximum paper black.

© Bognovitz.

Metering Methods

Some standard methods of metering may make it easier to deal with the rather complex task of determining proper camera settings. Recording metering data in a permanent notebook will give you a reference for analyzing your results and increase the speed with which you learn to handle various metering situations.

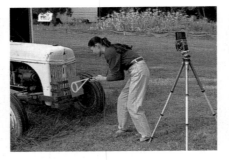

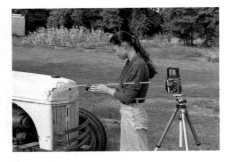

Overall Reading. (Method used in chapter 1.) To make an overall reading, an averaging meter (30°–45° angle of view) is pointed at a subject from the position of the camera. In-camera meters with a metering pattern covering the full field of view of the lens—including center-weighted systems—give an overall reading. This is a quick and easy type of reading to make and will give good results in a high percentage of situations. Since an overall meter reading averages the luminances of the subject, the average tone must be close to middle gray to get proper exposure. Luckily, many subjects do come close to this average. If the subject has a predominance of light tones, an overall reading can be adjusted by opening up one or more stops. A predominance of dark tones will require stopping down to achieve correct exposure.

Substitute Reading. If a subject is difficult to meter because of its small size, inaccessibility, or unusual tonal distribution, something other than the subject can be metered in its place and camera settings can be based on that reading. A standard substitute is a card that is 18 percent gray in tone, available at photographic stores. Other substitutes might be objects that are similar to the subject but more accessible for metering. Some photographers meter their own hand for a skin tone exposure when it is inconvenient to measure the skin tone of the subject. The principal thing to remember about substitute readings is that they were not made directly from the subject and may therefore give incorrect exposure.

Close-up Reading. One area of the subject is chosen as important and a close-up meter reading is made of that area. The meter must be kept on a line from the camera lens to the area being metered. If the average tone in the area being metered is not close to an 18 percent reflectance, the camera settings suggested by the meter must be adjusted using the illustration and chart on page 31 as a guide. Since proper exposure on the negative is determined by the amount of detail in the areas corresponding to the dark tones of the subject, a common use of this method is to meter the darkest area of the subject in which full detail and texture are desired, then stop down two stops from the camera settings suggested by the meter.

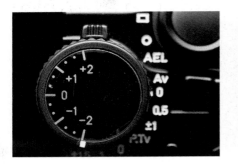

Automatic in-camera meters without exposure override can be "fooled" into giving more or less exposure by adjusting the ISO. Doubling the ASA (adding three to the DIN) will give one stop less exposure; quadrupling the ASA (adding six to the DIN) will give two stops less exposure. **IMPORTANT:** When metering a specific tone of the subject, be sure that only that tone is included in the field of view of the meter for correct results.

A. Close-up Readings with Automatic Metering. The automatic in-camera meter must offer automatic exposure override and a way of locking in meter readings for proper close-up readings. For a fully detailed dark tone, set the exposure override on −2 (×1/4 on some cameras).

B. Make a close-up reading of the dark tone and lock it in, back up for proper composition, and shoot. Remember to reset the exposure override to 0 (×1 on some cameras) when finished.

Difficult Metering Situations Some frequently occurring metering situations do not respond well to a straight overall meter reading.

Backlighting. A backlit subject has the largest amount of illumination coming from behind it. In the illustration on the left, the bright background has given a falsely high overall meter reading, resulting in underexposure of the subject. To prevent this problem, do a close-up reading of the important subject area. If it is impossible to get up close

to the subject, open up one stop—or more if the background is very bright or occupies a large part of the image area—from an overall meter reading. The illustration above shows the effect of a close-up reading from the central subject.

Light Subject Tones. A **high key subject** has predominantly light tones. Open up one or more stops from the overall reading. A small subject against a large, light background requires the same type of correction to an overall reading or, if possible, take a spot meter reading or move up and take a close-up reading of the subject.

© Bognovitz.

Dark Subject Tones. A **low key subject** has predominantly dark tones. Close down one or more stops from the overall reading. A small subject against a large, dark background will require the same type of correction to an overall reading, or take a close-up reading or spot meter reading of the subject.

© Bognovitz.

Bracketing In difficult metering situations or when exact exposure is critical, a technique called **bracketing** can be used. To bracket, make several exposures of a subject, intentionally overexposing and underexposing from the supposed correct exposure. Bracketing is not feasible if a subject is rapidly changing but it can be used quite successfully in more controlled shooting situations. Bracketing is widely employed by professional photographers to provide insurance against exposure variations due to equipment, materials, or metering errors.

The bracketing sequence depends upon the situation. A photographer working with color transparency film, which has little exposure latitude, might bracket in half-stop increments, one or two stops each direction. For negative films, with their greater exposure latitude, one-stop or even two-stop increments might be used:

f/2.8 at 1/125 sec	Two stops overexposed
f/5.6 at 1/125 sec	**Metered exposure**
f/11 at 1/125 sec	Two stops underexposed

Bracketing can also be done with the shutter speed:

f/5.6 at 1/30 sec	Two stops overexposed
f/5.6 at 1/125 sec	**Metered exposure**
f/5.6 at 1/500 sec	Two stops underexposed

Some of today's cameras provide computer-controlled bracketing.

Common Metering Errors

For a more detailed discussion of possible metering errors, see chapter 6, page 107.

Tilting the Meter Up. Because of the placement of dials on the meter, care must be taken not to tip the meter up while reading. If bright sky or overhead lighting is included in the reading, underexposure will result.

Metering Your Own Shadow. If your shadow falls on the area being metered, falsely low readings will result in overexposure. This is most likely to occur when doing close-up meter readings or when the light is coming from behind the photographer.

Creative Use of Exposure

The amount of exposure given to a negative affects the reproduction of tones in the final photograph. The "correct" exposure discussed so far is for a **representative photograph,** which is one that resembles the original as much as possible. For creative control, exposure changes can vary this representative appearance and thus create mood or isolate a subject.

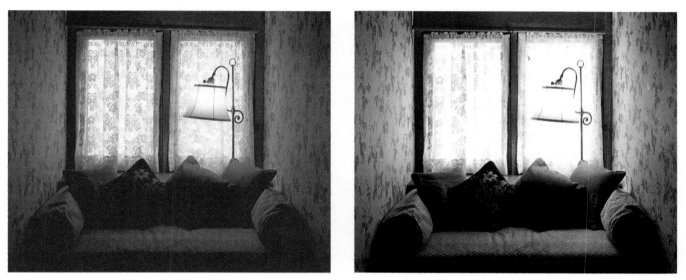

Creative Use of Exposure. The photograph on the right was given more exposure on the film. Note that both the graphic impact and the emotional values of the image change with exposure.

© Bognovitz.

Determining Exposure Without a Meter

Someday you may find yourself in a situation without a meter, because of battery failure or other malfunction. It is still possible to determine proper camera settings for various subjects to some degree of accuracy. Two good tools are used to do this:

Film data sheet. An exposure chart may be packed with the film. Following those guidelines will usually give good results. Only one camera setting—shutter speed and f-stop—is given for each case, but any equivalent exposure setting could also be used.

f/16 rule. In direct sunshine showing distinct shadows, using f/16 and a shutter speed of 1 divided by the ASA of the film being used will usually give good results. For example, using Plus-X film (ASA 125) in direct sunshine would give a camera setting of f/16 at 1/125 second, or any equivalent exposure setting. Tri-X (ASA 400) would give f/16 at 1/400 second; use the nearest shutter speed, f/16 at 1/500 second. Corrections to the f/16 rule can be made for cases other than direct sunshine:

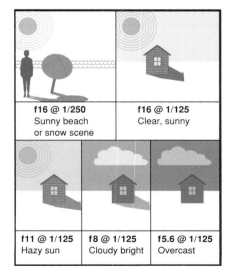

f16 @ 1/250 Sunny beach or snow scene	**f16 @ 1/125** Clear, sunny

f11 @ 1/125 Hazy sun	**f8 @ 1/125** Cloudy bright	**f5.6 @ 1/125** Overcast

Exposure Chart on Film Data Sheet.

Direct sun on light sand or snow	Close down one stop
Weak, hazy sun (soft shadows)	Open up one stop
Cloudy bright (no shadows)	Open up two stops
Open shade or heavy overcast	Open up three stops

Exposure in Low Light

If the level of illumination on a subject is very low, it may be difficult to determine camera settings for proper film exposure. Many meters are not sensitive enough for low light levels. The reciprocity law (page 21) may no longer apply. This is called **reciprocity failure** and requires exposure corrections. When working at long exposure times the camera must be stabilized to avoid image blurring.

Exposures of 1 second or longer are usually called **time exposures.** Some cameras have exposures longer than 1 second marked on the shutter speed dial. For exposures longer than those marked on your shutter speed scale, set the shutter speed at B and hold the shutter release down

for the appropriate time. Some shutters have a T setting: Push the shutter release once to open the shutter, which will remain open until the shutter release is pressed a second time. To avoid movement of the camera during the exposure, mount it on a tripod and use a cable release.

Camera on Tripod with Cable Release Attached.

Determining Initial Camera Settings If your meter is sensitive enough to meter the available light, use it to get a starting point for camera settings. An alternative is to use a chart (like the one below) or a calculator for low-light exposures.

Correcting for Reciprocity Failure After determining the initial camera settings, check the charts on the facing page to see if the time of the exposure requires correction for reciprocity failure. Color films will show interesting color shifts in addition to the density differences due to reciprocity failure. See the manufacturers' data for reciprocity failure corrections for color films. **IMPORTANT:** Meter calculators and exposure charts do *not* include reciprocity failure correction, so this step must be performed regardless of the source of the initial camera settings.

Bracketing Bracket sufficiently when working at long exposure times. If the first calculated exposure is 10 seconds, doing a second exposure at 11 seconds gives only a 10 percent change in exposure. Try doubling and halving the exposure several times for proper bracketing.

Night Exposure Chart

Choose the aperture for the ISO of your film: f/4 for ISO 25, f/5.6 for ISO 50, f/8 for ISO 100, f/11 for ISO 200, or f/16 for ISO 400. Find the indicated exposure time from the chart. If you wish to use a different f/stop, divide the time by two for every stop you open up, multiply by two for every stop down from the recommended f/stop for your ISO. NOTE: These times are not corrected for reciprocity failure. Use the graph or table on page 37 to make the necessary corrections.

SCENE	TIME	SCENE	TIME	SCENE	TIME
Open fire as subject.	1/30 sec	Brightly lit downtown streets. Brightly lighted sports arenas, gymnasiums, or circus performances.		Scene lit by candlelight. Floodlighted buildings.	4 sec
Brightly lit ring sports events (boxing, wrestling).	1/15 sec		1/2 sec	Dimly lit interiors of public buildings.	15 sec
Scene lighted by campfire. Neon signs. City skyline at twilight. Store windows.	1/8 sec	Carnivals, fairs, amusement parks. Aerial fireworks: Exposure from fireworks depends mostly on the f-stop. Bracket with the aperture around the suggested f/stop for your ISO film at 1 second time. The shutter can be kept open for several seconds to capture multiple bursts if the sky is dark.		Dimly lit outdoor industrial facilities.	15 sec
Brightly lit buildings interiors. Well lit stage scenes. Outside night sports (football). Bright color television pictures (use 1/8 second or longer for focal plane shutters to prevent scanlines).	1/4 sec		1 sec	City skyline at night.	30 sec
				Dimly lit city streets. Snowscape lighted by full moon.	1 min
				Landscape lit by full moon.	2 min

Corrections for Reciprocity Failure with General-Purpose Black-and-White Films

CALCULATED EXPOSURE TIME (SECONDS)	ADJUST APERTURE (STOPS)	OR	ADJUST EXPOSURE TIME TO (SECONDS)
	BLACK-AND-WHITE FILMS		
1	+1		2
10	+2		50
100	+3		1200
	T-MAX 100		
1	+1/3		—
10	+1/2		15
100	+1		200
	T-MAX 400		
1	+1/3		—
10	+1/2		15
100	+1 1/2		300

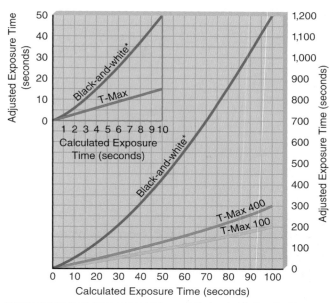

*These are average values for most general-purpose black-and-white films. See the manufacturer s film data for more accurate values for each film.
Source: Reprinted courtesy of Eastman Kodak Company.

Correcting for Reciprocity Failure. The accompanying graphs help to find values between those in the table. For situations where contrast is critical, adjustments can be made to development: for an adjusted time of 2 seconds, reduce development 10%; for 50 seconds, reduce development 20%; and for 1200 seconds, reduce development 30%. T-Max films require no adjustment of development.

Time Exposure Example

Determine initial camera setting. Working in a low-light situation, a meter reading is made at f/8 at 2 seconds. (This camera setting could also have come from an exposure chart.)

Correct for reciprocity failure. A 2-second exposure will require reciprocity failure correction for a standard black-and-white film. Looking at the reciprocity failure corrections graph, we see that a calculated time of 2 seconds requires an adjusted time of 6 seconds, so our adjusted camera setting is f/8 at 6 seconds.

Bracket. If we wish to keep the aperture at f/8, we must bracket with the time. The following settings will give a good variation of exposure:

f/8 at 1 1/2 sec	Two stops less exposure
f/8 at 3 sec	One stop less exposure
f/8 at 6 sec	Calculated exposure
f/8 at 12 sec	One stop more exposure
f/8 at 24 sec	Two stops more exposure

If you are unsure of your initial exposure determination, the bracketing can be carried even further.

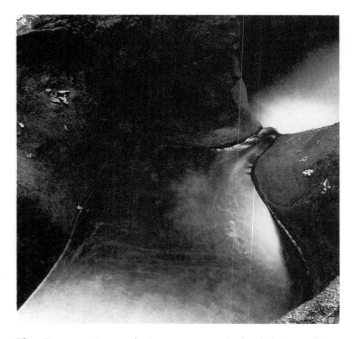

Time Exposure. The use of a long exposure under low lighting conditions blurred the water and gave a more abstract feeling to this photograph of water flowing through a rock basin.

© Bruce Warren.

CHAPTER 3

Camera and Lens

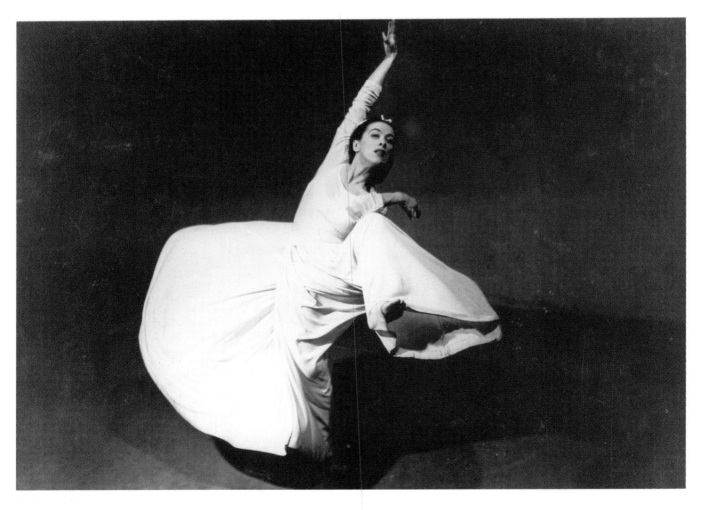

Barbara Morgan, *Martha Graham in "Letter to the World."*

© Barbara Morgan, Willard & Barbara Morgan Archive/Time Inc. is the licensee.

Modern cameras are extremely sophisticated devices, involving computer-designed lenses, complicated electronics, and construction from high-tech materials. In spite of this complexity, all cameras are basically the same. They provide a light-tight container for photosensitive materials—film—and a lens to form an image of the subject matter on the film. The other parts of the camera provide ways of controlling the exposure on the film and various devices for handling film and controlling focus of the lens. These tasks may be performed automatically by the camera or manually by manipulation of the controls. An understanding of the basic parts and operation of the camera and lens will clarify the role that the more sophisticated electronic devices play in the functioning of the camera.

■ The Camera

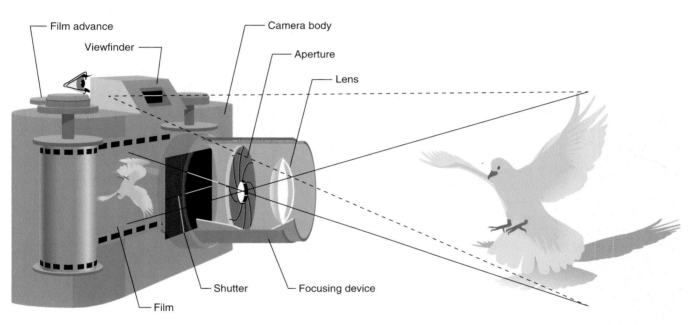

Camera. This is a simple camera, but it contains all the parts necessary for complete control in making photographs.

Camera Body. Light-tight enclosure protecting the film from unwanted exposure to light. Opens to allow loading of film.

Lens. Forms an image of the subject matter on the film.

Focusing Device. Moves the lens in and out to select the subject distance that will be in focus.

Viewfinder. Shows an approximate view of the part of the subject that will appear in the image on the film and may include a method for checking the focus of the image.

Aperture. An opening adjusted by means of a dial, lever, or ring with marked f-stop numbers. Controls the amount of exposure on the film.

Shutter. Shields the film from the image until the shutter release is pressed. It then opens for a measured amount of time (the shutter speed), which is controlled by a knob, lever, or ring. Controls exposure on the film.

Film Advance. A lever or knob that moves the film forward for the next photograph.

Format Size

An important influence on the technical quality of a photograph is the format size—the size of the image on the film. The rendition of detail and fineness of grain generally increase with increasing format size. Film format is also discussed on page 16.

Miniature-format cameras are generally of the Advanced Photo System (APS) design, with a special cartridge film giving a 16 × 24mm format. Because of the small size of the negative, these cameras are generally used where extreme enlargement of the image is not necessary. Their compactness makes them popular as snapshot cameras. The Minox—famous as a "spy" camera—produces an 8 × 11mm image on specially packaged film. The Minox is a precision instrument, but because of the small image size, great care must be taken to get images of any clarity.

Small-format cameras normally use 135 (35mm) film and produce a 24 × 36mm image. The original Kodak Instamatic cameras and other cameras using 126 film are also small format, with a 28 × 28mm image. Small-format cameras offer compactness and ease of handling. With

Format Size. Counter-clockwise from bottom center; Miniature-format APS viewinder camera, small-format 35mm single-lens reflex camera, large-format 4 × 5-inch view camera, medium-format 120 single-lens reflex camera.

modern films and lenses, 35mm cameras give technical quality good enough for most photographic purposes.

Medium-format cameras use 120 or 220 roll film and produce several different image sizes depending on the model, including 6 × 4.5cm (usually called the 645 format), 6 × 6cm (2 1/4 × 2 1/4 inches), 6 × 7cm, 6 × 8cm, and 6 × 9cm. Medium-format cameras are useful when a larger image size and a reasonably compact camera are desired. Modern medium-format cameras are typically expensive and designed for professional use, though over the years many simple medium-format snapshot cameras have been produced.

Large-format cameras produce images 4 × 5 inches, 8 × 10 inches, and larger and usually use sheet film. Large-format sizes require less enlargement for viewing and produce sharper images, more detail, and finer grain. However, as the format size increases, the camera becomes larger and more difficult to handle. Film and processing costs also increase accordingly. Large-format cameras are used when the highest-clarity images are desired and the camera size and relatively slow operation are not a disadvantage.

Camera Types

Cameras are often categorized by the method used for viewing the image. Two basic methods are used to see what subject matter will be included in the image on the film. One is looking through a **viewfinder,** which is an optical device included in the camera body separate from the lens that produces the image on the film. The other is **direct viewing** of the image formed by the camera lens. To be visible, this image must be formed on an actual surface, usually glass with a roughened surface, called **ground glass.** Several designs make use of a ground glass in the viewing system. Since the ground glass image is

dim, it must be shielded from extraneous light with a housing or a dark opaque cloth while viewing.

Viewfinder/Rangefinder Camera In a viewfinder camera, viewing is done through an eyepiece with its own simple lens, having the advantages of lighter weight, quieter operation, less vibration, and a brighter view than comparable cameras with other viewing systems. Since the viewfinder is not in the same position as the camera lens, it shows a slightly different view of the subject, called **parallax error.** Most viewfinders are adjusted to give the correct subject inclusion for distant subjects. For closer subjects, the different viewpoint of the viewfinder begins to be noticed, causing part of the subject seen in the viewfinder to be cut off in the film image. In some viewfinder cameras, the framing lines change as the camera is focused at different distances to show correct framing. Others may have additional framing lines for close distances. Even when the subject inclusion is corrected, parallax causes an image difference due to the different point of view. The rangefinder is a focusing aid included in many viewfinder cameras (see page 42). Viewfinder/rangefinder cameras are available in a variety of format sizes.

Viewfinder-type Camera.

Single-Lens Reflex Camera In a **single-lens reflex (SLR) camera,** the image from the lens is deflected to a ground glass by a mirror, which swings out of the way when the shutter release is operated. The image on the ground glass is reversed right to left, since it is a mirror image. Many single-lens reflex cameras use a **pentaprism,** a specially designed prism that is located above the ground glass and shows a correctly oriented image through an eyepiece.

Single-lens reflex cameras offer the advantage of viewing the actual image that will fall on the film. Focus can be seen in the eyepiece. Interchangeable lenses are common with this type of camera, since any changes

Single-Lens Reflex Camera. SLR cameras do not have parallax error. The only difference between the eyepiece view and that on the film is that the edges of the subject are cut off by most SLR viewing systems. This is known as **viewfinder cutoff** and results in slightly more of the subject appearing on the film than is seen in the viewfinder.

to the image can be seen directly. Disadvantages are the extra noise, weight, and bulk caused by the moving mirror and shutter types needed to provide reflex viewing, and the blacking out of the viewfinder while the shutter is open. Single-lens reflex cameras are generally available in 35mm and medium-format sizes.

Twin-Lens Reflex Camera In a **twin-lens reflex (TLR) camera,** two identical lenses are mounted on the camera. One forms the image on the film. The image from the other is deflected by a mirror to a ground glass for viewing and is reversed left to right.

Because of the small distance between the two lenses, twin-lens reflex cameras are subject to parallax error, just

as with viewfinder cameras. They tend to be bulkier because of the separate viewing and taking lenses but are quieter and less expensive than comparable single-lens reflex cameras. Twin-lens reflex cameras are less generally available today than in past years and are usually medium format. If you would like to move in to medium-format photography, but cannot afford the current equipment, look for a used TLR, which may be very reasonable in price.

View Camera The **view camera** is a direct-viewing system. The ground glass is placed in the exact position the film will occupy and then moved out of the way when the film, enclosed in a special holder, is inserted into the camera. The image seen on the ground glass of a view camera is upside-down, just as the image on the film will be.

The lens and back of a view camera can be tilted or swung to alter the focus or shape of the image, an advantage when photographing buildings or tabletop still life subjects. Since the image is viewed directly, focus can be checked by placing a magnifier on the ground glass. An opaque cloth must be draped around the ground glass for viewing the dim image. Disadvantages of the view camera are its bulk—making a tripod or other support necessary—and its relatively slow operation. View cameras are normally 4×5-inch format or larger and accept sheet film in holders.

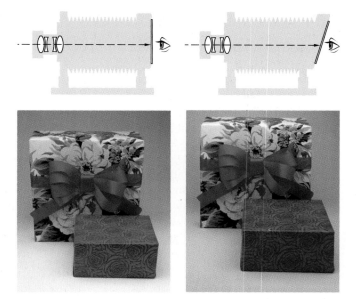

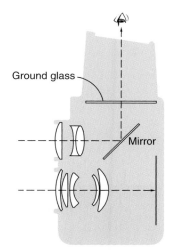

Twin-Lens Reflex Camera. TLR cameras have the viewing lens mounted directly above the taking lens. The subject inclusion is correct for distant subjects. Near subjects will result in a higher view with possible cutoff of the top of the subject on the film.

View Camera. Left: There is no parallax error with a view camera. The convergence of the sides of the tall box is a result of looking down on the subject from above. Right: This shows the effect of tilting the back of the camera to restore the parallel appearance of the sides of the box.

Specialized Cameras

Some cameras are built for specialized purposes. Underwater cameras have watertight seals for use in water without special housings. Aerial cameras produce large-format images for mapping purposes. High-speed cameras take exposures as short as a few millionths of a second for studying short-term events like explosions. Panoramic cameras record up to a 360° view of a subject, depending on the model. Instant cameras provide photographs that develop on the spot for immediate viewing.

Photograph Taken with Underwater Camera.
Orange tube coral, 3 × life size.

© Bruce Warren.

Photograph Taken with Panoramic Camera. Craig Stevens, *Calla Lilies, Pacific Grove, California.*

© 1981 Craig Stevens.

Focusing Methods

In ground-glass viewing systems the focus can be seen directly on the ground glass. Viewfinder designs may include a **rangefinder,** which is an optical device for determining the distance to the subject and focusing the lens. Simpler viewfinder cameras may have fixed focus or may require a measurement or visual estimate of the distance, which is then set on a focus scale on the camera. Autofocus of the lens is offered on many point-and-shoot viewfinder cameras as well as many 35mm single-lens reflex cameras. For more on focusing, see page 49.

Rangefinder Focusing. The small rectangular image superimposed in the center of the viewfinder moves with the focus control on the lens. Adjust the focus control until the small image aligns with the main viewfinder image. The viewfinder view on the left shows the rangefinder out of focus; on the right it is in focus.

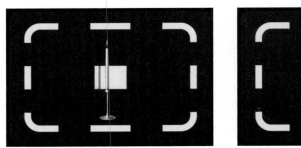
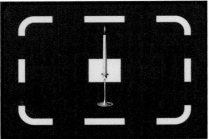

Ground-glass Focusing. The ground-glass view on the left is out of focus. Adjust the focus control on the camera until the image is in focus as shown on the right.

Shutter

Two types of shutters are generally available on modern cameras: the leaf shutter and the focal plane shutter. A leaf shutter has several overlapping metal blades controlled mechanically or electrically to open for marked lengths of time. It is usually located within the body of the lens. Advantages of the leaf shutter include light weight, lack of noise, and the ability to synchronize with flash at any speed. Disadvantages include difficulty in achieving very fast shutter speeds. Also, since the shutter is in the lens, special provisions must be made for cameras with through-the-lens viewing systems or removable lenses.

Focal plane shutters are located in the camera body as close as possible to the film plane. They consist of two cloth curtains or sets of metal blades that form a slit that travels across in front of the film. The width of the slit can be reduced for faster shutter speeds. Advantages of the focal plane shutter are the ability to achieve fast shutter speeds and the convenience for through-the-lens viewing systems. Disadvantages include bulkier construction and somewhat noisier operation. Also, use with a flash is restricted to shutter speeds for which the moving slit is the full width of the image.

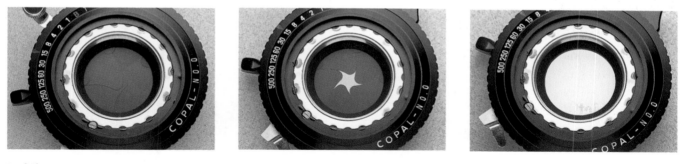

Leaf Shutter. Shown here closed, partially open, and fully open.

Focal Plane Shutter. In this shutter the slit is formed by two sets of overlapping metal blades, shown here closed and in midtravel for a high speed. This shutter travels vertically. Some focal plane shutters use cloth curtains rather than metal and in some the slit moves horizontally rather than vertically.

Motion Blur

If the subject or the camera moves during an exposure, the image is blurred. Since nearly everyone is familiar with this effect, a feeling of motion can be conveyed by appropriate blurring of an image. Some of the factors affecting the amount of image blur due to motion are shown in the following section.

Image Blur. The blur in the image on the left is due to movement of the subject during the exposure. The blur in the image on the right is due to movement of the camera during the exposure.

Factors Affecting Motion Blur

Comparison Blur. The blur in this image resulted from a slow shutter speed and a subject close to the camera moving relatively rapidly across the field of view of the lens. The camera was stationary and equipped with a normal focal length lens. See the facing page for the effects of changing each of these factors.

Shutter Speed: **1/30 sec.**
Subject Distance: **30 ft.**
Lens: **Normal.**
Subject Speed: **30 mph.**
Direction of Motion: **Across.**
Camera: **Stationary.**

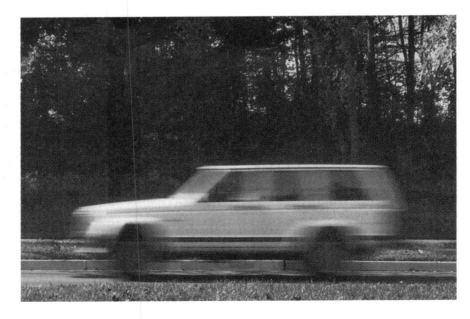

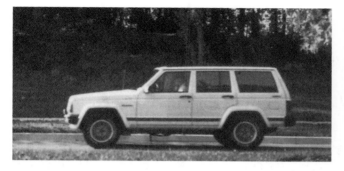

Shutter Speed. Faster shutter speeds produce less blur.

Shutter Speed: **1/500 sec.**
Subject Distance: 30 ft.
Lens: Normal

Subject Speed: 30 mph.
Direction of Motion: Across.
Camera: Stationary.

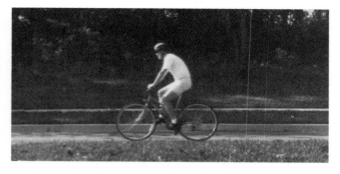

Subject Speed. Slower moving subjects produce less blur.

Shutter Speed: 1/30 sec.
Subject Distance: 30 ft.
Lens: Normal.

Subject Speed: **5 mph.**
Direction of Motion: Across.
Camera. Stationary.

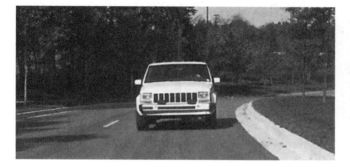

Direction of Movement. Subjects moving toward or away from the camera produce less blur than those moving across in front of the camera.

Shutter Speed: 1/30 sec.
Subject Distance: 30 ft.
Lens: Normal.

Subject Speed: 30 mph.
Direction of Motion: **Toward camera.**
Camera: Stationary.

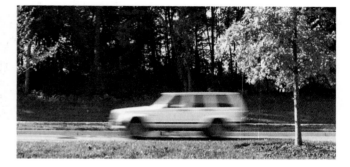

Subject Distance. More distant subjects produce less blur than close subjects.

Shutter Speed: 1/30 sec.
Subject Distance: **60 ft.**
Lens: Normal.

Subject Speed: 30 mph.
Direction of Motion: Across.
Camera: Stationary.

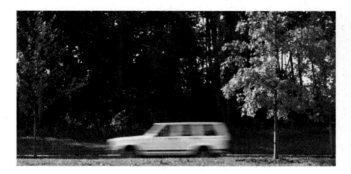

Lens Focal Length. Shorter focal length (wide-angle) lenses produce less blur than longer focal length (telephoto) lenses (see pages 50–53).

Shutter Speed: 1/30 sec.
Subject Distance: 30 ft.
Lens: **Wide angle.**

Subject Speed: 30 mph.
Direction of Motion: Across.
Camera: Stationary.

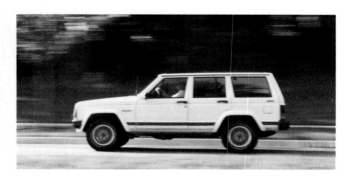

Panning. Swinging the camera to follow the movement of the subject during the exposure produces less blur in the moving subject, but more blur in the stationary background.

Shutter Speed: 1/30 sec.
Subject Distance: 30 ft.
Lens: Normal

Subject Speed: 30 mph.
Direction of Motion: Across.
Camera: **Moved to follow subject.**

Portraying Motion

Freezing Motion. Faster shutter speeds can produce a sharp image of a moving subject so that the movement appears stopped or frozen. The shutter speed needed depends on the conditions listed in the preceding section, but most subject movement can be effectively stopped by using a shutter speed of 1/500 or 1/1000 second. If the feeling of motion is to be shown by freezing the action, the subject must be in a position it could not maintain while at rest. A moving car frozen by a fast shutter speed simply looks like a car at rest, but a jumping person frozen in midair is obviously in motion.

© Bognovitz.

Panning. If a slow shutter speed relative to the subject motion is used but the camera is moved to follow the motion of the subject—a technique called **panning**—the result is a reasonably sharp subject against a blurred or streaked background. Successful panning requires practice and is most easily achieved with subjects moving in a straight line across the field of view of the camera. To insure smooth panning, start following the subject before the shutter is triggered, trip the shutter at the desired point while continuing the following movement, and continue following through the motion after the shutter closes.

© Bognovitz.

Blurring the Subject. If the camera is held stationary and a shutter speed that is slow relative to the subject movement is used, the subject will appear blurred against a sharp background in the photograph, giving the feeling of movement. Again the shutter speed needed depends on the conditions listed in the preceding section and the amount of blur desired. Fast-moving subjects may be blurred at 1/60 second, but slower-moving subjects may require speeds of 1/8 second or slower to produce appreciable blur. If a shutter speed slower than 1/60 second is used, care must be taken to prevent camera movement (see the next section).

© Bognovitz.

Preventing Camera Movement

When releasing the shutter by hand, use a gentle squeezing motion of the finger rather than a jabbing or pushing movement.

Brace your arms against your body and the camera against your forehead.

Rest your arms on a nearby object.

Lean against something solid.

Set the camera on something solid. A cloth bag filled loosely with rice or lentils will stabilize the camera.

Special clamps and various other devices are also available for steadying a camera.

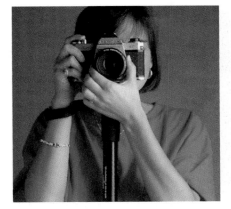

A monopod offers some stability.

A good tripod allows adjustable support. The important characteristics are rigidity and convenience of use. Weight may be a consideration, but usually greater weight provides better stability. On better tripods the head is available separately from the legs.

A **cable release** allows tripping the shutter without actually touching the camera, reducing the possibility of camera movement during exposure.

■ The Lens

Image Formation

A **lens** forms an image out of the light coming from the subject. The image formation depends upon a property of light called **refraction**, which is the bending of light as it passes between different transparent media. Images of light can be most simply formed by a small hole in the side of a darkened enclosure, as in the pinhole camera.

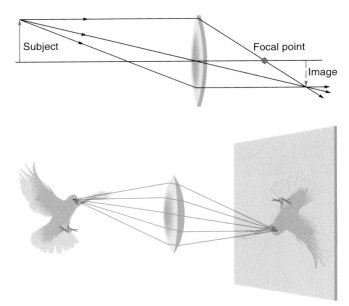

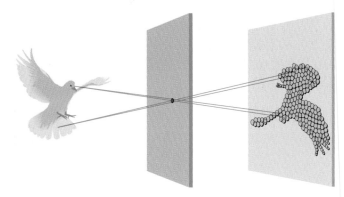

Pinhole Image. Image formation by a pinhole depends entirely upon the straight-line travel of light, with a small disc of light in the image corresponding to each point of the subject. Since the rays of light from each point are diverging, they do not come to a focus. The image is sharper closer to the pinhole because it is less magnified. Smaller pinholes produce somewhat sharper images but give a dimmer image, requiring long exposure times. The effects of diffraction at the edges of the pinhole reduce sharpness for extremely tiny holes.

Simple Lenses Glass lenses produce much brighter, sharper images than a pinhole but focus sharply on only one subject distance at a time. A **lens** is focused on a particular subject distance by changing the distance between lens and films. A **simple lens** consists of a single piece of glass, with one or both surfaces curved. Image formation depends on refraction of the rays of light striking the lens.

Photograph Taken with Uncorrected Simple Lens.

© Bruce Warren.

Simple Lens. The type of lens shown is a convex lens, as both surfaces curve out. The image formed by a simple lens is sharper than the pinhole image, but must be refocused for each subject distance.

Compound Lens A simple convex lens with spherical surfaces does not form a perfect image, introducing image flaws known as **aberrations.** Combining two or more simple lenses—called **lens elements**—of different curvatures and types of glass can reduce or eliminate most of these aberrations. A lens with more than one element is called a **compound lens.** For use, lens elements are mounted in a lens body of metal or plastic.

Compound Lens.
Cross-section of a compound lens mounted in a barrel.

Canon Compact-Macro EF 50mm f/2.5 Lens, Canon USA.

Image Quality The quality, or **sharpness,** of the image formed by a lens depends on the control of all the aberrations as well as the aperture used. Many other factors also affect the image sharpness in the finished photograph, including camera or subject movement, accuracy of focus, and variables in printing such as enlarger lens quality, image movement, or print focus problems.

The perception of sharpness in an image is somewhat subjective and is difficult to test. Two objective measures of lens quality often used in lens testing are **lens resolution,** which is the ability of a lens to produce a distinct image of closely spaced lines, and **lens contrast,** which is the difference the lens can reproduce between light and dark in fine detail. Some testing methods combine these and other considerations into a subjective quality rating.

The image quality will vary with the aperture used and the distance from the center of the image and is generally improved by stopping down approximately two or three stops from the maximum aperture. Resolution is normally better at the center of the image than at the edge. Another consideration in image quality is the evenness of illuminance in the image. All lens images get dimmer as the distance from the image center increases, but this effect, called **image fall-off,** can be reduced by careful lens design.

Flare In passing through a lens, light may be reflected internally from the surfaces of the elements. This reflected light, known as **flare,** can spread throughout an image, reducing contrast by adding undesirable light to the dark parts of the image. In some cases flare causes unexpected images of bright light in streaks or shapes.

Flare is reduced in modern lenses by coating the surfaces with rare earth elements. It can also be reduced by making sure that no direct light from a light source outside the picture strikes the surface of the lens. A **lens shade** may be used for this purpose. Flare is increased by dirty or damaged lens or filter surfaces.

Focus

The focusing mechanism (also discussed on page 42) allows changing the distance between the lens elements and the film to focus on subjects at different distances. The closer a subject is to the lens, the longer the lens-to-film distance must be for the subject to be in focus. The lens may be on a geared track and attached to a flexible bellows as in a view camera, or the lens body may be a barrel with nesting helical threads that move the lens elements in and out as the outside sleeve of the barrel is twisted. With automatic focus lenses the movement is performed by an electric motor controlled by a distance-sensing device.

Macro lenses are designed for close-up work, and have the ability to focus close enough for an image size equal to or half that of the original subject. The lens elements are designed for optimum image quality at these focusing distances, though a good 50mm macro lens can be used at distances to infinity and makes an excellent all-purpose normal lens. See pages 204–05 for techniques of close-up photography.

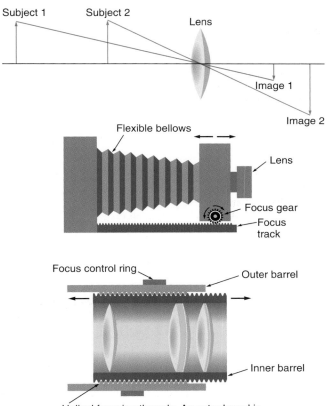

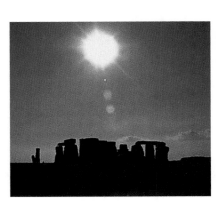

Patterns Due to Lens Flare.

© Bruce Warren.

Focusing for Different Subject Distances. Top: Focal Distance for Two Different Subject Distances. Center: Focusing Bellows and Geared Track as Used on a View Camera. Bottom: Cross Section of a Lens Barrel with Helical Focusing Threads.

Lens Focal Length

As subjects become more and more distant from a lens, the lens-to-film distance for a focused image approaches a fixed minimum. For a simple lens focused on an infinitely distant subject (stars make a good substitute), the distance between the center of the lens and the film is called the **focal length** of the lens, a fixed distance determined by the curvature of the lens surfaces and the type of glass used.

Most compound lenses have a fixed focal length. **Zoom lenses** are compound lenses with internally mov-

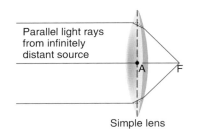

Simple lens

Focal Length of Simple Lens. Light rays from an infinitely distant subject are parallel when they enter the lens. The actual travel of two light rays is shown, with extensions to indicate the center of the lens (A), from which the focal length is measured (A to F).

ing elements that alter the focal length, producing a range of possible focal lengths with one lens.

Angle of View The focal length of a lens determines the size of the image—**the image magnification**—for a subject at a given distance. The longer the focal length, the more the image is magnified. A 100mm lens will produce an image of the subject that is twice as large as that produced by a 50mm lens used at the same distance from the subject. Since the size of the film remains constant, the amount of subject matter included changes with the focal length, usually indicated by the **angle of view** (see the facing page).

Normal Focal Length The lens that most closely approximates the view of the unaided human eye is known as a **normal focal length lens**. For the 35mm camera format, which gives a 24 × 36mm image, the normal focal length is about 50mm. As format size increases, the focal length must be increased to produce a larger image to retain the normal field of view. A 60 × 60mm image requires a normal lens of about 80mm focal length and a 4 × 5-inch format requires about a 150mm focal length. The normal focal length is approximately equal to the diagonal of the image format.

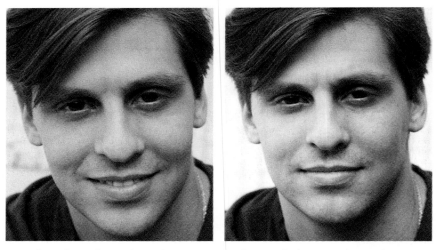

Normal Focal Length Lens (50mm) at 2 Feet. **Moderate Telephoto Lens (100mm) at 4 Feet.**

Effect of Normal Focal Length Lens at Close Distances. Moderate telephotos (80mm to 100mm on a 35mm camera) are often used for head-and-shoulders portraits, as most people find the slight flattening of the features more pleasing than the forced perspective—especially the apparent enlarging of the nose—that occurs when normal or short focal length lenses are used at close distances. For more on perspective, see page 53.

Lens Angle of View. The angle of view of a lens is measured across the diagonal of the rectangle seen in the subject. The angle of view of several popular focal lengths for 35mm cameras is shown in the table.

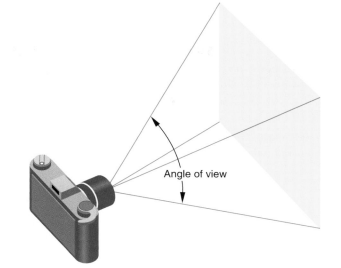

Angle of view

LENS FOCAL LENGTH	ANGLE OF VIEW
7.5mm	180°
14mm	114°
24mm	84°
50mm	46°
100mm	24°
200mm	12°
400mm	6°
800mm	3°

7.5mm

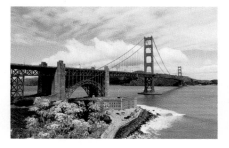

14mm

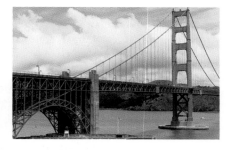

24mm

50mm Normal

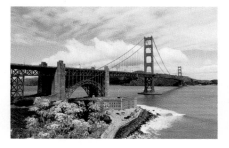

100mm

200mm

400mm

800mm

Focal Length and Subject Inclusion. This subject was photographed from the same position with different focal length lenses as labeled.

Wide-Angle Lenses Lenses with focal lengths shorter than normal are called **wide-angle lenses.** On 35mm cameras, a moderate wide-angle is 35mm in focal length. A 28mm or 24mm lens will give wider coverage and a more exaggerated depth. The 16mm and shorter focal length lenses give super-wide coverage and extreme depth expansion. Fish-eye lenses produce a circular image on the film and cover up to 180° of the subject.

Long-Focus, or Telephoto, Lenses Lenses with longer focal length than normal are usually called **telephoto lenses,** though technically the word *telephoto* refers to a particular type of long-focus lens design, producing lenses with bodies shorter than the effective focal length. Telephoto lenses for 35mm cameras range from a moderate 70mm to 500mm (giving ten times the image magnification of the normal lens) and longer.

Zoom Lenses Some zoom lenses cover focal lengths from a moderate wide-angle to a moderate telephoto; others may offer only a range of wide-angle or telephoto focal lengths. Zoom lenses are generally larger and heavier than single focal length lenses and do not offer as large a maximum aperture, typically f/4. The image quality of zooms is generally slightly less, although the better modern zoom lenses offer results that are more than adequate for most purposes.

Lens Extenders Lens extenders—also called tele-extenders—are mounted between the lens and the camera body and contain lens elements that increase the effective focal length of a lens by two or three times. A 100mm lens combined with a 2x lens extender gives an effective focal length of 200mm. Lens extenders deteriorate image sharpness and cause a reduction of exposure on the film—two stops less for a 2x extender—limiting their use in low-light situations. Some manufacturers of quality lenses offer lens extenders carefully designed to work with specific focal lengths of their lenses. These give quality that is surprisingly high but does not approach that of an equivalent single focal length lens, and they are expensive.

Mirror Lenses Telephoto lenses with curved mirrors in place of glass lens elements are much more compact, lighter in weight, and less expensive than compound glass lenses of equivalent focal length. The image quality is usually not as good and control of exposure is complicated

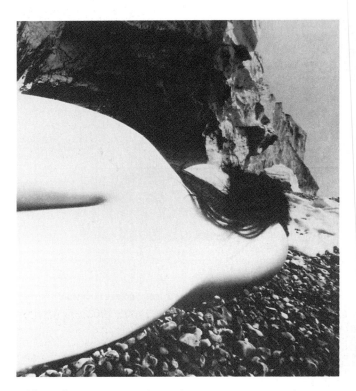

Wide-Angle Lens. Bill Brandt, *Nude East Sussex, 1957.* This image shows the expanded depth achieved when working close to the subject with a wide-angle lens.

© Bill Brandt/Bill Brandt Archive Ltd.

Long-Focus (Telephoto) Lens. When used at a distance, a long telephoto lens will give a compressed spatial feel, as seen here with a 500mm Lens.

500mm Mirror Lens and Example. Note the doughnut shape of the out-of-focus points of light in the background of the photograph, a characteristic of mirror lenses.

because a standard diaphragm aperture cannot be used with a mirror, but they offer a good alternative for many applications.

Perspective

Perspective changes with the distance from camera to subject. The apparent compression of distances with a telephoto lens is a result of the magnification of what is actually normal perspective for the distance to the subject. Wide-angle lenses have the opposite effect, apparently expanding the distances in the subject. If distance from camera to subject is changed to alter perspective, the focal length can be changed to retain the size of one object in the field of view (below).

It is mistakenly thought by many that **perspective**—the relative sizes in a picture of objects at different distances from the camera—changes with the focal length of the lens. Careful inspection of the images on page 51 shows that this is not true. The relative size of objects within the photographs—both taken from the same position—is the same, more easily seen by enlarging the normal focal length image, as seen below.

24mm at 10 feet.

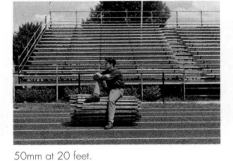

50mm at 20 feet.

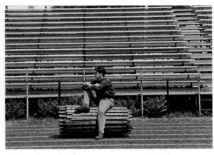

100mm at 40 feet.

200mm at 80 feet.

Perspective Change with Distance. This series was photographed with lenses of different focal length, but the camera distance was changed with each to keep the central subject the same size. Note the change in the relative size of subject and background—the perspective—with distance.

Perspective at the Same Distance with Different Focal-Length Lenses. Left: Full frame with 200mm lens. Right: Section of frame with 50mm lens taken from same position, magnified four times as much in printing for same image size.

Aperture

The aperture is a variable opening located near or in the lens, used for controlling the amount of light reaching the film. The numbers used to indicate the size of the aperture are called f-stop numbers or f-numbers or **relative apertures** and are defined by a formula:

$$F\text{-stop} = \frac{\text{Focal length}}{\text{Effective aperture diameter}}$$

A lens with a focal length of 100mm and an effective aperture diameter of 25mm would have a relative aperture or f-number of f/4. The f-stop number gets smaller as the aperture gets larger because the aperture diameter appears in the denominator of the definition. Two lenses of different focal lengths require different aperture sizes to achieve the same relative aperture. A 100mm lens has an aperture diameter of 25mm at f/4, but a 200mm lens would require an aperture diameter of 50mm to have the same relative aperture of f/4.

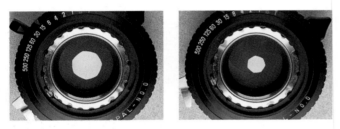

Relative Aperture Size. Diaphragm-style aperture set for f/8 (left) and f/16 (right).

The most common type of aperture is the iris diaphragm, which is a series of metal blades overlapping to form a nearly circular opening.

Since the aperture is located in or near the lens, the brightness of an image seen in the viewfinder of a single-lens reflex camera would be affected by changing the aperture. To eliminate this inconvenience, most modern single-lens reflex cameras employ an **automatic diaphragm,** which remains fully open regardless of the f-stop setting until the picture is taken, at which time it stops down to the set aperture and reopens after the exposure.

Depth of Field

That a lens can be focused on only one subject distance at a time would seem to present a considerable disadvantage, leaving parts of any three-dimensional subject out of focus. In fact, parts of the subject at distances other than that focused on appear acceptably in focus as well. The reason for this can best be seen by looking at image formation.

The image formed by the lens on the film can be thought of as consisting of an infinite number of points of light, which emanated originally from corresponding points of the subject. When the image is "in focus," a point on the subject images as a point on the film. When the image is "out of focus," the point is imaged as a circle of light. These circles are known as **circles of confusion.**

If the circles of confusion are small enough, they are perceived as points by the eye and the image looks acceptably sharp—that is, in focus—even when it technically is not. This gives **depth of field** in the finished photograph, which means that objects some distance in front of and behind the focused distance appear acceptably sharp. Depth of field is given as the nearest and farthest distances that are acceptably sharp in a finished photograph. Several factors affect the depth of field for a given photograph, all by changing the sizes of the circles of confusion.

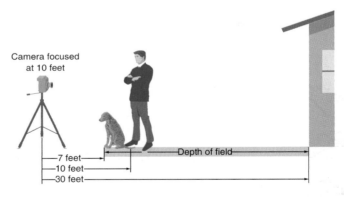

Camera focused at 10 feet

7 feet
10 feet
30 feet

Depth of field

Depth of Field. If the camera was focused on the man at 10 feet, but the dog at 7 feet and the front of the house at 30 feet are acceptably sharp in the finished photograph, the depth of field is said to be from 7 feet to 30 feet.

FACTORS AFFECTING DEPTH OF FIELD	MORE DEPTH OF FIELD	LESS DEPTH OF FIELD
Aperture	Smaller (e.g., f/16)	Larger (e.g., f/2.8)
Focused distance	Farther	Nearer
Lens focal length	Shorter (e.g., wide-angle)	Longer (e.g., telephoto)
Print size	Smaller	Larger
Print viewing distance	Farther	Nearer

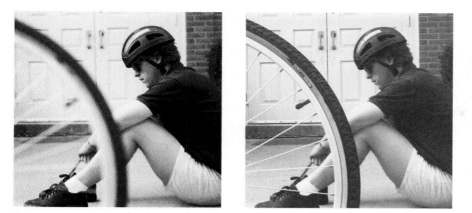

Controlling Depth of Field with the Aperture. This subject has objects at three different distances: the bicycle wheel is at 3 feet, the man is at 8 feet, and the door is at 20 feet. The photograph on the left was taken with the aperture set at f/2.8 and the one on the right at f/16. The shutter speed was adjusted to keep the film exposure the same. The lens was focused on the man (8 feet) for both photographs.

Depth-of-Field Control Of the factors that affect depth of field, the most easily controlled is the aperture. Changing the aperture to give more or less depth of field requires only a compensating change in the shutter speed to keep correct film exposure. The distance focused on can also be used for control. If you have a near and a far distance you wish to be in focus, the lens should be focused at an intermediate point (see the following section for depth-of-field calculations). Using lens focal length changes to control depth of field is not practical, however. Although the shorter focal length will give more depth of field, it will also include more of the subject. If you move closer to give the same subject inclusion, you lose the depth of field gained by the lens change.

Depth-of-Field Calculator Lenses on many cameras provide a scale to calculate depth of field. Depth-of-field calculators are normally based on calculations of depth of field for an 8 × 10-inch print made from the full negative and viewed at about 10 inches. If you plan to make changes in these standards—for example, to produce a larger or more highly magnified print—you should make allowances for the decreasing depth of field by stopping down more than the depth-of-field calculator indicates.

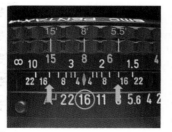

Depth-of-Field Calculator. Once the lens is focused, the depth of field is read by finding the distances bracketed on each side by the f-stop number set on the aperture ring. In this example, focusing the lens at 8 feet gives depth of field from 5.5 feet to 15 feet when the aperture is set to f/16.

Prefocusing Two methods for pre-focusing the camera are hyperfocal focusing and zone focusing. **Hyperfocal distance** is the minimum focus distance for which infinity remains within the depth of field. Focusing at the hyperfocal distance provides the greatest possible depth of field for any given aperture, from half the hyperfocal distance to

infinity. The hyperfocal distance changes with the f-stop. This setting is handy for situations where you may not have time to focus, but you know subject matter will be at least half the hyperfocal distance away from the camera. Zone focusing is explained in the illustration caption.

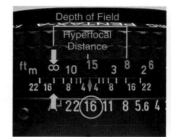 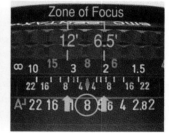

Hyperfocal Distance. A lens with a depth-of-field scale can easily be focused at the hyperfocal distance by setting the infinity mark opposite the appropriate f-stop number on the scale. The f-stop mark on the opposite side of the scale will tell you the minimum distance that will be in focus. Here the hyperfocal distance is 15 feet for an aperture of f/16, giving depth of field from 8 feet to infinity.

Zone Focusing. If you are going to be shooting in a situation where you know your subject distances fall between a certain minimum and maximum, you can prefocus the camera and choose the proper f-stop to cover that zone of distances using the depth-of-field scale on the lens. In this example, depth of field from 6.5 feet to 12 feet was achieved by focusing at 8 feet and setting the aperture to f/8.

Depth-of-Field Preview In cameras offering through-the-lens-viewing, the change in depth of field can be seen through the eyepiece or on the ground glass as the lens is stopped down. Some single-lens reflex cameras with automatic diaphragms have a preview button for this purpose. An image viewed through a stopped-down lens may be dim and hard to distinguish and therefore may not give as accurate an assessment of depth of field as the depth-of-field calculator. In good light, however, the depth-of-field preview button can give a fairly reliable indication of the relative focus of the various subject distances.

■ Equipment Purchase and Care

Camera Selection

First try to envision your uses for the camera. If you plan to take only occasional photographs of friends and family to be printed as snapshots, burdening yourself with an unnecessarily bulky and complicated camera will waste your money and probably discourage you from taking as many photographs as you would with one of the many excellent point-and-shoot cameras. Most of these use 35mm or APS film, and some give such good results that they can be considered for serious uses where their limitations are outweighed by the advantages of compactness and ease of operation. The waterproof feature on a few models is useful in situations where a normal camera would be damaged by exposure to dirt or moisture.

Camera System If you plan to pursue photography as a serious hobby or as a profession, using your camera in a variety of situations, flexibility becomes important. You should then consider cameras with interchangeable lenses and a wide selection of accessories. Purchase of a particular camera restricts you not only to its features but also to its system of lenses and accessories. Select a system carefully so that you will not find your needs outgrowing the system in a short time. In addition to the lenses and accessories offered by the camera manufacturer, you may also be able to find "aftermarket" equipment that will work with your model of camera.

Format Size Larger format sizes generally give better image quality. Photographers doing advertising, landscape, architectural, or still life photography often use 4 × 5-inch or 8 × 10-inch view cameras for the excellent image quality and the focusing flexibility offered. Wedding photographers may prefer medium-format cameras because they combine reasonable portability with the quality of a larger negative, making the large prints sometimes requested by clients look their best. Photojournalists and others needing portability, flexibility, and convenience turn to 35mm cameras.

If you are just starting out in photography, a high-quality 35mm camera system will probably be the best choice. Because of the continuing improvements in films and lenses, careful use of 35mm equipment will yield excellent results for a wide variety of purposes.

Metering System The features of an in-camera meter may be a determinant in camera choice. Features of in-camera meters are covered in detail on pages 24–28.

Camera Accessories The accessories in a system add convenience to your picture taking or improve, enhance, or alter the quality of an image. For example, **motor drives**—or winders, which are usually slower and lighter

duty than motor drives—will automatically advance the film after each exposure. Automatic film advance is an obvious advantage when quick, repeated exposures are needed. It can play an important role in improving your photography in other situations as well, since it eliminates removing the camera from the eye when advancing the film, allowing a more continuous visual connection with the subject. Many of today's cameras have built-in motor drives or winders.

Other accessories, such as filters, flashes, and close-up attachments, are discussed in chapters 7 and 10.

Electrical versus Mechanical Operation The move toward totally electrically controlled cameras has raised an issue of reliability for some photographers. Most modern 35mm cameras incorporate electrical operation of several or all functions, many of which cannot be operated mechanically. Often the functions of the shutter and aperture are integrated into the operation of the meter. That means when the battery goes dead or a malfunction takes place in one of the components, the camera is useless.

A few cameras offer one mechanical shutter speed that will operate with a dead battery. Even fewer—for example, the Nikon FM10 and the Nikon FM2—offer the full range of shutter speeds and apertures without batteries. Carrying spare batteries is a must for electrically controlled cameras, and a spare camera body or two is an excellent idea if you want to be sure you get your photographs.

Automatic versus Manual Functions The trend today is to offer automation of many of the functions of the camera and lens: automatic exposure controls, automatic film winding and rewinding, automatic film speed setting, automatic focus. Each of these features adds convenience but takes away control. As you become more knowledgeable about photography, you will find yourself in situations where you can get better results by controlling the camera manually. A number of cameras allow manual override of some or all of the automatic controls. Buying a totally automatic camera will limit your flexibility sometime in the future.

Automatic focus is often useful, allowing faster work in moving situations. Autofocus systems are being improved at a rapid rate but still make undesirable focus choices in some situations, so thought should be given to choosing a camera with manual override of the autofocus feature. Try the camera you are considering to be sure that the manual focus controls provide accurate focusing and are comfortable to operate.

Lens Selection

Lens Mounts The mounts on lenses vary considerably from brand to brand and even from model to model within a brand. You cannot, for example, use a Nikon lens on a Canon camera or a Minolta autofocus lens on a Minolta manual focus camera. A number of independent lens companies, however, make lenses with mounts adaptable to nearly any current camera model. If you have purchased a high-quality camera, you may be better off staying with lenses built by the same company. The image quality of adaptable-mount lenses is usually not as good as that of original equipment, but such lenses may offer a good value for many purposes. Some extremely high-quality lenses on the market will adapt to most quality cameras, but they carry a correspondingly high price tag.

Focal Length Unless the work you are doing is very specialized, a lens of normal focal length will be useful. If you will be working in confined spaces, prefer working close to your subject matter, or like the feeling of wide-angle depth expansion, you will want to purchase a short focal length lens. Long-focus, or telephoto, lenses are useful when you wish to photograph subjects from a distance, if you want to isolate details of inaccessible subjects, or if you like the compressed spatial look of the telephoto image. If cost, weight, and size are considerations, you might investigate mirror lenses or lens extenders to achieve more extreme image magnification, keeping in mind their shortcomings (see pages 52–53).

Zoom versus Fixed Focal Length Zoom lenses, with their easily adjustable focal length, offer precise and rapid framing of a subject without lens or position changes. A zoom lens covering moderate wide-angle to moderate telephoto focal lengths—about 28mm to 80mm focal lengths on a 35mm camera—might be a good general-purpose lens if you can only buy one lens to begin with.

Minimum Focus Distance If you plan on extreme close-up photography, then the minimum focusing distance of the lens should be examined. Macro lenses provide the closest focus without accessories but are relatively expensive and do not offer large maximum apertures, typically around f/4.

Zoom lenses that offer a "macro" feature should not be confused with true macro lenses. Although these lenses may offer a somewhat closer focusing distance than comparable lenses, they cannot focus to the closeness of a true macro, nor are they optically designed especially for close-up work.

Image Quality Some simple tests of the image quality of a lens are discussed on pages 120–21, but initial judgments can be made by reading test reports in photography magazines and asking the advice of knowledgeable professionals.

Maximum Aperture The maximum aperture of a lens is often used as a selling point but is not always an important feature. The difference between a lens marked f/1.8 and one marked f/2 is only one-third stop. Even if a lens offers a maximum opening of f/1.4, it may not be useful to you unless you plan to do a lot of very low-light photography and do not care about the loss of depth of field when shooting at such extreme apertures. The wider apertures do give brighter viewing and somewhat easier focusing for a single-lens reflex camera, but lenses of large maximum aperture are much harder to design and build, and quality in such lenses costs more money. If faced with a choice of an f/1.4 lens and an f/2 lens from the same manufacturer, focal length and image quality being equal, buy the f/2 lens and save some money unless you have definite need for the larger opening.

Camera System. This is a complete system of lenses and accessories produced by the manufacturer for the camera in the center.

Canon EOS System.

Camera Equipment Purchase

Brand Preference Once you have decided which type of camera to buy, you have to make the next choice—what brand to buy. Some correspondence can exist between brand and quality, but too often equipment is bought on blind brand loyalty, when another brand may offer a better solution to an equipment problem. Asking photographers with extensive equipment experience is a good way to get some idea of the reliability and quality of various brands, but make any such survey as wide as possible. Any photographer who shows a fierce loyalty to one brand or implies that only one decent brand of camera is on the market is not being objective. A number of manufacturers produce quality camera equipment, and you should choose on the basis of what suits your needs and feelings.

Camera store salespeople are often knowledgeable and can give excellent advice. On the other hand, many are not well-informed or may have a hidden agenda for selling particular models—higher profit margin, excess inventory, and so on. The more people you ask for advice and the more equipment you handle and use, the more informed your choice will be. This is not a place to be lazy and take whatever is easily available or cheap. Your first camera choice can lead to purchases of lenses and accessories, and before you realize it you have a considerable investment in equipment. Should you begin to feel limited by the system, changing brands can then become an expensive undertaking.

Used Equipment Some bargains are to be found in used equipment, but make sure the equipment is in excellent condition. If you are not qualified to judge the condition of the equipment, enlist the aid of a qualified service center. Never buy used equipment without thorough testing in advance. The higher price of new equipment may be justified by the warranty offered.

Camera Dealers Some advantage exists in buying from a local camera dealer with a reputation for backing up its merchandise, even if its prices are slightly higher. If a problem with a piece of equipment occurs immediately after purchase, local dealers will normally exchange for new equipment on the spot. Ordering from mail-order houses can prove much less expensive, but certain risks are involved. Investigate the reputation and reliability of the mail-order house. Many are reputable and have been in business for years, but others may take your money and go out of business. Long waits for equipment ordered by mail are not unusual, and if any problems with the equipment arise, solving them by mail or telephone may take considerable time, even if the company is willing to make good on the merchandise.

Point-and-Shoot Cameras. These models offer a variety of automatic features. The camera on the bottom has a variable focal length lens.

Prices and Warranties Advertised prices can sometimes be misleading. The most widely used ploy is to offer a piece of equipment at the "gray market" price. Gray market equipment is imported into the United States without the permission of the U.S. distributor. The equipment is the same, but the warranty is not. The international warranty included with gray market equipment is not accepted by U.S. factory service warranty centers, so if problems arise under warranty you must ship your equipment to Japan or another foreign country for servicing. A second misleading practice is to advertise a price that does not include a case or other item that the manufacturer normally packs with the equipment.

Camera and Lens Care and Maintenance

Cameras and lenses are delicate instruments and require care in handling for optimum performance.

■ Avoid rough handling, bumping, dropping, and banging.

■ Protect the glass lens from fingerprints and scratches. A lens cap should be used when not taking photographs. A clear glass or ultraviolet (UV) filter can help to protect the

lens in potentially damaging situations. The filter should be of high quality and should be treated just like the lens. If damaged or scratched, it should be replaced.

■ Protect both the camera and the lens from moisture (especially salt water), extreme humidity (basements can be bad), heat (watch out for hot glove compartments or car trunks), dust, sand, and other grit.

■ When possible, protect the camera and the lens from the direct rays of the sun.

■ Never force any of the controls on the camera or the lens. If they are not moving when you think they should, check to make sure you are operating them correctly. A low battery can cause controls on electronic cameras to lock. If you cannot figure out the problem, seek professional help.

Battery A main source of problems with modern cameras and meters is improper maintenance of the battery. Check the battery on a regular basis and replace if necessary. Sometimes the problem is poor contact within the battery holder. Contacts can often be cleaned using a new pencil eraser. Take care not to touch the contact surfaces of the battery during installation. Batteries should be removed if the equipment is not used for any length of time.

Periodic Service Center Maintenance Cameras and lenses should be returned to a factory service center or other authorized repair service center for general maintenance on a regular basis for cleaning and checking. Equipment that receives heavy use, especially in extreme—hot, dusty, cold, damp—environments, should be serviced about once a year. Cameras receiving more moderate use and careful maintenance should be checked for meter and control accuracy periodically but would require professional cleaning less often.

Testing Methods You can do a few things yourself to make sure your camera and lens are in good basic operating condition. Chapter 6 covers these and more extensive testing techniques for specific problems on pages 120–21.

Cleaning Wipe the camera body clean with a soft cloth. Do not use solvents or cleaners. Dust can be brushed out of crevices with a soft camel hair brush. The interior of the camera should also be cleaned periodically. Use a lens brush to carefully remove dust, but never try to clean the blades or curtain of the focal plane shutter, as they are easily damaged. Take special care to clean the pressure plate, a spring-mounted plate that is located on the camera back and holds the film flat. Remove the lens and carefully clean the mounting surfaces. Do not try to clean the mirror in a single-lens reflex camera, as it is silvered on the front surface and is extremely delicate.

Lenses should be regularly inspected for cleanliness. Clean them only when necessary, as excessive cleaning may cause damage to the delicate coatings. If dust is seen on the surface, usually a simple brushing with a lens brush and a squirt of compressed air—or a canned air substitute—is enough. If some residue remains on the lens surface after removing the dust, clean with a photographic lens cloth or lens tissue; do not use tissue or cloths designed for cleaning non-coated eyeglasses.

Cleaning a Photographic Lens

A. Use a brush and compressed air to make sure the lens surface is free of dust.

B. Breathe on the lens to mist it.

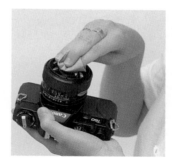

C. Use the lens-cleaning cloth to *gently* wipe the lens clean in a circular motion. Blow off any remaining lint or dust with compressed air.

D. If stubborn deposits resist this cleaning, you may use a photographic lens-cleaning solution as a last resort. Place a drop of the lens-cleaning solution on a folded lens tissue and gently wipe the lens clean. A bit of compressed air will remove any lens tissue fibers remaining on the lens after cleaning.

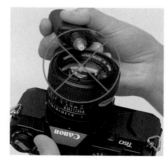

E. Never place the lens-cleaning solution directly on the surface of the lens, as it may seep into the lens mount and loosen the cement holding the elements in place.

Developing Film

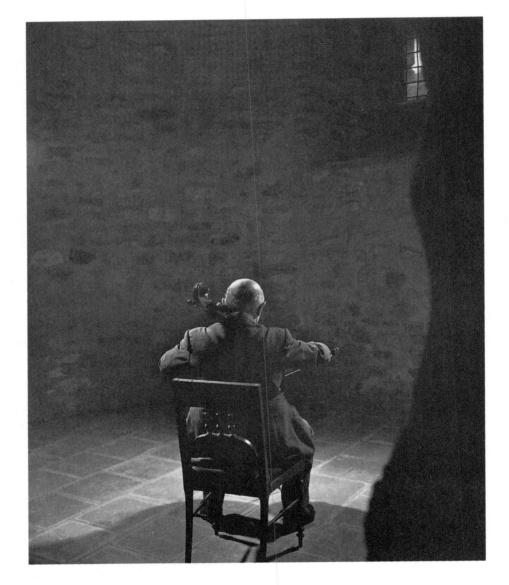

Yousuf Karsh, *Pablo Casals.*

Developing Black-and-White Film

The purpose of development is to convert the latent image formed at the time of exposure to a lasting, visible image on the film that can be viewed or printed. Developing of black-and-white film is discussed in this chapter. The procedures illustrated in the following sections are for 35mm film. Medium-format films are processed in much the same way, with slight differences in loading film onto reels.

Equipment, Facilities, and Materials

Panchromatic film is sensitive to all colors of light and must be handled in total darkness until most of the processing is complete. Daylight developing tanks are light-tight and have a specially designed lid that allows solutions to be poured in and out without allowing light to reach the film. Reels fit into the tank to hold the film so that the chemistry can reach all of its surfaces. Once the film is loaded into the tank, processing can be done in normal room light.

Developing tanks are available in plastic and stainless steel. High-quality stainless steel is a more durable material and is more impervious to contamination by chemicals, but it is more expensive than plastic. Most people find the stainless steel reels more difficult to load. Plastic tanks and reels can serve well with proper handling and cleaning. Choose a tank that has a lid system allowing inversion of the tank without loss of chemicals. If you intend to process both 35mm and medium-format films, purchase a tank that will hold at least two 35mm reels or one medium-format reel. Some plastic reels are adjustable, accepting several different sizes of film. Nonadjustable reels require a different reel for each size of film.

To load the film into the reels and place them in the developing tank, you must be in a totally dark room. Even a small closet will do, as long as it is completely light-tight. To check for light, enter the darkened room, allow your eyes 5 to 10 minutes to adjust, then move throughout the room watching for light. Peripheral vision is more sensitive to low levels of light, so watch for light leaks at the edge of your vision. If you cannot find a dark room, light-tight changing bags may be purchased for loading film.

Buy a thermometer that is designed for photographic use and can be read accurately to the nearest 0.5°F or 0.25°C. Stainless steel dial thermometers have quick response and are less likely to break than a glass thermometer but go out of adjustment more easily. Do not try to save a few dollars buying a cheap thermometer, since accurate control of temperature is critical, especially in the developer.

The additional chemicals, containers, and tools needed are summarized in the following table. For more detailed information on the chemistry, see the in-depth section beginning on page 64.

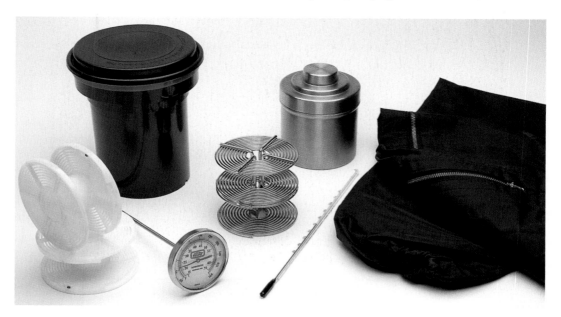

Film Developing Tanks, Changing Bags, and Thermometers.

Film Processing Equipment and Supplies

ITEM	FUNCTION	REMARKS
1. Light-tight room or changing bag	Protect film from light while loading tank	Test room for light leaks as described on page 61.
2. Daylight developing tank	Protect film from light while processing	See page 61 for desired tank design.
3. Bottle opener	Open 35mm film cassettes for loading	Any standard bottle opener will work.
4. Scissors	Cut film for loading	
5. Thermometer	Determine temperature of processing solutions	See page 61 for thermometer types.
6. Timer	Time each processing step	A watch or clock that measures in minutes and seconds will do, but a stopwatch or countdown timer will reduce the chance of errors.
7. Mixing utensils	Mix chemical solutions from packaged form	You will need open containers and mixing paddles of glass, inert plastic, or stainless steel.
8. Measuring utensils	Accurately measure liquids used in processing	Divisions on large containers may be too far apart to accurately measure small quantities, so use a container of a size close to the quantity being measured.
9. Storage containers	Store processing solutions between uses	Storage containers should be clean and made of glass or inert plastic. Bottles previously used for other purposes may be difficult to clean well enough for photographic use.
10. Water	Mix chemicals and wash film	A mixing tap for running water at controlled temperature adds convenience. You can instead use a large bucket of water at the desired temperature.
11. Developer	Convert latent image into usable image	Choose a general-purpose film developer such as Kodak D-76 or Sprint Standard. Mix according to the directions on the package.
12. Fixer (also known as "hypo")	Make image permanent and safe to expose to light	Choose a general-purpose film fixer. Follow the directions on the package for mixing and use.
13. Washing aid	Shorten washing time and insure clean film	Many brands are available: Permawash, Orbit, Kodak Hypo Clearing Bath, Sprint Fixer Remover, and others. Follow directions for mixing and use.
14. Wetting agent	Prevent water spots while film dries	Most popular is Kodak Photoflo, but other brands are available. Follow directions for mixing and use.

Suggestions for Success

The results you get when you develop film depend on the care you take with each step. To prevent errors, it helps to follow some basic procedures.

Organization. When you are in total darkness loading the film, it can be troublesome to discover you do not have the necessary tools to get the film into the tank. Once processing begins, you should not pause, so it is important to have everything organized in advance. Lay out all your equipment and materials before starting.

Cleanliness. Many problems in developing can be traced to contamination of one chemical by another. See page 64 for complete information on preventing contamination. Hands are a source of contamination. If they have been in contact with any of the chemicals, wash them carefully with soap and warm water and dry them on a clean towel. Careless splashing and dripping of chemicals is also a source of contamination.

Adherence to directions. Photography is a well-documented craft. Materials come with explicit directions. Read them completely *before* beginning work and follow them carefully.

Consistency. Use exactly the same procedures each time you process for consistent results. Think about what you are doing so that you can reproduce your activities precisely each time.

Record keeping. Recording data on the procedures and materials you use in a permanent record book can save time in the long run and accelerate the learning process.

Health and Environmental Concerns

Health concerns: Be sure to read and follow health hazard notices on each package of photographic chemical. Chemicals can be taken into the body in three ways: by breathing, by skin contact, and by mouth (ingestion).

Ventilation: Good ventilation in any area where chemicals are stored, handled, or used is important. Darkrooms should be equipped with exhaust fans to give a good supply of fresh air. Avoid breathing the dust from chemical powders while handling them.

Skin contact: The response to contact of chemicals with the skin can be direct irritation such as burning and itching or may consist of an allergic reaction. Chemicals may also be absorbed through the skin and cause internal damage. Protective clothing, rubber gloves or tongs, and safety goggles help to prevent skin or eye contact. When diluting a strong acid, slowly add the acid to the water. Caution: Never add water to acid, which may cause splattering.

Allergies: A few people are sensitive or allergic to some of the components of photographic chemistry. The presence of Metol—p-methylaminophenol sulfate, also known as Elon, Pictol, or Rhodol—in developers is especially troublesome to some people. Following the preceding suggestions regarding ventilation and reducing contact should help. Sometimes a change to a developer of different makeup can reduce the reaction to the chemistry.

Ingestion: Ingestion of chemicals would seem unlikely for adults, but can happen through contamination of hands, food, or cigarettes. Use or storage of photographic chemicals in a kitchen or other food preparation area may cause accidental ingestion. All chemicals should be kept from the reach of children. Highly toxic chemicals are found in developers, toners, bleaches, and many of the solutions used in color processing.

Environmental concerns: Photographic chemicals should not be poured down the drain thoughtlessly. Even the small amounts of chemistry generated by home darkrooms are enough to produce an environmental hazard, depending on the type of sewage disposal in the area. The federal environmental protection standards mention three concerns for photographic wastes: (1) the presence of silver, (2) the presence of cyanide, and (3) the pH—a measure of acidity-alkalinity, with 7 being neutral—which should be between 6 (slightly acidic) and 9 (slightly alkaline). Most of the chemicals used in processing present little environmental hazard, especially if highly diluted before disposal.

OK to pour down the drain: The dilute acids used in stop bath, the mild detergents used in wetting agents, and the chemicals in washing aids and most developers fall into this category.

Don't pour down the drain: Fixer and photographic bleaches contain silver after use and should not be poured down the drain. Bleaches may also contain cyanide compounds. Silver is a toxic environmental pollutant and should not be disposed of in any sewer or septic system. In addition, silver is a bactericide and will impede proper operation of a septic system.

Recycling silver: Collect any chemistry containing silver and take it to a toxic waste or silver recovery center. Call your county or state environmental protection agency for information on disposal. Some schools with photography programs run silver recovery programs and may be willing to accept fixer for recycling. The reclaiming system may not accept bleaches, so check before bringing any photographic chemical waste. Alternatively, steel wool immersed in fixer will take the silver out of solution, forming a sludge, which can then be sold for silver recovery.

Photographic Chemicals

The availability of packaged chemicals with clear directions makes it possible to perform the steps in the photographic process without understanding what the chemicals are or how they work, but in-depth knowledge of the form and function of the constituent chemicals allows better control over the process. If problems arise, you will be better equipped to solve them.

Dilution When liquids must be diluted for use, the directions may give the amounts in terms of parts or a ratio. For example, if directions call for one part of a concentrate to be mixed with nine parts of water, this is the same as a dilution of 1 to 9, usually written as the ratio 1:9. In any ratio the first number refers to the chemical and the second number refers to water.

In actual usage, you must figure out how much chemical solution you need and then adjust the size of the parts accordingly. In the preceding example we have a total of ten parts: one part chemistry and nine parts water. If we needed 20 ounces of working solution of this concentrate, each of the ten parts would have to be 2 ounces, so we would mix 2 ounces of the concentrate with 18 ounces of water. A ratio of 1:1 would be achieved by mixing equal quantities of the chemistry and water.

Water Water is used for mixing chemical solutions and for washing films. In most areas tap water is adequate for these purposes. If your water is high in mineral content—especially iron or sulfur compounds—or has large amounts of sediment in it, it may not be suitable for mixing chemistry or possibly even for washing film. Filters can be fitted to water lines to remove sediment but not dissolved minerals. If in doubt, mix chemicals with distilled water.

Forms of Photographic Chemicals Most of the solutions used in photography are mixed from formulas that have several chemical components. Prepackaged chemicals designed to make specific solutions, such as developers or fixers, already have the proper mix of components and usually require only the addition of water to put them in usable form.

An alternative is to buy the component chemicals and mix them yourself according to formulas that can be found in various reference sources. The required investment in basic chemicals and weighing and measuring tools and the extra time spent in compounding formulas usually make this an impractical approach. However, some specialized solutions are not available in prepackaged form, or you may want to alter the available formulas. Mixing from basic components may then become worthwhile.

Prepackaged photographic chemicals come in either dry (powder or crystal) or liquid form. Dry chemicals must be dissolved in water to be used. Several terms are used to describe chemicals in liquid form, depending on their use:

Working solution. A working solution is at the proper strength for using directly in a photographic process. Working solutions are sometimes fairly dilute forms of the chemistry and may have a short shelf life—some must be used within a few hours after mixing. A few solutions can be bought already packaged at working solution strength, but most require the addition of water to reach working strength.

Stock solution. A stock solution is a liquid form of a photographic formula that has a reasonably long shelf life. Some stock solutions are already at working strength: D-76, for example, when mixed from the powder into a stock solution, can be used at that strength to process film. Other stock solutions must be diluted further to reach working strength: D-76 can also be used in a diluted form. Depending on the formula, a stock solution may be compounded by dissolving a packet of dry chemicals in water, mixing powders and liquids, or diluting a concentrated liquid.

Concentrates. Concentrates are prepackaged concentrated liquid forms of the various formulas used in photography—developers, fixers, washing aids, and so on. Some are intended to be diluted directly before use in the quantities needed at the time. Others may be a multipart formula mixed together into a stock solution.

Handling and Storage of Photographic Chemicals If properly handled, photographic chemicals are relatively safe to use. Nevertheless, the chemicals, especially in concentrated form, require a few precautions. See the information on health and environmental concerns on page 63.

Contamination. Contamination of a solution with other chemicals can reduce its useful life, so take care that containers and other objects, including hands, that come in contact with the chemistry are clean. A thorough wash with warm soap and water and then a rinse in clean running water performed immediately after use will keep utensils and tools clean. Careless working habits in the darkroom, with splashing and dripping, are another source of contamination.

One principal mechanism of contamination is neutralization. Some photographic chemical solutions, like developers, are alkaline, or basic; others, like stop bath and fixer, are acidic. Whenever acids and bases mix, they neutralize each other. Other mechanisms of contamination

can also occur, especially with color chemicals, which are complex organic compounds.

Stop baths and fixer are designed to accept a certain amount of neutralization, since their purpose is to neutralize the developer. Failure to thoroughly drain the developer before proceeding to the next step can prematurely exhaust stop or fixer. Developers are not designed to accept any acid, so it is especially important to prevent contamination of developers with other chemistries.

A previously used container may contaminate a solution, even if thoroughly washed. Developers are especially susceptible to contamination, so it is recommended that new containers be purchased for their storage. Containers and lids should be carefully labeled and always used for the same type of chemistry.

Utensils and Containers. The container can affect the life of a solution in several ways. Some plastics actually let air through by osmosis. Some plastics and metals other than quality stainless steel will react with many photographic chemicals. The safest inert plastics for photographic use are polyethylene and polypropylene, but Teflon, polystyrene, and polyvinylchloride (PVC) are also good. If a plastic cannot be identified, it is best to avoid using it. Avoid metal lids. Any utensils that come in contact with the chemicals should also be of glass, inert plastic, or stainless steel.

The graduate used for mixing the working solution of a film developer should have divisions at least to the nearest ounce and should exceed the fluid capacity of the developing tank. A 1-quart container marked in ounces or a 1-liter graduate is sufficient for most small tanks. If you are using concentrates and measuring small quantities, you should have a second, smaller graduate marked in half ounces.

For mixing solutions from powders you will need large open containers. Plastic buckets or large open-mouth glass jars are inexpensive and work well. To avoid contamination, it is a good idea to have a separate mixing bucket used only for mixing developers. Use stirring rods of inert plastic, stainless steel, or glass.

Storage Life. Many of the chemical solutions used in photography deteriorate over time. Proper storage can help to lengthen their useful life. Developers are especially sensitive to contamination and improper storage, but other solutions can be affected as well.

Manufacturers normally supply a shelf life in the instructions for formulas that have a limited storage life. Shelf life is given for specified environmental conditions. To be sure that the shelf life is not exceeded, label the container with the date mixed. For example, the

instructions for a developer may give a storage life of 6 months in a full, tightly stoppered dark brown glass bottle, stored at normal room temperature (close to 68°F). If these storage conditions are not met, the life of the developer may be shortened. If a stock solution is diluted for use, the storage life of the diluted working solution may be shortened drastically. Some working strength developers may have a life of only a few hours; other chemicals, such as stop bath, may last indefinitely in diluted form.

The major cause of developer deterioration is oxidation, which is accelerated by high temperatures or the action of light. This explains the storage conditions listed: brown bottles reduce exposure to light; storage at room temperature prevents exposure to higher temperatures (low temperatures can also damage some solutions, so they should not be chilled or refrigerated); full bottles reduce exposure to the oxygen in air. Several methods for keeping air out of the storage containers are available. Plastic bottles can be squeezed to expel the air, then capped. A chemical solution can also be divided among small containers so that a large air pocket does not occur as the solution is used.

Working Life. Most photographic chemical solutions may be used more than once. Since a chemical gradually deteriorates with use, its reuse is limited. This limit is called the **working life** or the capacity of the chemistry. The manufacturer should supply in the instructions the working life of a chemical. This is normally given as a number of 8 × 10-inch sheets of material that may be processed in the solution. For example, the working life of a chemistry might be given as 100 8 × 10 sheets per gallon of stock solution. If different sizes of material are used, the capacity is calculated by considering the change in area. A 4 × 5-inch sheet has one-fourth the area of an 8 × 10 sheet, so four times as many 4 × 5s can be processed in the same chemistry. A thirty-six-exposure roll of 35mm film has about the same area as an 8 × 10 sheet.

One-shot developers are designed for one-time use after dilution to working strength, with the advantage of consistently fresh developer. Other developers can be reused; however, the strength of the developer changes with use and the developing time must be increased for each use. Some developers can be replenished by the measured addition of replenisher, containing the constituents of the developer that are altered with use. Replenishment is difficult to do accurately on a small scale and is more suited to use in processing labs. Most photographers developing film in small tanks prefer the one-shot developers for their ease of use and consistency.

Loading Film into the Developing Tank

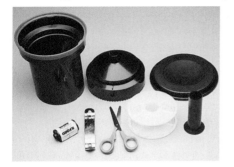

A. Lay out your equipment in the darkroom or changing bag as shown. Make sure the tank is clean and dry. Check that adjustable reels are set for the correct film size.

B. Turn off the light. Use the bottle opener to pop the cap off the flat end of the film cassette. Remove the film on its spool from the cassette by pushing on the long end of the spool.

C. Trim off the narrow leader so that the end of the film is square.

D. *Plastic Reels.* Holding the film and reel as shown, slide the end of the film into the opening of the spiral until it locks under the stainless steel balls.

E. Move the reels back and forth to "walk" the film into the reel.

F. *Stainless Steel Reels.* Holding the film and reel as shown, insert the end of the film into the clip at the center of the reel.

G. While holding the film by the edges to produce a gentle curvature of the film, turn the reel and guide the film into the wire spiral. When you reach the end of the roll, cut the film just before the tape and wind the remainder onto the reel. Note that some films do not have tape at the end of the roll, but are simply hooked to the spindle.

H. Place the reel into the tank. Some plastic reels must be put on a plastic spindle before being placed in the tank.

I. Put the double-lid system on the tank. You may now turn on the lights.

Film Processing

Before starting, read through all the steps (pages 67–71) and make sure all your equipment and materials are set up. Also read the section "Health and Environmental Concerns" on page 63.

Timing The developing process is continuous, with each step timed. Once you have begun, you should continue through all the steps without pause. The time it takes to pour the solution in at the beginning of a step and out at the end should be included in the time given for each step. Always try to keep pour-in and pour-out times to a minimum, but make sure the tank is thoroughly drained.

Temperature Control Developer temperature must be determined accurately and maintained throughout the developing process. If the temperature of the room is different from that of the developer, then between agitation intervals you may want to immerse your tank in a bowl or tray of water that is at the exact developing temperature.

The temperature of the remaining solutions and washes is not as critical, but all should be within + or −5°F of the developer temperature to prevent **reticulation** (see illustration below), which is a wrinkling of the emulsion on the film caused by sudden temperature changes. For example, if your developer mixture is at 70°F, the remaining steps should fall between 65°F and 75°F. Check all solution temperatures before beginning. Warm or cool any as needed.

Protection from Light When pouring chemistry into or out of the developing tank be sure to use the lid designed for that purpose to prevent exposure to light.

■ **WARNING** Do not remove the main tank lid until after the fixing step.

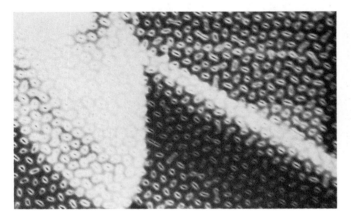

Reticulation. Enlarged portion of a print from a reticulated negative.

Agitation during Film Development If film is placed in developer and left undisturbed, uneven developing takes place. The developer near the heavily exposed areas of the film becomes exhausted in the process of reducing silver salts to silver. Bromide ions are also produced in this process and, being heavier than the developer, they drag downward across the surface of the film, inhibiting development in those areas and leaving streaks of uneven development, called **bromide drag**. Agitation during development brings fresh developer to all areas of the film and flushes away the bromide by turbulence within the developer.

For even development to take place, the agitation must provide random turbulence equally to all areas of the film. Any repeated patterns in fluid flow within the developing container may cause increased or decreased development in some areas. Since agitation is usually done by hand, it is the most common source of uneven and inconsistent development of film.

An excellent treatment of agitation techniques is an article by George Post, published in *Darkroom Photography* (see the bibliography at the end of the book). In testing several methods of agitation, Post found three methods that gave excellent results for plastic tanks. All involve vigorous inversion as the primary source of agitation. The standard agitation sequence in this chapter is one of the three. An air space above the developer seems to be an essential requirement for even agitation.

Even agitation is more difficult to achieve with stainless steel tanks and reels because of the constricted space and tightness of the reels. Post found only one technique that gave excellent results with stainless steel. A four-reel tank was used, with film loaded only in the bottom reels and the tank filled half full of developer. The large air pocket combined with the use of the vigorous inversion technique gave results comparable to those with the plastic tanks.

Consistent agitation is achieved by performing the agitation in exactly the same way each time. Time and count the inversions and follow a standard pattern for the agitation sequence, as shown on the next page. Some films and developers may require different agitation sequences from the one shown. These will be specified in the manufacturer's directions.

Film Processing Steps

1a. Preparation. Mix developer to proper working dilution. For example, you may have mixed a solution of D-76 from the powder and you decide to use it at a dilution of 1:1—recommended for small-format films. If your tank requires 10 ounces of solution, you would mix 5 ounces of the D-76 solution with 5 ounces of water to make 10 ounces of D-76 1:1. For Sprint Film Developer, which is used at a dilution of 1:9, mix 1 ounce of the concentrate with 9 ounces of water for 10 ounces of working-strength developer.

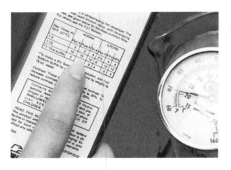

1b. Adjust the temperature of the water added to the developer so that the temperature of the developer mixture falls in the desired range, which should be 68°–75°F for best results with most developers. Hold the developer in its graduate for now. Using the exact temperature as measured, calculate the developing time using charts or tables supplied by the manufacturer.

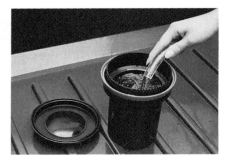

2. Prewet. The prewet stabilizes the temperature of the tank and film and helps to keep air bubbles from sticking to the surface of the film during development. Remove the topmost lid from the tank. Fill the tank completely with water at the same temperature as your developer mixture. Replace the cap. Tap the bottom of the tank on a table or sink several times and invert repeatedly for a total time of 1 minute. Drain the water from the tank. After use, it is normal for the water and subsequent solutions to show some color from the dyes used in the film.

3. Developer. Check the developer temperature to make sure it has not changed. Start the timer and quickly pour the developer into the tank. Some tanks must be tilted slightly for rapid pouring in of the developer. Replace the lid and begin the agitation cycle immediately. The basic agitation is to turn the tank upside down—that is, invert it—and then return it to its upright position. A complete inversion and return should take about 1 second. Inversions are done in groups of five. Before each group, rotate the tank 90° about its vertical axis. The quarter turn is followed by five inversions. Following a standard agitation pattern will help maintain consistent development:

Start timer	
Pour in developer	10–15 sec
Tap two times on sink	5 sec
Quarter turn and five inversions	5 sec
Quarter turn and five inversions	5 sec
Quarter turn and five inversions	5 sec

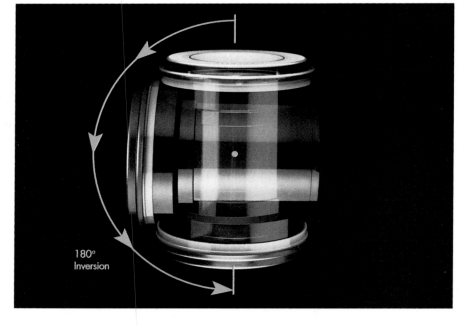

180° Inversion

Quarter turn and five inversions	5 sec

Let tank rest until 1 minute has elapsed on the timer, then do:

Quarter turn and five inversions	5 sec
Let tank rest	25 sec
Quarter turn and five inversions	5 sec
Let tank rest	25 sec

Continue this pattern of 5 seconds of agitation out of every 30 seconds for the remainder of the developing time. Allow 15 seconds for draining the tank at the end of the developing time.

Some developers may be saved and reused with time adjustments, but if you have diluted the developer for use, dispose of it.

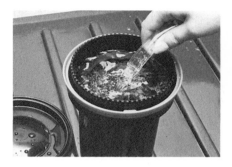

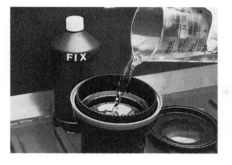

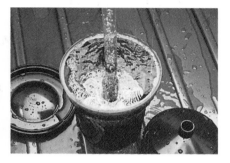

4. Stop Bath/Rinse. The purpose of this step is to rinse the developer from the film and stop the developing process. Concentrates for mixing an acid stop bath solution are available, but a pure water rinse can be used for small-tank developing of small- or medium-format film. Fill the tank with water at a temperature within plus or minus 5°F of the developer's, slosh it around, and drain. This is called a fill and dump. Fill and dump with water twice. Drain the tank. Total time for this step should be about 1 minute.

5a. Fixer. The fixer removes the undeveloped silver salts from the film, rendering it no longer sensitive to light. Pour the fixer—at a temperature within plus or minus 5°F of the developer's—into the tank, using the amount specified by the tank directions. 5b. Agitate with ten inversions initially and then for 10 seconds out of every minute for the remainder of the fixing time. The fixing time is not as critical as the developing time, but stay within the time range suggested in the fixer directions. Fixer may be saved and reused. Keep track of the number of rolls of film processed and dispose of the fixer when the manufacturer's suggested limit is reached. As an alternative to counting rolls, hypo-test solutions can be purchased for checking the condition of fixer. Used fixer contains silver, which is an environmental pollutant, so it should be recycled. Drain the tank.

6a. Initial Wash. Fixer must be removed from the film to prevent staining and damage. It is safe to expose the film to light at this stage. Unless an accessory for the tank that provides forced washing is available, both parts of the double lid should be removed to allow free circulation of the wash water. With both tank lids removed set the tank under a faucet with a good flow of water adjusted to a temperature within plus or minus 5°F of the developer temperature. Direct the flow of water into the center of the film reel. Wash for 1 minute. Dumping the water out of the tank occasionally during the wash will help flush fixer out of the tank. Drain the tank.

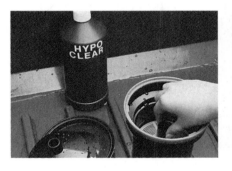

6b. Washing Aid. Mix a working solution of the washing aid—at a temperature within plus or minus 5°F of the developer's—following the manufacturer's directions. Fill the tank with the solution and gently agitate by lifting and turning the film reel continually for the time specified in the directions. Drain the tank.

6c. Final Wash. Again set the tank with the top removed under a flow of good water. Wash for 5 minutes. Efficient film washers allowing shorter washing times are available, but when washing directly in the tank stay with a minimum final wash of 5 minutes. Drain the tank.

7. Wetting Agent. The wetting agent prevents water spots. Mix according to the manufacturer's directions at a temperature within plus or minus 5°F of the developer's. Agitate gently by lifting and turning the reel continually for the time specified in the directions—30–60 seconds for most brands. A few bubbles in the wetting agent are normal.

continued

Film Processing Steps—Continued

8. Drying. Carefully remove the film from the reel and hang in a dust-free place to dry. Clip a weight—such as a clothespin—to the bottom of the film to prevent curling. The film is very susceptible to damage at this stage, so keep handling to a minimum. Leave the film hanging until it is completely dry before looking at your results. Depending upon humidity conditions and temperature, this can take 2 hours or more. It is safest to leave the film overnight before handling. The film is dry when it takes a smooth curve toward the shiny side and the lower end of the roll does not feel cooler than room temperature; coolness is a sign of evaporating moisture still in the film.

9a. Storage and Handling of Processed Film. Transparent polyethylene storage sleeves help protect the film from damage. Using scissors, cut the dry film into lengths appropriate for the sleeves. If your working space allows, the dry film should be cut while hanging, to minimize handling and dust. Otherwise, lay the film out on a clean worktable to cut.

9b. Even after drying, film is very delicate. Never touch the image area of the film—handle only by the ends or edges. The film also scratches easily, so avoid rubbing or dragging it across other surfaces.

Summary of Black-and-White Film Processing Steps

STEP	MATERIALS	PROCEDURE	REMARKS
1. Preparation	Film loaded in tank, developer, fixer, washing aid, wetting agent, running water source—all stabilized to proper temperature, preferably 68°–75°F unless otherwise specified in manufacturer's directions	Dilute developer to proper strength, measure temperature, and calculate proper developing time. Hold developer for step 3.	It is best to use developers at the suggested temperature, but time-temperature charts allow some flexibility. Care should be taken at temperatures much in excess of 75°F, as the film becomes soft and susceptible to damage.
2. Prewet	Water at same temperature as developer	Fill tank. Tap to dislodge bubbles. Agitate by inversion and drain thoroughly. Total time is 1 min.	The prewet step can be optional, though if air bubbles are on the film during development, permanent spots will be left on the negatives.
3. Developer	Developer mixture prepared in step 1 (recheck temperature to make sure it has not changed since mixing)	Set timer for time calculated in step 1. Start timer and pour developer into tank. Follow standard agitation cycle using inversions of the tank. Include pour-out in time.	Set the tank in a bath of water at the developing temperature during the rest periods to maintain constant temperature.

STEP	MATERIALS	PROCEDURE	REMARKS
4. Stop bath/rinse	Water at a temperature within 5°F of the developer's	Fill and dump tank twice. Drain thoroughly.	Commercially available acid stop baths may be used here and are recommended for sheet film or developing times less than 5 min. Follow manufacturer's directions.
5. Fixer	Fixer in proper amount for tank, at a temperature within 5°F of the developer's	Start timer. Pour fixer into tank. Do 10 sec of initial agitation by inversion. Do 10 sec of agitation out of every minute thereafter. Follow manufacturer's directions for time. Drain tank.	Fixer may be reused. Pour it back in the bottle and keep track of the usage. The main tank lid may be removed after this step.
6. Wash	Running water and properly diluted washing aid, both at a temperature within 5°F of the developer's	Three-step wash procedure as follows is recommended.	Dump the water completely out of the tank two or three times each minute of wash to make sure fixer is flushed from the tank.
a. Initial wash	Running water at a temperature within 5°F of the developer's	Place tank with main lid removed under tap with good flow of water for 1 min.	
b. Washing aid	Washing aid mixed according to directions at a temperature within 5°F of the developer's	Immerse film in washing aid with gentle agitation for time specified by manufacturer's directions.	
c. Final wash	Running water at a temperature within 5°F of the developer's	Place tank with main lid removed under tap with good flow of water for 5 min.	
7. Wetting agent	Properly diluted wetting agent such as Photoflo at a temperature within 5°F of the developer's	Immerse film in wetting agent with very gentle agitation for time suggested by manufacturer.	If in any doubt about the quality and cleanliness of the tap water, mix the wetting agent with distilled water.
8. Drying	Dust-free drying area such as film-drying cabinet or shower stall, film clips or clothespins	Handling very carefully to avoid scratches and dust, hang film by one end and place a weight on the other. Let dry thoroughly before handling.	Dust settling on the film while it is wet is difficult or impossible to remove. Watch out for nearby furnace vents or fans that could throw dust on the film. Also be careful about handling wet film around sweaters or other clothing that could cause lint.
9. Storage and handling	Negative sleeves, scissors	Cut negatives to proper lengths for sleeves. Carefully insert into sleeves.	Do not cut film into single frames, as these are difficult to handle. Handle film only by the edges, never touching the image area. Beware of scratching.

■ Commercial Labs for Film Processing

If you do not have the facilities for processing film or do not wish to process it yourself, you may take it to a lab. Most photography done today is in color, so finding a lab to process black-and-white film may be difficult. Costs are sometimes higher for black-and-white processing and return times longer. If you need black-and-white negatives and only color processing is available, use Ilford XP2 Super or Kodak Black and White +400, black-and-white films that can be processed in color negative (C-41) chemistry.

■ Effect of Development on the Negative

Amount of Development

Since the silver image in the negative is formed during the developing step, the amount of development is critical in determining negative quality. The amount of development is the total amount of reduction of silver salts to silver. As with any chemical reaction, a number of factors affect the amount of development:

Time. The amount of development increases with time.

Temperature. The amount of development increases with temperature.

Agitation. The amount of development increases with increased agitation, since fresh developing agents are brought in contact with the emulsion (see the section on agitation during film development on page 67).

Ansel Adams, *Clearing Winter Storm, Yosemite National Park, California,* c. 1944. Adams invented a method called the Zone System for partially controlling tones in the print by the exposure and development of the negative. See the bibliography for references discussing the Zone System.

Nature of developer. High-energy developers result in more development. Greater dilution of a developer decreases the amount of development. Contamination, aging, and reuse of a developer all decrease the amount of development.

Effect of Development on the Negative

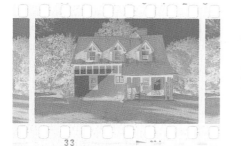

50% Underdeveloped.

Normally Developed.

50% Overdeveloped.

These negatives with the same exposure show the effects of 50 percent underdevelopment, normal development, and 50 percent overdevelopment. As development increases, the dark subject tone areas (the less dense areas of the negative) change very little, while the light tone areas increase in density, resulting in more contrast.

Negative Contrast

In general, increasing the amount of development increases the amount of silver (the density) produced in a negative. However, areas that received more exposure (light subject tones) show greater changes in density as development changes than do areas that received less exposure (dark subject tones). In other words, the density of negative areas representing subject dark tones (shadows) changes little with development, but the density of the subject light tone areas (highlights) changes a good deal. This results in a change in the *difference* between light tone and dark tone densities as the development changes. This density difference is called the **negative contrast**. To summarize: *The contrast of the negative increases as the amount of development increases and decreases as development decreases.*

Several other factors affect negative contrast:

Subject contrast. **Subject contrast** is the difference between the amount of light coming from the light areas of a subject and that coming from the dark areas, and it can be measured using a reflected-light meter. The subject contrast depends on the nature of the lighting on the subject and the tones of the subject itself. Direct light, such as undiffused sunlight, usually results in higher subject contrast, and diffused light, such as light on a cloudy day, normally produces lower subject contrast. (Chapter 7 discusses the effect of lighting on subject contrast in more detail.) Subjects with a large range of tones from very dark to very light will have higher subject contrast.

Type of film. The manufacturer's suggested development times include the necessary corrections for the different types of film to produce a negative of average contrast from a subject of average contrast (see page 13).

Exposure. Underexposure of a negative will reduce the negative contrast. Overexposure may slightly increase the negative contrast for small amounts of overexposure, but extreme overexposure will reduce negative contrast.

Flare. When light enters a lens directly from a light source or if very bright subject areas are included in a picture, the resultant flare may reduce negative contrast.

Reduction of Contrast Due to Flare.

Normal Subject Contrast.

© Bognovitz.

High Subject Contrast.

© Bognovitz.

Low Subject Contrast.

© Bognovitz.

Summary of Film Exposure and Development Effects

We have seen that both film exposure and film development affect the quality of a negative. A simple exercise will summarize the effects of exposure and development on film and how they relate to each other. Identical sets of exposures (two stops underexposed, normally exposed, two stops overexposed) are made on three different strips of film. One strip

A. Two Stops **Underexposed** and 40 Percent **Underdeveloped.**

B. **Normally Exposed** and 40 Percent **Underdeveloped.**

C. Two Stops **Overexposed** and 40 Percent **Underdeveloped.**

D. Two Stops **Underexposed** and **Normally Developed.**

E. **Normally Exposed** and **Normally Developed.**

F. Two Stops **Overexposed** and **Normally Developed.**

G. Two Stops **Underexposed** and 50 Percent **Overdeveloped.**

H. **Normally Exposed** and 50 Percent **Overdeveloped.**

I. Two Stops **Overexposed** and 50 Percent **Overdeveloped.**

Effects of Film Development Changes

■ *Contrast.* Contrast increases in both negative and print as film development is increased.
■ *Dark tone detail.* The negatives show little change in the thin areas—corresponding to dark subject tones—with development.
■ *Grain.* Examination of actual prints shows an increase in negative grain size with increasing film development.

is developed 40 percent less than normal, the second is developed normally, and the third is overdeveloped 50 percent. Each of the nine resulting negatives is printed with the same tonal value in a detailed light tone. Negatives are displayed to the left and prints to the right. The results are summarized below.

A. Two Stops **Underexposed** and 40 Percent **Underdeveloped.**

B. **Normally Exposed** and 40 Percent **Underdeveloped.**

C. Two Stops **Overexposed** and 40 Percent **Underdeveloped.**

D. Two Stops **Underexposed** and **Normally Developed.**

E. **Normally Exposed** and **Normally Developed.**

F. Two Stops **Overexposed** and **Normally Developed.**

G. Two Stops **Underexposed** and 50 Percent **Overdeveloped.**

H. **Normally Exposed** and 50 Percent **Overdeveloped.**

I. Two Stops **Overexposed** and 50 Percent **Overdeveloped.**

Effects of Film Exposure Changes (also discussed on page 22)

■ *Contrast.* Underexposed negatives show a loss of contrast. Overexposed negatives show an almost unnoticeable increase of contrast. Several stops of overexposure will result in a loss of contrast and may block up highlights.
■ *Dark tone detail.* Underexposure causes a loss of detail in dark subject tone areas.
■ *Grain.* Negative grain size increases with increasing exposure.

Effects of Combinations of Changes Some of the effects of incorrect exposure can be corrected by changing the development, but the end result will not be identical. In other words, *exposure and development are not interchangeable.* For example, an underexposed negative can be overdeveloped to correct for the loss of contrast due to underexposure (see print G on the previous page), but the loss of dark tone detail cannot be corrected by increased development. The result will also show more grain. Photographers may intentionally underexpose and overdevelop—this is called

pushing the film—to get faster shutter speeds under low-light conditions, but they are sacrificing shadow detail and increasing grain size (see the boxed section: "Pushing Film" below). On the other hand, we can see from the prints that a negative that has been overexposed is not improved by underdeveloping. The result is simply a low-contrast dense negative (see print C on the previous page). The best solution for overexposed film is to develop normally and deal with the resultant dense negatives by printing them at longer times (see print F).

Effects of Overexposure and Overdevelopment on Grain Structure.

Normally Exposed and Normally Developed Negative (40× enlargement).

Overexposed and Normally Developed Negative (40× enlargement).

Normally Exposed and Overdeveloped Negative (40× enlargement).

Pushing Film

If you wish to shoot in low-light conditions and are willing to live with some increase in grain and loss of dark tone detail, you can "push" a film, which means giving intentional underexposure and then increasing the development to bring the contrast back to printable levels. Usually the actual sensitivity of the film changes little with push processing. To underexpose the film, set the ISO scale of your meter for a higher value. Each doubling of the ISO/ASA value will underexpose your film one more stop. For example, if your film is ISO 400, setting the meter for ISO 800 will underexpose the film one stop, and setting it for ISO 1600 will underexpose the film two stops.

Some film developers, such as Acufine or Diafine, may give directions for push processing. Otherwise, you must simply use trial and error to find the amount of development that will restore normal contrast. Increases in development can be achieved in three dependable ways: (1) increase the development time, (2) increase the development temperature, or (3) increase the strength of the developer. The following

guidelines are for general-purpose black-and-white films and developers.

For one-stop underexposure (double the ISO): Try increasing the development time by 50–60 percent. For example, if your normal development is 7 minutes at 70°F, try 11 minutes at 70°F. T-Max films require no change in development for a one-stop push.

For two-stop underexposure (quadruple the ISO): Try increasing the temperature by 5°F and the time by 50–60 percent. For example, if your normal development is 7 minutes at 70°F, try 11 minutes at 75°F. For T-Max films, keep the temperature the same and try increasing the development time by 25–35 percent.

If you would like to push film but prefer working at shorter development times, try a more active developer like Kodak HC-110 dilution A. Any of the ultrahigh-speed films offer an alternative to pushing. The grain of these films will also be coarse, but you may preserve more dark tone detail on the film. ■

Control of Negative Quality through Exposure and Development

A "good-quality" negative transforms a range of subject tones into an acceptable range of tones in the photograph, with desired detail in dark and light tones.

Controlling Detail Only correct film exposure will insure correct dark tone detail, since development has little effect on these areas. Highlight detail in the negative can be lost by gross overexposure.

Controlling Contrast Photographic print materials will display only a limited range of tones, so the negative contrast must be matched to the capability of the print material. Careful film processing will prevent variations in negative contrast due to inconsistent development. Subject contrast also affects negative contrast and is not always under the photographer's control. However, the amount of film development can be changed—usually by varying the development time—to compensate for subjects that are not of average contrast. Increase the development time for low-contrast subjects and decrease it for high-contrast subjects.

Low-Contrast Subject with Normal Development.

© Bognovitz.

Film Development Increased to Raise Contrast.

© Bognovitz.

High-Contrast Subject with Normal Development.

Film Development Decreased to Lower Contrast.

Printing Photographs

Brian Lanker, *Eva Jessye*.
© Photograph by Brian Lanker.

The desired final presentation of a photograph is most often a print. The original tones of the subject are reversed in a negative, with light subject tones showing as dark areas. Printing the image from the negative onto a photographic printing paper reverses the tones a second time, resulting in a positive image, showing the subject in its proper tonal relationships. This chapter deals with black-and-white printing techniques in detail.

Black-and-White Printing Papers

Black-and-white printing papers provide a positive monochrome image when exposed to the image from a negative. As with black-and-white films, the image is formed in an emulsion containing silver halides. However, the support—also called the base—is paper rather than a transparent film.

Characteristics

Base Print base materials come either as resin coated (RC) or fiber-base. Both types use paper as a base for the emulsion, but the paper in the RC print is coated on both sides with a plastic layer. Advantages of RC prints include more rapid processing and drying. Fiber-base print mate-

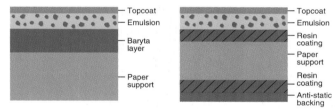

Paper Base Types. Left: Fiber-base photographic paper structure. Right: Resin-coated (RC) photographic paper structure

rials are generally higher in quality, though a few RC materials yield high-quality prints. Fiber-base prints give more flexibility in surface choice and are somewhat easier to retouch and mount for presentation than RC prints. If you are concerned about the long-term permanence of your photographic prints—on the order of many decades or even hundreds of years—fiber-base prints are generally thought to have a longer life, although more recent research seems to indicate longevity differences are not that great. A few emulsion types are available in either fiber-base or RC, but most give only one choice.

The **base weight** of a paper is an indication of the base thickness. Single-weight paper is the thinnest base for most print materials, although a few come in lightweight, also known as document weight. Medium weight and double weight are progressively thicker. Single-weight and double-weight papers of the same emulsion and surface type will yield identical prints. Single weight has the advantages of less bulk and lower cost. Double weight is easier to handle in processing—less likely to crease or suffer other damage—and tends to curl less after drying.

Emulsion Types A large variety of papers are offered with different emulsions. The emulsion type is usually indicated by the name of the paper. Characteristics of the paper that depend on the emulsion are image color, tonal rendition, sensitivity, and method of contrast control.

Surface Most photographic papers are offered with several different surface textures. Common descriptions of the surface—listed in approximately decreasing smoothness—are glossy, pearl, luster, semimatte, matte, silk, tweed, and so on. Manufacturers sometimes limit the number of surfaces available in specific emulsion types on the basis of their marketability.

Color Sensitivity Black-and-white printing papers are usually blue sensitive, which means limited exposure to yellow or amber light will not affect the paper. This allows working with the papers under lights of special color called **safelights.** The manufacturer will specify in the literature of a paper the type and power of the safelight that may be used. A safelight with an amber filter—Kodak's OC filter—is suitable for most general-use black-and-white papers. The red safelights used in graphic arts darkrooms are not safe for some black-and-white printing materials. Black-and-white **panchromatic paper** is sensitive to all visible colors and is used for making black-and-white prints from color negatives. Panchromatic paper must be handled and processed in total darkness or under an extremely dim dark green safelight. Black-and-white prints can be made on most enlarging papers from color negatives, but the rendition of tones is more representative of the subject with the use of panchromatic papers.

Speed The sensitivity to light varies from paper to paper and determines the amount of exposure needed in printing. Less sensitive papers, called **slow** papers, are used for contact printing. More sensitive papers, called **fast** papers, are needed for enlarged images. Since the grain structure of a paper is not enlarged, it is not perceptible to the unaided eye. For that reason, increasing the paper speed has no visible effect on grain. Paper speed is not calibrated as closely as film speed, so you may find variations from box to box of the same type of paper.

Sizes Photographic printing papers are available from postcard size to giant mural sizes. Common sizes are 4 × 5, 5 × 7, 8 × 10, 11 × 14, 16 × 20, and 20 × 24 inches.

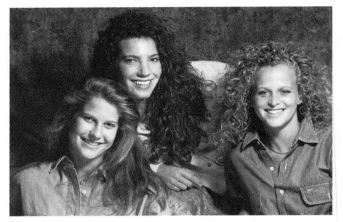
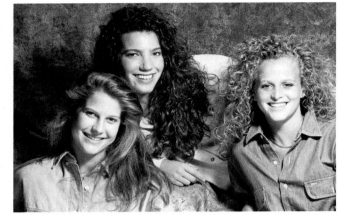

Image Color in Photographic Papers.
Left: Neutral- to Cold-toned Paper. Right: Warm-toned Paper.

© Bognovitz.

Image Color Although black-and-white papers are monochrome, the actual color of black varies from paper to paper and can be warm (tending toward brown), neutral, or cold (tending toward blue). The image color of a paper is determined partly by the emulsion type and sometimes by a tint added to the base material. Papers using silver chloride as the light-sensitive salt—as do some contact papers—tend to be warm in image color, and silver bromide papers are usually more neutral or cold toned. Many modern papers use both silver salts and are called chlorobromide papers. The image color of a paper can be changed after the processing by treating the print in a toning solution. Toners are available in a variety of colors.

Paper Contrast Print contrast is the difference in tones between light and dark. **Paper contrast** is the physical response of a paper to differences in exposure and is one factor affecting the resulting print contrast. A higher-contrast paper produces greater differences in tone.

Paper contrast is given as a number, the contrast **grade,** which may range from 0 to 5. Grade 0 produces the least contrast and grade 5 the most. The normal contrast grade is 2, which means that a properly developed negative should yield a print with correct tonal rendition on a paper of contrast grade 2.

Two different products are offered for changing the paper contrast:

Graded papers. The paper contrast of a graded paper is fixed. Each pack contains paper of one contrast number, which is indicated on the package as a whole number. To change the contrast, you must buy another pack of paper with a different contrast number. Some emulsions offer the complete range of contrast numbers from 0 to 5, in whole numbers only; others may offer a smaller range.

Variable-contrast papers. The emulsions of variable-contrast papers change contrast with the color of light used to expose them. Yellow light produces lower contrast and magenta light produces higher contrast. By mixing the amount of yellow and magenta light through filtering on the enlarger, contrast can be varied widely using paper from the same pack.

Variable-contrast filters are available as sets and control the contrast in half-grade steps. Most variable-contrast papers can produce contrast grades from 0 to 5 in half steps. Printing without a filter approximates grade 2. Enlargers with built-in color filtering systems can be used to control the contrast of variable-contrast papers. Note that variable-contrast filters cannot be used to alter the contrast of graded papers.

The purchase of only one box of variable-contrast paper and a set of filters provides the complete range of paper contrasts in half grades. Graded paper requires a much larger inventory of packs of paper of different contrast grades and gives only whole-grade changes. On the other hand, it is easier to manufacture premium-quality graded papers, so the best-looking papers in terms of clean whites and rich blacks are graded papers. Recent advances in the technology of paper manufacturing have produced several excellent variable-contrast papers. They are highly recommended for all but the most demanding of uses.

Printing Paper Contrast

Grade 0.

Grade 1.

Grade 2, Normal Contrast.

Grade 3.

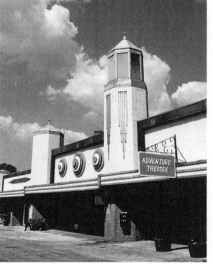
Grade 4.

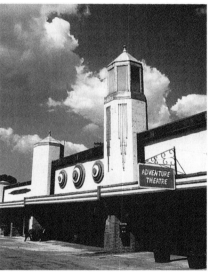
Grade 5.

This series shows the effect of changes in paper contrast grade. The same negative was used throughout, printed for equal subject light-tone values in each print.

© Bognovitz.

Storing and Handling Photographic Paper

Black-and-white papers have a fairly long shelf life if properly stored. Avoid heat, moisture, and exposure to chemical fumes. Paper can be refrigerated for longer life, but be sure to enclose it in an airtight container. When removing it from refrigeration, allow plenty of time for the paper to come to room temperature before unsealing the container.

Warm-up Times for Refrigerated Photographic Papers (in Hours)

	FROM 35°F TO 70°F	FROM 0°F TO 70°F
25-sheet package	2	3
100-sheet box	3	4

Photographic papers must be handled carefully. The emulsion is susceptible to fingerprints and scratches, so touch only the edges. Make sure hands are clean and dry. When processing paper, handle gently to prevent creases, bends, and scratches.

Printing Paper Selection

Photographic stores should have samples of prints made on the various papers. Variable-contrast papers are wonderful to learn on because of the low investment and ease of use. Although RC papers have the limitations listed earlier, their ease of handling in processing may be important, especially if you are working in a home **darkroom** with barely adequate washing and drying facilities. Once you have mastered the basic skills of printing, the best way to learn about photographic papers is to experiment with several different ones; then a choice can be made on the basis of the results.

■ Printing Equipment and Facilities

Darkroom

Most rooms can be made light-tight with a little ingenuity. Rooms without windows are the easiest, but windows can be blocked with opaque materials. Doors can be made light-tight with weather stripping or flaps of black sheet vinyl—available from hardware stores—stapled to the edges.

Electrical power and running hot and cold water should be supplied to the darkroom. Power requirements are usually not very high, unless a heated print dryer is being operated. It is possible to print in a darkroom without running water, but the prints must then be taken to another room for washing.

The size of the darkroom is often determined by available space. Darkrooms have been constructed in spaces as small as a few feet square. Many home darkrooms are in converted bathrooms or closets. If large prints are to be made, more space is needed. If possible, spaces used for working with wet materials should be separated from those used for dry materials.

Enlarger

The enlarger is much like a slide projector. It has a light source, a place for holding a negative, and a lens that projects the enlarged image of the negative down onto the baseboard. The head of the enlarger can be moved up and down on a column to allow for different magnifications of the image.

Lamp Housing Designs Two basic lamp housing designs are made for enlargers: condenser and diffusion. Condenser enlargers generally provide more light to the negative and shorter exposures. They also produce slightly more contrast in black-and-white printing.

Diffusion enlargers supply the light to the negative in diffused, or scattered, form. They suppress the effect of dust and scratches on the negative and give a more even gradation of tonal differences, especially in the light tone areas. It is easier to design built-in color filtering systems for a diffusion head, so most color head enlargers are of the diffusion type.

Several types of light sources are used. Most condenser enlargers use frosted light bulbs with a tungsten filament.

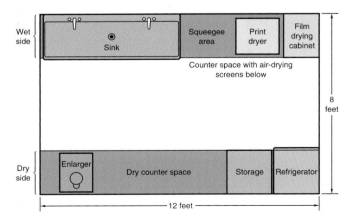

A Comfortable, Well-designed Darkroom Floor Plan, with Wet and Dry Areas Separated by Distance.

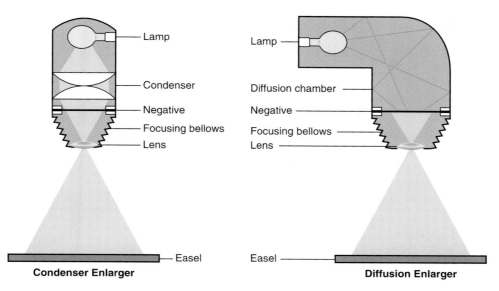

Condenser Enlarger

Diffusion Enlarger

In a condenser enlarger the light is focused by large lenses and reaches the negative traveling basically all in the same direction. In a diffusion enlarger the light is diffused by being supplied indirectly to the negative through a mixing chamber with white walls or by being passed through a diffusion material such as frosted glass or plastic.

Some diffusion enlargers may use high-wattage quartz-halogen tungsten bulbs, but others use "cold-light" sources such as fluorescent or mercury-vapor tubes or other discharge-type light sources. Some cold-light sources may not be suitable for color printing.

Format Size Most enlarger designs will accept a range of film format sizes and are usually described by the maximum format size. A 6 × 7 enlarger will accept format sizes up to and including the medium-format 6 × 7 cm format size, and a 4 × 5 enlarger will accept formats up to 4 × 5 inches. Adjustments or changes in lens, negative carrier, and light source are usually needed to change format size.

Enlarger Lenses Since the enlarger lens forms the image of the negative on the print material, the quality of the final print is heavily dependent on the quality of the enlarging lens. The lenses come in different focal lengths and coverage. Coverage indicates the maximum-size negative from which the lens will produce a good-quality, evenly illuminated image. Focal length is generally chosen according to the format size. The 50mm lenses are used for 35mm film. The 75mm to 90mm lenses are used for medium formats such as 4.5 × 6, 6 × 6, and 6 × 7 cm. The 135mm to 150mm lenses are used for 4 × 5-inch film.

The enlarger lens contains an aperture control with a range of f-stops. Lenses with a larger maximum aperture provide a brighter image when opened up for composing and focusing. Although this may offer some convenience, prints are not normally made at wide-open apertures.

Such lenses are more expensive, but this does not necessarily guarantee better quality at the f-stops normally used for printing. In general, however, the overall quality of a lens is in direct relationship to its price.

Other Darkroom Equipment

Safelight The instructions for a print material should specify the type and power of safelight that may be used. Many safelights have interchangeable filters, allowing their use with a variety of different materials. A safelight of the wrong color or one that is too bright may give unwanted exposure, called **fog**, on the print.

Timer Enlargers do not have built-in shutters, as cameras do. Instead the length of exposure is controlled by turning the enlarger lamp on for the needed length of time. A timer into which the enlarger is plugged will insure accurate, repeatable exposures. Timers can be electrically driven mechanical devices or may be totally electronic, with a variety of features and accessories. The electronic timers are typically more accurate, especially for short exposure times. An audible beeping signal that marks the seconds can be a great convenience when printing, since it allows counting the progress of an exposure without looking at the timer face.

Easel A photographic printing easel is a frame that holds the printing material during the exposure. It is essential for accurate positioning of the image on the paper and allows the print to be exposed with clean, straight borders.

Many types and sizes of easels are available, some with standard borders, others with widely adjustable borders. A special type of easel known as a contact printing frame contains a glass or plastic cover plate and is used for making contact prints.

Focusing Magnifier The image of the negative must be focused on the easel for maximum sharpness. The focusing magnifier enlarges the image for more accurate focusing. Some focusing magnifiers, known as grain focusers, magnify the image enough that the actual grain structure of the film can be seen.

Cleaning and Dusting Equipment Dust and lint on the negative will show up in the prints as white marks. Static electricity causes dust and lint to adhere to the film surface, so cleaning requires an antistatic device, available in the form of a brush, cloth, or gun. After antistatic treatment, the dust can be blown off with clean compressed air or a canned air device. Canned air is actually a gas that is liquid under compression. Some of these substances are damaging to the ozone, so shop for ones that are advertised as more environmentally safe. Fingerprints and other oily or greasy deposits may require the use of a film-cleaning fluid and cotton balls or cotton swabs. Use only film cleaner designed for still photography purposes.

Magnifying Loupe A magnifying loupe is used to directly inspect your negatives for sharpness or defects. Inexpensive loupes are not very useful because of the poor quality of the optics.

Printing Equipment. Back row: 8 × 10 inch printing easel, 11 × 14 inch adjustable printing easel, and electric/mechanical timer. Front row: Electronic timer, safelight with OC filter, and contact printing frame.

Cleaning and Focusing Equipment. Clockwise from the bottom: Antistatic brush, enlarging focusing magnifier, antistatic cloth, magnifying loupe.

Print Processing Equipment The following equipment is used for preparing the photo chemistry and handling the prints during the processing stages:

Trays. You will need a minimum of four trays designed for photographic use. Choose trays at least one size larger than the printing paper. For 8 × 10-inch prints use an 11 × 14-inch tray and so on.

Tongs. To avoid contact with chemicals, use print tongs for handling prints in the solutions. Tongs of stainless steel or inert plastic are less likely to cause contamination than tongs of bamboo.

Storage containers. Dark brown plastic or glass bottles are used for storing the stock or working solutions of the chemicals.

Thermometer. The thermometer described for film processing may also be used for measuring the temperature of the print processing solutions.

Timer. A clock or timer that is easily visible under the safelight is needed for timing the steps in processing prints.

Washer. A print washer is necessary for clean, long-lasting prints. Good washers are expensive. An alternative is the tray siphon shown on the following page.

Squeegee. A print squeegee is used to remove excess water from prints before drying. Buy one slightly larger than your maximum print width. Squeegees are available in photographic stores. Standard, soft rubber window squeegees available in hardware stores also work well.

■ Black-and-White Print Chemistry

The steps in print processing are similar to those used for film but are fewer in number. Although some of the chemical solutions can be used for processing either films or prints, it is a good idea to mix and store separate chemistries for each process. This will help prevent dirt or contamination in the film chemistry.

Developers

Paper developers convert the latent image on the printing paper to a visible silver image and are generally more active than film developers. The type of developer used with a paper can affect a print's image color, contrast, and tonal rendition. When you shop for a paper developer, read the manufacturer's description of its qualities. The almost unlimited combinations of paper types and developers allow a wide range of print qualities. Do not hesitate to mix brands of paper and developer.

Print developers have limited storage life and working capacity. Most have a life of less than 24 hours once they are diluted to working strength, especially when left in an open tray. Follow the manufacturer's recommended storage and usage conditions. Be sure to use clean bottles for storage.

Stop Bath

The stop bath neutralizes the developer, stopping the development process and extending the life of the fixer. It can also prevent **dichroic fog**, an iridescent coating on

Print Processing Equipment. Front row: Print tongs, trays, squeegee. Back row: Tray siphon for print washing, vertical print washer, containers.

the print resulting when developer is carried into the fixer.

Stop bath is usually a weak solution of acetic acid. An indicator stop bath contains a yellow dye that becomes bluish purple as the stop bath becomes exhausted. Under an amber safelight, the exhausted stop bath will turn dark. Mix the stop bath carefully according to the manufacturer's directions.

Fixer

Fixer dissolves out the unused silver halides. Both standard and rapid fixers are available for use with photographic papers. Some can be used at the same strength for either film or paper, but others require different dilutions. Since the same fixers are used for either prints or films, you will find that most have hardener incorporated in them. Print toning is easier with unhardened prints. A few fixers come without hardener or can be mixed without it (e.g., Sprint Fixer). Follow the manufacturer's directions for mixing, use, and storage life.

Fixer can be reused if the working capacity or storage life is not exceeded. Hypo-check kits are available for testing the condition of fixer, but a rough test is to immerse a strip of unexposed, undeveloped film into the fixer. The film should "clear"—that is, become transparent—in less than half the suggested minimum fixing time.

Washing Aids

The same washing aids—also called hypo-clearing bath or fixer remover—used for film can be used for prints. The times may vary, depending upon the weight and type of paper. Follow the manufacturer's directions. Washing aids can be reused, but do not exceed the working capacity of the solution.

Handling and Storage of Photographic Chemicals

Refer to the section on pages 64–65 for information on handling and storing photographic chemicals.

■ **HEALTH AND ENVIRONMENT NOTE** See page 63 for important health and environmental information regarding photographic chemicals. Protect yourself from adverse chemistry contact as described in that section. Use of tongs or rubber gloves is highly recommended for handling prints in processing solutions. Good ventilation in the printing darkroom is very important. Be sure to properly dispose of chemicals containing silver or other environmental pollutants.

◼ Black-and-White Negative Printing

If the preceding equipment and chemistry have been assembled, you are ready to begin printing. The following techniques are demonstrated for 35mm film but apply to other format sizes as well, with the use of equipment appropriate to the format. Two basic techniques are used for exposing the photographic paper to the image: contact printing and enlargement—also called "projection"—printing. The enlarger can be used as a light source for both methods of printing. Processing of the exposed printing paper is the same for both methods and is described in the section beginning on page 98. Remember that all handling, exposing, and processing of photographic papers must be done only under the appropriate safelight.

Enlarger Preparation

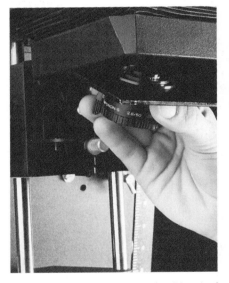

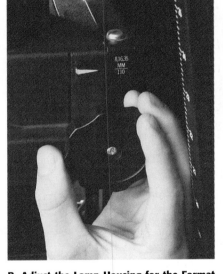

A. Install the Lens. Choose the focal length of lens that is appropriate for the format size being printed (see page 83; for 35mm film use the 50mm lens). Orient the lens so that the f-stop scale and indicator are visible.

B. Adjust the Lamp Housing for the Format Size. On a condenser enlarger this may be done by changing the placement of the condenser lenses in the lamp housing with a control knob or by opening the housing and physically moving one of the condenser lenses from one position to another. Some enlargers may require the insertion or removal of a supplementary condenser lens. This step is extremely important to insure even lighting with condenser enlargers. Diffusion enlargers may provide even lighting over a large range of format sizes without adjustment of the lamp housing. Some diffusion enlargers designed for large formats provide an accessory diffusion chamber for use with small-format—such as 35mm—negatives, which will shorten exposure times by concentrating the light on the smaller area.

C. Insert the Negative Carrier. Choose the negative carrier that is appropriate for the format size being printed. The negative stage of the enlarger is between the lamp housing and the lens stage and is usually opened by use of a lever. Be sure that the negative carrier is properly centered and sitting flat in the negative stage.

D. Turn Enlarger On. The enlarger is now ready for use. Turn the enlarger on, and you should see a rectangle of light projected onto the baseboard.

E. Adjust Size of Image. The size of this rectangle can be increased by moving the enlarger head up on the column. If the enlarger has a lock to hold the head in place, be sure to unlock it before moving the head.

F. Focus. The edge of the rectangle can be made sharp—that is, put in focus—by turning the focus control knob.

Contact Printing

Contact printing is the oldest method of producing prints from negatives. The negative is simply laid on top of the photographic paper and covered with a sheet of glass to ensure close contact. Light is then allowed to fall on the negative, producing exposure on the paper in the pattern of the negative. The amount of exposure the paper receives depends on the brightness of the light and the time it is allowed to fall on the negative. Processing the paper will reveal a positive image the same size as the negative.

If a contact print large enough for easy viewing is desired, the negative itself must be the same size, requiring the use of large cameras. The contact print does not require the use of an enlarger, however, as any light source of the appropriate brightness and evenness can be used to expose the paper. Since no projection or enlargement of the image takes place, the resulting image is of the highest possible quality in sharpness and rendition of tone and detail. Edward Weston made 8 × 10 inch contacts of his negatives (see the frontispiece of the book).

Small- and medium-format users will find the contact print useful for editing negatives. Although small, the images are in positive form, and a whole roll of film can be included on one sheet of paper, providing an excellent

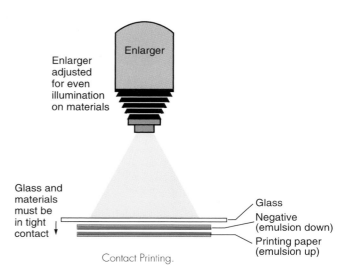

Contact Printing.

reference for choosing images. If you number your rolls of film and the corresponding contacts, you can make a useful negative filing system by storing the contacts in a binder. Some polyethylene sleeves allow space at the top for writing index numbers or information; these will print directly onto the contact sheet.

Filing System Using Contact Proofs. To prevent unnecessary handling of the negatives, use separate binders for the negatives and contact proofs.

Setup An enlarger can be used as a light source for making contact prints, providing even lighting of the negatives and easy exposure control with aperture and timer. Use photographic papers intended for enlargements when contact printing with the enlarger. Exposure times with contact papers will probably be too long to be practical.

Exposure Determination Exposure meters designed for use in determining print exposure do exist, but they are typically expensive and require complicated calibration for successful use. It is far easier to determine print exposure by trial and error using a **test strip.**

A test strip is a small piece cut from the printing paper that you will use to make the full-size print. It is important that the test strip be from the same pack of paper, since even the same type of paper can vary in sensitivity from package to package. Test strips should be large enough to include the important parts of the negative or negatives being printed. Two-by-five inches is a convenient minimum size. Larger strips may be cut if needed.

Contact Printing Method

A. Set up the enlarger as described earlier. Be sure to install the negative carrier, even though you will not be placing the negatives in it for this process. Proper installation of the negative carrier and adjustment of the light housing will provide even lighting throughout the rectangle of projected light. Adjust the height of the enlarger head until the rectangle of light is somewhat larger than the size of the printing paper. All remaining steps should be performed with the darkroom illuminated only by a proper safelight.

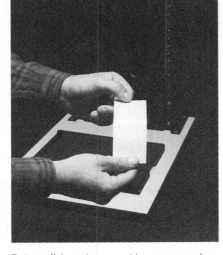

B. Turn off the enlarger and lay a test strip from the printing paper with the emulsion side up in the area that was illuminated by the enlarger. The emulsion side of a glossy-surface paper is the shiny side. The emulsion side of matte-surface papers is more difficult to identify. Photographic papers usually curl slightly toward the emulsion side. Sometimes the brand name is printed on the back of the paper. As a last resort, a slightly moistened finger touched to a corner of the print will stick slightly on the emulsion side but not on the base. Unfortunately, this may also leave a fingerprint on the surface of the paper.

C. Place the negatives emulsion side down on top of the test strip. The emulsion side of the film is the dull side. If you are making proofs of negatives in clear polyethylene negative sleeves, the negatives may be left in the sleeves for contact printing. This will slightly deteriorate the sharpness of the contact image but is adequate for proofing. Take the negatives out of the sleeves if the sleeves are not transparent or if you desire maximum sharpness.

D. Place a sheet of plate glass over the negatives and test strip and press down if needed for good contact. Commercially available contact printing frames as shown make this procedure easier.

E. Make a series of exposure times on the strip by setting the timer for the longest time to be tried, then covering the strip progressively in sections as the time elapses. For making 8 × 10-inch contact prints on projection paper with many enlargers, try an f-stop of f/8 or f/11 and times of 5, 10, 15, and 20 seconds. Set the timer for 20 seconds. With the test strip in place, start the timer. After 5 seconds have elapsed, cover up one-fourth of the strip with an opaque card. After 5 more seconds—a total of 10 seconds—cover up one-half of the strip. After 5 more seconds—15 seconds total—cover up three-fourths of the strip. The timer will turn off the enlarger after 20 seconds.

F. Process the strip (see pages 143–50) and inspect it under white light. Choose the section that shows the best tones for the image or images. The light end of the strip received the least exposure. If the whole strip is too dark, it received too much exposure. Stop down the lens—for example, from f/11 to f/16—and make a new test strip. If the whole strip is too light, open up the lens or lengthen the time increments.

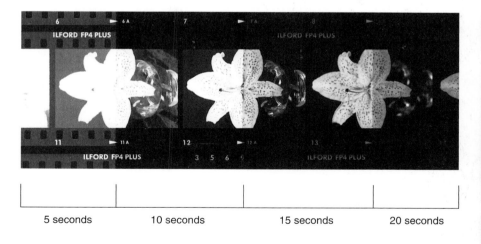

| 5 seconds | 10 seconds | 15 seconds | 20 seconds |

G. In this example, the 10 second exposure section is slightly light and the 15 second section is too dark, giving an estimated printing time of 12 seconds. If the negative exposure varies on a roll of film, it may be difficult to decide from the appearance of the images themselves which time to use. In that case, the appearance of the sprocket holes along the edges of the film can help to determine a printing time. Look for the longest time on the test strip that shows a slightly visible difference between the sprocket holes and the surrounding black and use that exposure time.

H. Once a good exposure has been found on the test strip, expose a full sheet of paper using the same techniques, exposure time, and aperture, and then process.

Projection Printing

Having chosen an image to print from your contact proof, you are ready to enlarge the image. The enlarger should be set up just as described earlier, but this time you are going to insert the negative you wish to print into the negative carrier and project its image down onto the baseboard.

Projection Printing Method

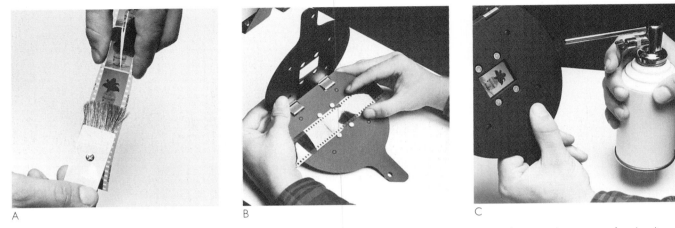

A B C

A. *Cleaning and Inserting the Negative.* Remove the negative carrier from the enlarger and open it. Make sure it is clean and free of dust and lint. If necessary, clean the carrier with a brush and compressed air. Clean your negative before inserting it into the carrier. Use an antistatic device—brush, cloth, or gun—to neutralize the static electricity on both surfaces of the negative, then blow dust and lint from the negative with compressed air.

B. Insert the negative into the negative carrier with the emulsion side of the film down (shiny side up). On small- and medium-format films, the numbers printed on the edges will read correctly when the emulsion side is away from you. An enlarger will project the image upside-down, just as a slide projector will, so if you wish to view the image on the baseboard right side up, you must turn the negative end for end when inserting it into the negative carrier.

C. Close the negative carrier and inspect the negative for cleanliness, once more using compressed air to blow any dust or lint off the negative. When using canned air do not tip the can because this will cause the contents to come out as a liquid rather than a gas and may cause damage to the negative. Fingerprints or other oily marks on the negative must be cleaned with film cleaner. To clean off such marks, first make sure the negative is clear of dust. Second, lay the negative on a clean sheet of paper. Third, moisten a cotton ball or swab with film cleaner and gently apply it without pressure to the entire negative, using a circular cleaning motion. Fourth, after the film cleaner has dried, reclean the negative with antistatic device and air to remove traces of cotton lint. Use film cleaner on negatives only if absolutely necessary. Spots that do not come off with film cleaner may be water soluble. Try rewashing the film, treating it in wetting solution and hanging it to dry.

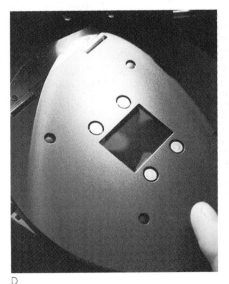

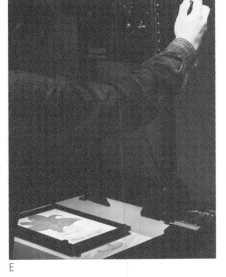

D E

D. The light projected by the enlarger is excellent for inspecting negatives, but if you are working in a group darkroom take care not to turn on the enlarger while the negative carrier stage is open, as you may fog other workers' paper. Inspect both sides. Once you are sure the negative is clean, reinstall the negative carrier in the enlarger and gently close the negative carrier stage.

E. *Composing the Image.* Place an easel for the size print you wish to make on the baseboard of the enlarger. Turn on the enlarger. You should see the image of the negative projected onto the easel. To make the image brighter and easier to see, open the enlarger lens to its maximum aperture, but stop it back down to the proper aperture before printing. Move the easel to center the image. If the image is too big or small, adjust the height of the enlarger head.

F

G

H

F. Focus the image until it is sharp, using the focus control. Focusing the image also changes its size, so you may have to readjust for proper image size and refocus until you get the desired size.

G. If you are projecting a 35mm negative onto an 8 × 10-inch easel, you will discover that the image is not the same proportion as the shape of the easel and that you must cut off part of the length of the image to get a full 8 inches in width. This is called a full 8 × 10 print. If you wish to see the full image of the negative, you will have an image narrower than 8 inches. This is called a **full-frame** 8 × 10 print.

H. You can choose to include only parts of the full image by raising the enlarger head to increase the image size, then moving the easel to select the part of the image you wish to include in the print. This process is called **cropping** the image. Although this is a convenient way to change the composition of your image, greater magnification of the image produces an enlargement of the grain structure, making it more visible in the final print, and also reveals any sharpness problems the negative may have. To achieve the best-quality images, always try to compose for the desired image through the camera viewfinder when taking the photograph rather than cropping excessively in printing.

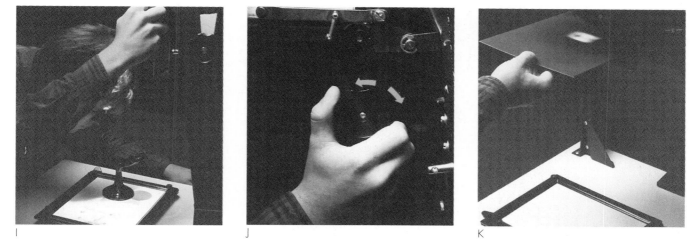

I

J

K

I. *Focusing.* After you have composed the image on the easel, carefully recheck the focus. This is easier to do with the lens opened to its maximum aperture. Accurate focusing is made easier by using a focusing magnifier. First focus the image using the unaided eye, then place the focusing magnifier in an area of the image with visible detail. Many focusing magnifiers will work efficiently only near the center of the image.

J. While watching the image through the focusing magnifier, gently adjust the focus back and forth until you are sure it is at the point of best sharpness. Stop the lens down to the aperture you intend to use for printing. On some lenses the focus will shift slightly as you stop down, so if your fo-

cusing magnifier provides a bright enough image, it is a good idea to recheck the focus at the printing aperture.

K. The heat of the bulb may cause the negative to buckle or "pop." This will cause a blurring of the image during exposure. If you are having this problem you may have to preheat the negative by leaving the enlarger on with the negative in place for about 1 minute before focusing. Before making the actual exposure you should again preheat the negative. One way to avoid a delay between preheating and printing—during which the negative might resume its original shape—is to place the printing paper in the easel, cover the lens with a black opaque card, preheat, remove the card, and immediately make the exposure.

continued

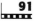

Projection Printing—Continued

L

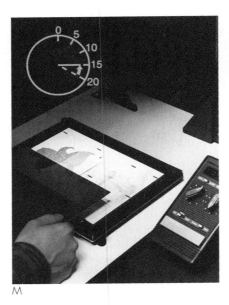

M

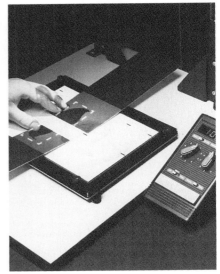

N

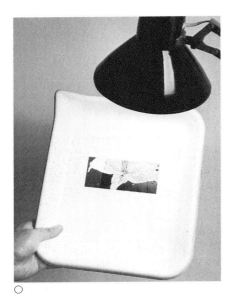

O

L. *Determining the Exposure.* Exposure for the enlargement can be determined with a test strip just as described earlier for the contact print. Choose a part of the image that contains the light areas of the subject, represented by the dark parts of the negative image. Turn off the enlarger, take the test strip out of the package, and lay the test strip emulsion side up in the area you choose.

M. Expose the strip to a series of exposures just as you did with the contact print test strip. A good starting trial test strip would again be f/8 or f/11 at 5, 10, 15, and 20 seconds. Be careful not to touch the test strip with the opaque card, as doing so will move it and cause a blurring of the image.

If you are unsure of your exposure time, you can cover a larger range of exposures on a single test strip by using proportional increments of time rather than equal increments or using more increments or both. By starting with 2 seconds and doubling the time for each of six increments, you would have exposures of 2, 4, 8, 16, 32, and 64 seconds all on one strip. If you know your exposure is somewhere around 10 seconds you might do a series of exposures of 6, 8, 10, 12, and 14 seconds on your test strip. Time increments that are too small make it difficult to see the dividing lines between sections.

N. For an alternative method of timing test strips, time each segment individually by setting the timer for progressively larger values, covering up all of the test strip but the segment being exposed. This yields accurate timing but is more time-consuming to perform.

Additive exposures are sometimes used to achieve the increasing increments of exposure. For example, the entire test strip is exposed for 5 seconds. One-fourth of the test strip is then covered, the timer is reset for 5 seconds, and a second exposure is made. This procedure is repeated, covering up progressively more of the strip each time. This method of exposure poses two problems. First, timer errors can add up to a sizable error after repeated exposures. Second, several repeated exposures on the paper do not produce the same amount of density as one long exposure of the same total time—a phenomenon known as the **intermittency effect.**

O. Process the test strip and inspect it in white light.

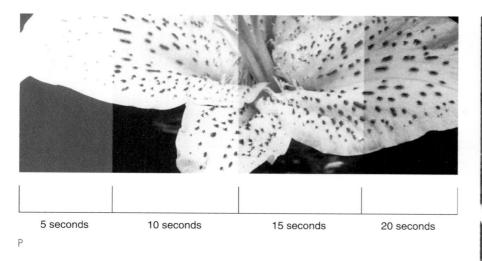

P

5 seconds 10 seconds 15 seconds 20 seconds

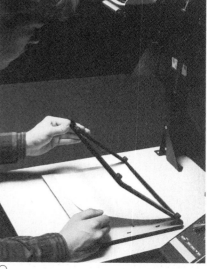

Q

P. Look for the lightest section that shows all the detail in the light areas. If one time is too light and the next too dark, choose an intermediate time. Here the best time is about 10 seconds. Remember that the longer the printing time, the darker the resulting print tones.

Q. After choosing a time from your test strip, set the enlarger timer for that time, place a full sheet of paper in the easel, and turn on the timer. Process the print.

Analysis of the First Print The first print of a negative is seldom a finished product and should be considered a trial or "work" print. After processing the print, inspect it under white light. Correct exposure of the print is indicated when the light areas of the subject have the correct appearance. Light areas should not be too dark but should not be so light as to lose important details in the subject or look washed out. Some printing papers appear lighter when wet than after they dry; this phenomenon is called **drying down** to a darker tone. Only experience will tell you if your paper dries down. If so, you must compensate for this when choosing exposure times from wet prints.

Correctly Exposed Print. The light tone areas are light as they should be, and show full detail.

Overexposed Print. The light tone areas show detail, but are too dark.

Underexposed Print. The light tone areas are too light, looking washed out and showing a loss of detail.

Local Exposure Controls The general exposure in your print may look good, but some areas of the print may be too light or too dark. Individual parts of the print can be lightened or darkened by changing the exposure only in those local areas. **Dodging** means reducing the exposure in an area of a print by covering up that area during part of the exposure. When printing from a negative, dodging will lighten the area. **Burning** means increasing the exposure in an area of a print by covering up everything else in the print and giving additional printing time to that area. Burning will darken the area when printing from a negative.

This print was made without burning or dodging.

© Bognovitz.

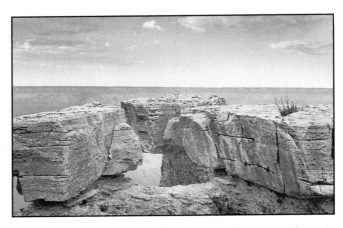

This is the finished print. The sketch below shows the times used for each area.

© Bognovitz.

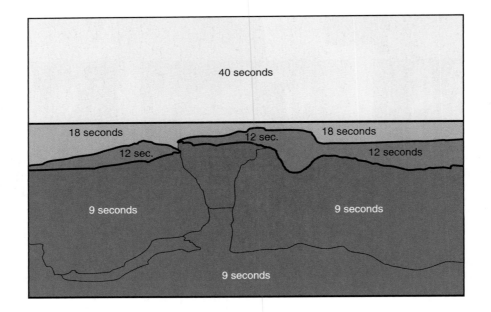

Burning and Dodging Techniques

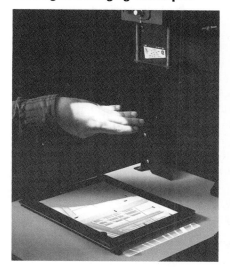

A. The tools needed for dodging or burning are opaque objects that can be used to block parts of the image during exposure. Your hands can often serve as dodging or burning tools, since they can be shaped to cover varying sizes and forms in the image.

B. For dodging small areas, shapes cut out of opaque—preferably black—cardboard work well. For areas in the middle of the image, the dodging tool can be taped to a piece of stiff wire to avoid casting an unwanted shadow from holding the tool with your hand.

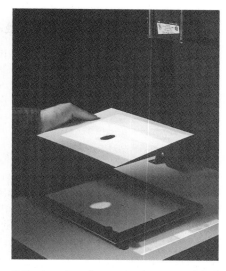

C. Burning of small areas can be accomplished with appropriately shaped holes in 8 × 10-inch pieces of opaque cardboard. The hole must be smaller than the area to be burned.

D. Careful techniques must be used to blend the dodged or burned areas into the rest of the image; otherwise, it would be obvious that exposure was altered in those areas. Two methods are used to blend the areas together. Method 1 is to keep the dodging or burning tool some distance above the printing paper. The closer the tool is to the paper, the sharper and more distinct the edge of the shadow it casts will be, making it more obvious. Since the image gets smaller the closer you are to the lens, dodging and burning tools must be of smaller size than the area being dodged or burned in the print.

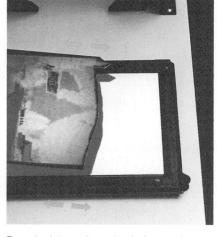

E. Method 2 is to keep the dodging or burning tool in motion while using it. A simple back-and-forth motion will work if you are dodging or burning a section of the print that extends from border to border, but a circular motion should be used if you are dodging or burning an area within the image. The amount of motion used depends upon the amount of blending necessary to give a smooth transition between the altered area and the rest of the print.

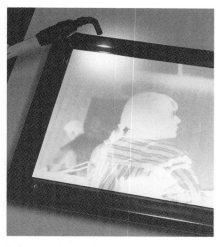

F. If you wish to darken an area of a print completely, without regard to its image content, a technique called **flashing** can be used. Flashing is the application of white light to an area of the print using an external light source. A pocket flashlight with the lens covered by black tape to allow only a tiny beam of light can be used for this purpose. Care must be taken not to affect other areas of the print, so some experimentation will be needed to determine the necessary brightness and length of time for the flashing.

Print Contrast Controls Once the desired highlight tones have been achieved by controlling the print exposure, you can inspect the full-sized print for proper contrast. **Print contrast** is the difference between the light tones and the dark tones. Since we have already determined correct light tones by exposure, we need only look at the dark tones to see if the contrast is correct.

Contrast is changed by altering the paper contrast. With variable-contrast paper, put a filter of a different number on the enlarger. Printing without a filter on variable-contrast paper yields approximately the same contrast as printing with a grade-2 filter. If your print was low in contrast when printing without a filter, place a filter with a number higher than 2 on the enlarger to increase the contrast. With graded paper, you must purchase a pack of paper with a higher grade number. See page 81 for the effect of changing paper contrast.

Depending on the design of the enlarger and the filters, variable-contrast filters can be used either in the lamp housing—if a filter drawer is provided—or on a mount below the lens. Some enlargers also allow the insertion of a filter between the negative and the lens. For best results, use filters in the lamp housing, since filters placed in the image path may adversely affect the quality of the image. If you must use filters in the image path, make sure they are optically flat, high-quality filters designed for such use. Filters used in the lamp housing need not be optically flat and therefore have the added bonus of being cheaper. If you are using a color head enlarger, the filter colors can be dialed into the head. The table shows some typical settings for contrast control of variable-contrast papers with a color head.

Summary of Print Tone Controls The techniques for controlling the tonal appearance of a print can be summarized in two steps:

1. *Print exposure.* The overall exposure of a print is judged by the appearance of the light areas of the subject. Increased exposure will darken the print overall. Decreased exposure will lighten it. Individual areas can be lightened by dodging or darkened by burning.

2. *Print contrast.* Once proper light tones are achieved by exposure, contrast can be judged by the appearance of the dark areas of the subject. If the dark tones are too dark, contrast should be decreased by lowering the paper contrast grade. If they are too light, contrast can be increased by raising the paper contrast grade. Remember that contrast cannot be changed in printing by altering the exposure (varying the f-stop or time) but can only be changed by altering the paper contrast (changing the filter with variable-contrast papers or the grade with graded papers).

Grain Appearance in Prints The grainy structure you see in an enlarged print is not due to the paper but is a direct image of the grain structure of the negative itself. Choice of paper or paper contrast therefore does not affect grain size, although amount of enlargement does. However, the perception of grain in a print depends upon much more than the actual grain size. The appearance of the grain can change with the smoothness of the edges of the grain. The contrast of the image can also change the appearance of the grain. Increasing the paper contrast will make the grain more apparent, even though the grain size itself has not changed.

Color-Head Enlarger Filtration for Variable-Contrast Papers

CONTRAST GRADE	FILTRATION*
0	80 Yellow
1/2	55 Yellow
1	30 Yellow
1 1/2	15 Yellow
2	No filtration
2 1/2	25 Magenta
3	40 Magenta
3 1/2	65 Magenta
4	100 Magenta
4 1/2	150 Magenta
5	200 Magenta

*Note that these filtration values should be taken only as starting guidelines. Actual filtration needed will vary depending upon the design of the enlarger and the brand and type of variable-contrast printing paper used.

Correcting Print Contrast If a print shows good highlight values, with detail where it is desired and good, deep blacks in the darkest areas without losing any important dark-tone details of the subject, the print is correctly exposed and the contrast is correct.

If a print shows good highlight values, but the subject dark-tone areas (the shadows) are too light, the print is low in contrast, or **flat**. Increase the paper contrast to correct for a flat print.

If a print shows good highlight values, but subject dark-tone areas are too dark, the print is too contrasty. Decrease the paper contrast to correct for a contrasty print.

Correct Print Contrast.

Low Print Contrast.

© Bognovitz.

Low Print Contrast Corrected by Increasing the Paper Contrast.

© Bognovitz.

High Print Contrast.

© Bognovitz.

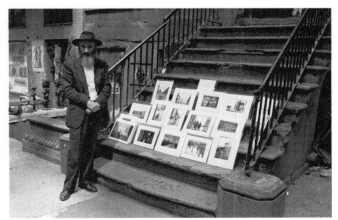

High Print Contrast Corrected by Decreasing the Paper Contrast.

© Bognovitz.

■ Black-and-White Print Processing

A typical black-and-white print processing line consists of developer, stop bath, fixer, hypo-clearing solution, and storage tray for holding prints for washing. If you have a smaller area for trays or wish to shorten the processing time for each print, you can take out the washing aid, holding the prints in the storage tray until you have enough to wash. The prints can then be processed in the washing aid as a batch before washing.

Temperature of the processing baths is not as critical for prints as it is for film, but the solutions should all be at a stable temperature near comfortable room temperature—68°–75°F for most materials. If the darkroom temperature fluctuates, you may wish to have the trays sitting in a water bath. This can be done by filling the sink up just enough to partially submerge the trays in water of the proper temperature.

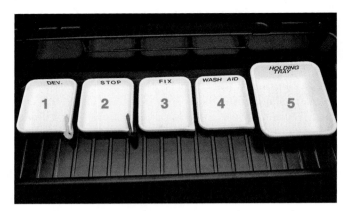

Processing Order. Be sure to follow the direction of processing beginning with tray 1. To prevent contamination, do not carry chemicals on hands, tongs, or prints back into previous trays.

Print Processing Steps

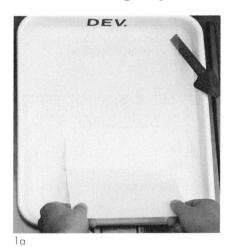

1a

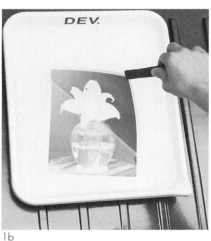

1b

1a. Developer. Watching the image develop right before your eyes is an exciting part of making your own prints. Since the image is formed here, care must be taken with procedures to produce consistent prints of good quality. Slide the print quickly into the developer, one end first. The print can be placed into the developer either face up or face down providing it is inserted rapidly and is turned over and the agitation begun immediately. Laying the print flat on the surface of the developer and trying to push it down under the solution is not a good method for quick insertion.

1b. Developer. Paying attention to the following aspects of print development will provide better results:

Print Handling. Tongs are preferred for handling the prints to help prevent contamination of the developer and to reduce contact with the chemicals. Two pairs are needed, one for only the developer and the other for the remainder of the solutions. The developer tongs should never be allowed to touch the other chemicals. If you must use your hands, rubber gloves are recommended to reduce chemical contact. If hands or gloves are used throughout the process, be sure to carefully wash them with soap and warm water after processing. Any traces of the other solutions on tongs, hands, or gloves will contaminate and weaken the developer. Hands should be clean and dry before returning to the enlarger or handling printing papers or negatives.

Agitation. The print should be agitated continuously while in the developer. Agitation consists of gently lifting the print by one side and turning it over, then gently pushing it down into the developer around the edges. Do not bend or crease the print. Take care not to rub or scratch the emulsion side of the paper. The print should be turned at regular intervals—for example, once every few seconds—but it can be lifted by a different edge each time to provide even development. Prints can also be agitated by tipping the tray. Establish a careful, repetitive pattern of lifting alternate corners of the tray to achieve controllable, consistent agitation. This method is not practical in group darkrooms using large trays.

Timing. The total amount of development time depends on the combination of printing paper and developer being used. The print developer directions should give a starting point. RC papers generally require less development than fiber-base papers. Most developer and paper combinations can be developed for 2 minutes for acceptable results, but with some papers longer development times will yield a richer maximum black in the print.

Once an acceptable developing time has been determined, it is best to stay with that exact time as a standard. Do not try to alter the development time during processing to control the appearance of the print. Print quality is difficult to judge under the safelight, so it is better to do standard processing, inspect the resulting print under white light, and correct any tonal problems in printing.

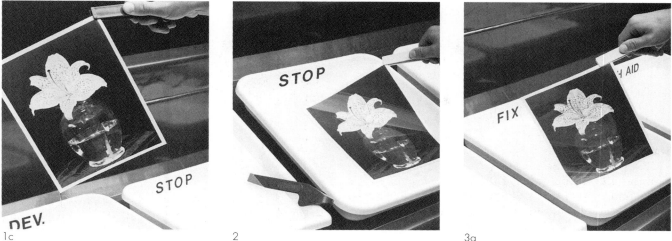

1c

2

3a

1c. Developer. Include in the development time the insertion of the print and a 10-second drain time at the end. The drain consists of holding the print up by one corner, allowing the surface liquid to drain back into the developer before proceeding to the next solution.

2. Stop Bath. After the print is drained, slip it into the stop bath. The developer tongs are used to transfer the print, but do not let them touch the stop bath. Pick up the second pair of tongs for handling the print during the rest of the process. Agitation in the stop bath is the same as in the developer. Follow the manufacturer's directions for time in the stop bath, which is generally less than 1 minute. Include a 10-second drain at the end of this step.

3a. Fixer. Transfer the print into the fixer. Agitate initially by turning the print three or four times, leaving it face down in the fixer. Prints need not be agitated continuously in the fixer but should be turned two or more times each minute. The time in the fixer depends on the type of fixer. Fixing times for fiber-base papers range from 2–5 minutes for rapid fixers to 5–10 minutes for standard fixers. RC printing papers require shorter fixing times, usually about half those of fiber-base papers. Follow the manufacturer's instructions. Insufficient fixing will shorten the useful life of the print and may give purplish-yellow staining. Fixing for too long can bleach the image and causes undesirable absorption of fixer, making the print more difficult to wash clean. Include a 10-second drain before proceeding to the next step.

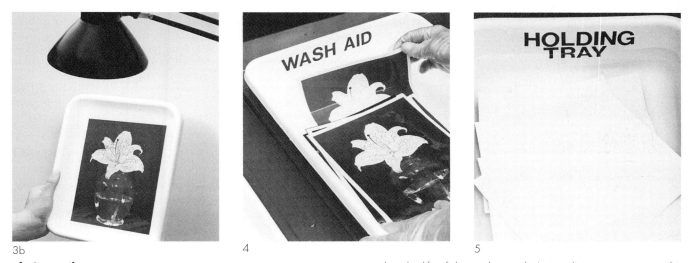

3b

4

5

3b. Inspection. If desired, the print can be inspected under white light for short periods of time after being fixed for about one-third of the minimum time. Complete the fixing time after inspection.

4. Washing Aid. The permanence of prints depends on thorough washing. Fiber-base prints need special care with washing. A washing aid—hypo-clearing bath, fixer remover—should be used for shorter wash times and better print permanence. A washing aid is not necessary for RC prints. Transfer the print directly from the fixer to the washing aid. Follow the manufacturer's directions for times and agitation. A tray of water may be inserted between fixer and washing aid to provide a rinse for the print,

extending the life of the washing aid. As an alternative, prints may be stored in a tray of water (see step 5) and then treated as a batch in the washing aid. Batch processing is done by leafing through the prints bottom to top. You may wish to extend the processing time to account for the larger number of prints being handled.

5. Storage Tray. After the washing aid the prints may be stored in a tray of water until you are ready to wash them. The storage tray should have regular changes of water. For best results with RC papers, the wet time should be kept to a minimum, so storage in holding trays should be reduced or eliminated.

continued

Print Processing Steps—Continued

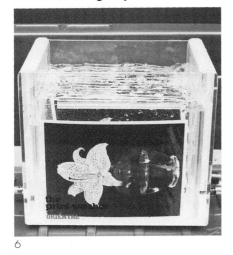

6

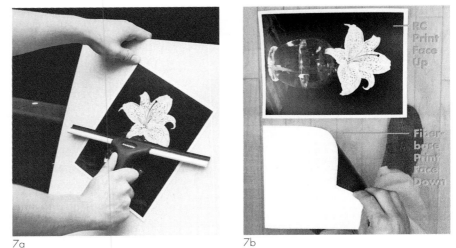

7a 7b

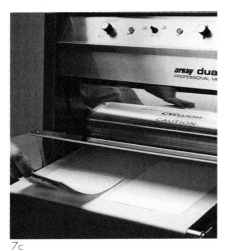

7c

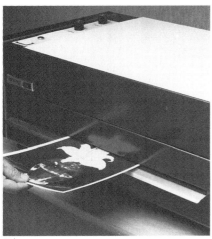

7d

6. Washing. Washing should remove as much of the residual fixer in the print as possible. A good wash must insure a continuous flow of fresh water across the surface of the print. Placing the prints in a tray with water running from a faucet will not provide the necessary washing action. Since fixer is heavier than water, it tends to accumulate in the bottom of the washing vessel. A good washer will flush or drain the fixer from the bottom of the washer. It will also provide for shuffling or separation of the prints to allow the wash water to flow over both surfaces of each print. Do not place unwashed prints into the washer during the washing cycle, as that will contaminate the partially washed prints. Double-weight fiber-base prints that have been treated in a washing aid and washed in an efficient washer need at least 20 minutes of final washing. Without the washing aid, prints must be washed more than an hour to approach the same standards. RC prints require less washing; in an efficient washer 5–10 minutes is sufficient.

7a. Drying. Before drying, excess water should be squeegeed off the surfaces of the print. Place the print on a clean sheet of glass or heavy plastic. Using light pressure, squeegee the back of the print—one pass is enough—pick up the print, squeegee the glass or plastic surface, then squeegee the front of the print. One important requirement for drying prints is cleanliness. Drying even one print that has been improperly washed will contaminate the entire drying process, with resulting damage to subsequently dried prints. Trays used for transporting washed prints, squeegees, squeegee boards, drying racks and screens, and the belts and drums of heated dryers should all be clean and free of contaminating chemicals. Drying screens, racks, belts, and implements should be thoroughly washed periodically to prevent chemical build-up.

7b. Air Drying. Fiber-base prints require some support, such as fiberglass window screening, during air drying to prevent excessive curling. Fiber-base prints should be squeegeed and laid face down on the screening. Double-weight printing papers will curl less during air drying. After drying, prints can be placed under a heavy weight or in a heated mounting press for flattening. RC printing papers do not have fiber-base paper's tendency to curl and are easy to air dry. They can be squeegeed and laid on fiberglass screening, but should be laid face up rather than face down. After squeegeeing, RC prints can even be hung by the corners with clothespins for drying.

7c. Heated Drying, Fiberbase Prints. Heated print dryers for fiber-base prints have a cloth belt to hold the print in contact with a heated drum or platen during the drying. Some are motorized and have built-in squeegee rollers, reducing or eliminating the preliminary squeegeeing needed. Drying temperatures may exceed 200°F, so these dryers should not be used for RC papers. Glossy fiber-base print materials that are air dried or dried with the face to the belt of a heated dryer will show a smooth but not high-gloss finish. Fiber-base papers with surfaces other than glossy should be dried with their face to the belt. The drum or platen may have a polished chrome surface for **ferrotyping** glossy fiber-base papers. To ferrotype the print, it is rolled or squeegeed into perfect contact with the chrome surface of the dryer. When dry, the print will have a shiny, high-gloss surface. Since the print actually adheres to the ferrotyping surface during drying, any dust, fingerprints, or scratches on the plate will show as imperfections in the print surface.

7d. Heated Drying, RC Prints. RC print dryers usually blow heated air across the surface of the print. A hair dryer set at low heat can be used to speed drying of RC prints.

Summary of Black-and-White Print Processing Steps

STEP	MATERIALS	PROCEDURE	REMARKS
1. Developer	Exposed print, print developer in tray at proper working dilution, tongs	Insert print rapidly one end first. Agitate continuously by turning the print over every few seconds. Time by the manufacturer's recommendations. Include a 10-sec drain at the end of the developing time.	Be careful not to contaminate the developer with traces of other processing chemicals. Use a standard developing time, making any needed changes of print tones during printing.
2. Stop bath	Stop bath at proper working strength in tray	Continuously agitate by turning the print over. Follow the manufacturer's directions for time. Drain for 10 sec.	Be careful to dilute the stop bath accurately to working strength. Too strong a stop bath can pit or otherwise damage prints.
3. Fixer	Print fixer at proper working strength in tray	Agitate 10–15 sec initially, then 10–15 sec each minute. Follow the manufacturer's recommended times. Drain for 10 sec.	Date the fixer and count the number of prints processed to prevent exceeding the working capacity. Do not splash or drip fixer around the darkroom. It is a strong contaminant as well as a corrosive for metal parts.
4. Washing aid	Washing aid, hypo-clearing agent, or fixer remover diluted to proper working strength in tray	Transfer prints from the fixer to the washing aid. Agitate continuously for the time recommended by the manufacturer. Drain for 10 sec. (An optional water rinse may be inserted between the fixer and the washing aid.)	Double-weight prints usually require more time than single-weight prints. Follow the manufacturer's instructions for working capacity and storage. Prints may be held in a storage tray of water and treated in the washing aid as a batch.
5. Storage tray	Water in tray	Store prints until enough are accumulated for a wash.	Change the water periodically in the storage tray.
6. Washing	Efficient print washer	Placement of prints in the washer depends on the design of the washer. Follow the manufacturer's recommendations. Washing times depend on the efficiency of the washer, whether the print has been treated in hypo-clearing agent, and whether the print is RC, single-weight fiber-base, or double-weight fiber-base.	The thoroughness of your washing can be tested with a residual hypo-test kit, available through photographic supply stores. Prints may be held in a storage tray of water and washed as a batch. Do not add prints to the washer during the washing cycle.
7. Drying	Heated dryer or drying screens, squeegee, squeegee board	Squeegee both sides of the print. (If the dryer has built-in squeegee rollers it is sufficient to squeegee only the face of the print.) Place the print in the dryer or lay it out on fiberglass screens, face up for RC, face down for fiber-base.	Glossy-surface fiber-base prints may be ferrotyped for highest gloss by drying in contact with a polished chrome surface. Prevent build-up of chemicals in the dryers by periodic washing of belts, drums, and screens.

NOTE: All solutions and washes should be at room temperature, preferably 68°–75°F.

■ Commercial Print Processing Labs

Since most photographs taken by the public are in color, processing labs are generally set up only for color film processing and printing. It is becoming increasingly difficult to find labs that can print black-and-white negatives. Custom photo labs that service professionals sometimes offer black-and-white processing and printing services.

Any lab that can process color negatives using the C-41 process can also process Ilford XP2 film, providing chromogenic black-and-white negatives. XP2 negatives can be printed on color print equipment but may show some color casts if the printer is unfamiliar with the film.

■ Print Finishing

Even with careful cleaning of your negatives before printing, you may find some white marks in a print due to dust, lint, or scratches on the negative. Print flaws can be corrected by retouching the print itself. The most basic retouching technique is **spotting,** in which dyes are applied to light spots or marks in the print with a fine brush. Although this is a relatively simple technique, it is handwork and takes practice to master.

Spotting Equipment and Supplies

Spotone is a commercially available spotting dye for black-and-white prints and comes in several colors of black to allow matching the color of black in your print. Spotone #3 dye will provide a close match for many neutral-toned printing papers. Kits with dyes of several different blacks come with a chart giving a starting mixture for most print materials. Test the mixture and your techniques on reject prints before beginning to work on good prints.

The dyes are applied with a good-quality watercolor brush, which can be purchased in an art supply store. A brush with a fine tip, numbered 00 or 000, is usually best for spotting prints. Once you have found a good spotting brush, protect it from damage and clean and shape it carefully after each use. Do not use your spotting brush for purposes other than spotting.

Black-and-White Print Spotting Procedures

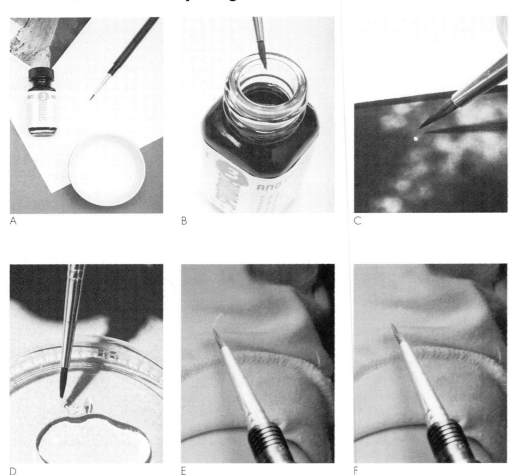

A

B

C

D

E

F

A. Lay out the materials: brush, spotting dye, clean sheet of paper, the print, mixing palette, water.
B. Dip the brush in the dye and draw it over the edge of the bottle to squeeze out excess dye. More of the dye can be drawn out on the typing paper.
C. Start spotting in the blackest areas of the print. The basic spotting action is a gentle dabbing with the brush.
D. For spotting lighter areas in the print, the dye in the brush must be diluted and the brush must be nearly dry. Pick up a tiny bit of water with the brush, then draw the excess moisture out on the clean paper. Repeat as necessary until the amount of dye in the brush matches the area being spotted.
E. White lines from scratches and lint are difficult to spot. Drawing the brush along the line will leave dark edges. Dabbing as before, move along the line. Do not try to complete the spotting in one pass.
F. Go back over the line with the dabbing motion until it blends with the surrounding area. If the line goes through different tonal areas, the dye must be diluted to match each area. Here part of the line has been spotted. Several passes may be required to match the surroundings perfectly.

■ Print Presentation

If you wish to display your print to others, you may want to mount it on a display board or put it in a display book or portfolio. Proper presentation can show the print to its best advantage and protect it from damage.

Mounting the print on a stiff material or inserting it into a holder of some sort keeps the print flat for easy viewing. To provide a barrier to prevent fingerprints, scratches, and other damage the print may be surrounded with high-quality cardboard—called mat board—or other materials to isolate it and set it off from the surroundings, or covered with a plastic sleeve or lamination. Styles of presentation vary with culture, social taste, use, and the style of the photographer. New presentation materials—adhesives, laminates, print supports—are constantly being developed, and these technical advances also affect the possible styles of presentation.

Presentation Styles

Surface-Mounting Surface-mounted prints are mounted directly on the surface of a supporting material and then displayed. If the support is larger than the photograph, the resulting border gives extra protection and visually separates the print from its environment. Using a high-quality mat board as a support produces an attractive presentation. An alternative to leaving a border is to trim the support to the same size as the image in the print, which is called **bleed** mounting or **flush-mounting,** a presentation style that can be effective when the print is shown in a more controlled environment.

A problem with surface-mounting is that the print is higher than its support and is subject to surface damage.

Additionally the edges of flush-mounted prints are vulnerable to fingerprints and chipping.

Overmatting Extra protection can be given to a mounted print with an overmat—also known as a window mat—which is a second mat board, larger than the print, in which a window the size of the print or somewhat larger is cut. Often the blade of the cutter is tilted to produce a beveled cut for the window. The finished window mat can be attached to the support on which the print is mounted by hinging, or it can be attached permanently with adhesives.

The advantages of an overmat include the protection provided by the border plus the recessing of the print so that it is less exposed to surface scratches. Overmatting is an excellent technique for protecting prints that are to be stacked in boxes, as each print does not come in contact with the board above it. It should also be used whenever a photograph is to be placed under glass or acrylic plastics, to prevent surface damage to the photograph.

Framing A print that is mounted and matted can also be framed with one of a wide variety of wood or metal moldings. Modern metal frames are easy to assemble with simple tools and are reasonable in price. Wooden frames are most easily assembled with specialized tools. Many cities have do-it-yourself frame shops, which will give you access to the necessary tools and materials.

Framing under glass or acrylic plastic offers maximum protection, but presents reflection problems in viewing the print. The "nonglare" framing glass is not a good option, since it has a matte surface that kills the tonal range of a print, especially the blacks.

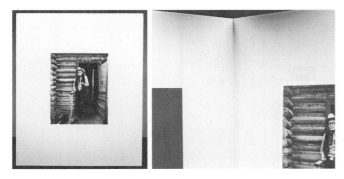

Hinged Overmat. Left: The hinged overmat is shown closed over the print as it would be for display. Right: The overmat has been opened to show its construction. The print in this case was hinge-mounted to the back mat board. Prints can also be dry-mounted or cold-mounted to the back board. A window of proper size was then cut in a second mat board, which was attached to the back board with an archival tape hinge.

Photos this page © Bognovitz.

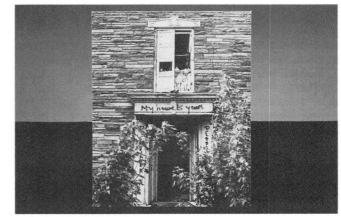

Flush- or bleed-mounted print. The print was dry-mounted to a mat board, and then mat board and print were trimmed right down to the image.

Mounting Methods

Several different types of adhesive are available for attaching prints to a support.

Cold-Mounting The development of adhesives that do not set and will adhere on contact makes it possible to mount prints without heat. Some print materials, such as glossy Ilfochromes and some digital prints, do not react well to heat-based mounting techniques, so **cold-mounting** is a good alternative for them. Cold-mounting adhesives are available in three forms: 1. *Transfer adhesives* come on a carrier sheet to which the print is applied. When the print is lifted, the adhesive comes up with it and the print can be attached to the support. 2. *Two-sided adhesive sheets* are paper or plastic carrier sheets with adhesive on both sides. 3. *Spray adhesives* require some care to insure even application and complete adhesion and present health issues with inhalation. Do not use rubber cement to mount prints. It is a temporary bond and may damage prints. One type of cold-mounting is demonstrated below.

Dry-Mounting Although **dry-mounting** strictly means any mounting technique that does not use a liquid adhesive, most often it refers to mounting techniques that use a press with a heated platen. Fiber-based and resin-coated prints in black-and-white and color can be easily and permanently mounted this way. Dry-mounting adhesives come in sheets that are placed between the print and the supporting surface. The adhesive melts when heated, adhering to both the print and the support. The expense of the dry-mount press deters many from this method of mounting. A household iron can be used, but it is extremely difficult to get correct, even temperature and pressure over the whole surface of the print. Dry-mounting adhesives are resin based, which provides a permanent bond nearly impossible to remove without damage to the print, or plastic based, which can be removed with reheating. Dry-mounting is demonstrated on the facing page.

Hinge-Mounting In **hinge-mounting**, the print is attached to the support with two or more small tabs (hinges) of paper or tape. Traditionally hinge-mounting has been done with rice paper hinges and rice glue, but several modern alternatives are available, including self-adhesive hinges. Hinge-mounting may be the best alternative when you are unsure how the print material (for example, digitally produced photographs) will react to other mounting methods. Hinge-mounted prints are normally overmatted. One problem with hinge-mounting photographs is that silver-gelatin emulsions tend to buckle and curl with humidity changes, so the surface of a print will not remain flat when supported only by hinges.

Cold-Mounting with Two-Sided Adhesive Sheets

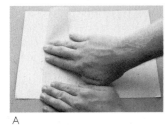 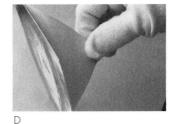

A B C D

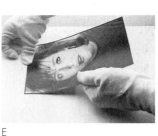

E F

A. The adhesive sheet will have a protective paper on each side. Peel back about 2 inches of the cover paper on one side and crease.

B. Make sure the back of the print is free of dust and dirt. Carefully lay the print onto the exposed adhesive and press into place.

C. Reach under the print and grasp the cover paper, pulling it out from under the print. Smooth the print onto the adhesive as you pull the protective sheet to prevent air bubbles. After the print has been adhered to the sheet, it may be trimmed to size.

D. Peel back the remaining cover paper on the back of the print. Again peel back only 2 inches and crease as in step A.

E. Place the corners of the print with adhesive exposed on the mat board. Most two-sided adhesive sheets will adhere on contact, so make sure the print is in the proper position before letting the adhesive touch the mat board. Making two light dots with a pencil for the corner positions will

help. Reach under the print and pull the cover sheet out as you did in step C, smoothing the print onto the mat board as you pull.

F. Once the print is entirely adhered to the board, place a protective piece of paper over the face of the print and apply pressure by rolling with a rubber roller—also called a brayer—available in art supply stores.

Dry-Mounting Procedure

A

B

C

D

A. Collect the materials and tools needed for dry-mounting: dry-mounting press, clean cover sheets, tacking iron, dry-mount tissue (see table for appropriate dry-mount tissues), mat board, print trimmer, ruler, white cotton gloves.

B. Turn on dry-mount press and tacking iron. Set temperature specified in dry-mount tissue instructions. Do not exceed a temperature of 205°F for RC prints, as you may melt the plastic coating. Set tacking iron between medium and high.

C. *Predry.* Make sure the mat board and the print are clean and free of grit. Insert the mat board and the print between two clean cover sheets of plain bond paper or release sheets made for this purpose, place in the press, and close the press for 30–60 seconds depending on the thickness of your materials.

D. *Tack Tissue to Print.* Place the print face down on a clean surface. Align the dry-mount tissue with the print and use the tacking iron to tack the tissue to the print in the center only.

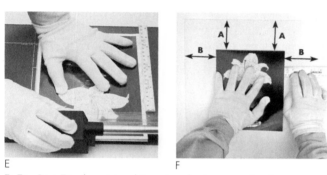
E

F

G

H

E. *Trim Print.* Trim the print and tissue together to remove borders or crop as desired. Use of a trimmer will insure square corners. Alternatively, a graphic arts knife and metal T square can be used.

F. *Align Print on Mat Board.* Lay the print on the mat board in the approximate position you desire. Measure the sides and two points on the top to make sure the print is centered and square on the board.

G. *Tack Print to Mat Board.* Carefully holding the print in position, pick up one corner of the print, leaving the tissue lying flat on the board, and use the tacking iron to tack the tissue to the board.

H. Tack at least one more corner of the tissue to the board. Take care not to let the tissue buckle or crease.

I

J

K

L

I. Insert the print–tissue–mat board sandwich into the dry-mount press between cover sheets with the print face up.

J. Close and lock the press for the time specified for the materials you are using.

K. Remove the mounted print from the press and immediately place it under weight for cooling. A weighted sheet of plate glass works well for this purpose.

L. Once the print has cooled, a very gentle flexing of the mat board will indicate if it has been properly mounted. A slight crackling sound or unadhered edges mean that the tissue was incompletely heated. In this case, the print can be placed back in the press for reheating.

CHAPTER 6

Troubleshooting

Robert Gibson, *Astronaut in EVA.*

© Courtesy of NASA.

The photographic process makes use of a system of equipment, materials, and technical procedures applied in a chain of events from the initial choice of subject to the finished photograph. The quality of the final result can be affected by changes in any step of the process.

Finding the reason for a problem is a lot like doing detective work. Possible sources of error are first narrowed down to the ones that might cause the undesired result. The one responsible can then be found by a process of elimination. This procedure is complicated by the possibility that a given problem may come from several different places in the photographic system. For example, the contrast of a print is affected by subject lighting, film exposure, film processing, printing procedures, and several other factors. It can take some time to figure out which of these may be the culprit. The following charts of photographic problems will help narrow down the possibilities. A few simple testing techniques that may help to further localize a problem follow the charts.

■ Troubleshooting Charts

Film Exposure Problems

Underexposure

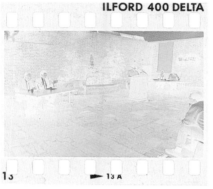

Overexposure

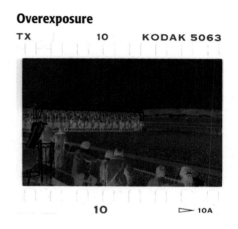

Indication Low overall density of the negative and loss of shadow detail.

Indication High shadow density and high overall density.

Problem-Remedy If the whole roll is improperly exposed, the cause may be one of the following:
■ Wrong ISO. The wrong ISO may have been set into the meter or camera. Setting the ISO too high will cause underexposure. Setting the ISO too low will cause overexposure (see page 23).
■ Equipment malfunction, meter or camera. The meter may have been reading too high (underexposure) or too low (overexposure). The aperture or shutter on the camera may have been operating improperly. The battery may have been bad (see pages 120–21).

If individual frames are improperly exposed (exposure is inconsistent), the cause may be one of the following:
■ Unusual subject tones. Large areas of dark tone may cause overexposure. Large areas of light tone may cause underexposure. Compensate for subject tone when shooting (see pages 30–31).
■ Background affecting meter reading. An extremely bright background may cause underexposure. A large, dark background may cause overexposure. Take a close-up meter reading of the subject if possible (see page 32).
■ Operator error. The wrong shutter speed or f-stop may have been set accidentally. The photographer may have neglected to compensate for the use of filters or reciprocity failure (see pages 36–37 and 201).
■ Equipment malfunctions. Individual shutter speeds or apertures may be inaccurate or erratic. The meter may be erratic, reading accurately at some light levels but not at others. If a written record of exposure information is kept, sometimes faulty camera settings or meter problems can be tracked down by seeing if a pattern of exposure errors for specific settings exists (see pages 120–21).

continued

Film Exposure Problems—Continued

Blank Frames

Indication No image on film, but visible edge numbers and labeling.

Problem-Remedy

■ Film did not go through camera. When loading film, make sure the film leader is securely fastened to the take-up spindle and advance the film until both edges are engaged with the sprockets before closing the back of the camera (see page 6).

■ Shutter did not open. A defective shutter may sound as if it is operating but still not be opening. The shutter tests following this chart may isolate this problem (see pages 120–21).

■ Mirror on a single-lens reflex camera failed to flip up.

■ Lens cap was left on. This would be likely only with a viewfinder-type camera, since a TTL viewing system would alert you to the problem.

If film has no image and no edge numbers, see "Other Film Developing Problems," page 113.

Fogged Film

Indication Dark streaks on negative, white streaks in print caused by unwanted exposure to light.

Problem-Remedy

■ Loading film in bright light. Vertical streaks near the beginning of a roll are most likely caused by loading the film in bright light, which allows some light to come through the felt light trap of the film cassette. Load film into camera only in subdued light.

■ Opening back of camera before rewinding. If this is noticed immediately and the back closed, it is worth processing the film, as the inner layers of the roll may still be usable.

■ Exposing film to light leaks in camera. If the seal between the camera body and the camera back has been damaged, film may be fogged while in the camera. Fogging from camera leaks usually takes on a specific pattern on one edge or the other of the film. When tracking down camera light leaks, remember that the image is upside-down on the film, so fogging at the top of the image indicates a light leak at the bottom of the camera.

■ Exposing film to light during tank loading or processing. If film is not loaded into the developing tank in total darkness, fogging will take place. Improper assembly of the developing tank or damage to the light seals in the tank may also cause fogging.

■ Exposing film to high temperatures or overactive developer. If the film shows an even overall fogging—excessive density even in its unexposed parts—this may come from two sources. Heat damage of the film can cause general fogging. Be careful not to expose the film to high temperatures—for example, those inside of cars in the summer. Chemical fogging can also take place during the processing as a result of overactive developers.

■ Exposing entire film to strong light. If the whole roll of film, edge to edge, is completely opaque (black), a high overall exposure to light is indicated, probably at some time when the film was completely unrolled or loosely rolled so that the light could reach every part of it. If just the frames are opaque, but the edges are clear as usual, gross overexposure of each frame is indicated.

■ Exposing film to X rays. Exposure to X rays, as in airport security scanning of luggage, affects film much as does exposure to light, resulting in fogging (see page 19).

Flare

Indication In the negative, dark streaks or patterns that may include the shape of the aperture or ghost images of bright objects in the photograph; in the positive image, light streaks or shapes; also general overall fogging of the frame and a resultant loss of contrast in the image.

Problem-Remedy
■ Lens design. Flare is due to internal reflections within the lens or camera and can be reduced by careful coating of the lens with thin layers of rare earth elements. Older or cheaper lenses may exhibit more flare than quality lenses.

■ Direct light falling on lens surface. Including the sun or other light sources in the photograph may cause flare. Even light sources outside the frame can cause flare if the light is falling directly on the surface of the lens. Use a lens shade or block the light from falling on the lens (see pages 49 and 136).

■ Dirty or damaged lens. Scratches, pits, dust, fingerprints, or other dirt on the lens surface—or on any filters used on the lens—will add to flare.

Vignetting

Indication In the positive, darkening of the corners or edges of the image.

Problem-Remedy
■ Improper lens shade. Using a lens shade designed for a lens with a longer focal length will cause vignetting, as the shade will extend into the field of view of the lens. Filters with thick rings or use of more than one filter may also move the lens shade out into the field of view.

■ Improper lens coverage or excessive camera movements. On a view camera or other camera allowing movements of the lens for image correction, extreme movements or use of a lens with the wrong coverage may move the film into the edge of the image, causing vignetting.

Double Exposure

Overlapped Images

Uneven Frame Spacing

Indication Two or more images superimposed on film. Varying width of spaces between frames or partially overlapping images on film

Problem-Remedy
■ Camera has a defective double exposure interlock, designed to prevent releasing of the shutter until the film is advanced.

■ Operator failed to advance the film on an older camera without an interlock feature, or to change the film holder on a sheet film camera.

■ A previously exposed roll or sheet of film was loaded into the camera and exposed a second time.

■ Camera has a defective film-advance mechanism, requiring repair.

continued

Film Exposure Problems—Continued

Sharp Image Over Blurred Image

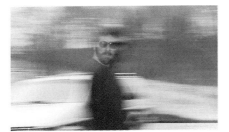

Indication Sharp image superimposed on streaky, blurred image.

Problem-Remedy

■ This problem occurs when using flash. If the existing continuous light is bright enough to record an image on the film and the subject is moving, a sharp image from the flash is recorded as well as a blurred image from the continuous light. To prevent this problem, use a higher shutter speed (do not exceed the synchronization speed) or increase the power of the flash.

Completely Blank or Badly Underexposed Section of Frame

Wrong Flash Synch Speed

Object in Front of Lens

Indication Partial frame in shape of rectangle, either vertical or horizontal.

Problem-Remedy

■ Operator used a shutter speed higher than the synchronization speed recommended by the camera manufacturer when using flash. The problem occurs with focal plane shutters, some of which travel vertically, others horizontally. If the existing continuous light is bright enough, some detail may be seen in the remainder of the frame (see page 144).

Indication Totally blank irregular area of film.

Problem-Remedy

■ A dark or unilluminated object was close to the lens, causing extreme underexposure of that area.

Film Handling Problems

Torn Sprocket Holes

Torn Film

Indication Torn sprocket holes on both edges of 35mm film or tear completely across a film's width, usually in jagged fashion.

Problem-Remedy The film was forced to move against the sprockets in the camera when the operator
- Tried to advance the film when the end of the roll was reached.
- Failed to push the rewind clutch release button before rewinding and then forced the film.

If the film advance or rewind seems hard to operate, try to figure out the problem rather than forcing the controls. Torn film can only be removed from the camera by opening the camera back in total darkness and loading the film directly into a film developing tank.

Scratches on Film

Indication White or black scratches in a positive print.

Problem-Remedy Two types of scratches occur:
- White scratches are from light surface scratches on either surface of the film, most commonly on the base side. Surface scratches on the negative can sometimes be corrected in printing. Scratch treatment liquids are commercially available. These are applied directly to the negative and fill the scratch while printing. Although effective, they are messy to use. Diffusion-type enlargers will suppress the appearance of surface scratches.
- Black scratches are from scratches on the emulsion side that are deep enough to completely remove the emulsion in that area. The only remedy for such scratches is retouching of the print by a professional retoucher.

Scratches may come from several sources:
- In-camera problems. Scratches caused by problems inside the camera are usually identifiable because they are perfectly straight and parallel to the edge of the film. They are caused by dust, dirt, or damage on the pressure plate, which holds the film flat in the camera. They can also be caused by dirt in the felt light trap of the film cassette. Users of bulk film may get scratches from the bulk film loader or from dirt trapped in the felt of the reusable cassettes.
- Rough handling. Scratches due to rough handling of the film are usually random scratches. Handle film gently only by the edges. Make sure that any surface the film is placed against—including negative sleeves—is free of grit. Dragging the negative through the negative carrier in the enlarger is a common source of scratches.

Contrast Problems

So many parts of the photographic process have an effect on the final contrast achieved in a print that pinning down the source of incorrect contrast can become difficult:

■ Subject contrast. The range of light values displayed by the subject determines subject contrast, which can be affected by the tonal nature of the subject itself and the nature of the lighting on the subject (see pages 73 and 126).
■ Film condition. Old film or film damaged by improper storage, especially heat, may show a loss of contrast.
■ Film exposure. Underexposure of the film causes loss of contrast. Overexposure may initially cause a slight increase of contrast, but substantial overexposure will cause a loss of contrast (see pages 73–75).
■ Film development. Contrast depends directly on the amount of development the film receives, with more development producing more contrast. Among the factors that change the amount of development are development time, developer temperature, developer agitation, developer type, developer freshness, and developer dilution (see pages 72–77).
■ Printing. Contrast can be affected by the type and quality of enlarger and enlarger lens; the paper contrast, either variable contrast or graded; the condition of the printing paper; and the print developing process (see pages 96–97).

If you are having contrast problems, the possibilities can be narrowed down somewhat by a little deductive reasoning. First look at the subject to see if it may have had inordinately low or high contrast. If the subject is of reasonably normal contrast, you must decide whether the problem is due to low contrast in the negative or a problem in printing. If the highlights in the film look low in density—you should be just barely able to read well-illuminated black print on a white page through highlights of correct density—the negative is probably causing the low contrast.

If most of the negatives from a roll are printing with good contrast and only one is giving incorrect contrast, the most likely problem is exposure, since a development error would affect the whole roll. If you are getting low contrast on a whole roll, it could be from either underexposure or underdevelopment. To decide which is the problem, look at the film. If the negatives are showing loss of shadow detail, underexposure is indicated. If shadow detail is present, then the problem is most likely underdevelopment of the film.

If the negatives look reasonably close, contrast problems in printing are most easily found by changing parts of the printing system—paper, developer—one at a time. Check the enlarger as well to make sure it is properly assembled, the lens is clean, and no variable-contrast filters have been left in it. Specific reasons for incorrect contrast follow.

Flat Print (Low in Contrast)

Indication Too little difference between light and dark areas of print.

Problem-Remedy
■ Low subject contrast. The lighting outdoors on overcast days or inside under diffused lights produces low subject contrast. A limited range of tones in the subject itself can also give low subject contrast.
■ Underexposed film. A loss of detail in the shadow area of the negative indicates underexposure of the film.
■ Extremely overexposed film. Extremely high densities in the negative— in other words, very dark negatives—indicate extreme overexposure of the film.
■ Old or damaged film. Check the expiration date on the film box. Protect film from heat and humidity.
■ Underdeveloped film. A reduction in any of the factors affecting film development will result in underdeveloped film: too low a developer temperature, too short a development time, too little developer agitation, overdiluted developer, contaminated developer, aging developer.
■ Old or damaged printing paper. Papers are not normally marked with an expiration date, so it is important to buy from stores that regularly turn over their stock of paper. Do not expose paper to extremes of heat or humidity. For long-term storage, paper can be sealed and refrigerated or frozen.
■ Underdeveloped print. Too short a print development time, overdiluted print developer, contaminated print developer, aging print developer, or cold print developer can all cause underdevelopment of a print.
■ Wrong printing contrast. A variable-contrast filter of a grade lower than 2 may have been accidentally left in the enlarger or a lower-grade pack of paper may have been used.

Overly Contrasty Print

Indication Too much difference between light and dark areas of print.

Problem-Remedy

■ High subject contrast. Areas with very clear atmosphere and harsh sunlight or with subjects having an extreme range of subject tones produce high subject contrast.

■ Overdeveloped film. An increase in any of the factors affecting development may produce overdevelopment of a film: too high a temperature; too long a time; too much agitation; underdilution of developer; use of wrong developer, such as the stronger print developers.

■ Overdeveloped print. Too long a developing time, underdiluted print developer, or too high a developer temperature may all cause overdevelopment of a print.

■ Higher-than-normal filter or grade of paper.

Other Film Developing Problems

Blank Film

Indication Completely blank film with no image and no edge numbers.

Problem-Remedy

■ Film was not developed but was fixed. This is due to a completely depleted or neutralized developer or to placing the film in fixer by mistake before developing.

Crescent-Shaped Marks

Indication Dark, crescent-shaped marks on film that print white.

Problem-Remedy

■ Film was crimped while loading into the developing reel.

Undeveloped Splotches

Indication Irregular splotches on film with no image but with undeveloped emulsion showing.

Problem-Remedy

■ Film was loaded on the developing reel improperly, so that adjacent loops were touching during the processing.

Uneven Density

Indication Uneven density from one part of negative to another; especially noticeable in subject areas with even tone, such as the sky.

Problem-Remedy Film received uneven development from two possible causes:

■ Poor agitation technique. In extreme cases this can show up as streaks of excessive or low density.

■ Not enough developer in film tank to cover film.

continued

Other Film Development Problems—Continued

Air Bells

Indication Small, blank, round spots or partially developed spots on film that print as black or dark spots.

Problem-Remedy

■ Air bubbles formed on the film during the development process. Use a water prewet and tap the tank on a hard surface to prevent air bubbles.

Static Marks

Indication Jagged lines resembling lightning or "spark" shapes, black on film, white on print.

Problem-Remedy

■ In very dry conditions, advancing or rewinding the film at too high a speed may cause the discharge of static electricity on the film.

Pinholes

Indication Very tiny clear spots in the emulsion that print as black spots.

Problem-Remedy

■ Faulty emulsion manufacture.
■ Overly strong acid stop bath.
■ Dust or dirt on the film in the camera.

Reticulation

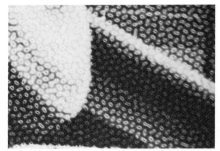

Indication Textured pattern on film; effect is often confused with large grain size, but closer inspection will usually reveal a specific pattern, unlike the random distribution of actual grain.

Problem-Remedy

■ The film emulsion wrinkled because of a rapid temperature change during the processing. Temperatures after the developing bath should be within plus or minus 5°F of the developer temperature.

Surface Marks

Indication Scum or deposits on surface of film.

Problem-Remedy

■ Hard water marks from not using wetting agent.
■ Scum or other residue from improperly mixed or dirty wetting agent or from placing a negative that still had fixer on it in wetting agent.
■ Rough handling or contact of the film with moist or dirty surfaces.

Milky Appearance

Indication Milky appearance in film.

Problem-Remedy This appearance results from insufficient fixing from two possible causes:
■ Too little time in the fixer.
■ Depleted fixer.

If the film has not been exposed to too much light, this condition can be corrected by immediately refixing the film in fresh fixer and then completing the process steps that follow the fixer as usual.

Printing Problems

Dark Print

Indication Excessive darkness in all tonal areas of print.

Problem-Remedy

■ Excessive exposure in printing.
■ Extreme overdevelopment of print.
■ Accidental exposure of the paper to white light or an incorrect safelight, if the borders of the paper are dark as well.

Fuzzy White Spots

Indication Fuzzy white spots on print.

Problem-Remedy

■ Dust or dirt was on parts of the enlarger in the image path fairly close to the negative, such as on the condenser lenses or a glass negative carrier. Dust on the surfaces of the lens itself may cause some deterioration of the image but will not show up as white spots in the print.

White Edges or Corners

Indication Completely white edges or corners of print image.

Problem-Remedy

■ Condenser on the enlarger was improperly set for the format size and focal length lens being used. This usually shows as white corners.
■ Obstruction—such as an improperly installed filter drawer or holder—was in the image path.
■ Defect or damage—such as improper alignment of the bulb or use of the wrong bulb or misalignment of the condenser optics—occurred in the enlarger lamp housing.

Light Print

Indication Excessive lightness in all print tones.

Problem-Remedy

■ Too little exposure in printing.
■ Paper inserted in easel emulsion side down.
■ Extreme underdevelopment of print.

Sharp White Spots or Wiggly Lines

Indication Sharp white spots or wiggly lines in print.

Problem-Remedy

■ Dust or dirt was on the negative itself.

Reversed Image

Indication Print image reversed left to right, so that lettering reads as mirror image.

Problem-Remedy

■ The negative was printed with the emulsion side up, rather than down.

continued

Printing Problems—Continued

Uneven Print Density

Indication Splotchy, streaky, weak blacks in print and inconsistent print darkness.

Problem-Remedy
■ Too short a print development time.
■ Failure to agitate print during development.
■ Cold print developer—below 65°F.
■ Weak or exhausted print developer.

Fingerprints

Indication Black or white fingerprints in print, life-size or enlarged.

Problem-Remedy
■ Fingerprints were left on the negative after processing. These will show in the print as enlarged and lighter than the surroundings.
■ Fingerprints were left on the printing paper from contaminated hands. These may show up as either black or white in the print but will be life-size.

Gray Cast in Print

Indication Overall gray cast to print; borders possibly gray as well.

Problem-Remedy If the borders are gray:
■ Paper was fogged by exposure to white light or a safelight of the wrong color or intensity.
■ Paper was old or damaged by heat.
■ Paper was chemically fogged by a contaminated or bad developer.

If the borders are clean white:
■ Enlarger is leaking light, which is scattered back to the paper during printing.

Black Streaks

Indication Uneven or random black streaks in print.

Problem-Remedy
■ Uneven exposure of the paper to white light.
■ Contact of the paper with liquids or chemicals before processing.
■ Rough handling of the paper, which can cause black marks or scratches.

Dark Marks

Indication Dark marks or lines on surface of print with appearance of streaks, abrasions, or scratches.

Problem-Remedy
■ Print developer was contaminated or paper contacted contaminating chemicals.
■ Print was handled roughly in processing: for example, tongs or fingernails were dragged across surface of print. Surface scratches can also result from rough handling.

Air Bubbles

Indication Areas of print lighter than their surroundings and in the shape of bubbles.

Problem-Remedy
■ If the prints are laid in the developer face down and not agitated, air bubbles could be trapped below the paper, causing underdeveloped spots.

Yellow Stains

Indication Yellow or brownish-yellow stains in print, random or overall.

Problem-Remedy
■ Overused or contaminated print developer.
■ Incomplete washing.
■ Contact of print with fixer after washing, as in contaminated dryer, tray, squeegee, and so on.

Brownish-Purple Stains

Indication Brownish-purple stains in print, random or overall.

Problem-Remedy
■ Inadequate print fixing.

Bleached Image

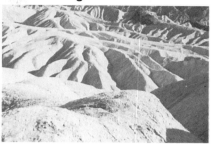

Indication Areas of print lighter than printed, especially noticeable in light tone areas.

Problem-Remedy
■ Excessive print fixing.

Cracks in Print Emulsion

Indication Cracks in print emulsion, either local or over entire print.

Problem-Remedy
■ The paper may have been bent too much in handling.
■ A cracked, melted appearance can be from overheating resin-coated paper in a dryer or mounting press.

Peeling Emulsion

Indication Print emulsion peeling from paper, especially at edges of print; called frilling.

Problem-Remedy
■ Excessive soaking of the print in liquid.
■ Rough handling of a wet print.

Uneven Gloss

Indication Splotchy or rough areas in glossy surface of print.

Problem-Remedy
■ On ferrotyped fiber-base print, this results from poor adhesion of the print to the ferrotype plate due to dirt or grease on the plate or print. Any marks or scratches on the plate will also show on the surface of the print.
■ This may also result if a print comes in contact with liquid after drying.

continued

Printing Problems—Continued

Curled Print

Indication Excessive curling of print (a slight curl, usually toward the emulsion, is normal).

Problem-Remedy
- Very low humidity.
- Air drying of fiber-based prints face up on a flat surface.
- Too much wet time for an RC print.
- Improper storage. Double-weight paper tends to curl less than single weight. Keep prints under some pressure in storage to prevent curling.

Sharpness Problems

If the image in a print is not sharp, the problem could have been either in the negative itself or in the printing of the negative. Two methods may be used to discover the source of the loss of sharpness. If the grain structure is visible in the print, look closely to see if it appears sharp. If the grain structure is sharp throughout the print, any sharpness loss is in the negative itself. If the grain is too fine to be seen in the print, the negative itself must be inspected with a good-quality magnifying loupe to determine if it is sharp.

Sharpness Loss in Negative Image

Movement

Indication Blurring, usually streaky in appearance, of all or part of image on film.

Problem-Remedy
- Movement of camera during exposure. Camera movement is indicated if the complete image is blurred.
- Movement of subject during exposure. Only moving subjects would be blurred if the camera was stable.

Focus Blur

Indication Blurring of all or part of image in negative, with a fuzzy rather than streaked appearance.

Problem-Remedy
- The photographer may not have focused on the subject.
- If part of the image is in focus but other parts are not, this could be due to insufficient depth of field.
- If the image is not sharp even though the camera was carefully focused and the camera and subject did not move, a problem with the camera or lens may be indicated. The focusing system in the camera may be out of adjustment. The lens could be of poor quality or could be dirty or damaged.

Sharpness Loss in Print Image

Movement Blur

Indication Streaky blur in print image, even though negative is sharp.

Problem-Remedy

- Enlarger or printing paper moved during the exposure.
- Negative popped because of the heat of the enlarger bulb. Preheat the negative or use heat-absorbing glass in the enlarger.

Overall Blur

Indication Blurring of entire image, with soft fuzzy look, even though negative is sharp.

Problem-Remedy

- Incorrect focusing of enlarger. Use a focusing magnifier.
- Excessive enlargement of image.
- Poor enlarger lens quality or dirty lens or filter.

Partial Blur

Indication Sharpness in part of image but blurring in remainder; so that only one area of negative can be focused on at a time.

Problem-Remedy

- Enlarger is out of alignment. The negative stage, lens stage, and baseboard or easel must all be perfectly parallel.
- Negative is not lying flat in negative carrier.

Grain Structure Problems

Large Grain Size

Indication Granular structure showing in print.

Problem-Remedy Grain is from the negative, not the print material. Excessive grain size has several causes:

- Using high-ISO films.
- Overexposing the negative.
- Overdeveloping the negative.
- Enlarging the image too much.
- Printing with high-contrast papers or filters. This does not increase the size of the grain but may add to the apparent graininess of the image.

■ Testing Procedures

Visual Shutter and Aperture Check

If your camera allows operation of the shutter with the back open, you can visually check the shutter and aperture operation. These rough tests will not tell you the accuracy of the settings but will let you know if any major problems exist, such as the shutter not opening or the aperture not shutting down.

Aperture Check Open the back of the camera, set the shutter speed to B, depress and hold the shutter release while looking through the back of the camera. Rotate the aperture ring and observe the diaphragm. It should open fully at the maximum aperture; then as you step down through all the stops, it should show a smooth reduction of the aperture with each step. If your camera does not operate with the back open, this same check may be done by looking into the front of the lens.

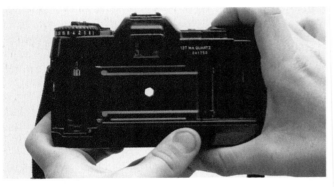

Visual Shutter and Aperture Check.

Shutter Check Open the back of the camera and point it at a brightly lit white wall or light source. While looking through the back of the camera, operate the shutter at each speed setting checking that the shutter opens on each setting. With practice, it is possible to tell by the sound of the shutter whether it is running fairly close to its proper speed, at all but the fastest speeds.

Shutter Speed and Aperture Test

To see if the shutter speed and f-stop pairs are giving the same amount of exposure, find or set up an evenly lit surface of uniform tone. A gray mat board works well for this purpose. Meter off the surface and then make as many exposures as possible with the different equivalent exposure settings on any black-and-white film.

For example, if the initial meter reading was f/8 at 1/60 second, shoot with as many of these cameras settings as

Shutter Speed and Aperture Test. For comparison, the first frame is one stop over and the third frame is one stop under. Most of the shutter speed-aperture combinations used in this test were consistent with each other, giving the same shade of gray. The first frame of the second strip shows some underexposure, estimated at about 1/3 to 1/2 stop when compared to the frame with one stop underexposure. The last two frames in the second strip, shot at 1/500 and 1/1000 second, show uneven exposure and about 1/3 stop underexposure. Older cameras often exhibit uneven shutter travel at higher shutter speeds.

you can with your camera: f/8 at 1/60, f/11 at 1/30, f/16 at 1/15, f/22 at 1/8, f/32 at 1/4, f/5.6 at 1/125, f/4 at 1/250, f/2.8 at 1/500, f/2 at 1/1000. For comparison, also shoot a frame that is one stop underexposed (e.g., f/8 at 1/125) and one that is one stop overexposed (e.g., f/8 at 1/30). Write down all the settings used.

When this film is developed, all of the frames with correct exposure should be the same density. If a contact print is made of this roll, printing so that the frames are a middle gray, easy comparison can be made of the various equivalent exposure settings. If any of these are lighter or darker than they should be, the frames that are over- and underexposed one stop will help to show how much that setting is off.

This tests only the combination, so any errors could be due to either the shutter speed or the aperture. Repeating the test at a different illumination level on the target will give different combinations, allowing you to narrow down the cause of any errors.

Camera Focus and Lens Sharpness Test

Pin a newspaper to a wall, making sure the newspaper is perfectly flat. Set the camera up on a tripod so that it is level with the center of the newspaper and pointed straight at it. Move the camera forward or backward until the newspaper fills the frame. Carefully focus the camera on the newspaper. Have a friend with good eyes and some photographic experience check your focus for you

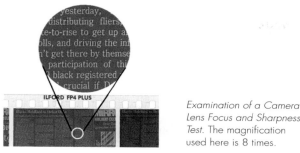

Examination of a Camera Lens Focus and Sharpness Test. The magnification used here is 8 times.

to verify that you are focusing correctly. Use a cable release to trip the shutter to prevent camera movement. Shoot at several different equivalent shutter speed and f-stop pairs, writing down the settings used. Be sure to include some shots with the maximum apertures on the lens: for example, f/1.4, f/2, and f/2.8.

After the film is developed, inspect the negatives for sharpness with a good-quality, high-magnification loupe. The newsprint in the image should be sharp from corner to corner. If it is not sharp anywhere in the frame and you have been careful to focus and to not let the camera move during the exposure, a problem with the focusing system or the lens itself may be indicated. Problems may be most easily seen when the large aperture openings (small f-numbers) are used. Sharpness generally improves as the lens is stopped down.

Enlarger Sharpness Test

If the negative of the newspaper from the preceding test is sharp corner to corner, it may be used to test your enlarging sharpness. Make several 8 × 10-inch or larger prints from it at different apertures on the lens, from the maximum aperture up to at least the middle range of apertures. If the resulting prints do not show sharp images from corner to corner, an enlarger problem is indicated.

If the image is sharp in the center but not around the complete perimeter, a poor-quality lens is the most likely reason, especially if an improvement in edge sharpness is noticed as the lens is stopped down. Alignment of the enlarger can also cause edge sharpness problems. A small level may be laid on the negative carrier stage, lens stage, and baseboard for a rough alignment check.

If misalignment is suspected, consult the instruction manual of your enlarger for alignment techniques. Some enlargers have a cast housing that does not allow alignment of the negative and lens stages, but the alignment with the baseboard can always be adjusted by inserting spacers under the column where it is bolted to the baseboard. After the rough alignment has been checked with a level, the sharpness of the projected image from the test negative can be used to judge final alignment.

Light Meter Testing

A rough test of a light meter is the f/16 rule. When pointing the meter at a subject of average tones in the middle of a sunny day, you should get a meter reading of about f/16 at a shutter speed equal to 1 divided by the ISO/ASA set into the meter. For example, if the meter is set for ISO/ASA 125, the meter reading should be about f/16 at 1/125 second.

Another testing method is comparison with another meter. Make sure both meters are measuring exactly the same area. A large, evenly lit wall is good for this purpose. If the meters disagree, further comparisons with other meters would be necessary to determine which is correct.

Alternatively, you can have the meter tested at a camera repair center.

Professional Testing

A fully equipped camera repair center can do several tests on your equipment to see if it is operating properly: shutter speeds can be tested for accuracy and focal plane shutters for evenness of travel; the aperture can be tested for accuracy at all the f-stops; the accuracy of light meters can be tested at several different levels. The camera industry has accepted standards for exposure accuracy at various shutter speeds and apertures, and the repair center can tell you how your equipment compares with the standards.

Standard Negative

It is helpful to choose one of your negatives to serve as a standard of comparison. A good standard negative should include subject matter that you normally photograph and should print easily on normal-grade (grade 2) paper. If you make a good print of this negative, you can store the negative and print for later comparison. If problems arise with your system, the standard negative can be reprinted to see if the problems lie in your printing procedures. The standard negative can also be used to compare different printing papers and developers.

Print from a Standard Negative. This image shows all the characteristics of a good standard negative. It prints well on grade 2 paper without burning or dodging. It has a large area of fully textured highlight (the white storefront at the top

© Bognovitz.

of the photograph), a good fully detailed dark tone area (the top of the shadowed door), and a full range of tones from black to white.

C H A P T E R 7

Light and Subject

Ralph Gibson, from *The Somnambulist*, 1970.

© Ralph Gibson.

The primary function of light in photography is the illumination of the subject. Many qualities of light, however, can change our perception of the subject matter. Lighting can reveal or hide the form, or three-dimensionality, and texture of the subject. Light can act as an important design element in a photograph. A subject can be isolated against its background by the presence or absence of light. Light can unify disparate visual elements and can affect the perception of space in the photograph. The quality of light can also carry psychological and emotional weight, setting a mood or feeling of time and place. Sometimes light can even become a presence in the photograph, transcending its role as illuminator or design element and serving as the subject of the photograph.

Most people in their everyday life pay little attention to light, thinking only of the practical applications: Is there enough illumination to do the job? The first step in gaining some control over the effect of light in your photographs is to develop a sensitivity to light's qualities. Study the light in everyday situations. You will find that even with a single light source, such as the sun, the effects of light can be amazingly subtle and complex. The quality of the light source itself can vary in intensity, harshness, and color. The light can then be further altered by the surroundings, being diffused, reflected, blocked, and filtered by objects in the environment. The presence of additional light sources can add even more complexity.

Studying the effects of light in photographs can also be helpful. Analyze the light in published photographs you see. Try to discover the type of light source and its direction by looking at the play of light, shadows, and reflections. Notice how the light changes your perception of the subject matter. If a photograph has an identifiable mood or feeling, see if you can determine how the light helps to promote this.

Remember that the way the eye sees is somewhat different from the way the subject is reproduced by the photographic process. The eye has a much larger range of sensitivity than the film. A forest scene with brilliant beams of light coming through the trees overhead may look beautiful to the eye, with the ability to enjoy the subtle tones in the dark shadows as well as to distinguish details in the sunlit patches. If you photograph this scene, you may be disappointed to see in the final result harsh splashes of white on areas of inky black shadow. The photographic response can be altered somewhat to accommodate different ranges of light, but the range of many natural scenes far exceeds the capacity of the photograph to reproduce tones.

Familiarity with the effects of light on the film will make for better lighting choices. If the preexisting lighting creates problems, it is possible to alter it or add supplemental light for the desired effect. The remainder of this chapter gives some basic techniques for analyzing and controlling the light in a photograph.

Quality of Light. Frederick Evans, *Kelmscott Manor: Attics 1896*. The photograph on the facing page by Ralph Gibson and this photograph by Frederick Evans make effective use of light. The light has a real presence in both, and several of the functions of light can be seen: the isolation of the hand in the first photograph, the depiction of texture in this one, a feeling of three-dimensionality and a sense of space in both. Nevertheless the mood established by the light differs, being eerie and unsettling in Gibson's image and warm and inviting in this one.

Courtesy of the Library of Congress. Used with permission.

■ Qualities of Light

Light exhibits several qualities that can be used in photography. These are the direction of light, the lighting contrast, the color of light, the intensity of the light source, and the specularity.

Direction of Light

The direction of the light on a subject is altered by the relative orientation of subject and light source. The position of the camera with respect to the subject and light source can also affect the appearance of the lighting. The position of the light source is usually given with respect to that of the camera, but occasionally it is given with respect to that of the subject. The height of the light—compared with the height of the subject—also changes the appearance of the subject.

Shadows The direction of the light affects the position and shape of **shadows** within the photograph. Lighting that produces noticeable patterns of light and shadow—

called *chiaroscuro* by painters—can add a certain amount of drama to the image, as in the high 45° lighting shown on the next page. The perception of volume in the subject—its three-dimensional form—is also changed by the direction of the light.

Reflections Reflections of the light source itself, called **specular reflections** or **specular highlights,** may be seen on reflective surfaces. Their position is affected by the relative positions of light source, subject, and camera.

Even though the examples in the following illustrations were made with artificial lighting, the same principles apply to the direction of any existing light, whether natural or artificial. In fact, studio lighting usually recalls naturally occurring situations. Sidelighting, for example, is seen naturally when a subject is illuminated from the side by window lighting or by the sun very early or late in the day. Backlighting occurs in many natural situations whenever the camera is pointed toward the light source.

continued

High Front Lighting

High 45° Lighting

Level Side Lighting

High Back Lighting

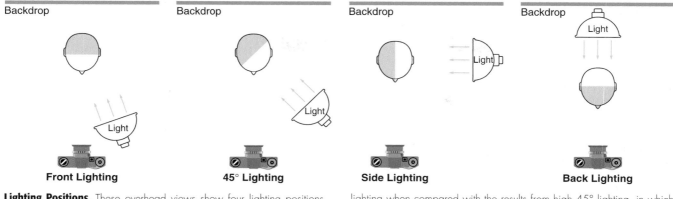

Backdrop — **Front Lighting**
Backdrop — **45° Lighting**
Backdrop — **Side Lighting**
Backdrop — **Back Lighting**

Lighting Positions. These overhead views show four lighting positions. The front, 45°, and side lighting positions may be used from right or left. In each position the light can be level with the subject, above the subject (high), or below the subject (low). Each lighting position alters the look of the subject. Note the lack of three-dimensionality resulting from level front lighting when compared with the results from high 45° lighting, in which the modeling provided by shadows clearly shows the form of the subject. Also note how the positions of both shadows and reflections change with the position of the light.

Level Front Lighting

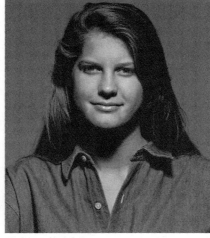
High Front Lighting

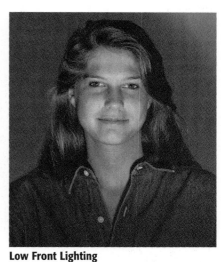
Low Front Lighting

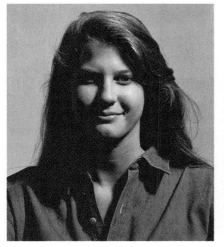
High 45° Lighting

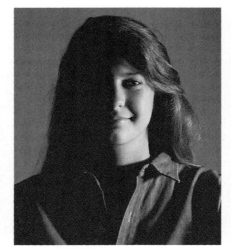
Level Side Lighting

High Back Lighting

Direction of Light—Continued

The texture of a surface can be accentuated by causing the light to cross the surface at a low angle relative to the surface. This is called **cross lighting**. Remember that cross lighting is caused by the position of the light relative to the textured surface, not the position of the light relative to the camera (see the example on page 130).

Cross Lighting. Left: Textured subject with light straight into surface. Right: Texture accentuated by cross lighting.

Lighting Contrast. Top: High lighting ratio—about 5:1. Bottom: Low lighting ratio—about 2:1.

Lighting Contrast

The type of lighting will affect subject contrast. **Lighting contrast** is the difference in the illumination supplied to the fully lit parts of a subject and the illumination supplied to the shadowed areas of the subject. The light in the shadowed areas usually comes from light reflected or scattered from the surrounding environment—known as **environmental light**—but may also come from secondary light sources.

The difference between the full effect of the light and the effect in the shadows can be measured with an incident-light meter and compared. This difference is the lighting contrast and is normally given as a **lighting ratio**. For example, if the difference is one stop, the full effect of the lighting is twice as great as the effect in the shadows and the lighting ratio is 2:1. The higher the lighting ratio, the higher the contrast. High-contrast lighting is sometimes called "harsh" and low-contrast lighting is called "flat."

The amount of environmental light illuminating the shadows depends upon the environment surrounding the subject, called the **ambience**. High ambience means the surroundings contain highly reflective or light-colored surfaces; more reflected environmental light will reach the shadows, producing lower contrast. Low ambience means dark-colored surroundings producing less environmental light and higher contrast. A large source of environmental light is skylight, which is sunlight reflected from the sky. Light reflected from parts of the subject itself, such as light-toned clothing, can also contribute to the amount of environmental light.

Natural lighting can exist in a variety of contrasts. Direct sunlight on a clear day, especially in areas with clear atmosphere, can lead to high contrast if the ambience is low—if no light-reflecting surfaces are near the subject. On the other hand, an overcast day may lead to low contrast, since nearly all shadows are filled by scattered light from all areas of the cloudy sky. As discussed in chapters 4 and 5, the contrast due to subject lighting can be compensated for in the developing of the film or in the printing.

Color of Light

In black-and-white photography small variations in the color of the light illuminating the subject have little effect on the end result. In color photography these changes will be recorded by the film—especially color transparencies—and seen in the finished photograph. Many factors can affect the color of the light:

■ *Type of light source.* The sun produces white light and is the standard by which we judge the color of light. Light produced by light bulbs with tungsten filaments contains less blue and more yellow or orange than daylight. Fluorescent lights usually produce light with more green than daylight.

■ *Variations in sunlight.* The color of sunlight is altered by its passage through the atmosphere. Late in the day the light is more yellow than it is at midday. The season can also affect the color of the light, as can weather conditions. The light in cloudy, rainy, or foggy conditions usually contains more blue than does direct midday sunlight. Conditions at dawn or dusk can add great amounts of reds, oranges, and yellows to the light. Haze and atmospheric effects over great distances can produce more blue in the light.

■ *Reflection.* Light reflected from a colored surface will take on the color of the surface; this is called **color contamination.** Reflected light from a green wall or green trees will cause a green cast in a color photograph. Reflected light from a clear sky—skylight—is bluish in color.

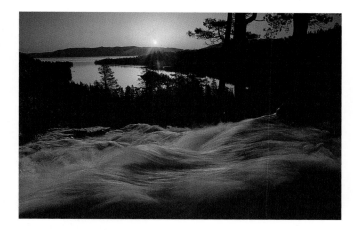

Using Color of Light. Galen Rowell, *Dawn over Eagle Falls, Lake Tahoe, California.* The warm orange or yellow light at the beginning and end of the day can produce feelings of restfulness or peace associated with those times of the day.

© Galen Rowell/Mountain Light.

We often associate emotions with the situations in which we see different colors of light. Use of similar colors of light in color photographs may recall these emotions. In black-and-white photographs the color of the light is not represented, so the other qualities of light must be relied upon to communicate such feelings and ideas.

Intensity of a Light Source

The intensity of a light source refers to the amount of light it produces. Changing intensity results in a change in the film exposure and must be compensated for by adjusting the camera settings—the f-stop and shutter speed. The intensity of the light source illuminating the subject is not directly perceivable from a photograph, since the representation of the subject tones is controlled by exposure, development, and printing. High-intensity light is usually represented in the photograph by printing for a lighter-than-usual tone in the highlights and by the presence of extreme contrast. Intensity of the source can also have some effect on the lighting contrast and the appearance of the specular highlights.

Color Contamination by Reflection. On the left, the shaded side of the face and the white shirt have a yellow appearance because of the light reflected from the yellow wall. On the right, the shaded side of the face and the white shirt take on a blue coloration.

Specularity

The light from a heavily overcast sky differs from direct sunlight in ways other than lighting contrast. Direct sun, especially in an area with exceptionally clear atmosphere, produces distinct, sharp-edged shadows and small, harsh specular highlights. An overcast sky produces light that yields indistinct, soft-edged shadows and large, low-intensity specular highlights. These differences are due to the change in the **specularity** of the light. Direct light from the sun is an example of **specular light,** in which the rays all travel in the same general direction, as if they emanated from one point. Sources of specular light are small in size, or appear small because of their distance from the subject—as with the sun.

Light from an overcast sky is an example of **diffuse** light, which has been scattered so that it reaches the subject from many different directions. Diffusion, or scattering, of light takes place during reflection from slightly textured surfaces or transmission through translucent materials. In effect, the diffusing material becomes a new light source of larger area, providing light to the subject from more directions. The larger the area of the light source, the more diffuse—and less specular—the light.

When clouds interpose between the sun and us, sunlight is diffused by them and appears to come from the whole cloud-covered sky, providing one of the least specular sources available. Subjects receiving no direct light from the sun but only skylight are illuminated by a very diffuse source as well.

Specular sources are often called "hard" and diffuse sources "**soft.**" This usage should not be confused with the common use of the same terms to describe high and low lighting contrast. Illumination by diffuse light sources usually produces lower subject contrast, but the loss of contrast is not due directly to the diffuse nature of

Subject Lit by Specular Source. Top: The subject is illuminated by a specular light source. Note how sharp and well-defined the edge of each shadow is. The specular reflection in the spatula is relatively small and harsh. Bottom: This is a magnified view of the shadow edge for a specular source.

Subject Lit by Diffuse Source. Top: Here the same subject is illuminated by a diffuse light source. The edge of the shadow is now softer and more graduated. The specular reflection is larger and less instense. Bottom: This is a magnified view of the shadow edge for a diffuse source.

Controlling Specularity and Contrast Independently. Top: Environmental light was carefully controlled to produce high contrast with a diffused light source. The shadow edge is soft. Bottom: Light was added to the shadows by use of reflectors to produce low contrast with a specular source. The shadow edge is sharp.

the light source. Two things cause this loss of contrast. The first is that in most situations, the environment contains reflecting surfaces that will scatter light back into the shadows. This environmental light is increased by most diffuse sources, since light is scattered in so many different directions. More illumination then reaches the shadows, and the contrast is reduced. The second reason for loss of contrast is that most diffuse sources are lower in intensity than comparable specular sources. Since the illumination in the shadows is affected less by this drop in intensity than that in the fully lit areas, the result is a reduction in contrast.

If care is taken to control the amount of light scattered by the environment—for example, by surrounding the subject with dark, light-absorbing surfaces—a considerable amount of subject contrast can be achieved with diffuse light sources. Conversely, the high lighting contrast often associated with specular sources can be reduced by providing more light to the shadows either by introducing light-toned reflective surfaces into the environment of the subject or by adding supplementary light to the shadows.

Our perception of the specularity of the light source in a photograph carries emotional and associative messages, as demonstrated by the examples below.

Use of Specular Light. Charles Sheeler, *Cactus and Photographer's Lamp,* *(1931).* The use of specular light, with its well-defined shadows and harsh specular highlights, can recreate the feel of sunlight and high intensity. The angular shadows contribute to a very geometric feeling in the design of this photograph. When combined with high lighting contrast, specular light produces hard-edged, deep shadows that carry a feeling of drama or theatricality because of the similar nature of most theater lighting. Specular lighting will also produce well-defined texture, emphasizing character lines in portraits of people.

Use of Diffused Light. Robert Mapplethorpe, *Lydia Cheng, 1985.* Diffuse lighting conveys a sense of softness, gentleness, and sometimes romance. Here, the contours of the body are gently outlined by the diffuse light.

© 1985 The Estate of Robert Mapplethorpe.

■ Working with Light

Two approaches can be taken to dealing with light in photography. In the first approach, the preexisting light is accepted as is with no attempt to modify it. Getting good results depends on discovering the chance moment when light and subject interact in a beautiful, meaningful, or exciting way. The only control available if this approach is taken is to move your subject matter within the light, change the camera position for a better view of the effect of the light, or wait for more desirable light. The second approach is to either modify the preexisting light to achieve the desired effect, add supplementary lights, or eliminate all preexisting light—as in a studio—and build the lighting you desire with artificial lights.

Even though these sound like opposite approaches, the principles involved are exactly the same. You are still searching for the play of light, shadow, and reflections that will reveal the subject as you wish to photographically portray it. Photographers working on assignment often resort to the second technique, since they may not have the leisure time to wait for or find the precise natural lighting conditions they need. In any case, even when the lights are being manipulated, the intent is often to reproduce

Ansel Adams, *Mount Williamson, the Sierra Nevada, from Manzanar, California*, 1945. The low back lighting provided by the sun accentuates the texture of the boulder field.

the look and feeling of a natural lighting situation. This would necessitate an understanding of natural light before attempting to control artificial lighting.

Daylight Photography

The light from the sun can undergo many natural modifications. One joy of photography is observing and recording the infinite variations of daylight. The direction, quality, and color of the light change from hour to hour, from day to day, and from season to season. A land-scape that looks perfectly ordinary in the middle of the day may be spectacularly transformed by the golden, raking light of the evening sun. Do not put your camera away on bad-weather days. The hazy, glowing light on a foggy day can add mystery or beauty to your subject. The effect of sunbeams splashing through a window or dappling a forest floor can be intensified by haze or smoke in the air. Daylight can also provide soft lighting on an overcast day or in indirect sunlight—as in open shade situations where the light is either skylight or light reflected from surrounding objects.

The very diffuse light resulting from a heavily overcast day can give the feeling of dreariness associated with bad weather, but if handled with proper exposure, development, and printing, it will give a luminous, glowing quality to highlights that the specular harshness of direct sun is unable to convey.

© Bruce Warren.

Working with Daylight Several methods are available to the photographer for controlling the effect of daylight on the subject.

Wait for Better Lighting. If the quality of the daylight is not giving you what you want, wait for a different time of day or year or for different weather conditions. The overhead lighting at noon may not produce at-

tractive portrait lighting, but waiting until later in the afternoon or shooting earlier in the morning may give a better position of the sun. This subject is seen in early afternoon on the left and at sundown on the right.

© Bognovitz.

Move the Subject. The direction of the sunlight falling on the subject can be altered by orienting the subject to the sun for the desired effect. On the left, the sun is providing a high 45° lighting. By turning the model toward the sun, as seen on the right, high front lighting is achieved.

Change the Camera Position. The point of view of the camera can radically change the appearance of the light on the subject. The difference between having the sun behind the camera, as on the left, and then walking around so that the sun is behind the subject, as on the right, is one example of this type of control.

© Bognovitz.

Modify the Daylight. A. To reduce the hardness of the direct sunlight, diffuse the light by placing a translucent material, such as thin white cloth, between the sun and the subject. This will also reduce the lighting contrast by cutting the intensity of the light illuminating the fully lit areas. At the top the still life is lit by direct sunlight. At the center a diffusion screen has been inserted as seen in the set shot.

B. To reduce the lighting contrast without affecting the hard-edged shadows produced by specular direct sunlight, more light can be added to the shadows by using a white reflecting surface, such as a large white card or other white material. The photograph at the center shows the effect on the shadows when the fill card is placed as shown in the set shot.

Available-Light Photography

In many situations it is impossible or ill-advised to introduce supplementary light, even though the preexisting level of light may be quite low. Most photographers use the term **available light** to describe this situation. Modern high-speed films have made photography under these conditions practical but at the price of larger grain structure. See pages 36–37 on photography with low illumination levels.

If the subject is not moving, placing the camera on a tripod will allow the use of slower films for finer grain. If the lights cannot be controlled, make the best of the situation by choice of camera or subject position.

Indoor Available Light

The most typical indoor lighting is a series of overhead lighting fixtures, either fluorescent or tungsten. Overhead lighting is not the most attractive for some subject matter—for example, eyes may be shadowed—but it is usually not difficult to get acceptably lit photographs in an evenly illuminated room.

A room illuminated by table or floor lamps provides more interesting light but is more difficult to work with. The result is a room with pools of light and shadow. If the exposure is for the light areas the dark areas may not show detail, and vice versa. If the room also has overhead lights they may be turned on for more general illumination.

© Bognovitz.

Another common indoor lighting situation is sunlight, either direct or indirect coming through windows. Try to avoid shooting directly toward windows unless you are looking for a silhouette or sufficient illumination exists from other sources to provide good exposure on the subject.

© Bognovitz.

Modifying Indoor Available Light

Here the subject is lit from the side by a table lamp.

Placing a white card or other white material on the side of the subject opposite the light reduces the lighting contrast.

This shows the arrangement of light, subject and reflector. This technique will also work with window light.

Outdoor Available Light

Gilberte Brassaï, *Avenue de l'Observatoire*, 1934. The only common low illumination levels with exterior sunlight happen just before dawn or after sunset or perhaps on heavily overcast or foggy days. The light comes from the sun indirectly at these times and is diffuse and low in intensity. Use a fast film if speed is important or use a tripod with slower-speed film. Outdoor artificial lights can provide good picture-taking opportunities but usually require long time exposures (see pages 36–37). Some streetlights provide enough illumination for photography with fast films.

© Gilberte Brassaï, Courtesy of Mrs. Gilberte Brassaï.

Available Light and Color Films When using color film, be sure to either match the film type to the lighting or use a filter on the camera to correct the color of the light (see pages 202–03). If the subject is illuminated by lights of more than one color—for example, fluorescent and tungsten—only one source may be corrected by a filter on the camera. Interesting nonstandard color rendition can be the result of photographing with mixed light sources of different color balance.

Carlsbad Caverns, New Mexico. The colors seen here are a result of several different types of illumination being used in the caverns, including tungsten lights, mercury vapor lights, and fluorescent lights. When viewed by the eye, these lights do not show the vivid color differences recorded by the film.

© Bruce Warren.

■ Controlled Artificial Lighting Techniques

Nice results in lighting can be achieved with relatively simple equipment. One or more studio lights and some reflecting and diffusing materials will get you started.

Some safety rules should be observed with studio lights:

■ Incandescent lights get very hot when operating. Keep flammable materials well away from the beam of the light and remember that the lamps and housings are very hot after the lamps have been on for any period of time.

■ Electrical cords should drop straight to the floor and lie flat between the lights and the outlets with enough slack to prevent tripping. Cords stretched out above the floor in a partially lit studio are easy to run into, with the danger of pulling the lights over on someone.

Lighting Equipment

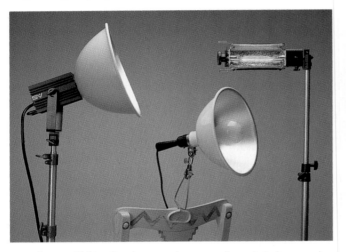

Incandescent Lights. The clamp-on aluminum reflector light fixture in the center can be purchased at many department or hardware stores. Install a photoflood bulb available at photo stores. Be sure the lamp is rated for 500 watts. The light with a bowl reflector on the stand also uses photoflood bulbs. The smaller light on the right uses more expensive quartz-halogen lamps.

Materials for Diffusing Light. White foamcore board is a lightweight and durable material for reflectors. You can also use white mat boards or any other white material. White cloth or translucent plastics may be used as diffusers. Frames for supporting materials can be improvised from wire, plastic tubing, or wood.

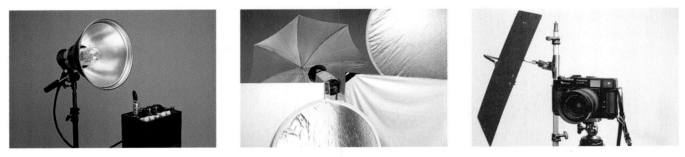

Advanced Lighting Tools. Professionals and advanced photographers make use of a number of more advanced lighting tools. These items can be expensive, but make difficult lighting tasks easier. Some of these items can be improvised from household items or materials you can buy at hardware or fabric stores, but if you find yourself doing a lot of artificial lighting, you may want to invest in the real thing. Left: This is a professional studio electronic flash (often—though inaccurately—called a strobe) with a high-voltage power pack separate from the light head. Units like this provide a very bright, brief burst of light and do not generate as much heat as the incandescent lights shown above. Center: These are various commercially available devices for diffusing light by reflection or transmission, including photo umbrellas and soft-boxes. Most of them fold for easy transport. Right: Professional quality stands and clamps are handy for holding lights, reflectors, or diffusers in the studio. In this case a black card, called a **gobo**, is being used to block light from directly striking the camera lens, preventing flare.

Portrait Lighting

The following illustrations show a few basic lighting positions for portraits. Each example is accompanied by a photograph of the set (a set shot) showing the relative positions of model, camera, background, and lights. The lighting diagrams on page 125 will also help you in setting up the side, front, and 45° lighting. You will need a room in which any preexisting light can be eliminated and a white backdrop or blank wall to use as a background. Notice that in each case the model is seated at least 6 feet from the background. This helps to keep the model's shadow from falling on the background and allows room for lighting the background. Any light source of the types shown on the facing page may be used.

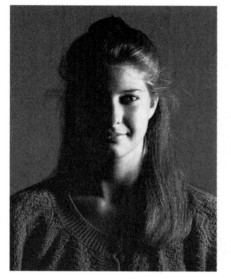 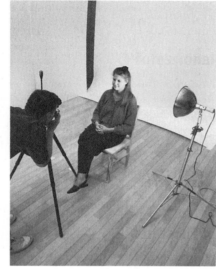

Sidelighting. The light is directly to the side of the subject—90° from the camera—and level with the model's head.

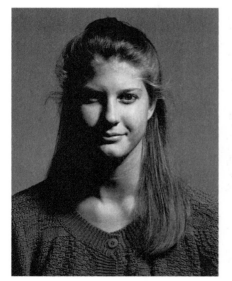 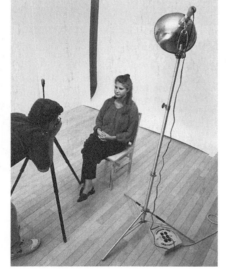

Rembrandt Lighting. The light is 3 or 4 feet above the model's head, pointed down, and located about 45° to the side of the camera. Adjust the position of the light until you see the triangle of light on the shadowed side of the face as shown. This position can be used from either side. The Rembrandt position is nearly equivalent to the high 45° position shown earlier, but is defined by a well-formed triangle of light under the eye.

continued

Portrait Lighting—Continued

Diffused Front Lighting. A white card is placed near the camera position, level with the model's head. The light is turned to illuminate the card, bouncing diffused light back toward the model. Be careful that no direct light strikes the camera lens. The front lighting shown earlier was a specular (direct) front light.

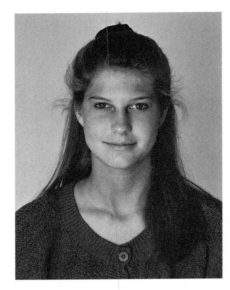 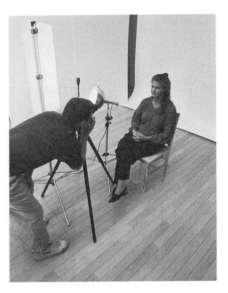

Silhouette Lighting. The white background directly behind the model is evenly illuminated by two lights. Do not let light fall directly on the model. The lights should be level with the model's head.

 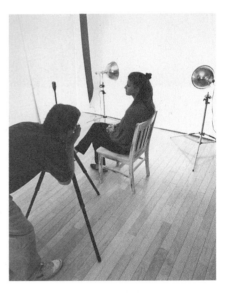

Metering for a Portrait

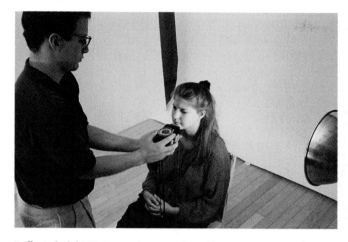

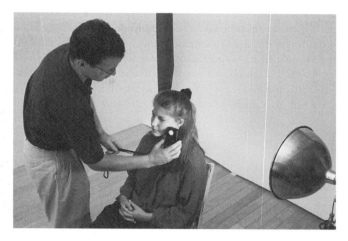

Reflected-Light Meter. A close-up reflected-light meter reading can be made of the lit side of the face. With a 30°–45° meter, hold the meter about 6–8 inches from the face. With an in-camera meter, move close enough that the lit half of the face covers the metering area in the viewfinder. Be careful not to cast a shadow when metering. For most subjects use the meter reading as is. If the model is blond and very light skinned, you may wish to open up one stop to insure correct exposure.

Incident-Light Meter. An alternative is to use an incident-light meter, placing it at the fully lit side of the face and pointing it back toward the camera. Use the indicated meter reading for your camera setting.

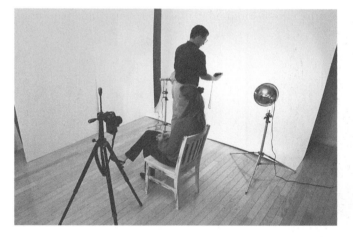

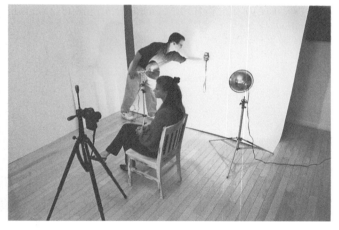

Metering for the Silhouette. A. Metering the silhouette lighting position requires a special technique. Since the skin tone is not illuminated, it is easier to make a reflected-light meter reading from the background. If you wish to be sure that the background will be white, open up three to four stops from the indicated camera settings. For example, if the background reads f/11 at 1/60 second, opening up three stops would produce a camera setting of f/4 at 1/60 second.

Metering for the Silhouette. B. An incident-light meter can also be used for metering the silhouette. Place the meter at the background, pointed back toward the camera. Use the camera settings as suggested by the meter or open up one or two stops for a brighter white background.

Combining Positions Notice that the contrast is high in the sidelighting and Rembrandt lighting positions, to the point of looking harsh. Front lighting, on the other hand, produces few shadows on the face, resulting in a flat, two-dimensional look. The silhouette is a special lighting position, giving only a simple outline of the subject. One of these positions may give approximately the desired effect but could be improved. For example, we may wish to reduce the contrast of the side and Rembrandt positions or add detail to the face with the silhouette. This can be done by combining more than one light or by modifying the light itself.

The mistake many people make when learning lighting is to turn on several lights and then shuffle them around trying to get some usable result. The best way to light is to start with one light and position it first, then add other lights as desired.

1a. Position the Main Light. The light that determines the shape and position of shadows and highlights on the subject is called the **main light** or key light. Turn on one light and position it for the desired shape and position of the shadows on the face. Do not worry about the contrast of the lighting at this point. Here the photographer has used Rembrandt lighting, which shows the shape of the face especially well. Sidelighting can also be used for a main light. Front lighting is used as a main light if a flattening of the features or a reduction of skin flaws and wrinkles is desired.

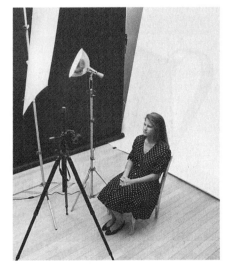

1b. Change Main Light Specularity. Once you have the main light positioned, look at the result and decide if any modifications are necessary. If you wish to soften the shadow edges, the main light can be made larger by diffusion. This will also reduce the lighting contrast. If you wish to reduce the contrast without softening the shadow edge, proceed to the second step. Shown is diffused Rembrandt lighting, produced by turning the light away from the model and reflecting it off of a white card.

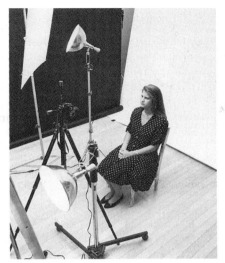

2. Add a Fill Light. The purpose of a **fill light** is to reduce contrast by adding light to the shadows created by the main light without overpowering them or creating additional shadows. The front lighting position is the best position for a fill light, since it creates the fewest shadows on the face. In addition, diffusing the fill light will soften any shadows that might be added, making them less noticeable. The intensity of the fill light should be less than that of the main light and can be adjusted by moving the light forward or back to change the lighting ratio. An alternative to adding a fill light is using a white reflecting card to reflect the main light itself back into the shadows. Shown is diffused Rembrandt lighting with a diffused front fill light.

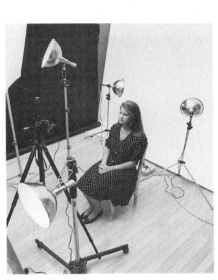

3a. Add Effects Lights. Once the main and fill lights have been placed, then other lights can be added for effect. So far we have let the background receive whatever illumination it can from the main and fill lights. If you want a truly white background, illuminate it as in the silhouette lighting.

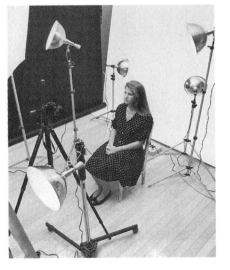

3b. Add Other Effects Lights. Other lights can be added at this point. Here a light above and slightly behind the model has been added to illuminate the hair; this is known as a **hair light.** Metering with combination lighting should be done as described on page 139, with a close-up meter reading of the lit skin tone or an incident-light reading. Metering should be done with main, fill, and effects lights on, since the lit side of the face is illuminated by both main and fill lights and all of the lights add environmental light to the studio. When bright lights are placed behind the model, as are background lights, take care that the light from behind is not allowed to directly influence the meter reading from the skin tone or allowed to fall directly on the camera lens, which would cause flare.

Still Life Lighting

The basic procedure for still life lighting is much the same as for portrait lighting. A main light is positioned to define the shape and position of shadows, a fill light is added to reduce the contrast if needed, and effects lights are added as desired.

A still life introduces an additional concern about proper rendering of the surfaces of the objects; the choice of lighting affects the appearance of the surfaces.

In addition to the appearance of the shadows, you should also look at the position and harshness of reflections in the subject's surfaces. If the specular reflections are undesirably small and harsh, diffuse the light source by passing it through a translucent screen or reflecting it off a white card to get larger, softer reflections. Repositioning the subject or the light slightly can also help to control reflections.

A. Specular Light Positioned Level and at the Side of the Subject.
This lighting situation produces fairly hard-edged shadows, highlighting contrast (dark shadows), and small, harsh specular reflections.

B. White Reflector Card Added at Right Side of Subject for Fill Light.
The fill light reduces the lighting contrast, producing lighter shadows without changing the appearance of the shadow edges. It also provides secondary soft specular reflections on the right sides of the billiard balls, clock, and center package, better defining their three-dimensional form.

The goal is not to get rid of shadows and reflections. These are the indicators of the form and surface nature of the subject. A shiny surface without reflections will not look shiny. A spherical object without shadows will look flat. Your goal is to show the form and surface of the object without distracting or ugly shadows and reflections.

Good still life lighting can be achieved with either natural or artificial lighting. With natural lighting, the subject can be placed in a position receiving the desired light. The natural lighting can also be diffused or reflected to control its quality and provide fill lighting.

C. Translucent Plastic Diffusion Screen Placed in Front of Main Light.
This has the effect of slightly softening the shadow edges and the specular reflections.

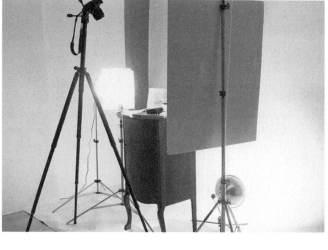

D. Light Added to Background.
This has no effect on the lighting of the subject itself, but causes the objects to stand out against the background.

■ Lighting with Small On-Camera Electronic Flash Units

Small electronic flash units for use on cameras are widely available and provide a convenient portable supplementary light source. They have replaced the older flashbulbs, which were used in the same fashion. Electronic flash provides light only in a very short burst, sometimes as short as 1/50,000 second or less. The effect of the flash cannot be seen, so positioning a flash for the desired lighting effect can be difficult. Nevertheless, a little experimentation can provide you with the knowledge you need to make good use of your flash.

Small On-Camera Flash Units. The flash on the right can be tilted to direct the light toward the ceiling. Some flashes can also be pivoted to direct the light toward a wall at the side of the camera.

Connecting the Flash to the Camera

Hot Shoe Connection. Flashes that mount directly on the camera may be set off by contacts contained in the shoe—called a **hot shoe**—in which the flash is mounted.

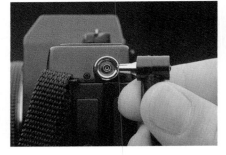

Synch Cord Connection. Other flashes can be set off by way of a cable connection—called a synchronization or **synch cord**—to the camera. Most cameras use a type of connector on the synch cord called a PC connector, shown here.

Off-Camera Flash. Flashes with PC connections can be operated off the camera if an extension synch cord is used. This permits more flexibility in the use of the flash. If your camera or flash offers only hot shoe connection, adapters are available for converting to PC connection, allowing use off camera.

Synchronizing the Flash with the Shutter

The flash must be tripped so that the subject is illuminated while the shutter is open, or synchronized with the shutter. **Synchronization** is achieved by contacts on the shutter that set off the flash. Older cameras may have more than one synchronization setting, to accommodate electronic flash (**X-synchronization**) or bulbs (M or FP synchronization). Most modern cameras have only X-synchronization. Flashbulbs may be used with X-synch and slower shutter speeds—usually 1/15 or 1/30 second.

Since focal plane shutters employ a slit that travels across the film plane to achieve higher speeds, care must be taken to use the slower speeds for which the shutter opens completely when using electronic flash. The camera instructions will give the flash synchronization shutter speed, or it may be marked on the shutter speed scale with an *X*, a lightning bolt symbol, or a different color of number. For many cameras using focal-plane shutters, this speed is 1/60 second, but a number of newer cameras

offer higher flash synchronization speeds. When using flash, do not set the shutter for speeds higher than the synchronization speed, or you will get only partial pictures due to the narrow shutter opening.

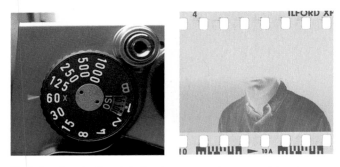

Flash Synchronization. Left: Synchronization shutter speed for electronic flash. Right: Result of a shutter speed higher than the synchronization speed with a focal plane shutter.

Determining the Flash Exposure

Flash cannot be measured with the meters designed for continuous light sources. Special meters are made for metering flash, but they are expensive. The illumination on the subject by the flash depends on the flash's power, duration, and distance from the subject. Correct expo-sure with electronic flash is determined in several ways, as shown in the following illustrations. Many automatic and dedicated flashes can read both the continuous light illuminating a subject and the light supplied by a flash, making it possible to use the on-camera flash as a fill light for natural lighting situations without any compli-cated calculations.

Manual Flash Exposure Control. Since the burst of light from small electronic flash units is much shorter than the length of time the shutter is open, the shutter speed has no effect on the flash expo-sure. Only the aperture can be used to control flash exposure. The proper f-stop is determined from the distance of the flash to the subject and the ISO of the film being used by means of a chart or calculator on the flash. The flash exposure calculator shown here has been set for 100 ISO film by turning the outer dial until the black triangle points at 100 (the dot just to the right of 125) on the ASA scale. To find the correct f-stop, determine the distance from flash to subject and refer to the dis-tance scales in feet (labeled FT) or meters (labeled M), which are the second and third scales from the top of the calculator. The required f-stop will be found on the topmost scale directly opposite the distance. In this case, if the distance from the flash to the subject is 10 feet, the camera aperture should be set at f/11.

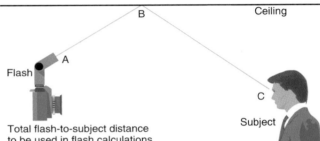

Total flash-to-subject distance to be used in flash calculations is AB + BC.

Exposure Corrections for Diffused Flash. If the light from the flash has been diffused by passing it through a translucent material or bouncing it off a white surface (see the next page), corrections must be made to ac-count for light losses occurring in the diffusion process. Bounce surfaces or translucent materials will cause a reduction of exposure by one stop or more. For bounce flash, use the combined distances from the flash to the bounce surface to the subject to calculate the f-stop, then open up one stop for a surface painted flat white (more for darker surfaces).

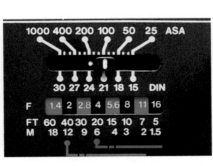

Automatic Flash Exposure Control. Left: Most flash units on the market today offer some type of automatic flash exposure control. A sensing cell on the flash measures the amount of light coming back from the subject and automatically shuts down the flash when the proper exposure is achieved. The f-stop specified for automatic op-eration—some flash units offer several choices—at a given ISO must be set into the camera. If the flash is removed from the camera for lighting, the sensor on the flash will no longer be reading the light reaching the camera. Some flashes offer an extension for the sensor so that it can remain at the camera position. Otherwise, set the flash on

manual for this situation. This flash has a choice of manual (M), or two automatic selections (the blue or red settings). Right: Referring to the cal-culator dial on the same flash, we see that when 100 ISO is set into the ASA scale, the red set-ting indicates that f/2 should be set on the aper-ture control of the lens. Just below the f-stop scale, a distance scale indicates the maximum distance for this setting, in this case 40 feet. As long as the subject is closer than 40 feet, the flash should produce correct automatic expo-sure. Other brands or models of automatic flashes may have a different system for determin-ing f-stop and maximum distance.

Dedicated Automatic Flash Exposure Con-trol. A more sophisticated method of automatic flash exposure control is employed by **dedi-cated flashes.** These work only with specific camera models and are coupled to the controls and meter in the camera through additional contacts in the hot shoe. The camera meter itself controls the flash for proper exposure, and the effect on exposure of any diffusion or bouncing of the flash will be compensated for automati-cally. If you wish to move a dedicated flash off the camera, a special cord containing all the contacts must be used. Most dedicated flashes automatically set the shutter speed to the proper flash synchronization speed.

Positioning and Modifying Flash

The principles for lighting with flash are the same as those given earlier for continuous light sources. When the light from the flash is diffused by reflection off a white surface—a wall or card—it is called **bounce flash.**

Direct Flash Used on the Camera

Direct Flash Moved off the Camera

Diffused Flash Used on the Camera

Diffused Flash Used off the Camera

Flash Bounced off a Nearby Wall

Flash Bounced off the Ceiling

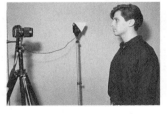
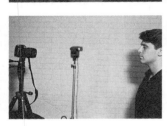
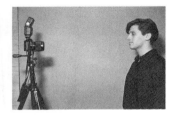

Methods for Diffusing Flash. Bottom photo: Left: A handkerchief has been draped over the flash. Center: This is a Lumiquest, a folding vinyl reflector attached to the flash. The flash must be capable of being tilted straight up for this device. Right: A translucent plastic dome has been clipped over the front of the flash.

Set Shot for Diffused Flash Used off Camera. In this case, a handkerchief has been used for diffusion and the flash positioned for level 45° lighting.

Set Shot for Flash Bounced off a Wall. The flash is aimed at a spot on the wall midway between flash and subject. If your flash can swivel, bounce flash from a wall can also be achieved with the flash mounted on the camera. Here, the lighting position is level side lighting.

Set Shot for Flash Bounced off the Ceiling. The flash is aimed almost directly at the ceiling here because the subject is close to the camera. In general, aim the flash at a point on the ceiling midway between flash and subject. The lighting position produced is high front lighting.

Stopping Motion with Electronic Flash

The short duration of the light from electronic flash is excellent for freezing moving subjects. This photograph was made with professional studio flash equipment, but similar motion-stopping effects can be achieved with smaller flashes if a little ingenuity is applied. Move the flash closer to the subject for more illumination. Diffuse the light from the flash by the methods shown on the facing page. Additional flash units can be used by plugging their synch cords into a device called a **slave,** which will set off the auxilliary flash when it senses the light from the flash connected to the camera. The background effect seen in this photograph could be approximated by illuminating a white backdrop with a second flash covered with a sheet of blue acetate (available at art supply stores).

© Gerald Zanetti.

CHAPTER 8

Seeing Better Photographs

Dennis Stock, Liz Claiborne advertisement.
© Dennis Stock/Magnum Photos.

A photograph does not exactly reproduce what you see with your eyes. Many of the peculiarities of the actual image produced by the human eye are adjusted for by the mind, giving us a perception of reality that is a result of the eye and mind interaction. Photography, on the other hand, depends upon the performance of a sequence of optical and chemical processes. Although it allows limited control over the appearance of the final photograph, it is still a set of essentially mechanical processes when compared with the impressionistic workings of the eye and mind.

Some obvious differences between the photographic image and visual perception can be easily cataloged:

■ In black-and-white photography, the colors of the original subject are reduced to gray tones. Even with color film, the colors of the original are not reproduced exactly.

■ The eye has the ability to see detail in all areas of a high-contrast subject, since it can adjust to the darkest and lightest light levels. The photograph can reproduce only a limited range of these subject tones.

■ Only a small central area of the vision is sharp—that is, in focus—and only at one distance at a time. This shortcoming is compensated for by the ability of the eye to quickly focus while scanning a subject. The mind integrates little snatches of clear vision gathered by the eye, so that the entire subject appears to be sharp and in focus. The camera, on the other hand, focuses only on a plane in the subject at one distance. The additional subject matter that can be brought into acceptable sharpness with depth of field is limited.

■ The mind has the capability of "filtering out" unwanted visual information when viewing the original subject, effectively isolating important details. In a photograph, such unwanted information is faithfully rendered and may be distracting. A person can comfortably view a ball game through a chain link fence, but in a photograph the fence could be a distraction to the point of obscuring the game.

■ Since photographs are two-dimensional, the ability to perceive depth due to binocular vision is lost when viewing them—except in the relatively rare three-dimensional photo processes. Depiction of depth in a photograph therefore depends upon other depth indicators such as relative size of objects, convergence of parallel lines, and atmospheric depth.

Simulation of the Actual Vision of the Human Eye.

© Bognovitz.

Many photographers like to be able to predict, or **previsualize,** what the photograph is going to look like while viewing the original subject. The more successful the previsualization, the more control the photographer can exercise over the appearance of the final photograph. Successful previsualization depends upon a thorough understanding of all the differences between human visual perception and the photographic image and careful technical control of the photographic process itself.

Previsualization is only part of the process. If true communication is to take place, the photographer must also understand the informational and psychological impact of the photographic medium on the viewer. Control over previsualization can be accomplished in a reasonably short time by anyone with an observant eye and the ability to pay careful attention to technical details. Communicating with photographs requires an understanding of both the medium and the viewer, and a lifetime can be spent on the complexities of their interaction. The material in this chapter presents some properties of the photographic medium and a few guidelines to help in the effort to communicate better with photographs.

■ Nature of the Photographic Medium

Photography has certain characteristics, some shared with other art media, a few unique. An understanding of the nature of the medium is important to its use in communication with the viewer.

Feeling of Reality

Because photographs are formed from an optical image of light coming from the subject itself, they have an authenticity or feeling of reality not found in paintings or other hand-done reproductions. The old saying that photographs never lie is evidence of the general belief that photographs are a faithful reproduction of the original subject. More sophisticated viewers know that a number of techniques can be employed to give a false impression of reality through photographs—especially with the latest computer image manipulations—but photographs still carry a powerful sense of being "the real thing." This is why photography, both moving and still, has been so useful in propaganda.

Ansel Adams, *Monolith, The Face of Half Dome, Yosemite National Park, California 1927.* Adams preferred to previsualize the appearance of a print before making the photograph. He devised an exposure/development system known as the Zone System to facilitate the previsualization process.

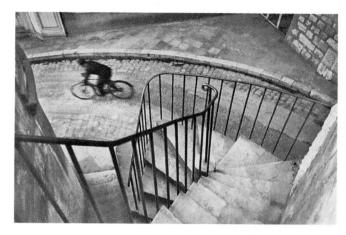

Henri Cartier-Bresson, taken in Seville, Spain. Henri Cartier-Bresson emphasized the importance of exposing at the instant that the details of the subject come together in a significant way: "If the shutter was released at the decisive moment, you have instinctively fixed a geometric pattern without which the photograph would have been both formless and lifeless."

© Henri Cartier-Bresson/Magnum Photos, Inc.

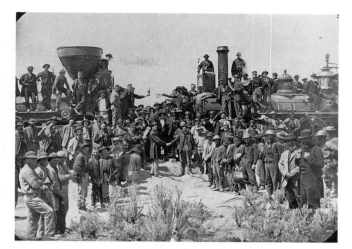

A. J. Russell, *Meeting of the Central Pacific and the Union Pacific, May 10, 1869.* This photograph of the ceremony celebrating the completion of America's first transcontinental railroad preserves the look of an era, as well as documenting an important event in America's history.

Courtesy of the Union Pacific Museum Collection.

Because of its relationship to reality, the first thing most people notice about a photograph is the **content,** or subject matter. Most photographs are taken with the prime intent of showing a representation of the original subject matter.

Time

A contributor to the impact of photographs is the general knowledge that they record a specific segment of time. Freezing movement allows appreciation of a moment that would have passed unnoticed in reality. The ability to record historical or period events and subjects for inspection many years later is one of photography's most seductive charms.

Two-Dimensionality

Photography is a two-dimensional art, like painting and other print media. Ways of depicting depth in a two-dimensional representation are discussed in detail later in this chapter.

Continuous Tonality

Photographs can reproduce an almost infinite scale of tones from darkest to lightest. Other media may have a palette of only a few different tones, some as few as two.

Reproducibility

A photographic negative can be reprinted almost indefinitely if it is protected from damage. This is one of photography's strengths in practical uses, but it has sometimes been a disadvantage in the art world where the

value of a work depends partly upon its scarcity. A few photographic processes, like the original daguerreotype process and most instant-print processes, produce one-of-a-kind photographs.

Framing

The edges of an image are called the **frame,** an important feature of two-dimensional art media. The process of selecting what is to appear in a photograph by camera position or lens choice is called *framing* the image, which produces certain visual effects. Being aware of these effects can help you to make more effective photographs.

Cutting Forms Since reality is not usually neatly arranged for picture taking, the photographer must make choices about what area of the subject is going to be included in the frame. One usually inevitable result is that some shapes and forms are not shown in their entirety but are cut by the frame.

Forced Visual Relationships It is difficult to ignore bothersome or extraneous visual information when it is immovably fixed in the photograph. You must learn to take note of everything appearing within the frame at the time you make a photograph, taking steps to eliminate any distracting visual information. Watch for foreground objects overlapping important subject matter, distracting objects or shapes in the background, and background objects that appear to merge with the main subject (see next page). These problems can usually be solved by either moving the camera to a different point of view or moving the subject.

Forced Visual Relationship. The sign that appears to be growing out of the model's head is an example of a forced visual relationship.

Format Shape. Werner Bischof, *Girls from a Village Near Patna, India, 1951.* The tall, narrow frame shape fits the tall, slender shape of the girls.

© Werner Bischof/Magnum Photos, Inc.

Filling the Frame. Eikoh Hosoe, *Embrace #46, 1970.* The strength in the embrace is accentuated by the tight framing and the textural lighting.

© Eikoh Hosoe.

Format Shape and Framing All of the modern formats are rectangular in shape but may have a different ratio of width to length—known as the **aspect ratio**—ranging from the square of the 6 × 6cm format to the extremely long rectangle of the panoramic camera format. Each aspect ratio has a different visual "feel." The square is more stable and self-contained. Longer rectangles seem to more readily extend beyond themselves visually. Sometimes the subject matter itself may demand a particular aspect ratio, either for reasons of subject inclusion (as with long, narrow subjects) or because of a match between the feel of the subject and the aspect ratio (stability, verticality, etc.).

The aspect ratio of commonly available printing papers may not match that of the negative, as with 35mm negatives and 8 × 10-inch paper. The choice to print full-frame or for a specific size paper should be considered when composing through the viewfinder. The problem of differing aspect ratios of negative and paper was discussed on page 91.

Filling the Frame Often photographs contain areas of background or subject matter that may not be actively distracting or ugly but add little of interest. For more dynamic images it is best to eliminate such areas. To "fill the frame" with a subject of central interest, move closer or change to a longer focal length lens. This can be carried to the point that only a small section—a **detail**—of the subject is seen. An alternative is to use the background as an environment for the subject or as a way of isolating the subject.

Vertical and Horizontal Framing Any camera with a rectangular format other than square will give a different framing of the subject if the camera is turned so that the long dimension of the rectangle is vertical (**vertical framing**) rather than horizontal (**horizontal framing**). See page 7 for examples of vertical and horizontal framing of the same subject.

Breaking Out of the Standard Rectangle Only convention and convenience limit you to the standard rectangular framing. The image can be cropped in printing to any desired ratio of sides and the printing paper trimmed accordingly. Of course you will lose part of the image seen on the negative. Many photographers have attempted to break away from the rectangular shape altogether, using circles, ovals, polygons, or irregular shapes for framing.

Frames within Frames Another way of breaking out of the feeling of the simple rectangle is to create the appearance of frames within the outer frame of the photograph.

The modern 35mm camera with its eye-level viewfinder gives great convenience and ease of operation but is so much an extension of the eye that it is easy to forget the frame. The common response is to see the part of the sub-ject that is of central importance and forget the rest. Cameras that use a directly viewed ground glass—like view cameras—often help the photographer to be more sensitive to all that is appearing in the frame, since the isolated rectangular ground glass looks much like the print. Users of eye-level viewfinders must consciously scan the entire frame to be sure that only the desired subject matter is appearing.

Breaking Away from the Standard Rectangular Frame. Emmet Gowin, *Hog Butchering, Near Danville, Virginia, 1975.* The use of a lens designed for a smaller format camera on an 8 × 10 view camera resulted in the circular image and the dark vignetting around the edges.

© Emmet Gowin, Courtesy of Pace/MacGill Gallery, New York.

Establishing Frames within the Frame of an Image. Lee Friedlander, *Buffalo, New York, 1968.*

© Lee Friedlander, Courtesy Fraenkel Gallery, San Francisco.

■ Composition and Visual Selection

The word *composition* is used in the arts to indicate the thoughtful arrangement of the **visual elements,** also called design elements, within a work. Artists painting or drawing can truly *compose* an image, since they have total freedom to place, arrange, and alter the appearance of the visual elements. Photographers are limited in this process by the actual physical appearance of the objects being photographed and more often depend on a process of **visual selection,** using camera position—that is, point of view—and lens focal length to alter the arrangement of visual elements within the frame. Because of these differences the word *composition* is perhaps not best suited to photography, but it is widely used.

Many authors and photographers refer to "rules" of composition, which are formulas for the arrangement of visual elements devised over the years, occasionally by artists but more often by critics and others who write about art. Slavishly following such rules may produce only safe, dull images. Great artists forge into new creative areas without regard to rules. On the other hand, some of these formulas are based on psychological and physiological principles of how people respond to visual stimuli. If you wish to communicate visually with others, some attention must be paid to these principles. A person's response to visual stimuli is partly culturally determined—what works for a person from the West may not be effective with someone from the Orient.

Following are some general design principles governing response to photographs, intended to familiarize you with some of the visual tools of the photographer and how they can be applied. It is up to the individual photographer to apply this information with some originality and sense of purpose. The important thing is not to get lost in overanalyzing an image to the point that you forget to make wonderful photographs.

Visual Elements

The basic visual element in a photograph is tonal value, which is the amount of light an area reflects, seen as lightness or darkness. If some colors of light are selectively absorbed, an area may also show *color.* Black-and-white photographs display only one color, usually close to neutral gray in most print materials, but can display any tone from the darkest black to the lightest white the paper is capable of reproducing. In color photographs a given color can be displayed in any tone from very dark to very light.

The boundary between darker and lighter tones defines **line.** Lines may be straight or curved. If a space is enclosed by lines or defined by the outer boundaries of a tonal value, it has **shape.** The three-dimensionality,

called **form** or volume, of a subject must be implied, since depth cannot be directly perceived in a two-dimensional photograph. The representation of shadows on the surface of an object, also called shading or modeling, shows the object's form. Form can also be implied by the distortion of lines on the surface of an object.

A visual element that is unique to photography, though it has been adopted by other media, is **image sharpness.** When the image of an object is out of focus or blurred by motion, its contribution to the design of the photograph is altered. Clear-cut lines or shapes that might have been formed by the object if it were sharp may become simply areas of tone or color.

Small shapes, lines, or tonal areas repeated over an area of a photograph are visually organized as **pattern.** A pattern of extremely small areas of shape, line, or tone is recognized as **texture.** In photographs, pattern and texture may come from a collection of many similar objects or may be due to pattern or texture that existed on the surface of an object.

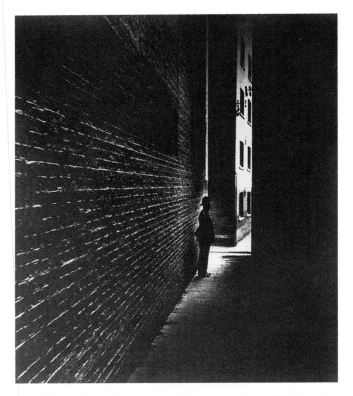

Use of Line. Bill Brandt, *Policeman in Bermondsey Alley, 1951.* Line plays an important role in this photograph. The converging lines of the brick wall draw the eye to the police officer. The vertical lines of the building edges accentuate his straight posture, and the horizontal lines of the paving add visual interest.

Tone	Line	Shape	Form

Design Elements. Tone (value), line defined by edge of tone, shape defined by closed line, form defined by shading and by distortion of lines on its surface.

Use of Form. Imogen Cunningham, *Pregnant Woman*, 1959. The form of the body is defined by the shadows on its surface, produced by backlighting.

Photograph by Imogen Cunningham, © The Imogen Cunningham Trust.

Use of Texture. Brian Brake, Untitled. Indian woman in monsoon rain. The raindrops form a visual texture on the woman's face.

© Brian Brake/Photo Researchers.

Associations

People associate emotions, ideas, or feelings with some types of visual elements. Dark tones imply seriousness, somberness, or drama, and light tones may provide a feeling of airiness, happiness, or warmth. Vertical lines may convey a sense of active strength, horizontal lines a feeling of stability or calm, and diagonal lines movement and instability. Curved lines may imply softness or gentleness and a sense of flow, straight lines briskness or hardness. Thin lines may have a feeling of delicacy or weakness, thick lines boldness and strength. A circle may mean completeness, a square passive stability, and a triangle active stability. Shapes can also call up associations with particular objects because of physical resemblance, as in imagined figures of animals seen in clouds.

These are only a few of the generalizations made. Making associations is a personal process, depending on one's cultural and individual background, and may be unpredictable. It can nevertheless be a useful tool for visual communication.

Symbolism and Metaphor

A symbol is an object, shape, or design that represents something else, often abstract ideas or concepts. The response to **symbolism** depends to a great extent on the cultural training of the viewer. Some symbols in art are nearly universal, especially those that deal with general human traits. Sexual symbols—for example, phallic symbols—are widely understood, but some religious symbols, like the cross, may only call up a specific response in cultures familiar with Christianity. The swastika was an infamous symbol of World War II, but a similar design was used by Native American and Eastern cultures in an entirely different context centuries before the Nazis adopted it.

Photographs that imply ideas unrelated to the original subject matter are called **metaphors** or **equivalents.** Alfred Stieglitz's photographs of clouds, taken in the early part of the twentieth century, were intended to call up feelings associated with music or direct emotions.

Association. The shapes and forms in this photograph call to mind objects other than those pictured.

© Bruce Warren.

Symbolism. W. Eugene Smith, from the *Life* essay "A Man of Mercy" (Albert Schweitzer), November 15, 1954. Several symbols reinforce the idea of a Christ-like Albert Schweitzer: the wooden cross-shaped beams seem to rest on his shoulder, the pencil looks like a nail, and the brim of the hat looks like a halo.

Estate of W. E. Smith/Black Star.

Metaphor. Alfred Stieglitz, *Equivalent*, 1930.

Alfred Stieglitz Collection, © 2000 Board of Trustees, National Gallery of Art, Washington, 1930, silver gelatin developed-out print.

Visual Attraction

When a viewer looks at a photograph the eye travels over the image, seeing only a small part at a time. Some visual elements attract and guide the eye more than others. The eye tends to follow the path of a *line*. Converging lines especially seem to draw the eye to the point of convergence. The eye is drawn to areas of *tone* different from the average. In most photographs the lightest areas draw attention, but in a high key image—one with mostly light tones—a dark area may initially attract the eye. If two elements are otherwise identical the eye will generally be drawn to the one larger in *size*. All other things being equal, visual elements at the *center* of the frame are given more importance. The eye can also be drawn by certain *subject matter*, such as a human presence in a photograph, particularly the eyes of those portrayed. This is especially true when the eyes of a subject are looking directly into the camera, and therefore directly into the viewer's eyes. Any subject matter that carries a strong emotional message, such as a shocking or extremely unusual event, will also attract the eye.

The movement of the eye throughout a photograph generates **implied lines.** An implied line may be defined by the mental connection of two or more elements that are visually attractive, similar in shape, or in close proximity to each other. The attempt to follow the direction of a subject's gaze in a photograph to see what the subject is looking at creates an implied line. A moving object implies a line of travel.

If implied lines enclose an area, they define an **implied shape.** Implied lines and shapes can carry the same associations as visible ones. For example, the arrangement of

Visual Attraction of Line. Robert Imhoff, Mercedes Benz. The converging lines of the wedge-shaped light area draw the eye directly to the emblem.

© Robert Imhoff.

Implied Line. Jim Brandenburg, *Arctic Wolf (Canis lupus) Leaping onto Ice Floe*, Ellesmere. Both real and implied lines can be seen in this image. The horizon forms an actual line, but the reflection and ice floes in the foreground form an implied diagonal. The movement of the wolf also implies a line that is an arc from one floe to the next.

© Jim Brandenburg/Minden Pictures.

interesting objects in a photograph may form a circle, with the accompanying associations of unity and a flowing from one to the next. An arrangement implying a triangle could give a stable feel to an image.

Visual and Psychological Contrasts

The word *contrast* simply means a difference. It has already been used in a technical sense to describe tonal differences in a subject or print or density differences in a negative. Many other types of contrast can be seen in a finished photograph.

The *tonal contrast* between adjacent areas of a print can affect the response to the image. The psychological perception of tonal differences sometimes differs from the actual physical tonal difference. A dark area looks much darker visually when it is surrounded by or adjacent to very light areas.

In color photography, **color contrast** is a difference in color. The difference may be subtle (as with slightly different related colors such as yellow in an arrangement of oranges and reds) or vibrant (as with complementary colors such as blue and yellow used together).

The *difference in sharpness* between parts of an image can draw attention to specific areas or provide a sense of movement, as discussed in the sections on depth of field and motion in chapter 3.

Visual variety can be added to a photograph by including *contrasting textures*. A smooth or glossy surface might be juxtaposed with a rough or grainy surface.

Opposite categories of *subject matter* in a photograph can draw attention to their differences or convey some kind of message to the viewer about the conflict between them. New might be juxtaposed with old, artificial with natural, rich with poor, and so on.

Shapes consisting of curved lines contrast with those made up of straight lines. *Forms* with irregularly curved shapes and surfaces (often called *organic forms*) contrast with forms made up of straight lines, flat surfaces, and regularly curved lines or surfaces (*geometric forms*).

A difference in *size* may be used to emphasize one subject over another. Sometimes objects of known and obvious size are included to demonstrate the actual size relationship—the **scale**—of another object in a photograph. Apparent size of objects may be altered by point of view and lens choice to create a false sense of scale.

Different parts of an image may call up differing *moods* or *emotions*. Different faces in a photograph may portray happiness and sadness, or a part of an image seen as beautiful may be contrasted with another part seen as ugly.

Lines, either implied or actual, in an image will contrast with each other if their *directions* are different. Horizontal lines contrast with both vertical and diagonal lines. Diagonal lines of one direction may contrast with diagonal lines of another.

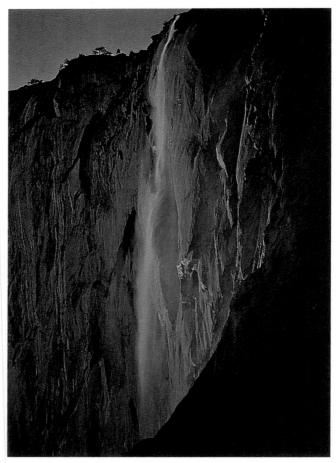

Visual Contrast. Galen Rowell, *Last Light on Horsetail Falls, Yosemite's "Natural Firefall."* The contrasts in color and tone cause the waterfall to stand out from its surroundings.

© Galen Rowell/Mountain Light.

Psychological Contrast. Arthur Fellig (Weegee), *The Critic*, 1943. The contrasts in clothing and attitude of the people make a pungent statement on society.

Weegee/ICP/Liaison Agency.

A regularly repeated pattern in a photograph can be changed in one or more places to create a visual contrast, called **repetition with variation.**

Contrasts can serve many purposes in visual communication. Attention can be drawn to a specific subject because it contrasts with other subject matter in the same photograph. Visual interest can also result from the use of contrasts. The psychological result of contrasts can be conflict, contradiction, or tension. Any of these add psychological interest to an image and can be used for conveying a message.

Subject Emphasis

Central placement, leading lines, and filling the frame can all be used to emphasize particular objects or areas in a photograph. Any of the methods for showing contrast—difference in tone, color, sharpness, texture, subject matter, shape, size, mood, and line direction—can also be used to make one object predominate.

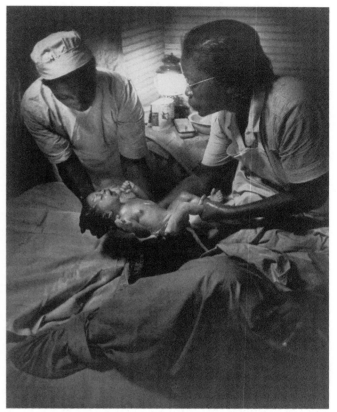

Emphasizing a Subject. W. Eugene Smith, from the essay "Nurse Midwife," *Life,* December 3, 1951. The central placement, the leading lines of the womens' arms and the wrinkles on the sheet, the implied lines of the womens' gaze, and the lighter tonal value all serve to concentrate attention on the newborn baby.

Estate of W. E. Smith/Black Star.

Repetition with Variation. Margaret Bourke-White, *Generator Stator, AEG, 1930.* The repeated pattern in the lower right is suddenly changed in the upper left corner. This contrast in pattern is known as repetition with variation and adds visual interest to the photograph.

© Margaret Bourke-White Estate/Courtesy Life Magazine. Contributors: Jonathon B. White & Roger B. White

Visual Structure

The mind is constantly trying to organize and make sense from visual information. Analysis of the spatial relationship of visual elements, recognition of identifiable shapes, and path of eye travel when viewing a photograph all lead to a sense of **visual structure.**

Knowing what attracts the eye can help in organizing the visual elements of a print to provide a rewarding visual experience. If you wish a viewer's eye to travel a comfortable path within the image—to not be led out of or to the edge of the photograph—take care not to have dis-

tracting visual elements (light tones, distinctive shapes or subjects) close to the edge of the photograph. Lines, actual or implied, leading out of the photograph can also break the viewer's interest but in some cases may provide a natural exit from the image.

An object of interest or a strong visual shape against a relatively neutral surrounding creates a simple visual structure called a **figure-ground relationship.** The object or shape is the figure and the "leftover" area of the photograph is the ground. If the ground is relatively featureless, with fairly uniform tonal values, it is often called **negative space.** The frame and the edges of the figure may cut the negative space into strong shapes as well.

Clarity, Simplicity, Complexity Careful arrangement of visual elements and the implied lines and shapes that result can produce an image that is easily "read" by the viewer. Clarity means that the viewer's eye can easily enter and travel about the image and that the message of the image is easily perceived. Sometimes clarity can be achieved by simplicity, which means that the number of visual elements is reduced to a minimum. Visual complexity is just the opposite, with a large number of visual elements competing for attention.

Complexity does not necessarily mean the loss of clarity, but greater care must be taken with visual design when an image becomes complex. A complex image that fails to organize the visual elements is often described by the viewer as "too busy," resulting in unclear visual relationships, unidentifiable shapes, or an uncomfortable path of eye travel through the image.

Negative Space. Aaron Siskind, *Martha's Vineyard 111a, 1954.* The light areas of the sky and its reflection form negative space in this photograph, which is cut into distinctive shapes by the figure of the rocks and the frame of the image.

© Aaron Siskind Foundation.

Visually Complex Image. Sebastiao Salgado, Gold miners in the Serra Pelada, Brazil. The figure of the man leaning on the pole in the foreground and the line of men walking down the path lend visual structure and awesome scale to this visually complex image.

© Sebastio Salgado/Contact Press Images.

Visually Simple Image. Edward Weston, *Nude, 1927.* Although the dark outline around the body is a complex line, it has the effect of simplifying this image, which is free of visual clutter.

© Center for Creative Photography, Arizona Board of Regents.

 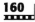

Balance Balance refers to the feeling that the visual importance, or weight, of the various elements within an image is equally distributed throughout the frame. The things that give a visual element weight are its tone, shape, size, psychological importance, and placement in the frame. An image may be balanced left to right (horizontally), or top to bottom (vertically), or both.

The simplest way to achieve a visually balanced image is through **symmetry,** which means that the exact same visual elements appear in both halves of a photograph in mirror image. Symmetry can be achieved horizontally, vertically, or diagonally. Although it may sometimes give a static or lifeless feel, symmetry is a potent psychological visual symbol, as witnessed by its use in many religious symbols.

Asymmetrical balance is a little harder to achieve. It depends upon balancing the weights of the various elements, taking into account all the variables that affect their visual importance. A large shape on the right of an image may be balanced by a much smaller shape on the left if the smaller shape is very light in tone. A large rock or natural form in one area of the picture may be balanced by a tiny human figure because of the psychological importance of the person.

Symmetry. Walter Chappell, *Nancy Bathing, Wingdale, NY, 1962.* This image shows nearly perfect symmetry about a vertical axis, but the contrast between the harsh lighting and geometric forms in the top half of the image and the soft-edged shapes due to reflection and flare in the bottom half adds mystery and interest.

© Walter Chappell.

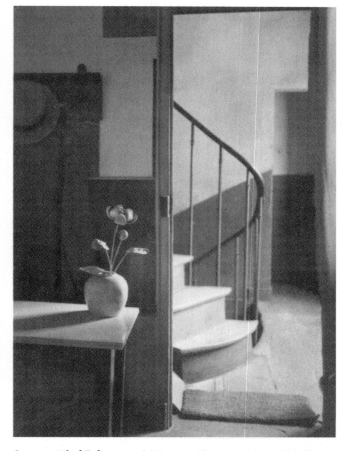

Assymmetrical Balance. André Kertész, *Chez Mondrian, 1926.* This image is far from symmetrical, yet it is carefully balanced. The interlocking rectangles of light and dark recall the paintings of Mondrian, who owned this house.

© The Estate of André Kertész.

Unity Unity in a photograph means a coherence of all the visual elements, the feeling that they belong together. This is a considerably more subjective response than others discussed here, but a few simple devices can lend unity to an image. Related subject matter throughout a photograph can give unity. The intrusion of a telephone pole into a beautiful natural landscape can destroy the unity of that image for many viewers (this shattering of unity might be used as a statement of the human race's effect on the environment). Use of related colors—all blues and greens, for example—or a common tonal value throughout an image can also lend unity. Low key prints (made up predominantly of dark tones with a few light areas) and high key prints (made up predominantly of light tones with a few dark areas) create unity and emphasize certain features of the subject.

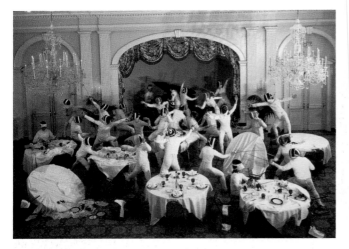

Unity. Neal Slavin, *Fencers*. Although this is a complex image, the repeated shapes of the tables and the similarly garbed fencers lend unity, which is reinforced by the implied oval shape they form.

© Neal Slavin/Superstock.

Point of View Changing the physical point of view—determined by the position of the camera at the time of making the photograph—can vastly alter the relationship of the compositional elements in a photograph as well as add a feeling of visual freshness. The usual point of view for most people is eye level, either standing or sitting. The natural inclination for a photographer is to shoot from these same comfortable positions. To break away from this custom, try getting close to the floor or choosing a high camera position.

Subject Placement Usually a number of different objects, called subject matter, are included in a photograph. Recall that placement in the frame emphasizes and organizes the elements in a photograph. A number of conventions have developed regarding subject placement.

These should be taken only as guides, not rules, but they may help in making effective photographs.

A **center of interest** is a single object or event that is of primary interest to the viewer. Occasionally a photograph has only one center of interest, but usually it has several and the strength of the photograph comes from the ways in which the photographer relates and organizes these various centers of interest.

Effective Use of Point of View. Sylvia Plachy, *Sumo Wrestlers*, New York, 1985.

© Sylvia Plachy.

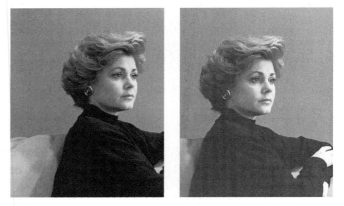

Direction of Implied Lines. Another guideline for placement is determined by the direction of implied lines due to motion or direction of gaze of the subject. The convention is that motion should lead into rather than out of the frame. On the left, the placement of the subject close to the edge causes her gaze to lead out of the photograph. On the right, the photograph has been reframed to allow space for the subject's gaze.

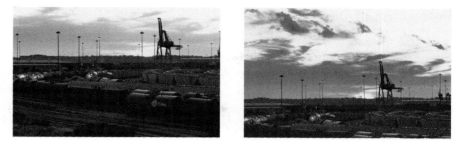

Horizon Placement. An extension of the rule of thirds applies to the placement of horizon lines in landscapes or implied horizon lines in interiors or table top still life photographs. Placing the horizon line at one of the two horizontal dividing lines may give more visual interest than centering it. Placement at the top divider emphasizes the land and at the bottom divider emphasizes the sky. Extreme placement turns sky or land into an accent.

© Bognovitz.

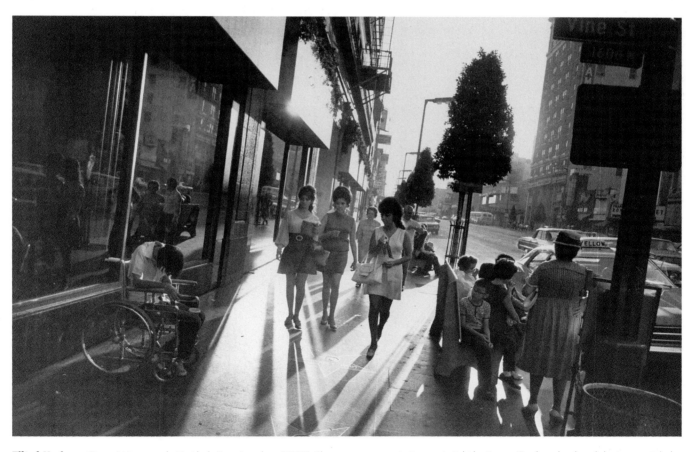

Tilted Horizon. Garry Winogrand, *Untitled,* (*Los Angeles, 1969*). The level of the horizon line can also affect the viewer's response. In a representative landscape most people are uncomfortable with tilted horizons, especially in scenes containing bodies of water. A landscape photographer may use a viewing screen with ruled lines or a small level on the camera to insure straight horizons. On the other hand, horizons might be radically tilted for an effect, such as to show disorientation or indicate movement.

© 1984 The Estate of Garry Winogrand/Photo Courtesy of the Center for Creative Photography. Courtesy Fraenkel Gallery, San Francisco.

Perception of Depth

Two-dimensional photographs cannot directly show three dimensions in a subject. A number of visual clues can be used to imply depth in a photograph:

Perspective. One indicator of depth is the diminishing apparent size of objects that are farther from the eye, called **linear perspective.** In a photograph, the relative size of an object is supplied optically, determined only by the distance from the subject matter, not by the focal length of the lens (see pages 50–53). Parallel lines are affected by perspective. The distance between parallel lines actually remains constant, but as the lines travel away from the viewer the distance appears to become shorter, causing an apparent convergence of the lines.

Atmospheric depth. The presence of haze, dust particles, and pollutants in the air causes distant objects to be less distinct than near objects and can portray depth in a photograph.

Tonal and color depth. In general, light tones tend to advance in a photograph and dark areas to recede. In color photographs some colors such as yellow or orange appear to advance and others such as blue or purple to recede.

Vertical location. For subject matter below eye level, objects that are placed higher in a frame usually appear to be farther away barring other depth clues. For subject matter above eye level, objects lower in the frame appear farther away, as with the ceiling of a room.

Overlapping. If one object overlaps another in a photograph, it must have been in front of the other and therefore closer to the camera.

Lighting. Depth in a subject can be shown by lighting it so that shadows indicate its form. This is especially useful if the subject is basically all of one tone or color.

If attention is not paid to the presence or absence of the proper depth clues, the viewer may gain a false impression of the actual distances within a subject. This can be disturbing if the intent is to give as true a representation of the subject as possible, but it can also be intentionally used in a photograph to alter the feeling of depth for aesthetic reasons.

Linear Perspective. A. Aubrey Bodine, *Parking Meters Baltimore,* ca.1960. The dwindling size of the parking meters lends depth to this photograph and is an example of linear perspective.

Courtesy Kathleen Ewing Gallery, Washington, D.C.

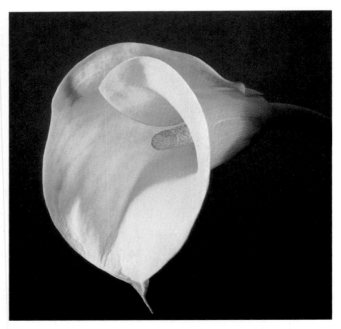

Depth through Lighting. Robert Mapplethorpe. *Calla Lily,* 1987. Careful lighting has given a great sense of depth and form to this flower. The light tone and bright color also make the flower come forward from the background.

© The Estate of Robert Mapplethorpe. Used with permission.

Photographs in Groups

Photographs are often presented in groups, either as a showing in a gallery or in a book or article. The effect of each individual photograph may be altered by the context in which it is viewed. Viewers will mentally relate two or more photographs in proximity, even if no relationship was intended by the photographer or photographers.

The order in which a group of photographs appears governs some responses. Sequencing can imply a narrative, as viewers try to form some sense of continuity from one image to the next. The force of the images can be enhanced by this narrative element. Some sequences might record an event in actual chronological order. Other sequences might simply show an interesting variation or progressive change in graphic design from image to image. Still other sequences might force a relationship between seemingly unrelated subjects or image ideas.

The arrangement of a group of photographs can be thought of as a design problem. The elements of design in each print must then be compared with those of adjacent prints and the group overall. If lines extending from one photograph lead naturally into the design of the next, the viewer can progress comfortably through the sequence. Consideration of comparative design in adjacent prints can strengthen or weaken the response. A complex, subtle image may suffer next to a bold, graphic image simply because attention is drawn from it. Response to subject matter in each print can be affected by the subject matter in surrounding prints. If photographs in the group are intended as metaphor or equivalent, the effect of each individual print can be enhanced by the cumulative effect of the group.

The photographic essay, a special application of photographs in groups, presents a subject or idea more completely than would be possible with a single image. It has often been used to explore a subject for photojournalistic uses.

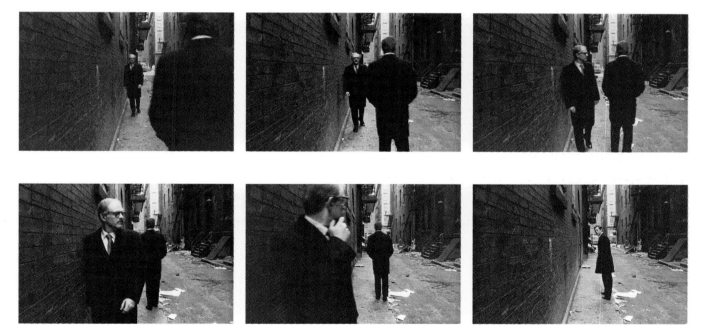

Sequence of Photographs as Narrative. Duane Michals, *Chance Meeting*, 1969.

© Duane Michals.

Style

Style means the way or manner in which a work of art is made. It can be determined by choices in subject matter, materials, techniques, and visual design. Similarities in style are often used to group artists into historical eras or schools of art. Within a given historical era or school, individual artists also show personal style, which is their own particular way of handling the medium.

Since photography is so often associated with its ability to represent reality, choice of subject matter is an important aspect of photographic style. However, two photographers may photograph the same subject matter in very different styles. Design choices—which determine the particular manner of organizing the visual elements in a frame—can completely alter the style. Differing points of view, arrangements of subject matter into specific shapes, recurring use of distinct symbols, choice of photographic material or technique, predominant use of particular tones or colors, choice of quality and feeling for light, arrangement of subject matter within the frame, perspective, and all of the other elements of design can be used in characteristic ways to produce an identifiable sense of style.

Photographic styles can be thought of as falling somewhere on a continuum from representational to nonrepre-sentational. Representational styles depend on the ability of photography to provide a realistic rendering of a subject. Color photographs of high technical quality are the most realistic; black-and-white photographs are a step away from realistic representation. A variety of materials and techniques are available that can subtly or vastly alter the ability of a photograph to represent reality and are often an integral part of a photographer's style. In addition, design choices can often change the realistic nature of a photograph through unusual perspectives, point of view, perception of depth, or lighting.

Style is hopefully a natural outgrowth of an individual photographer's personality and vision of the world, seen through photography. Too often, in an attempt to distinguish their work from that of others, artists seek their personal style in the discovery of a new technique or "gimmick." If your ideas require special techniques or materials to support the image or aid in visual communication, then use them. If, on the other hand, these techniques are being used to "dress up" a photograph that is otherwise of little interest, it might be better to think about the substance and value of the image itself. Chapter 9 traces the development of some historical schools of style in photography.

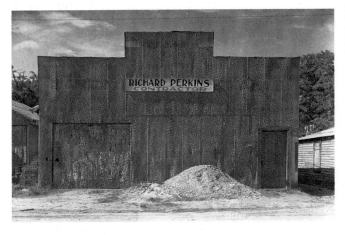

Walker Evans.

Courtesy of the Library of Congress.

Lewis Baltz, *West Wall, Unoccupied Industrial Structure, 20 Airway Drive, Costa Mesa, 1974*, from *The New Industrial Parks Near Irvine, California*.

Courtesy of Gallery Luisotto, Santa Monica, CA.

Style. The different styles of Walker Evans and Lewis Baltz are apparent in their photographic approaches to similar subject matter.

Thanks are due to Jonathan Bayer for pointing out this stylistic comparison in his book. *Reading Photographs: Understanding the Aesthetics of Photography.*

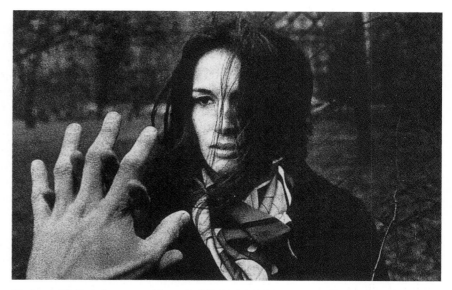

Abstraction as an Element of Style. Aaron Siskind, *Jerome, Arizona, (21), 1949.* The representation of the original subject matter is less important here than the associations and ideas that are generated by the graphic qualities of the image.

© Aaron Siskind Foundation.

Photographic Technique as an Element of Style. Ralph Gibson, Mary Ellen Mark touching man's hand, from *The Somnambulist.* The coarse grain and high contrast couple with the imagery to give a real sense of the sleepwalker's dream.

© Ralph Gibson.

Purpose of a Photograph

Design choices and approach grow out of the purpose of a photograph. If you take some time to think about your reasons for taking a photograph, your own choices will be more likely to support the use you intend. For a more detailed discussion of functional uses of photography, see chapter 9, beginning on page 181.

Because of their ability to show what was in front of the camera at the time, the most common purpose of photographs is informational. Photographs that are taken to give us information about the appearance of a subject or the occurrence of an event are called *documentary* or record photographs. **Snapshots** are documentary photographs of a personal and casual nature.

Some photographs present a pleasing or aesthetically interesting design or pattern in which the actual subject matter that was in front of the camera is important only in respect to its visual properties. Such photographs are often referred to as *graphic images* or *pattern pictures.*

continued

Documentary Photograph. Margaret Bourke-White, *Clinton, Louisiana.* Although this is a document of a time and situation, the photograph nevertheless has elegant graphic qualities. The relative scale of the people and columns and the deteriorated state of the mansion symbolize the plight of the poor in the rural South.

Margaret Bourke-White/Life Magazine, © Time, Inc.

Photographs can also be used in a symbolic way. The real objects that were being photographed may call up ideas or emotions, possibly even an idea seemingly unrelated to the original subject matter. A photograph of a mother and child is a document of particular individuals, but the intent of the photographer may be to present a more universal symbol of motherhood.

In conceptual photography, the photograph as an art object is secondary to the idea or concept it conveys. See chapter 9, page 194, for more on conceptual photography. Sometimes photographs serve as records of conceptual art in other media.

Many photographs serve several purposes. A documentary photograph may provide a record of a subject but do so in a way that is pleasing or interesting from a graphic design standpoint. At the same time, the photograph may be symbolic in character or may be intended as a tool to effect social change or sell a product.

Craft and Idea

The craft of photography is embodied in the control of the technical steps needed to create a photograph. To successfully convey the idea behind a photograph, to fulfill its function, or to establish style, different levels of craft may be necessary.

Although a high level of craft may be seen as unnecessary for some conceptual pieces, a careful control over the nuances of the visual elements may be required for communication in other photographs. It would be difficult to convey the complexity and subtle tones of subjects, as Brett Weston has done in his exquisite prints, if little attention were paid to tonal scale, detail, fine grain, sharpness, and a generally high level of craft. On the other hand, the cumbersome equipment and painstaking techniques needed to produce such quality would not allow the freedom for the wonderfully witty photographs taken on the street by Elliot Erwitt.

Advertising Photograph. Peter Arnell (Donna Karan advertisement). In advertising photography, the ultimate purpose is to encourage someone to choose one thing over another. One purpose of the advertisement may be to show the product clearly to the public. At the same time the graphic design of the photograph is used to attract attention to the product, and symbols are used to associate the product with ideas or activities that will hopefully make the viewer prefer that product over others.

Courtesy of Peter Arnell.

Elliot Erwitt, *Cannes*, 1975.

© Elliot Erwitt/Magnum Photos.

In music, students are expected to master the craft of producing sound from their instrument as well as mastering the emotional and conceptual nature of the music. Too often students of photography lose that balance between concept and craft. Some concentrate almost totally on conceptual aspects and are left without the craft necessary to successfully convey ideas depending upon nuance in the photographic print. Others develop a fascination with technical aspects to the exclusion of conceptual awareness. What you should strive for is a successful wedding of craft and concept. Do not limit your ideas because you are too impatient to master the necessary craft—to practice your scales, so to speak.

Brett Weston, *Mono Lake, California*, 1957.

◼ Better Photographic Seeing

As you can see from the preceding discussion, the task of visually communicating with photographs is complex. Gaining technical control over the medium is only the beginning. More difficult is learning to control the many visual elements of an image to communicate exactly what you want to the viewer. Three ways to learn more about this process are to practice photography, to look at other photographers' work, and to show your work to others for their response.

Practicing Photographic Seeing

The more photographs you make, the more you will learn about how the medium works visually. When you see something you think will make a good photograph, immediately record your first impression. After you have captured this spontaneous response to the subject on film, you can then consider the subject in more detail. Try to previsualize what your first impression will look like in the finished photograph. Consider through the viewfinder the visual design of the photograph you have just made. Think about your reasons for taking the photograph in the first place, then try more photographs to see if you can better capture what you have in mind. Employ different points of view, different perspectives, different lighting, different moments in time, and so on. What you are doing as you make these photographs is visually exploring the subject.

The argument of quality versus quantity is often raised against photographers who shoot a considerable amount of film exploring a single subject. One photographer may shoot a dozen or even a hundred photographs to get the single image that says what he or she wants to say; another, who has carefully previsualized each possibility and

gone through a process of mental elimination, may shoot one. What counts is the finished photograph. The value of an effective photographic image is not lessened because more than one photograph was made to come to that particular vision.

Film is relatively inexpensive, especially when compared with the time many people invest in photography, so do not be shy about using it. This is a recommendation not to mindlessly make repetitive shots of a subject but to thoughtfully investigate the subject in a variety of visual approaches. As you become more experienced, you will discover for yourself how many exposures it takes you to get a satisfying image, but in the beginning, quantity can promote learning.

Certain images have been used repeatedly in photographs, to the point that they could be called visual clichés. The nature of the photographic cliché is sometimes due to the subject matter but is more often a combination of popular subject matter and a common visual style of showing the subject. Cats, cemeteries, children, and weatherworn buildings are only a few examples of a long list of repeatedly photographed subject matter. If you begin to think that you should not photograph a particular subject just because it has been photographed before, you will make very few photographs. To keep familiar subjects from looking like clichés, approach them in a personal way that tells something new or interesting about them.

The initial attraction to a photographic subject often comes from familiarity, sometimes subconscious, with other photographs of the same thing. If you are aware of this motivation you may decide not to take a particular photograph because something similar has been done. However, too much thought about the sources of your in-

Seeing Exercise in Contact Proof Form. A variety of images have been produced by simply changing the distance from the subject or the point of view. If you have different focal length lenses, they can also be used to produce new visual approaches to the subject.

© Merle Tabor Stern.

spiration could inhibit picture making. Recording your first impression and then exploring the subject visually with the camera will keep you making photographs and eventually allow your own personal style to surface.

Many situations do not allow a leisurely photographic investigation. Events may be occurring very rapidly and camera position may not be flexible. Photojournalists are often faced with such conditions. Speed in seeing is then crucial, and a great deal of practice under more controlled conditions will provide you with visual skills that can be employed rapidly and almost instinctively when needed.

As an exercise to encourage visual exploration, shoot a whole roll of film on a single subject. Try to make every frame a different visual approach to the subject.

Learning by Example

Looking at the work of other photographers can help you understand the ways in which photographs communicate visually. Books, magazines, museums, and galleries publish or show photographs. Photographs for applied purposes, such as advertising and news, are widely published. A useful learning tool is an **idea book,** also called a clip file or source book, which you can assemble by clipping published images out of magazines and newspapers. Many photographers give talks during which they show and discuss their images.

To get the most out of looking at photographs, it might help to follow some guidelines. First see if you can define the *function* or use of a photograph. Is it intended for creative expression, simply giving enjoyment, disseminating information, advertising a product, recording a newsworthy event, or some other purpose? Next try to determine what the *intention* of the photographer was in taking the photograph and the idea or concept that lies behind the image. For example, an advertising photograph may have the function of selling perfume and may do so by promoting the concept of romantic associations with the product. It helps in considering a photograph to put it in a *context* of other photographs of its type. Helpful comparisons can be made to other work by the same photographer and contemporary and historical photographs of similar function or concept.

Look also at the relationship between the image and the technique used. How do the *technical choices*—black and white or color, grain, sharpness, lighting, and so on— help to present the intention of the photographer? Look at the *graphic design* of the image. How has the photographer used the visual design elements? And last think about the *psychological impact* of the image. Does it call up in you certain emotions, moods, or ideas, and what specifically causes your reaction? Inspection of other photogra-

phers' work can help you understand the visual tools at your disposal for communicating with photography.

A useful exercise may be to try to reproduce specific photographs or emulate the style of well-known photographers in your own photographs. This forces you to look carefully at the style of the photographer being copied and helps you to acquire the technical skills necessary to produce a similar quality of work. If you decide to sell or otherwise use for profit any photographs that closely resemble or are specific copies of the work of other photographers, keep in mind the copyright laws. Numerous lawsuits have been brought and won against artists who have copied, appropriated, or adapted the work of other artists. Securing permission from the original creator of the work will avoid possible legal problems.

Presenting Your Work to Others

To see how successfully you are communicating with your photographs, you must show them to other people. You are looking for a critique, which is an expression of the viewer's response to the photograph, and perhaps some suggestions for improvement. Many people are not very verbal about photographs, so you may have to encourage some responses. Do not influence viewers by explaining what you were trying to accomplish. Most people, being agreeable, will simply say what they think you want to hear or will seize on your comments just for something to say. If you have to explain the image, you are not communicating visually.

You may get some response by asking questions, following the guidelines given earlier for looking at others' photographs. "What kind of feelings or emotions do you get from this photograph?" is a nonleading question, but "Don't you get a scary feeling of foreboding from this image?" will probably influence the viewer's response. If you are to learn from this kind of encounter, you must take remarks or criticisms in a positive way, rather than becoming defensive about your work.

Remember that each viewer brings a different background to a photograph. Consider a viewer's training and knowledge of photography and the other arts when evaluating her or his comments. You will quickly discover that responses are individual and subjective but that some general responses begin to emerge. It is not necessary that everyone respond in exactly the same way to each photograph. A work of art can sometimes be more effective as a direct result of its various layers of meaning and possible interpretations. Nevertheless, if nearly everyone you show a photograph to responds with confusion about what he or she is seeing or has no response at all, you might rethink what you are doing with that particular image.

CHAPTER 9

History of Photography

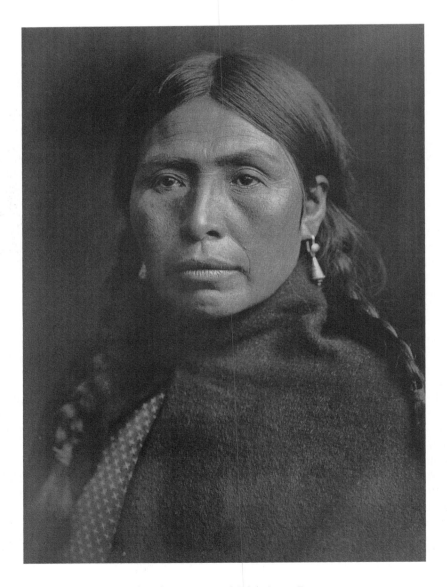

Edward Curtis, *Coastal Salish, Lummi Type.*

Courtesy of the James Jerome Hill Reference Library, Saint Paul.

Photography is so much a part of our environment that it is difficult to understand its impact on the world. Photography (including its derivatives, movies and television) has had perhaps the greatest cultural effect of any technical invention. Before the invention of photography, the only visual record of distant places and events was the stylized hand rendering of artists. Suddenly photography offered a realistic representation of objects and events with an objectivity and detail never before possible. Couple this ability to record reality with the communication possibilities of an art medium, and you have a potent tool for altering cultural attitudes and views of the world.

A look at the historical development of photography helps to clarify the role it plays in our daily life and offers inspiration and a context for our own photographic endeavors. It is particularly helpful to look at the technical history of photography, photography's functional role since its invention, some aesthetic approaches in photography and important photographers, and styles and trends in applied photography.

■ Technical History of Photography

The camera obscura (*camera* = room, *obscura* = darkened) was the first of the discoveries that made photography possible. In its earliest form, a camera obscura was simply a darkened room with a small hole in one wall and a white screen on the opposite wall. An upside-down image of objects outside the room was formed on the screen by light coming through the hole. This effect was noted by Arabic scholars as early as the tenth century A.D., and some evidence indicates that Aristotle was familiar with the camera obscura as early as the fourth century B.C.

Lenses were added to the camera obscura in the middle of the sixteenth century, producing a brighter, sharper image but requiring a focusing mechanism. The camera obscura became more compact, with the image projected onto thin paper supported on glass, where it could be traced, and was widely used as a sketching aid by artists.

Many users of the camera obscura dreamed of capturing an image without laborious hand tracing, simply by the action of the light itself. The discovery by Johann Heinrich Schulze in 1725 that certain silver salts darkened when exposed to light eventually made this dream a reality. Over the next seventy-five years a number of scientists investigated the light-sensitive property of silver salts, but none of them attempted to make practical use of the discovery in producing permanent images formed by light.

Thomas Wedgwood, son of the famous potter Josiah, was the first to make such an attempt. He and his friend Sir Humphry Davy produced some temporary images on white leather treated with silver nitrate around 1800. Wedgwood's desire was to capture the camera obscura images, but he was unable to do so because of the low sensitivity of silver nitrate. He was, however, successful in producing the outlines of such things as leaves or paintings-on-glass laid on the treated white leather and exposed to the rays of the sun. Unfortunately he discovered no way of making the images permanent and they subsequently darkened when exposed to light for viewing.

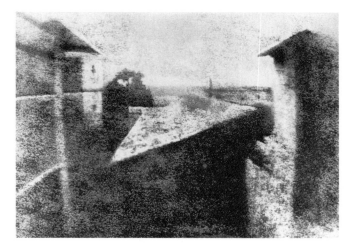

Joseph Nicéphore Niépce, The World's First Photograph, 1826. View from His Window at Gras.

Courtesy of the Gernsheim Collection, Harry Ransom Humanities Research Center, The University of Texas at Austin.

The First Photographs

The first person to permanently record the images of the camera was a Frenchman, Joseph Nicéphore Niépce. He and his brother Claude had been experimenting with various materials for capturing the effect of light, and as early as 1816 he succeeded in producing a paper negative of a camera image. Niépce even realized that by then sandwiching this negative with another piece of sensitized paper he should get a positive image, but he was unsuccessful in his attempts. He had also not discovered a method for making these images permanent.

Niépce turned to a different process, using pewter plates coated with bitumen of Judea, an asphaltic varnish that hardens with exposure to light. Initially he exposed these plates to sunlight through an oiled etching on paper,

washing the plates with a solvent such as lavender oil after exposure to remove the unhardened parts of the image. The result was a positive representation of the etching on a metal plate, which he called a heliograph, from the Greek words for "sun writing." This plate could be etched by acid and then inked and printed.

Niépce then proceeded to place his light-sensitive plates in a camera and expose them, producing the first permanent photographs in 1826 or 1827. The exposure in the camera was about 8 hours. The direct positive camera images he produced from nature were too faint to be etched and printed, so Niépce's photographs were one-of-a-kind. The process did not use a light-sensitive silver salt and could reproduce the tones of light and dark in a subject, but not the colors. Niépce continued over the next few years in attempts to improve his process.

The Daguerreotype

Meanwhile, some distance away in Paris, another Frenchman, Louis Jacques Mandé Daguerre—a painter and owner of the Diorama, a popular entertainment employing huge, semitransparent illusionistic paintings and special lighting—was using the camera obscura for a sketching aid and was also experimenting with the use of light-sensitive silver salts to capture the camera image. Through their mutual lens maker, Daguerre learned of Niépce's experiments in 1826 and contacted him with the purpose of sharing their efforts. In spite of Daguerre's reported charm, Niépce was initially wary of his intent, but a partnership was eventually formed in

1829 and the two shared their research information until Niépce's death in 1833.

Daguerre did not perfect a practical photographic process until 1837, and it shared little with the heliograph technique, other than that both were done on metal plates. Daguerre's process used a copper sheet plated with silver, which was polished and fumed with iodine vapor, producing light-sensitive silver iodide on the surface of the plate. The plate was then inserted in a camera and exposed to an image. After exposure the plate was treated with the fumes from heated mercury—which produced a stronger, more visible image—and then fixed, rather ineffectively, with salt water. The resulting image was delicate, silvery, monochromatic, and one-of-a-kind. Daguerre eventually named images made by this process daguerreotypes.

The opportunistic and somewhat arrogant side of Daguerre's personality began to manifest itself in his relations with Niépce's son, Isidore, as he looked for ways to profit from this invention, in the process trying to accumulate to himself as much of the benefit as possible. After exploring several potential ways of exploiting the discovery, he found a champion in the distinguished scientist François Arago. Daguerre's invention was announced publicly to the Académie des Sciences on January 7, 1839, and through Arago's urging, the French government was persuaded to provide pensions to Louis Jacques Mandé Daguerre and Isidore Niépce in exchange for the rights to the invention. The details of the process were announced to the public in August of 1839, opening up its use to any interested person in France.

People were definitely interested. The response to the first photographs ranged from comments like "he was in ecstasies over the stove-pipes; he did not cease to count the tiles on the roofs and the bricks of the chimneys; he

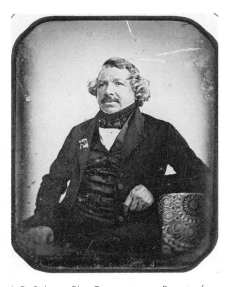

J. B. Sabatier-Blot, Daguerreotype Portrait of Louis Jacques Mandé Daguerre, 1844.

Courtesy of the International Museum of Photography at George Eastman House.

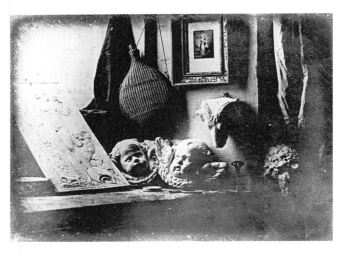

Louis Jacques Mandé Daguerre, *Still Life*, 1837. Daguerreotype.

Courtesy of the Collection de la Société Française de Photographie.

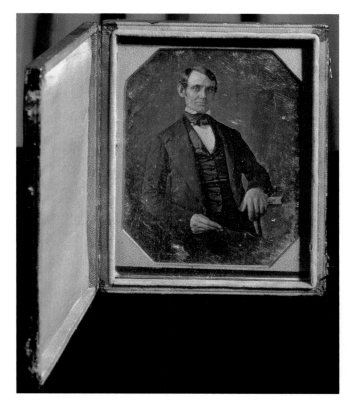

N. H. Shepherd, *Abraham Lincoln*, 1846. Daguerreotype in Case.

Courtesy of the Library of Congress.

The negative image was converted to a positive image by placing it in contact with a second sheet of sensitized paper and exposing it to light in a process we now call contact printing. Talbot was thus the inventor of the negative-positive system of photography commonly used today. The great advantage of this process is its reproducibility, since nearly unlimited positives can be made from the original negative.

Talbot continued to make improvements on his process. In 1840 he introduced the calotype—later, after further improvements, called the Talbotype—which was made on paper sensitized with silver iodide. After an exposure that produced only a latent image, Talbot discovered that the negative image could be made visible by chemical development in a second bath of gallo-nitrate of silver and then fixed in a solution of potassium bromide.

Portrait of William Henry Fox Talbot.

Courtesy of the Science Museum, London.

was astonished to see the cement between each brick; in a word, the poorest picture caused him unutterable joy, inasmuch as the process was then new and appeared deservedly marvelous" to the remark by French painter Paul Delaroche that "from this time on, painting is dead!"

The Calotype

News of Daguerre's initial announcement early in January 1839 quickly traveled across the English Channel and reached the ears of William Henry Fox Talbot in England. A cultured man knowledgeable in both literature and the sciences, Talbot had experimented with photographic processes since 1834. He quickly gathered his materials and presented his invention, which he called "photogenic drawing," to both the Royal Institution and the Royal Society at the end of January 1839.

Talbot's process made use of paper sensitized with silver chloride. Early images were made by laying objects on the sensitized paper and exposing them to light, as in what is now called a **photogram.** Later Talbot exposed the sensitized paper to an image in a camera, producing a negative image that was fixed by being bathed in salt water.

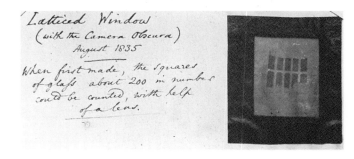

William Henry Fox Talbot, *Latticed Window in Lacock Abbey*, 1835. Earliest Known Existing Photographic Negative.

Courtesy of the Science Museum, London.

Development of the latent image resulted in much shorter exposure times. The negative was then contact printed on a sheet of sensitized paper to form a positive. Talbot patented the calotype and zealously prosecuted those he thought were infringing on his patents.

In spite of the improvements and the obvious advantages of a reproducible photograph on a paper base that was easily transported and incorporated into books, the calotype was never as popular as the daguerreotype. At

William Henry Fox Talbot, *The Open Door*, April 1844. Talbotype print published in *The Pencil of Nature*, 1844. Since no method was yet available for directly reproducing photographs in ink, original photographs were glued into each copy of *The Pencil of Nature*.

Courtesy of the Science Museum, London.

David Octavius Hill and Robert Adamson, *The McCandlish Children*, 1845. The characteristics of the calotype were well utilized by Hill, a painter, in collaboration with Adamson, a chemist. The inability of the calotype to render fine detail was seen as an advantage by Hill and Adamson, who rendered their subjects in broad masses of tone.

Collection, The Museum of Modern Art, New York.

the time, the public valued the daguerreotype for its superior detail and for its preciousness. Being a unique image on a silver plate seemed to imbue it with special value. Nevertheless a number of photographers used the calotype process and produced many images of lasting value, including the first book of photographs, *The Pencil of Nature*, published by Talbot in 1844.

Credit for the Invention of Photography

Credit for the invention of photography must be attributed to more than one individual. Niépce takes primacy as the inventor of the first working photographic process, though it was never very practical or satisfying. Talbot followed with a practical positive-negative system. But most of the glory went to Daguerre, partly because he was the first to make a public announcement of his process but mostly because of the public's preference for the daguerreotype.

Other inventors devised workable photographic processes. The Frenchman Hippolyte Bayard announced a direct positive process in 1839 and even mounted a public showing of examples of his photographs before daguerreotypes were publicly exhibited. Unfortunately for Bayard he lacked Daguerre's political connections and received little notice or reward for his independent invention.

Any discussion of the early days of photography would be incomplete without mention of the Englishman Sir John Herschel. The quality of Herschel's mind was demonstrated by his ability to reproduce Talbot's process within a few days, even though Talbot had kept the de-

Hippolyte Bayard, *Self Portrait as a Drowned Man*.

Courtesy of the Collection de la Société Francaise de Photographie.

Julia Margaret Cameron, *Sir John Herschel in a Cap.*

Courtesy of the Ashmolean Museum, Oxford.

Gustave Le Gray, *The Imperial Yacht, La Reine Hortense*, 1856. Gold-Toned Albumen Print from a Wet-Plate Collodion Negative.

© The Board of Trustees of the Victoria and Albert Museum.

tails secret. In addition Herschel discovered a true fixative for the image in sodium thiosulfate, which he had earlier discovered and incorrectly identified as sodium hyposulfite, shortened to hypo. This same fixer is used today and is still called hypo in spite of the incorrect identification.

The use of hypo was quickly adopted by both Talbot and Daguerre to replace their imperfect methods of fixing, and Talbot went so far as to include its use in his patents without credit to Herschel. Herschel was also instrumental in establishing some of the terminology we use today, including the terms *photography*, *negative*, and *positive*.

The Collodion Wet-Plate Process

The obvious advantages of the negative-positive system encouraged the search for a process that would give the sharpness and detail of the daguerreotype combined with the reproducibility of the negative-positive system. Several methods were explored for coating the silver halide onto glass plates rather than paper.

In 1847 Niépce de Saint Victor, a cousin of Joseph Nicéphore Niépce, introduced one of the first successful glass plate processes, using albumen (egg whites) as a clear substance that would carry the silver salts and adhere to glass. Unfortunately the albumen plates were not nearly as sensitive as either the calotype or the daguerreotype, requiring very long exposures. Because of this, albumen glass plates were never widely used, but it was found that the albumen and silver salt mixture could

also be applied to paper, producing prints with a smooth finish capable of showing better detail than the papers treated directly with silver salts. Albumen papers were popular, and billions of eggs were used for photographic papers in the last part of the nineteenth century.

In 1851 an English sculptor, Frederick Scott Archer, discovered the use of collodion as a carrier for silver salts. Collodion is made by dissolving gun cotton (nitrocellulose) in ether and alcohol, giving a clear liquid that adheres to glass and dries to a tough, transparent skin. For

Alexander Gardner, *Home of a Rebel Sharpshooter, Gettysburg,* July 1863. Wet-Plate Collodion Process.

Collection, The Museum of Modern Art, New York.

use in photography the collodion was mixed with potassium iodide and then coated on a glass plate. The plate was then sensitized by dipping it in silver nitrate, forming silver iodide. It was found that the plate had to be exposed and developed before the collodion was allowed to dry or the developing chemicals could not penetrate, so the process became known as the wet-plate process. The results were excellent. The glass negative could be printed as many times as desired, with sharpness and detail comparable to those of the daguerreotype. The wet-plate process quickly took over the industry. By the end of the 1850s only a few studios were still using the daguerreotype process.

Still, the wet-plate process had some major disadvantages. Since the coating, exposure, and developing had to be done while the plate was damp, wet-plate photographers had to carry a complete darkroom with them wherever they went. The glass plates were heavy and fragile. At the time, printing by enlargement was not practical due to the slowness of the photographic papers, so prints were made by contact printing. Print sizes of 11 × 14

inches and larger were common, requiring glass plates of the same size. The photographers who handled these large plates and the bulky cameras that accepted them under the adverse conditions of the day have to be admired for their courage. They were photographing in wartime and in the still-wild American West, hauling the huge amounts of gear needed by mule or wagon.

Nonsilver Processes

Although the main technical developments in photography have been in light-sensitive materials using silver salts, a number of nonsilver processes—beginning with Niépce's heliographs—have been developed over the years. Each photographic process had its own visual characteristics and aesthetic possibilities. Some processes had only a brief popularity after their introduction, but many of these have been revived and are currently used—mostly by art photogra-

Timothy O'Sullivan, *Canyon de Chelly* (White House Ruins), Wheeler Expedition, 1873. Wet-Plate Collodion Glass Plate Negative.

Courtesy of the International Museum of Photography at George Eastman House.

Robert Demachy, *A Study in Red,* ca. 1898. Gum-bichromate Print.

Courtesy of the Royal Photographic Society, Bath.

phers, since the laborious handwork makes them expensive from a commercial standpoint.

Herschel experimented with the light sensitivity of iron salts, the basis of the cyanotype or blueprint process. Although sometimes used by photographers as a print material, the cyanotype has been most widely used for reproduction of architectural and industrial drawings.

Another process based on iron salts is the platinotype or platinum print. Invented by William Willis in 1873, platinum papers were commercially available from 1880 until the early part of the twentieth century. Only recently has platinum paper again become commercially available.

The carbon process was invented in 1856 and used paper coated with a mixture of gelatin, potassium dichromate, and carbon particles. When exposed to light the dichromate caused a hardening of the gelatin. After exposure, unhardened gelatin and dichromate were washed away with hot water, leaving an image of carbon suspended in gelatin. Improvements in 1864 by Sir Joseph Wilson Swan provided for a carbon tissue that was transferred to a sheet of paper after exposure and processing. The carbon print was also an extremely permanent process. Similar tissues that were commercially available contained pigments rather than carbon in a variety of colors.

The gum process or gum-bichromate print was also dependent upon the hardening effect of light, in this case on gum arabic mixed with potassium dichromate. Watercolor pigments can be added to the gum-dichromate mixture, producing prints of any desired color.

The Evolution of Modern Film Processes

Gelatin Emulsions The quality and reproducibility of the wet-plate process made it useful, but investigation into eliminating some of its problems continued. The search for a dry plate with the sensitivity of the wet plate was finally ended with the discovery of gelatin as a carrier for the silver salts. Richard L. Maddox was the first to make this discovery in 1871, and Richard Kennett and Charles H. Bennett improved it into a practical process by 1879.

The gelatin dry plates were a revolution, since they allowed the manufacture of photographic plates that could be stored, carried to a site and exposed, and then developed at the photographer's leisure—in one early case, 8 months after the exposures were made. No longer did a photographer have to carry a darkroom on location. Also, since the gelatin plates could be made in a factory, standardization of materials was introduced to photography.

Flexible Film Base The next step was to replace the heavy, fragile glass plates with a lightweight, flexible material. This idea was conceived as early as 1854, but George Eastman was the first to invent a practical way of manu-

George Eastman, *Portrait of Nadar.* Taken With a No. 2 Kodak Camera. The images produced by the general public using the new Kodak cameras became known as snapshots, which indicated that they were taken quickly and easily with little thought for anything other than the subject being recorded.

Courtesy of the International Museum of Photography at George Eastman House.

facturing the flexible film base. Eastman introduced a camera, called the Kodak, using roll film on this base in 1888. The first flexible base was not transparent, and the emulsion had to be stripped from the backing and transferred to glass plates before developing and printing. This was a difficult procedure, so Eastman had his customers return the entire camera to him for removal, processing, and printing of the film. Eastman's motto was You Push the Button, We Do the Rest! and popular photography was born.

Hannibal Goodwin invented a usable transparent film base made of nitrocellulose, but before he was finally able to patent it in 1898 Eastman had already begun to manufacture transparent films and Kodak cameras that used them. Eastman Company was later sued and lost a patent infringement case regarding the use of these transparent films.

The introduction of transparent-based films made photography truly convenient, with the ability to take many exposures on one roll of film, change rolls at will, and even develop and print your own film with a minimum of

equipment and without elaborate and difficult procedures. The public responded, and the boom in popular photography persists to this day.

Further Improvements The twentieth century brought mostly improvements of processes that had been devised in the nineteenth century, with a few revolutionary inventions. Films were improved by increasing speed and broadening color sensitivity. Early photographic emulsions were blue sensitive, but panchromatic emulsions were gradually developed. The flammable and unstable nitrocellulose film bases were replaced with safe, long-lived acetate. More sensitive photographic papers allowed for the use of enlargers, making possible much smaller camera formats. Lens optics were improved with the discovery of new glasses and new design and grinding techniques. Cameras became more compact and sophisticated. The Ermanox camera was introduced in 1924 with a lens boasting an f/2.0 maximum aperture, fast enough to allow available-light candid photography.

Several color processes were devised in the nineteenth century, but the first commercially available color process was the Autochrome, introduced in 1907 and discontinued in 1932. Autochromes were positive color transparencies on glass plates and gave beautiful results. The first practical and affordable color transparency process was Kodachrome, introduced by Eastman Company in 1935.

Electrically ignited magnesium had been used for artificial illumination, but the first electric flashbulbs came on the market in 1930. The first photoelectric light meters were introduced in 1931. Before this, exposure had been determined by experience or by using crude comparison devices.

First Leica Camera. The first camera using 35mm film, originally a movie film, was the Leica, introduced to the public in 1925.

Courtesy of Leica Camera, Inc.

Many special techniques had been explored in the nineteenth century, including photography through microscopes and under water. The improving materials allowed even higher quality results in these endeavors. One revolutionary development was announced by Edwin Land in 1947. His Polaroid process produced a finished monochrome print only 1 minute after exposure. "Instant" photography has progressed to the point that you can now see color images develop in room light right before your eyes.

More recent advances in the technical areas of photography include extensive automation of cameras, with metering, aperture and shutter speed setting, and focusing all being performed automatically. In films, continual improvements are made, with finer grain and more sensitive emulsions being offered. Kodak's T-grain emulsions are the latest advance in the battle to reduce grain size while retaining sensitivity and are being used in several black-and-white and color films.

Electronic Imaging

The new revolution in still photography is coming from the electronic imaging industry. Electronic digital still cameras replace the film with a screen that is a gridwork of light-sensitive cells. The response of each cell is digitized, and the information is stored in the same manner as computer data. This mass of information can be reassembled into the image and played back on a television screen or, with special printers, printed out as color prints. Since the image is stored as digitized electronic information, it can be easily transmitted by telephone or satellite. Digital cameras are competing successfully with film cameras in many areas of the industry.

Computers are more widely used in photography every day, both as controlling devices and for digitizing and managing visual information. Once a photograph is digitized, it can easily be modified or retouched by computer graphic techniques or even combined with any number of other photographs. The result is so high in quality that it is impossible to tell the photograph has been manipulated.

The hardware and software for high-resolution results of this kind are widely used in publishing for retouching, combining, and altering photographs. The skill with which these can be done has raised some ethical issues, especially with regards to the possibilities of photographic deception in the areas of photojournalism, propaganda, advertising, and criminal proceedings. Copyright issues have also been raised, with questions about the incorporation of parts of a photographer's image into a new image without recompense or credit.

Computer Assembled and Retouched Image. Fil Hunter, *Swords Turning into Plowshares.* The four images shown on the left were 4 × 5-inch color transparency originals. They were combined into the larger image using computer retouching techniques and output as an 8 × 10-inch color transparency.

© Fil Hunter. Courtesy of the Dodge Color Lab. Computer retouching by the Dodge Color Lab, Washington, D.C.

■ Functional History of Photography

Of the visual media, photography is most closely related to painting, drawing, and print media such as lithographs, etchings, and engravings. Before photography was introduced, these two-dimensional media served a number of functions, the major one being representational. People, architecture, scenic views, and events, both historic and current, were all presented to the viewer in relatively realistic representations. The artist was free to alter the realism to make the subject look more attractive, dramatic, or interesting or for reasons of propaganda, but the underlying purpose was still to give the impression of a realistic rendering.

Because of the time and cost for painting, only the well-to-do could afford personal paintings, and these were often portraits. Benefactors of the church commissioned many paintings, both portraits and works of a religious nature. The invention of mechanical printing techniques for illustrations, especially the rotary press, made inexpen-

sive images available to the public, and by the time photography came into general use a large number of illustrated weekly magazines were published. The illustrations were generally from woodblocks that were hand engraved using drawings or paintings—and sometimes photographs after 1839—as a guide. Books were also illustrated, sometimes with separately printed pictures done in color.

With the introduction of photography, some people felt that the representational uses of painting, drawing, and other print media had been made obsolete and expected photography to take over these functions immediately. In fact it was a more gradual process. Once exposures were shortened enough to make portraits feasible, it became possible for nearly anyone to afford a portrait. The painters who had been doing relatively low-cost miniature paintings found their business suffering, and many turned to photography. Painting still had the advantage of color

and size over photographs for many years, and the rich continued to commission paintings.

The use of photography in illustrated magazines and newspapers was limited at first. The technical problems of photomechanical reproduction were partly responsible, but in addition the public still considered the woodblock engravings to be more artistic than photographs. It was not until the twentieth century that photography finally began to take over most of the functions that engraving had filled in the popular press.

The realistic nature of photography is useful in news and other reportorial areas but can be a disadvantage in illustrations for fiction, many of which are still done today by photomechanical reproductions of drawings, paintings, and other hand-done artworks. A few of the uses to which photography has been put are outlined in the following sections.

Portraiture and Social Photography

Portraits of individuals and groups have been made with nearly all of the photographic processes, from the daguerreotype on. Early sitters had to endure the discomfort of holding absolutely still, clamped into neck and head braces for minutes at a time, but as exposures became shorter the experience became more pleasurable. Styles in portraiture were influenced by the formal poses and props used by painters. Formal photographic portraiture evidences some of that influence even today. These early portraits were of great importance to families, serving as remembrances of those distant or deceased.

Although many people were much taken with these representations of their loved ones or of famous personages, the subjects of the photographs themselves were not always so pleased with the results. One writer in the early days of photography put it this way: "The most terrible enemy which the daguerreotype has to combat is, without contradiction, human vanity." Techniques of posing, lighting, and retouching have been developed to answer this complaint, but today's portrait subjects are more accustomed to seeing photographs of themselves and thus find naturalistic portraits more acceptable. Photographic portraiture is still a thriving business.

In spite of the ease with which snapshots can be made, people often seek a professional photographer to document the important events in their life. Many photographers make a good part of their living from photographing ceremonial rites of passage like weddings, bar mitzvahs and bas mitzvahs, and christenings. In earlier years it was even common to photograph funerals.

Lately the home video camera tends to supplant the still camera in many areas of personal photography.

Nadar (Gaspard Félix Tournachon), *Sarah Bernhardt*, 1865.

Collection of the J. Paul Getty Museum, Malibu, California.

Kerr's Studio, *Wedding Photograph of Edward and Johanna Thornblade*, 1904.

Courtesy of the Thornblade family.

This trend, coupled with the overwhelming use of color materials in still photography, threatens the photographic heritage that we will leave to our descendants because of the impermanent nature of videotapes and most popular color materials.

Travel, Exploration and Nature Photography

One early use of photography was to bring back views of exotic and distant places. Initially reproduction of the images was achieved by painstaking hand engraving using the photograph as a guide. Travel and exploration continues to be a popular photographic application, as witness the long-standing success of the *National Geographic.*

Photographers have been drawn to the natural environment, photographing landscapes, wildlife, and other details of nature, for both scientific uses and aesthetic pleasure.

Francis Frith, *Pyramids from the Southwest, Giza,* 1858. Frith and Maxime DuCamp used the calotype process to excellent effect in Egypt.

Courtesy of the Stapleton Collection, London.

Eric Valli and Diane Summers, Honey Hunters of Nepal. Photographs from this project appeared as the cover article in the November 1988 issue of *National Geographic.*

© Valli-Summers/Minden Pictures.

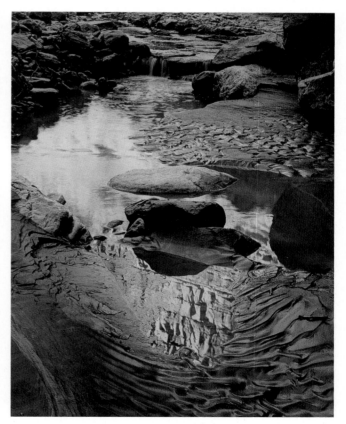

Eliot Porter, *Dark Canyon, Glen Canyon,* 1965.

© 1990, Amon Carter Museum, Fort Worth, Texas. Bequest of Eliot Porter.

Berenice Abbott, *Pennsylvania Station Interior, New York,* 1936.

© Berenice Abbott/Commerce Graphics Ltd., Inc.

Robert Capa, *Death of a Loyalist Soldier,* 1936.

© Robert Capa/Magnum Photos, Inc.

Sam Shere, *Burning of the Hindenburg,* Lakehurst, New Jersey, May 6, 1937.

© Corbis.

Architectural Photography

A popular early subject for photography was architecture, especially since stationary objects were so suitable for the long exposures needed. The purpose was usually to show especially famous or interesting buildings, a use that continues today. The business world also offers a market for architectural photography, since many corporations use their buildings as an expression of their success and image.

Photojournalism and Documentary Photography

Photography's ability to record events as they happen is one of its great strengths. The earliest news photographs were taken on daguerreotypes by Hermann Biow and C. F. Stelzner of the results of a disastrous fire in Hamburg in 1842. These views never made it into the illustrated news magazines of the day, but soon other news events recorded by photographers were seen in the newspapers, first as engraved copies and later as photomechanical reproductions. Wars, disasters, affairs of state, crimes, photo interviews, and even ordinary, everyday events were all subject to the camera.

Today photojournalists cover the world, with modern communications bringing photographs of important events to the public within hours of their occurrence. Some of the best photojournalists have joined into groups such as Magnum and Black Star for marketing their images and have had great influence on the style of photojournalism.

Any photograph that gives information about the subject photographed could be thought of as a record or document. Documentary photography is often associated with photographers who are trying to convey a personal perspective about a subject. Jacob A. Riis, in photographing the poor people in the slums of New York City during the 1880s,

wished to show "the misery and vice that he had noticed in his ten years of experience . . . and suggest the direction in which good might be done." Two decades later Lewis Hine used his photographs to show the plight of immigrants and child laborers in an eventually successful struggle to pass laws protecting children from such exploitation.

Adam Clark Vroman, *Zuñi Pueblo*, 1897. Vroman and Edward S. Curtis (see the opening photograph of this chapter) both documented Native American life and culture in the late nineteenth and early twentieth centuries. Later research has cast some doubt on the validity of Curtis's photographs as documents, since they were often staged, mixing props and clothing from various tribes.

Courtesy of the Seaver Center for Western History Research, Natural History Museum of Los Angeles County.

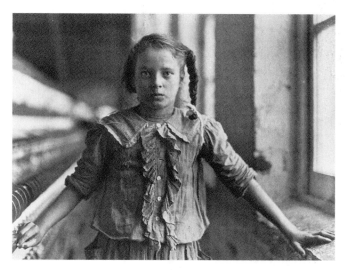

Lewis W. Hine, *Ten-Year-Old Spinner, North Carolina Cotton Mill*, 1908–09.

Courtesy of the International Museum of Photography at George Eastman House.

Eugène Atget, *La Marne à la Varenne* 1925–27. The photographs of Paris that Atget took over a period of many years beginning in 1898 served much the same purpose as snapshots. However, they share nothing of the casual seeing of most snapshots because of his slow, careful technique and his elegant way of looking at the city and its people.

Collection, The Museum of Modern Art, New York.

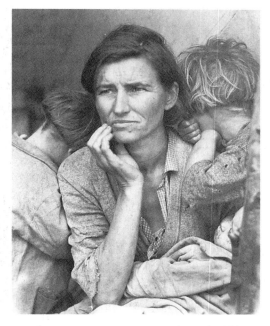

Dorothea Lange, Depression Era Mother and Children, Farm Security Administration Photograph. In a spectacularly fruitful interaction of government and art, the Farm Security Administration sent a number of photographers out across America in the 1930s to document the effect of the Depression on the American people.

Courtesy of the Collections of the Library of Congress.

Snapshot Photography

Snapshots, the largest single use of photography since the advent of small, easily used hand-held cameras, are a kind of documentary photograph, since they are intended to serve as a personal record of a person, place, or event. Most of these are casually composed, usually with the important subjects centered in the image. Occasionally photographs taken for personal purposes have a more universal appeal, as with those of Jacques Henri Lartigue.

Edward Steichen, *Peeling Potatoes,* Advertisement for Jergen's Lotion, 1923.

Reprinted with permission of Joanna T. Steichen.

Jacques Henri Lartigue. Lartigue was given a hand-held camera at the turn of the century when he was only seven years old. He photographed his well-to-do French family in a fascinating variety of antics and adventures.

© Ministere De La Culture – France/AAJHL.

Advertising and Fashion Photography

With a few scattered exceptions, little use was made of photographs for advertising purposes until the 1920s, when the problems of quality mass reproduction of photographs began to be solved. During the 1920s and 1930s a number of respected art photographers involved themselves in commercial applications of photography, among them Edward Steichen, Man Ray, László Moholy-Nagy, Sir Cecil Beaton, and others. The effectiveness of photography in advertising has been well proven and is today nearly omnipresent.

Fashion photography also came into its own in the 1920s with the appearance of magazines like *Vogue* dedicated to the fashion world.

Helmut Newton, Untitled, Model Cindy Crawford.

© Helmut Newton/Maconochie Photography.

Hiro, *Elsa Peretti Bracelets*, Tiffany & Co.

© 1990 Hiro.

Paul Strand, *Oil Refinery, Tema, Ghana, 1963*.

© 1971, Aperture Foundation, Inc., Paul Strand Archive.

Industrial and Scientific Photography

Early photographs of the machinery and structures associated with the industrial age were made because of a fascination with these new applications of technology. Later photographers, especially in the period following World War I, found great strength and beauty in industrial subjects and portrayed them in the positive way most people then viewed industry—as a path to a better way of life. Much industrial photography was commissioned by companies for advertising or annual reports, and photographers like Margaret Bourke-White and Charles Sheeler

Harold Edgerton, *Milk Drop Coronet*. Edgerton was another pioneer in the study of motion. He invented the gas-filled flashtube used in electronic flashes of today.

© Harold & Esther Edgerton Foundation, 1999. Courtesy of Palm Press, Inc.

Eadweard Muybridge, Plate 408 from *Animal Locomotion*, 1887. Muybridge was a pioneer in motion studies. Commissioned by Leland Stanford, former governor of California, Muybridge set out to photograph a racehorse in action. He succeeded in 1878, proving that horses have all four feet off the ground sometime during their stride and that they never have legs extended fore and aft as mistakenly shown by generations of painters. Muybridge continued his motion studies with a wide range of subjects, including people in various forms of motion. He also extended this work to projecting the successive images rapidly, introducing the possibility of motion pictures.

Courtesy of the Miriam and Ira D. Wallach Division of Art, Prints and Photographs; The New York Public Library.

were among those hired. Others photographed industrial subject matter for aesthetic reasons.

Photography has been used from the beginning to record the results of all types of scientific work, from showing the minute appearance of natural objects through microscopes to investigating things in motion. As the necessary length of exposure shortened over the years, the motion-stopping capability of photography began to be recognized.

Photography as Art

While some photographers were busy using photography for practical purposes, others were making photographs for pleasure, producing a visual object to give aesthetic enjoyment—in other words, using photography as art. Even in most photographs taken for utilitarian purposes, attention was paid to the visual design of the image. Nevertheless for many people who were accustomed to thinking of art as entailing handwork, the technical procedures involving optics, mechanics, and chemistry used to produce photographs cast doubt on photography's viability as an art form.

The discussion as to whether photography is a true art form has continued since the beginning. As more and more photographs were made, it became clear that the photographer's personal intelligence and visual style differentiated his or her images from those made by others. With the proliferation of new ways of producing visual objects based on technology, the public has become more comfortable with a definition of art having less to do with actual handwork than with the capability for a medium to display personal visual style differences and concepts. All of the media based on photography—including cinema, video, photocopying, and so on—and those based on computer generation of images seem to satisfy that criterion. Many of the shifts in stylistic direction in photography depended upon reconsideration of the definition of art and of how photography related to that definition. The following section traces the development of photography as an art form.

■ Aesthetic History of Photography

The initial fascination with photography was for the wonderful technical miracle it performed, but the similarities with other arts were noticed immediately and it was not long before photography was being explored as an art form. Much of Talbot's early work, including the first book of photographs, *The Pencil of Nature*, (page 176) could be classified as art photography, since his main purpose appears to have been the production of attractive visual objects.

Early photographers typically followed the visual conventions and styles then current in painting. In fact many photographers were or had been painters. The response of the art establishment to photography was generally inimical. Many painters scorned the use of photography as an expressive medium, considering it useful only as a source of studies and for scientific purposes. As interest in photography as an art increased, some theorists began to look for the unique characteristics of photography and to form philosophies for the making of photographs as art.

Two important figures in the battle to establish photography as a serious medium were Oscar G. Rejlander and Henry Peach Robinson. Both were painters-turned-photographers and felt that photographs should, to be considered a true art, be bound by the same conventions governing paintings. They used multiple printing techniques **(photomontage)** to achieve photographs that they felt satisfied these conditions.

P. H. Emerson, *Gathering Water-Lilies.*

Courtesy of the International Museum of Photography at George Eastman House.

Oscar G. Rejlander, *The Two Ways of Life*, 1857. Rejlander worked in an allegorical style used by painters. Photographers—among them D. O. Hill and Robert Adamson and Julia Margaret Cameron—took up this style, producing many allegorical tableaux illustrating scenes from the Bible or from literature.

Courtesy of the International Museum of Photography at George Eastman House.

This pictorial approach to art photography was so predominant that in the 1880s Peter Henry Emerson presented a forceful argument for photography as an art form independent from painting. In his book *Naturalistic Photography for Students of the Art* (1889), Emerson presented an aesthetic theory for photography that was based on the way the eye sees and the properties of the photographic image. He was an advocate of differential focus—meaning careful choice of focus and depth of field—in which central, important subject matter was sharp and the remainder of an image was slightly soft. Otherwise the image was to be presented straight as the camera reproduced it, with no cutting and pasting of multiple images or heavy retouching and handwork on the negative or print in an attempt to yield a more "painterly" look. Emerson's photographs lived up to his theories.

Unfortunately many photographers who considered themselves naturalists interpreted Emerson's remarks on sharpness to mean that nothing in a photograph should be sharp, and fuzzy pictures were the order of the day for many years. In 1890, partly motivated by studies by Ferdinand Hurter and Vero Driffield showing the firm scientific basis of photographic reproduction, Emerson recanted on his feeling that photography was a viable art form.

Pictorialism

The pictorialists were a loosely structured group of photographers who fought the battle for photography as an art from about 1890 through the first decade or two of the twentieth century. Pictorialism covered a wide range of styles, but the main principle that gave coherence to the movement was that photography was a valid art form to be considered on an equal footing with painting, drawing, sculpture, and the other fine arts.

In England art photography had been dominated since 1853 by the Photographic Society of London, changed to the Royal Photographic Society of Great Britain in 1894. Tired of what they felt to be a lack of attention to art photography, a group of pictorialists seceded from the Photographic Society in 1892, calling themselves the Linked Ring. Members included many naturalists, followers of

Frederick H. Evans, *Steps to Chapter House: A Sea of Steps, Wells Cathedral*, 1903. Platinum print.

© 2000, The Museum of Modern Art, New York.

Gertrude Käsebier, *Alfred Stieglitz*, 1902.

Courtesy of the Metropolitan Museum of Art, the Alfred Stieglitz Collection.

Edward Steichen, *The Flatiron Building, New York*, 1905.

Reprinted with permission of Joanna T. Steichen.

Emerson's theories, but Emerson himself had recanted by this time and remained a member of the Photographic Society. Members in the Linked Ring worked in a wide range of styles, from the heavily manipulated images of Henry Peach Robinson to the straight, unmanipulated, and elegant architectural images, beautifully printed on platinum paper, of Frederick H. Evans.

During the 1880s and 1890s a young American photographer named Alfred Stieglitz had gained international acclaim in exhibits in America and Europe. After studies in Europe he returned to America and became an important force in the movement for photography as art. He was a formidable figure in the amateur camera clubs in New York and in 1902 formed a new society with the avowed intent to further the fight for the establishment of art photography. The new society was named the Photo-Secession, to indicate its separation from the traditional, academic approach to the arts.

The membership of the Photo-Secession, like that of the Linked Ring, covered a wide range of stylistic approaches to photography as art and included Stieglitz, Edward J. Steichen, Clarence H. White, Frank Eugene, Gertrude Käsebier, and others.

Stieglitz also published a new journal of photography, *Camera Work*. The fifty issues of *Camera Work* produced from 1903 to 1917 featured beautifully reproduced and presented photographs as well as reproductions of modern art, introducing the works of Rodin, Brancusi, Matisse, and others to the American public for the first time. Stieglitz was instrumental in many exhibits of photography and modern art through established museums and galleries and a series of private galleries that he operated, beginning with the 291 gallery.

Steichen, a painter and photographer, worked with Stieglitz, contributing to the design and production of *Camera Work* and traveling in Europe to find and collect the works of the new artists that Stieglitz exhibited. Steichen also played a strong role in the Photo-Secession group as a photographer and eventually became a great influence in photography as the director of photography at the Museum of Modern Art from 1947 to 1962.

The importance of Stieglitz and his colleagues in the American establishment of modern art and photography as art should not be underestimated.

Straight Photography

Even though Stieglitz supported the work of many photographers who practiced extreme manipulations of the photographic medium, he himself took a different approach in his work. Stieglitz believed that the photographic images should be printed without manipulation. He also championed the use of smaller hand-held cameras for the spontaneity that could be gained.

In the last issues of *Camera Work* Stieglitz displayed the photographs of a young man, Paul Strand, who was working in a direct manner, employing a fully detailed, sharp image printed without manipulation.

Alfred Stieglitz, *The Terminal, New York*, 1892.

© The Museum of Modern Art, New York. Gift of Georgia O'Keeffe.

This approach to photography culminated in a style known as **straight photography,** which was epitomized by photographers like Edward Weston, Ansel Adams, and Imogene Cunningham. Group f/64 was formed by these and other photographers in 1932 to promote an aesthetic of photography that included a clear and uncompromised purity in the approach to photographic techniques. The name of the group indicated a concern with a sharp depiction of the subject, using the great depth of field achieved with small apertures. Weston was a central figure in this school of photography, and the clarity and directness of his vision has had a major effect on art photography as practiced to this day. For a fascinating insight into the mind of a practicing artist, read Weston's *Daybooks.*

Although the straight approach to photography demands an unmanipulated use of the materials, a wide variety of visual styles can be achieved. The work of the Group f/64 members and other practitioners of the straight approach such as Brett Weston, Wynn Bullock, Paul Caponigro, Aaron Siskind, and Minor White shows distinctly personal approaches to photography as an expressive medium.

Most of the work of these photographers was done in black and white, but Edward Weston did some work in color and a number of contemporary photographers have explored similar working techniques using color.

This group of straight photographers worked almost exclusively with large-format view cameras on tripods—a

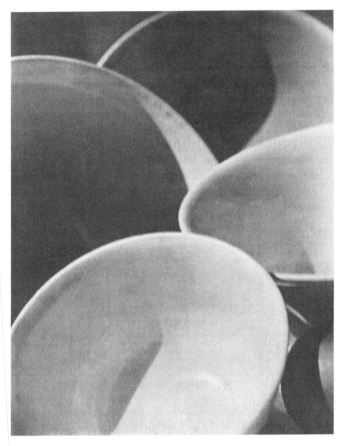

Paul Strand, *Bowls,* 1906.

Courtesy of the Metropolitan Museum of Art, The Alfred Stieglitz Collection.

Edward Weston, *Artichoke Halved, 1930.*

© 1981 Center for Creative Photography, Arizona Board of Regents.

working method still alive and well—but straight photography today covers a wide variety of visual approaches and equipment, including small hand-held cameras.

Bauhaus Movement

In the 1920s and 1930s the Bauhaus—a German school of architecture and design—was a center for artists influenced by a number of radical trends in art including dadaism, cubism, constructivism, and surrealism. Experimental work in photography was promoted by members of the Bauhaus like László Moholy-Nagy and independent photographers such as Man Ray, incorporating cameraless images, called photograms; extreme angles; photomontage; extreme close-ups; and a range of other techniques. Earlier experimenters with some of these techniques were Louis Ducos Du Hauron and Alvin Langdon Coburn.

László Moholy-Nagy, Untitled, ca. 1928.

Social Landscape Photography

Since the birth of photography, photographers have been documenting the social landscape—the people, events, and artifacts that present a cultural and social picture for the times. Many of the photographs discussed previously are part of this broad category, and the work done falls under the umbrella of straight photography. Most photographers recording the social landscape were concerned with a kind of truth that they felt the photographic process gave and for that reason did not manipulate the images in printing. War photographers, photojournalists, social documentary photographers—all contributed to this vast body of work. Although some of this work was done with a specific agenda—as were the Farm Securities Administration photographs or Hine's work—it was still performed in a way that attempted to be objective.

In the 1950s, Swiss photographer Robert Frank used straight photography techniques in a new way to show the social landscape from a distinctly personal and idiosyncratic viewpoint. His photographs of America, published

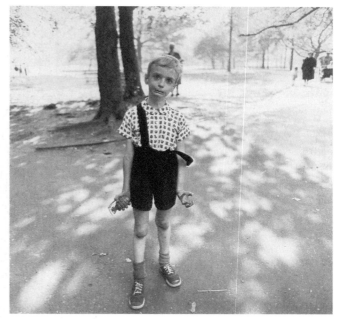

Diane Arbus, *Child with a Toy Hand Grenade in Central Park, New York City*, 1962. Arbus first started making photographs in the early 1940s, but it was not until 1955–57, while enrolled in courses taught by Lisette Model, that she began to seriously pursue the work for which she has come to be known. Often thought of as a photographer of the fringes of society—those considered to be social aberrants or freaks—Arbus also frequently photographed middle-class Americans. More than just a documentation of different stratas of society, her photographs seem to draw viewers into a powerful confrontation with their own preconceptions and prejudices.

in the book *Les Americains* in 1958, raised considerable furor because of the uncomplimentary and, some felt, cynical view of America presented. Although Frank's technique can be classified as straight photography, his results, achieved with a hand-held 35mm camera, shared little in visual style with the photographs of Group f/64. Although somewhat formal, his images more often exhibit the loose composition and casual technical results associated with snapshots than the pristine technique and careful regard for visual structure associated with the West Coast group. Frank was a strong visual influence on a generation of photographers. (Because Mr. Frank has refused to allow publication of his photographs, no example of his work appears here.)

Other influential photographers of the social landscape in the 1960s and later include Diane Arbus, Lee Friedlander, Garry Winogrand, and Danny Lyon.

Conceptual Photography

Since *concept* simply means idea, all art is essentially conceptual. The idea may be simply to present a beautiful, aesthetically pleasing object to the viewer. On other levels the beautiful object could have associative properties or content that conveys some message to the viewer. Traditionally, the production of a pleasing physical object has been the goal of an artist, even when deeper levels of idea are intended. Some artists have rebelled against this view of art. When the dadaists in the early part of the twentieth century placed mink-lined coffee cups or urinals on display in galleries and museums, the intent was not to provide a beautiful art object to the public but instead to challenge people's ideas of what art was all about. In other words, the object itself was only incidental to the concept.

Kenneth Josephson, *Stockholm, 1967*. In his image of a car mirrored by its shadow in snow, Josephson is making a sly conceptual comment on the positive/negative nature of the photographic medium.

© Kenneth Josephson, Collection, The Museum of Modern Art, New York.

Art where the object created is of secondary importance to the idea is called **conceptual art.** Sometimes the conceptual artist produces an object that is only temporary, or does not produce an object at all but simply orchestrates an event. Photography has often been used to document conceptual art. The resulting photographs are not, strictly speaking, art objects themselves but simply evidence of the concept. In photography some conceptual work has been done that plays on the characteristics of the medium.

Current Directions

Photography today offers a variety of possible stylistic directions. Many of the historic styles are still pursued by contemporary photographers. Vital work is being produced in the style of straight photography as well as the subjective realism typified by Frank's work. Old processes are being revived. Multiple printing techniques and many other special techniques are employed for breaking out of the boundaries of the straight photograph. Combinations with other media are being explored. Technology, especially computers and the digitizing of images, has opened new frontiers in the creation of images.

With photography firmly established as an art form, photographs are appearing on the walls of nearly every venerable museum and gallery. The work of contemporary photographers makes it clear that many can link choice of technique, craft, and concept into exciting new work.

John Pfahl, *Blue Right Angle, Buffalo, New York, 1979*, from the series *Altered Landscapes*. Although this looks like an altered photograph, in fact the blue marks are material carefully placed on the subject, altered in size, shape, and position so that they appear to be a uniform geometric shape superimposed on the photograph.

© John Pfahl, Courtesy of the Janet Borden Gallery.

Lucas Samaras, 10/19/84 Panorama. Samaras assembles Polaroid prints into a single work.

© Lucas Samaras, Courtesy of Pace/MacGill Gallery, New York.

Bea Nettles, *Tomato Fantasy*, 1976. This image was done using the Kwikprint process, which gives considerable freedom in the coloration and assemblage of images.

© Bea Nettles, Courtesy of the International Museum of Photography at George Eastman House.

Irving Penn, *Cigarette No. 37*, 1972. Platinum Print. Penn has had a long commercial career doing fashion, still life, and portrait photography, but he has also shown his photographs in prestigious museums and galleries and his prints are sought-after collectors' items.

© 1974 Irving Penn.

CHAPTER 10

Special Techniques

Bill Silano, "Night Lights."

In addition to the basic shooting, processing, and printing methods discussed in earlier chapters, photography offers a variety of shooting and darkroom techniques for altering or improving the final image. Some of these techniques are subtle enhancements of the quality of an image; others can so radically manipulate the appearance of a photograph that the boundaries of what is and is not photography are challenged.

■ Special Shooting Techniques

Some alterations of an image can be done in-camera, through either special equipment or special materials. Most of these techniques involve a gentle expansion of photographic vision past the normal point of view or interpretation of the subject, such as by using filters or close-up equipment. Others offer extreme modifications of the photographic rendition, as with special films and multiple exposures.

Filters

Chapter 5 introduced filters for use with variable-contrast printing papers. Different types of filters can also be used on the camera to modify an image. A photographic **filter** is made of a transparent material—glass, plastic, or gelatin—with dyes incorporated so that it selectively removes specific colors or wavelengths of the light that passes through it (see below).

Filters for Black-and-White Films Some filters are designed primarily for black-and-white films, but others can be used with either black-and-white or color films.

Color Contrast Filters When a filter removes a specific color of light, the result is that any subject matter of that color receives less exposure on the film and reproduces darker in the print. Filters used to change the relationship of subject tones in this way are called **color contrast filters.**

Filter exposure corrections as described on page 201 must be applied in each case. Color contrast filters cannot be used with color films for selective darkening of subject tones, since the film will record the color of the filter.

continued

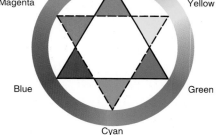

Additive Primaries Are Red, Blue, and Green
Red + Blue + Green = White Light

Additive Primary + Complement = White Light
Red + Cyan = White Light
Blue + Yellow = White Light Green + Magenta = White Light

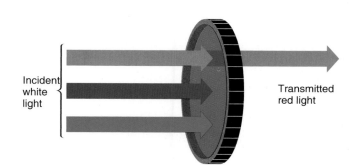

How Filters Work. A red filter appears red because it allows red light to pass, absorbing the other colors of light (i.e., blue and green). A pure red filter would let through only red light, but most filters allow amounts of adjacent colors to pass as well, filtering mostly the colors opposite on the color wheel (right), especially the complementary. A red filter therefore filters out cyan, blue, and green but usually allows some magenta and yellow to pass. In general, in the print a filter darkens most strongly its complementary color. A yellow filter darkens blue (and usually magenta and cyan), a red filter darkens cyan (as well as blue and green), and a green filter darkens magenta (as well as red and blue). The reverse works as well: a blue filter will darken yellow (as well as red and green) and so on.

How Light Mixes to Form Colors. The photographic color wheel tells how the colors of light mix and can help in predicting the effect of color contrast filters. Because of the way the human eye responds to color, white light can be thought of as a mixture of equal amounts of red, blue, and green light, called the **additive primaries.** The other colors on the wheel are mixtures of the additive primaries: red + blue = magenta; blue + green = cyan; red + green = yellow. Colors opposite on the wheel are called **complementary colors.** White light results from adding any two complementaries. For example, blue + yellow = blue + (red + green) = white light.

Color Contrast Filters—Continued

Red Filter Use. A filter cannot lighten an area. It can only darken the colors opposite it on the color wheel. The reason the red stop sign appears lighter in the filtered version is because of the exposure compensation given to the film. If a color contrast filter is used to darken a specific area of the subject, don't forget that any other area containing colors near the complement of the filter will also be darkened in the print. In the landscape picture, the photographer wished to darken the sky, but when the red filter was used, the trees, shadow areas, and other areas containing blue, cyan, or green darkened as well. Landscape shadows are usually illuminated by cyan light, which is a mixture of light reflected from the sky and surrounding foliage. The red filter absorbs some of the cyan light, darkening the shadows and creating an apparent increase in contrast.

No Filter. Red Filter.

Filtering in a Portrait. A cyan, bluish-green, or green filter will darken the reds in a portrait, giving darker lips and a more dramatic look.

No Filter. Blue‑Green Filter.

No Filter. Yellow Filter. Red Filter.

Use of Color Contrast Filters to Darken Sky. A common use of color contrast filters is darkening a blue sky with a yellow, orange, or red filter. A yellow filter helps to compensate for the excessive blue sensitivity of most black-and-white films, giving a rendition closer to the way the eye sees the subject. Notice that the red filter darkens the sky more than the yellow, even though the sky is seen as blue. This is because the red dyes are more efficient and also because the sky often tends to be somewhat cyan in color.

© Bognovitz.

Polarizing Filter Light is a waveform of electric and magnetic energy. In normal light the waves are vibrating in random directions. In **polarized light** the waves all vibrate in the same direction. The eye cannot distinguish between polarized and nonpolarized light.

A **polarizing filter** removes all but the light vibrating in one direction, polarizing any random light passing through it. If a polarizing filter is rotated, the wave orientation of light allowed to pass is changed. Light that is polarized before reaching the filter can be allowed to pass or be absorbed, according to the orientation of the filter.

Polarizing filters can be used to eliminate some reflections, reduce glare, and darken skies, but their applications are limited because of the nature of polarized light. The effect of a polarizing filter is judged by looking through it while rotating it. To find the area of the sky with polarized light, follow the procedure outlined in the sketch in the lower right corner of the page.

Polarizing filters require an exposure correction that varies. Meter through the filter for best results with most cameras. The TTL metering in a few cameras does not give correct results with polarizing filters. Refer to your operating manual to see if your camera is one of these.

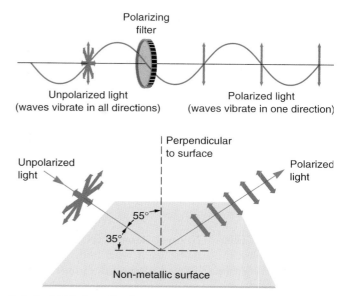

Polarized Light in Reflections. Polarized light appears in nature under specific circumstances. Light reflected from nonmetallic surfaces (e.g. water, glass, sand, snow, and rock) at an angle of 35° is polarized and can be filtered out (i.e. darkened) by orienting a polarizing filter against its direction. Reflections not satisfying these strict requirements cannot be eliminated with a polarizing filter.

No Filter.

With Polarizing Filter.

Polarizing Filter Used to Eliminate Reflections. Note that the reflection of the car is not eliminated because it is not at an angle of 35°.

Polarizing Filter Used to Reduce Glare. Reflections off many nonmetallic surfaces appear as glare. If viewed at an angle of 35°, glare can be eliminated or reduced with a polarizing filter.

Polarizing Filter Used to Darken the Sky.

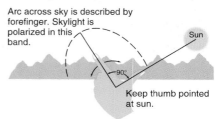

All Photos © Bognovitz.

UV Filter The UV filter removes ultraviolet (UV) radiation. Although our eye is not sensitive to UV, photographic films are, usually resulting in a somewhat hazy look in situations where a good deal of UV is present, such as in mountain and ocean scenery. UV filters may be used with color as well as black-and-white films.

No Filter.

UV Filter.

Neutral Density Filters **Neutral density (ND) filters** are neutral in color and can be used with both black-and-white and color films. They have no effect on the tonal relationship of various subject colors but simply reduce the overall exposure on the film. This is convenient if a larger aperture (for less depth of field) or slower shutter speed (for a feeling of motion) is desired but the light is too bright. Neutral density filters also allow the use of fast films in bright light.

The amount of exposure change for a neutral density filter is indicated by a density number. A filter marked ND 0.3 requires one stop more exposure. Densities add, so a filter marked ND 0.6 requires two stops more exposure, and so on. Stacking two or more neutral density filters will yield higher values. For example, ND 0.3 and ND 0.6 add to give ND 0.9, or three stops change in exposure. Some neutral density filters may be marked in filter factors (see the section on exposure correction on the opposite page) or stops rather than density.

Diffusion Filters Filters that scatter (diffuse) some of the light passing through them are called diffusion filters and are used to soften an image. The effect of a heavy diffusion filter is to scatter light areas into dark, giving a light, glowing, "romantic" look to the image. Slight diffusion can also be used to reduce the appearance of skin flaws and character lines in portraiture and fashion photography. Filters may be purchased with varying amounts of diffusion or can be improvised with window screening, nylon netting, or nylon stocking material stretched over the lens. Applying hair spray or rubbing a petroleum jelly like Vaseline on a clear glass filter will provide extreme diffusion. The amount of diffusion varies with the f-stop.

Using a diffusion filter on the enlarger while printing a negative will not yield the same effect, since the most light in the negative comes through the areas representing the dark tones of the subject. The result is a scattering of dark areas into light areas, typically producing a subdued, muddy-looking image. Most diffusion filters require little or no filter exposure correction, though any improvised diffusion filter should be metered through to find correct exposure. Diffusion filters are neutral in color and can also be used with color film.

Special Effects Filters A number of filters are commercially available that optically alter the image to produce special

Use of Neutral Density Filters. Wynn Bullock. *Sea, Rocks, Time, 1966.* Neutral density filters were placed in front of the camera lens to give an exposure time of three minutes during daylight, blurring the action of the surf on the rocks. A red filter was also used to darken the sky.

© Wynn Bullock, Courtesy of the Wynn and Edna Bullock Trust.

Diffusion Filter. Left: No diffusion filter on camera. Right: Heavy diffusion filter on camera.

Special Effects Filter. The subject before the camera was a single cup and saucer. The five images of the cup around the outside were produced by prisms in the filter.

© Bognovitz.

On-camera Filter Types. On the left and right are custom screw-mount glass filters. At top center are optical-grade plastic filters with holder. In the foreground center are gelatin filters with holder.

effects, from multiple image prism effects to star patterns. Special effects filters can also be improvised using any transparent material that optically distorts the image. Usually exposure corrections are low for these filters but vary with the type of effect. Most can be used in either black and white or color, though some are specifically designed for color effects that cannot be reproduced in black and white.

Exposure Corrections with Filters Since a portion of the image light is removed by a filter, additional exposure must be given. Two basic ways of making filter exposure corrections can be used: metering through the filter and multiplying exposure by a filter factor.

Metering through the Filter If the filter is placed over the light meter while metering, a close approximation of the correct exposure will be found. Cameras with TTL metering will automatically take account of the loss of light due to the filter if the meter reading is taken after the filter is attached to the lens. This method is less convenient for hand-held meters, since the filter would have to be removed from the camera for metering, then replaced for making the exposure. Metering through the filter will give generally acceptable results.

Multiplying Exposure by a Filter Factor The literature packed with a filter should give a **filter factor.** Multiply the exposure indicated by the meter without the filter by the filter factor to produce correct exposure with the filter. Filter factors should be applied when it is impractical to meter through the filter.

A multiplication sign following the filter factor indicates that it is a multiplication factor. For a filter factor of 2×, double the exposure time or open up one stop. If more than one filter is used, multiply the factors to find the total filter factor. The total filter factor for two filters with factors of 2× and 3× is 2 × 3 = 6×, about two and one-half stops more exposure. The filter summary chart on page 203 gives the conversion from filter factor to amount of exposure increase in stops. Manufacturers may give the needed exposure increase in stops rather than as a filter factor.

Some light sources have a preponderance of one or more colors. Tungsten light, for example, has more yellow and red in it than does daylight. The amount of light removed by a filter—and therefore the filter factor—varies with the color of the light. The filter factors for tungsten light and daylight are usually provided, and these are indicated in the filter summary chart when appropriate.

Filter Types Filters for use on the camera must be optically flat to prevent deterioration and distortion of the image. The filters that satisfy this requirement are made of high-quality optical glass, optical plastic, or gelatin. Filters made of other materials, such as acetate, are usually not suitable for introduction into the image path and should be used only for filtering the light source.

Glass Filters The most popular filter configuration is the custom screw-mount glass filter. The glass is mounted in a threaded ring that screws into the threads on the front of the lens. These filters must be purchased in the correct size for the front diameter of each lens. The diameter is normally given in millimeters. If you have lenses with different size filter needs, you can avoid buying filters for each by buying for the largest lens and then using adapter rings (also called step-up rings) on the smaller lenses. Since the adapter rings cause the filter to extend farther out from the lens, be careful that the addition of other accessories, such as lens shades, does not cause vignetting—a blocking of the image around the edges.

Usually a good indication of the quality of a filter is the price. It makes no sense to place a cheap, low-quality filter on an expensive, high-quality lens. Even the best filters cause a slight deterioration of image quality, so for maximum image quality filters should only be used when necessary.

Gelatin Filters Gelatin filters consist of a dyed layer of gelatin that is carefully lacquered on each side for protection. They are extremely thin, and are used in situations where several filters must be used on a lens at a time. Gelatin filters are delicate and comparable in price to glass, so are usually considered a professional accessory.

Care and Handling of Filters Filters to be placed in the image path should be treated with the care accorded lenses, since any defects will affect the image quality. Keep them clean and free of scratches. Glass filters can be cleaned using the same procedures outlined for cleaning lenses on page 84. Gelatin filters are easily scratched and are nearly impossible to clean without damage if fingerprinted, so they must be handled with great care. Acetate filters are susceptible to scratching and fingerprinting and should be handled with care, although small defects are less important here, since these filters are not being placed in the image path.

Filters as Lens Protection The best filters to use for protection are either clear optical glass, which has little effect on the image and transmits all colors of light relatively equally, or the ultraviolet (UV) filter, which filters out ultraviolet light invisible to the eye but not to the film. Since the effect of ultraviolet light on the film is generally undesirable, the UV filter is often a best choice, and it is more generally available than clear glass. The skylight (1A) filter is often recommended as a lens protector, but this is a pinkish filter designed to warm up the blue light in open shade, and will cause a slight color cast if used for sun-lit color pictures.

Since any filter causes slight image deterioration, the use of a filter for lens protection exacts a small price in image quality. When working in situations where the lens is exposed to possible damage—from blowing dirt, saltwater spray, scratching, or other rough handling—a protection filter is a good idea, since it is cheaper to replace than the lens. In other situations, where maximum image quality is desired, the filter should be removed.

Filters for Color Films The largest category of filters for use with color films are those used for balancing the light source to the color balance of the film. Those used for large changes of balance—for example, correcting tungsten light for daylight film—are called **color conversion filters** (see the previous page). **Light balancing filters** are used for smaller differences in the color of the light source. **Color compensating (CC) filters** come in varying densities of the additive and subtractive primary colors and can be combined and used in the image path for any desired change in color balance.

A polarizing filter should be used for darkening skies with color films, since a yellow or red filter would simply turn the whole image yellow or red. A second option for darkening skies with color films is a split, or graduated, neutral density filter, half of which is clear.

A polarizing filter can often saturate the colors by eliminating surface glare. Neutral density and special effects filters can also be used with color. Color contrast filters designed for black-and-white films can be used as special effects filters for color, giving a monochromatic image the color of the filter

Balancing the Color of Illumination. Daylight balance film will produce a yellow or orange cast when the subject is illuminated by tungsten lighting. Here a color conversion filter, the 80A, has been used to bring the color rendition closer to a correct balance.

Daylight Film with Tungsten Lighting.

Daylight Film with Tungsten Lighting and 80A Filter on Camera.

Summary of On-Camera Filters

NAME (DESIGNATION)	DESCRIPTION AND USE	FILTER FACTOR*	
		DAYLIGHT	TUNGSTEN
Color-Contrast Filters for Black-and-White Film			
Blue (47)	Absorbs red, yellow, and green. Used to darken red or yellow subject matter or to increase the appearance of haze.	6×	12×
Light Blue-Green (44)	Absorbs magenta, red, yellow, and ultraviolet. For portraits, darkens lips and ruddiness in cheeks.	4×	8×
Yellowish Green (11)	Absorbs blue, violet, ultraviolet, and magenta. Used to darken skies without darkening green foliage.	4×	3×
Yellow (8)	Absorbs violet, ultraviolet, and some blue. Darkens skies and other blue subject matter. Darkens haze.	2×	1.5×
Orange (21)	Absorbs blue, violet, and ultraviolet, and some green. Darkens sky more effectively than yellow (8) or deep yellow (15). May slightly darken greens.	4×	2.5×
Red (25)	Absorbs green, cyan, blue, and ultraviolet. Darkens sky with more effect than orange (21). Darkens foliage, haze, and shadows in landscapes.	8×	5×
Special Purpose Filters (Black-and-White and Color Films)			
Polarizing	Absorbs polarized light when properly oriented. Can reduce or eliminate reflections and glare from nonmetallic materials such as water, rocks, glass, etc. at 35°. Darkens the sky at 90° from the sun.	minimum 2.5×	
UV	Absorbs ultraviolet light. Has no visible color. Reduces the appearance of haze in scenes with high UV content (seascapes and mountain landscapes). Can be used as a protective cover for lens. No exposure correction needed.	1×	1×
Neutral Density (ND)	Reduces amount of exposure on film. Used to provide larger apertures or longer exposure times for creative effect. Open one stop for each increment of 0.3 neutral density.	depends on density	
Filters for Color Films (See Filter Instructions for Exposure Corrections)			
Color Conversion	Designed for major changes of color balance to adjust the color of the illumination from a light source to a film of a different color balance. The 80A is a conversion filter used to correct the light from studio tungsten lights for use with daylight balance film.		
Light Balancing	Produces smaller changes in the color of the light. The 82 series filters are bluish in color and give a cooler color rendering. The 81 series filters are yellowish in color and give a warmer color rendering. The 81A filter is often used to remove some of the blue in light from overcast skies.		
Skylight	A pale pink filter that reduces some of the blue in subjects in open shade illuminated by light from a clear blue sky. Also absorbs ultraviolet light. Exposure correction less than 1/3 stop.		

*Filter factors given here are approximations to be used only as starting points for calculating exposure corrections.
NOTE: For a complete description of filters for both color and black-and-white films, see the Kodak publication B-3, *Kodak Filters for Scientific and Technical Uses.*

CONVERSION FROM FILTER FACTOR TO STOPS

Filter Factor	1	1.3	1.6	2	2.5	3	4	5	6	8	10	12	16	32
Open up (Stops)	0	⅓	⅔	1	1⅓	1⅔	2	2⅓	2⅔	3	3⅓	3⅔	4	5

Close-Up Photography

Normal lenses designed for most single-lens reflex cameras will focus reasonably close to the subject, usually about 18 inches away. At this distance the amount of subject shown covers an area approximately 6 × 9 inches with a 35mm camera. Anything closer than this requires special equipment and techniques and is generally called close-up photography.

The size of the image produced on the film can be compared with the size of the original subject, given in the form of a ratio. The size of this ratio indicates the magnification of the subject. Magnification of the subject is increased by moving the lens closer to the subject.

For example, the image dimensions of a 35mm negative are about 1 × 1.5 inches (24 × 36mm). If the subject size included is about 6 × 9 inches (144 × 216mm), the image is 1/6 the size of the original subject. The magnification is therefore 1/6 and the image ratio is 1:6.

If the image on the film is the same size as the subject, the image ratio is 1:1. If the image is larger than the sub-ject, the magnification is greater than one. An image ratio of 2:1 means the image is twice as large as the subject—the magnification is 2×. On a 35mm negative the subject area covered at 2:1 would be 0.5 × 0.75 inch (12 × 18mm).

To focus closer with a lens, which increases the magnification, the lens must be moved farther from the film. The distance between the lens elements and the film—the lens extension—needed depends on the focal length of the lens, with longer focal length lenses requiring more extension for the same image magnification.

If the focus mechanism built into a lens has been extended to its maximum, other techniques must be used for increasing the lens-to-film distance. These are called **photomacrography** (which most photographers call macrophotography) techniques. Photomacrography seldom produces image magnifications exceeding 3× or 4×, although somewhat higher magnifications can be achieved with difficulty.

Even greater magnification is possible by optically coupling the camera to the lens system in a microscope, a process called photomicrography. The greatest magnifications are achieved by photographing the electronic image produced by electron microscopes. Photography's ability to record these unusual views of nature is one of its most fascinating and vision-expanding possibilities.

Photomacrography The tools and techniques required for photomacrography are usually within reach of the average photographer. Any of these techniques is most easily performed with single-lens reflex cameras with interchangeable lenses, though other cameras can be used with some difficulty in attaching accessories and viewing.

Tools for Photomacrography Four devices are used for closer focusing: macro lenses, extension tubes, bellows attachments, and supplementary close-up lenses. The first three work by increasing the lens-to-film distance, and the last one works by optically magnifying the image.

Any of these tools used for closer focusing can be combined for even greater image magnification. For example, extension tubes or a macro lens can be used in combination with a bellows. Supplementary close-up lenses can also be combined with lens extension devices up to a point, but the image deteriorates rapidly at higher magnifications.

Photomacrograph. Amy Lamb, *Peach* 1995. This photograph was taken with a macro lens.

© Amy Lamb

Techniques for Photomacrography The magnification of a photographic image creates exposure changes, depth-of-field changes, and camera and subject movement issues.

Depth of field becomes smaller the closer a lens is focused. At the focusing distances used in photomacrography, depth of field becomes so small that it is usually necessary to work at the smallest possible apertures, such as f/16 or f/22. Even then depth of field may be only fractions of an inch.

Any extension of the lens causes a reduction in the brightness of the image on the film. In photomacrography, these changes become appreciable enough that exposure corrections must be made.

The long exposure resulting from the small aperture and exposure correction for lens extension gives rise to two possible problems. The first is image blurring due to subject or camera motion. The second is reciprocity failure. Camera movement can be minimized by placing the camera on a solid tripod. Reciprocity failure can be compensated for using the chart in chapter 2 (page 37). Both problems can be alleviated by supplying higher illumination levels on the subject. Many photographers working in photomacrography use electronic flash to provide high levels of illumination and short exposure times. However, unless your camera has the capability of coupling with the electronic flash to meter and control the flash exposure, the exposure corrections for lens extension will have to be applied manually. The flash power or the distance of the flash from the subject is then changed until the desired aperture is achieved.

Exposure Corrections for Photomacrography (35mm Film). If you have a TTL viewing system, view a ruler marked in inches through the viewfinder and note the length of ruler visible across the long dimension of the frame. Reading across the table will give you the image ratio,

image magnification, and the necessary exposure correction, either in stops or as a multiple of the exposure time. The corrections are often made by altering the exposure time or, with flash, by changing its power or distance, since the aperture is usually kept small to provide depth of field. Supplementary close-up lenses do not require these exposure corrections. No corrections need be applied when metering through the lens with the close-up equipment in place.

LENGTH (INCHES)	IMAGE RATIO	MAGNIFI-CATION	OPEN UP (STOPS)	MULTIPLY TIME BY
½	3:1	3×	4	16.0
¾	2:1	2×	3⅓	9.0
1½	1:1	1×	2	4.0
3	1:2	½×	1⅓	2.25
6	1:4	¼×	⅔	1.56

Tools for Photomacrography. *Left: Macro Lens.* A lens with extra focusing extension built into the lens body is called a macro lens. A true macro lens is also optically designed for working at very close focusing distances and will usually provide a 1:2 image ratio without additional attachments, at the same time having the capability to focus on objects at infinity. Some macro lenses feature up to a 1:1 image ratio with the built-in focusing. Many lenses offering a "macro" feature are not true macro lenses (see page 57).

Right: Extension Tube. Extension tubes are metal tubes designed to fit between the lens and the camera body and are therefore custom designed to fit the lens mount of the camera. They normally come in sets of several different lengths so that a range of image magnifications can be chosen. Some extension tubes contain the necessary coupling levers for the operation of the automatic diaphragm; others may not. If automatic diaphragm operation is not supported, focusing and composing must be done by opening up the aperture, then stopping down to the desired aperture before shooting.

Left: Bellows Attachment. The bellows attachment is mounted between the lens and the camera body and has a flexible bellows that allows easy choice of lens extension. With a normal lens on a 35mm camera a bellows will usually offer image magnifications from about three-fourths life size to three times life size. Because of the minimum extension introduced by the bellows with lens and camera mounts, a lens mounted on a bellows cannot be focused on more distant subjects. Although more flexible than extension tubes, bellows attachments are typically more expensive, more delicate, and somewhat more clumsy in operation.

Right: Supplementary Close-up Lenses. These are attached to the camera lens like filters but have curved surfaces to produce a magnification of the image. Supplementary lenses may often be the cheapest way of getting into close-up photography, but the introduction of additional lens elements deteriorates the image quality, especially at the higher image magnifications in macrophotography. For better image quality, use the more expensive two-element supplementary close-up lenses available from a few manufacturers.

Special Films

A few photographic films are available for special uses. These were originally designed to solve specific scientific or technical needs, but the resultant image modifications can provide alternative renditions of subject matter for the creative photographer.

Infrared Film Infrared films are specially designed for sensitivity to the invisible infrared wavelengths of light near the red end of the spectrum and are available in both black and white and color. These near-infrared wavelengths are not the longer wavelengths associated with heat. Special electronic techniques are needed to record the effect of heat infrared. Photography with infrared films therefore requires illumination of the subject by light containing infrared, which includes sunlight, tungsten light, and electronic flash.

Infrared film requires special handling. Since the 35mm film cassettes allow the passage of some infrared, the film must be loaded into the camera in total darkness, and the film cassette itself must never be exposed to light. Exposure of infrared film is somewhat difficult to determine, since photographic light meters do not indicate the amount of infrared light coming from a subject. Guidelines for determining exposure are supplied in the data sheet that comes with the film.

The lens focuses infrared rays differently than visible light, so adjustments must be made to the distances marked on the focus scale of the lens. Some lenses have a small red mark for focusing for infrared, but this is only an

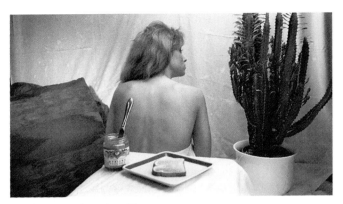

Panchromatic Film without Filter.

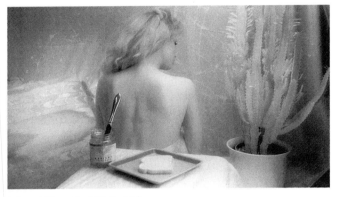

Infrared Film with 25A Red Filter.

Infrared Film with 87A Filter.

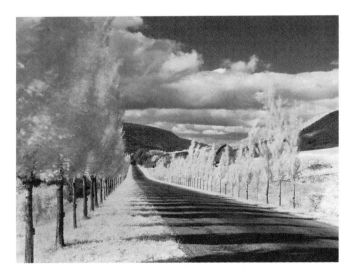

Infrared Film. Minor White. "Vicinity of Naples, New York," from *Sequence 10/Rural Cathedrals*, 1955. Taken on 4 × 5-inch infrared film.

© 1982 The Trustees of Princeton University, Courtesy of the Minor White Archive.

Filtering with Infrared Film. Since infrared films are also sensitive to visible wavelengths, the effect of the infrared on the film can most easily be seen if other wavelengths are filtered out by a deep red filter, such as a 25A or a 29. Filters that absorb most visible light but allow infrared to pass, such as the 87A, can also be used, but on single-lens reflex cameras such a filter would not allow composing or focusing through the lens. For flash photography the 87A filter can be placed over the flash instead. When the flash is fired, no visible light will result but enough infrared will be supplied to the subject to provide illumination for the infrared film.

© Bognovitz.

approximation, since the amount of focus correction depends on the focused distance and the aperture.

The qualities of infrared film are clearly shown in the illustrations and include a noticeable grain structure. This can sometimes be used to good effect, but if it is bothersome a larger-format camera should be used to produce a larger negative. Color infrared films will produce a variety of false colors depending on the filtration and are widely used in scientific photography, especially in satellite studies of vegetation.

High-Contrast Film General-purpose films are called continuous-tone films, which means that they reproduce somewhat faithfully most of the tones in a subject. High-contrast films are designed to produce images from normal subjects that show only two tones in the print, black and white.

An example of a high-contrast film that can be used in 35mm cameras is Kodak Technical Pan. Developed in an active developer such as Kodak D-19, Technical Pan will produce a high-contrast image. Developed in Kodak Technidol developer, it gives a continuous-tone image. Images originally made on continuous-tone films can be modified by copying onto high-contrast sheet film designed for darkroom use, such as Kodalith Ortho Type 3.

Ultrahigh-Speed Films Several films with ISO numbers of 1600 or higher are available today, both in color and in black and white. High-speed films may also be push-processed for similar effect. The primary purpose is to allow low-light photography, but grain structure will also be coarse. Grain may carry emotional messages that can complement an image. Grainy black-and-white images may have a gritty feeling of reality, perhaps because of the widespread use of high-speed films in photojournalism.

Color Infrared. NASA. Color Infrared Aerial Photograph. Aerial infrared photographs clearly differentiate between urban and vegetated areas. Types of vegetation are easily distinguishable and even the health of vegetation can be determined. In this photograph of Jamaica, the various crops would appear as similar shades of green in a normal color photograph.

Courtesy of NASA.

Grainy color images often carry a romantic feeling for many viewers, especially if image diffusion and pastel color rendition are incorporated. See Ralph Gibson's photograph on page 122 for an example of grain as effect.

High-Contrast Film. Left: Print from Continuous-tone Film. Right: Print from High-contrast Film.

© Bognovitz.

■ Special Darkroom Techniques

After the film is exposed, a number of manipulations are possible during the processing to create effects different from the standard rendition. Even for normally processed films, an image can be modified through special printing techniques or by copying it onto special materials and then applying special processing techniques. The possibilities here are almost limitless. Refer to the many publications on special darkroom techniques—some of which are included in the bibliography at the end of the book—for more detail on these and other manipulations. Also see chapter 11 for an introduction to special image manipulations available electronically with digital images.

■ **HEALTH NOTE** Many of these darkroom techniques involve the use of chemicals or materials that may be health hazards. Take care in handling any photographic chemical, using hand and eye protection and good ventilation. Follow directions carefully. Contamination of some materials may release poisonous gases. For more information on health hazards, see page 63 and consult the bibliography.

Reticulation

Film reticulation is the result of extreme temperature variations during processing of the film. Although this may be an undesirable effect for normal image production, it has a wide range of creative possibilities for modifying the photographic image. For extreme reticulation effects, the film can even be frozen during processing or some of the processing solutions can be heated to high temperatures. The effects of reticulation are both permanent and unpredictable, so an element of chance is introduced into the creative process. When experimenting with the effects of reticulation, it may be more productive to make copy negatives of the originals by contact printing or enlarging onto sheet film in the darkroom and then produce the reticulation on the copy negative during processing. For an example of film reticulation, see page 67.

Sabattier Effect

The **Sabattier effect** is a result of exposing the film or printing paper to light partway through the developing step and then continuing the development and remaining processing steps. The outcome is a partial reversal of tones in the image. A thin line, known as the Mackie line, is also produced along boundaries between adjoining ar-

eas of dark and light subject tones. Variations of the amount of exposure during processing and the amount of development before and after processing can create a whole range of effects.

The Sabattier effect is often mistakenly called solarization, which is the result of gross overexposure of the film in the camera and produces a partial reversal of tones of similar appearance.

Print Sabattier may give a muddy effect unless carefully controlled, since no real highlight values are produced in the print. A mild bleach or reducer used on the print after processing will help to lighten the highlight areas.

In a variation of the print Sabattier effect, called *POP solarization*, the print is pulled from the developer; placed under the enlarger again, using a red filter over the lens to allow registering the print with the image; and reexposed to the same image a second time. This causes partial reversal in shadows and some midtones but leaves the highlights relatively clean and unaffected.

Film Sabattier Effect. Man Ray, Male Torso. Note the black line around the edge of the figure, an example of the Mackie line.

Print Sabattier Effect. *Danny Conant.*
Left: Unmanipulated print. This photograph was made on infrared film. Right: Print Sabattier effect.

© Danny Conant Photography.

Photomontage

Photomontage is the combination of parts of images from two or more negatives into one print. The simplest photomontage is the negative sandwich, in which two negatives are placed one on top of the other in the negative carrier at the same time and printed. A more controllable method for photomontage is to print multiple images from different negatives on one sheet of printing paper.

Photomontage. Jerry Uelsmann, Untitled, Photomontage, 1968. This photomontage was created by repeated printing of different images on the same sheet of paper. For each portion of the image taken from a different negative, the remainder of the paper must be masked or blocked from receiving light. This can involve as simple a technique as covering up the part of the print that you do not want to receive light—as in dodging and burning—or more complicated masking techniques using high-contrast sheet film materials.

© 1968 Jerry Uelsmann.

209

Continuous-Tone Negative Printing

To produce a continuous-tone negative print, make a standard positive image on single-weight paper. Once this print is processed and dried, it can be placed face-to-face with a new sheet of printing paper and exposed just as you would a contact print, with the light passing through the positive print to expose the new sheet of paper. Retouching and alterations can be done on the back of the positive print with pencil or dyes before printing. This method is quick and easy but does produce a considerable increase in contrast and will show some of the texture from the exposure through paper, as well as the brand names imprinted on the back of some papers.

For a higher-quality negative print, contact print the original negative onto a sheet of any continuous-tone film. Panchromatic sheet film can be used but requires working in total darkness and with short exposures. An orthochromatic or blue-sensitive continuous-tone film, such as Kodak Professional B/W Duplicating Film SO-132, will allow working under safelights. The resulting film positive can be printed directly to yield a negative print.

Photograms

Photograms are made by laying objects directly onto the printing paper and exposing them to light. Experimenting with objects of various translucency, moving objects during exposure, or suspending objects above the paper during exposure can produce a full scale of print tones and interesting images.

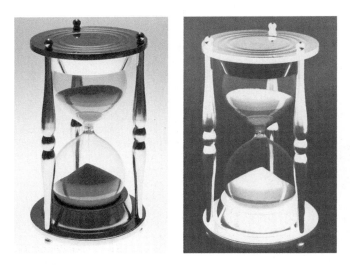

Continuous-Tone Negative Print. Left: Positive continuous-tone print. Right: Continuous-tone negative print from paper positive. Note that the image is reversed. This can be avoided by placing the negative emulsion side up when printing the original paper positive to give a reversed positive print.

Photos © Bognovitz.

Toning

After processing, black-and-white prints can be treated in toners to change the color. A great deal of variation can be achieved depending on the toner dilution, toning time, and printing paper used. In addition to the color change, some toners—such as selenium toner—also increase the life of the print and are part of standard archival processing techniques.

Hand Coloring Black-and-White Prints

A number of water-based or oil-based paints and dyes, including food colors, Marshall's oil paints, and acrylic paints, can be applied to black-and-white prints for selective coloration. Matte-surface papers accept hand coloring more easily than glossy-surface papers. The departures from reality possible with this process allow great creative freedom and provide a crossover area between photography and the visual media of painting and drawing.

Photogram. Man Ray, *Rayograph*, 1927.

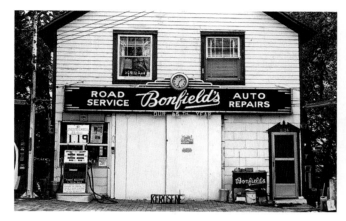

Sepia-Toned Print. Sepia toner produces brownish print tones.

Photos © Bognovitz.

Blue-Toned Print. Other toners are available to produce red, green, blue, and nearly any other desired color.

Hand-Tinted Black-and-White Photograph.
Allen Appel, *Kingbird with Flowers*.
© Allen Appel, Courtesy of the Kathleen Ewing Gallery, Washington, D.C.

CHAPTER 11

Digital Photography

Peter Garfield, *Siren*.

© Peter Garfield

Digital photography is the production, viewing, or reproducing of photographic images by electronic means. Today it is possible to produce photographs entirely electronically, without the use of traditional silver-based photographic materials. The images are produced in or converted to digital (numerical) form.

The use of digital cameras has begun to make inroads into the photography industry, with models ranging from consumer point-and-shoots to professional cameras. While today most photography is still done on traditional films with conversion to digital form as needed, we will soon have reasonably compact, moderately priced digital cameras that can compete with film.

Digital images have some advantages over traditional images. They retain their original quality no matter how often they are copied digitally. Since digital images are recorded as numbers, computers can be used to manipulate or alter them in ways that are difficult or impossible with traditional photographic materials. Digital images can also be easily transferred via the World Wide Web.

■ What You Need to Get Started

To create digital images, you will need a digital camera or a scanner (pages 214–15). Alternatively, you can use photofinishing labs or digital service bureaus to make scans from your existing traditional negatives, slides, or prints. One of the least expensive ways to get your photographs **digitized** is the Kodak Photo-CD, offered by most photofinishing labs (see page 215).

To work with digital images, you will need at minimum a reasonably fast computer with a generous amount of RAM and data storage. Most current computers have the capabilities to handle digital images for production of good quality prints up to 8 × 10 inches or larger. You will also need **digital image-processing** software, such as Adobe Photoshop®. Photoshop® is a sophisticated profes-

sional program, but there are many other smaller and less expensive programs that perform most of the image processing tasks you may need, for example Adobe Photoshop® Elements® (see page 216).

You will probably also want a computer printer, such as a photo-quality inkjet printer, so you can make printed versions of your digital photos. Service bureaus can also provide print output from your digital files in a variety of materials and processes (see pages 224–25).

If you wish to transmit your digital photographs electronically, you will need an Internet connection and browser or a removable storage drive, such as a CD burner.

More detail regarding each of these requirements can be found in the following sections.

Digital Darkroom. This is a modern, chemical-free darkroom using digital images. When performing color correction, black-out drapes are placed over the windows to control room illumination.

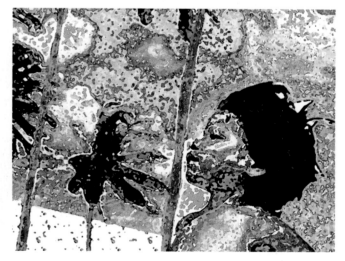

Maria Eugenia Poggi. Jijoca de Jericoa coara, Ceara, Brazil, July, 1994. This is a digitally manipulated and produced photographic image.

■ Digital Image Production

The five basic stages of image production (covered in the following sections) are: (1) creating the image; (2) storing the image; (3) viewing the image; (4) editing (modifying or correcting) the image; and (5) outputting the image.

These stages also apply to traditional photographic reproduction, though the order of the steps may vary. Digital imaging can be used at any one of these stages, with traditional means used for the remainder. For example, a photograph might be created, stored, viewed, and edited digitally, but output onto traditional materials (film or photographic paper) using digital output devices. Or, the photograph can be created traditionally on film, then scanned to produce a digital image, and the remaining steps performed digitally.

Creating Digital Images

Digital Image Structure A dot technique similar to that used in television or halftone printing is used for creating digital images. In a digital camera, the optical image formed by the lens falls on a solid-state electronic "chip" that contains a grid of light-sensitive elements. Each element, called a picture element or **pixel** for short, can measure the illuminance ("brightness") and the percentage of the additive colors of the light falling on it. This information is recorded as numbers. All of these numbers are recorded as a digital data file on computer storage devices. In order to view an image stored as numbers, the data representing the grid of pixels must be reassembled by a computer in a visible form, such as on a computer monitor or a computer printer.

Pixel Structure of Image. This digital image is magnified enough to see the individual pixels.

Resolution The quality of a digital image depends on how many pixels it contains and the size of the output (screen view or print). The combination of total number of pixels available in an image and the size at which it is output results in a specific number of pixels appearing per inch (ppi) or centimeter, known as the **image resolution.** The higher the resolution of an image (i.e., the more pixels appearing per inch), the better the image can reproduce detail.

Image Size in Pixels The desired dimensions of the image in pixels are a major consideration when choosing a method of creating digital images. As a basis of comparison, consider outputting a digital image to a computer printer. Most computer printers will produce photo-quality results from an image file with a resolution of 150 pixels per inch. If you wish to print an 8 × 10-inch print, you will need an image 8 × 150 = 1200 pixels wide, by 10 × 150 = 1500 pixels high, or 1200 × 1500 pixels.

Other types of output devices, such as offset printing presses or digital enlargers, may require more than 150 pixels per inch. If a device required 300 pixels per inch, the 1200 × 1500 pixel file above would print out at only 4 × 5 inches. To get an 8 × 10 print, you would need a file size of 2400 × 3000 pixels.

Color Mode The **color mode** refers to the way colors are represented in the digital image. The two modes you will most likely deal with in your digital darkroom are **grayscale** for black-and-white images and **RGB color** (Red-Green-Blue) for color images. See the color wheel on page 197 for information on how colors are formed using the RGB color mode.

Bit Depth: Bit depth refers to the size of the numbers that are used to represent the colors or shades of gray in the image. A **bit** is a single binary digit as used by computers and can only represent one of two numbers, so a one-bit image can only show two colors or shades of gray. Image software primarily works with 8-bit numbers, which provide 256 shades of gray in a grayscale image and millions of colors in an RGB image.

Digital Image Capture. There are two methods for creating digital images: (1) original digital images can be created with a digital (filmless) camera, and (2) photographs created using traditional materials and equipment can be converted to digital form with scanners.

Digital Cameras **Digital cameras** are developing at such a rate that it is difficult to predict the features and quality of image that will be available even within a year or two. Current cameras costing a few hundred dollars offer sufficient quality for production of 8 × 10 prints on photo-quality computer printers. This price range provides such features as viewing on a built-in LCD screen and the same metering modes and control over settings that film cameras do, including manual setting of f-stop and shutter speed. A few also offer connection to external flash. One advantage of a digital camera with viewing screen is the ability to edit images on the spot, reshooting as needed and deleting images you don't want.

The operation of a digital camera is nearly identical to that of a film camera, since digital cameras use lenses, metering, f-stops and shutter speeds as discussed in chapters 1–4. Access to controls is often different, being performed through menus viewed on the LCD screen, but the principles of making photographs remain the same.

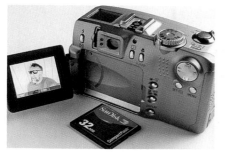

Digital Camera. This camera uses flash card media (foreground) for file storage, and has a flip-out LCD viewing screen that can be used for composing images or for controlling camera functions and managing images via menus.

Digital cameras are usually described by the number of pixels in the sensing grid of the camera. The larger the number of pixels, the higher resolution or output sizes the camera is capable of providing. A 2 megapixel camera would produce an image about 1200 × 1600 pixels, which is enough for a good quality 8 × 10 inch print from a photo-quality inkjet printer, as discussed on page 214.

Scanners A **scanner** passes a light-sensitive chip over the photograph to successively "scan" it and record the light values and color for each point of the image as a digital file. Scanners can be of the flat-bed type (commonly seen in offices) or dedicated film scanners. A flat-bed scanner must have transparency capability to scan film. Even then, better results are usually achieved with film scanners.

The resolution of the scanner refers to the number of pixels it can create per inch of the original. When comparing scanners, only **optical resolution** should be considered. Some scanner manufacturers advertise higher **interpolated resolutions. Interpolation** means that new pixels are mathematically created between the "real" optical pixels that the scanner produces, which does not give a poorer quality image than optical pixels.

The size and resolution of your finished print will determine the necessary scanner resolution. A 35mm negative or transparency is about one inch on its narrow dimension, so to achieve a 1200 × 1500 pixel file size, the scanner must scan at an optical resolution of 1200 pixels per inch. Today's consumer film scanners offer resolution up to 4000 pixels per inch, which would give higher resolution or larger print sizes.

An inexpensive alternative to buying a scanner is the Kodak Photo-CD, a CD-ROM disk providing five scans of each image, the largest of which is 2048 × 3072 pixels.

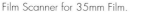

Film Scanner for 35mm Film.　　Kodak Photo-CD.

Storing Digital Images

Decisions about how to store (**save**) your digital images are governed by the size of the data files, the speed with which you can record and read the data, and the amount of money you wish to spend on storage media.

File Size File size depends on the number of pixels in the image, the color mode, and the bit depth and is measured in **bytes** (8 bits), kilobytes (1.024 bytes), or megabytes (1,024 kilobytes, usually rounded to one-million bytes). For example, a grayscale (8-bit monochrome) image 1200 × 1500 pixels would have a total of 1200 × 1500 = 1,800,000 pixels. Each pixel requires an 8-bit or 1-byte number, so the size of the file is 1,800,000 pixels × 1 byte/pixel = 1,800,000 bytes or about 1.8 megabytes.

If the image is in 24-bit RGB color, then three 8-bit binary numbers are needed for each pixel (one each for red, blue, and green) to record its tonal information. RGB files are therefore three times as big for the same image size in pixels. The 1200 × 1500 pixel image above would then require 3 × 1.8 megabytes = 5.4 megabytes.

File Formats The file format affects the size of the file as it is stored. There are several different file formats, used for various purposes. For working in your own digital darkroom or with service bureaus for individual print output, you need deal with only TIFF, Photoshop, and JPEG formats.

File size is reduced if the file is compressed. There are two basic types of compression, lossless and "lossy." Photoshop uses a lossless type of compression in its file formats. TIFF format also offers a lossless compression known as LZW. The JPEG file format, on the other hand, is a "lossy" compression, since it throws away data on compression, and attempts to reconstruct it on decompression. If you are working in Photoshop, use the Photoshop file format. For a more universal file type acceptable to service providers, use TIFF file format. If you need small file sizes, for example to send files over the Web, use JPEG format to compress them, keeping in mind that some image quality will be lost. Most digital cameras store image files in JPEG format, though some can be set to store in TIFF or other formats.

Storage Methods Once you know the basic size of your files, you can then decide which of the many storage devices are most appropriate for you. The hard disk built into your computer would normally be a first choice, but if you are working with large or high-resolution digital images, you may fill up even a large hard disk drive quite quickly.

Removable media offer the advantage that with one drive you can get unlimited storage by simply buying more media. The most commonly available currently are

magnetic media, such as Zip disks, or optical, such as recordable or rewriteable CDs, which are relatively slow, but very inexpensive.

Digital cameras and some portable computers use memory chips designed to record data. These may be removable, and are often called **flash cards** or **PC** (formerly PCMCIA) **cards.** Memory cards are very compact, but are extremely expensive per megabyte, and are generally used only for transporting the image from the point of creation to your computer.

Any removable media require their own drive, so the cost of both media and drive should be considered when choosing a storage method. New solutions to data storage appear regularly, so consult recent catalogs or vendors for the latest ones before you buy.

Flash Card Removable Media. On the left, a card is seen partially inserted into a digital camera. On the right is a flash card reader that can be attached to a computer for direct access to the images on the card.

Viewing Digital Images

The computer monitor is used for viewing the digital image while you are working on it. Most current models of monitors are of the **cathode ray tube (CRT)** type, but the **liquid crystal display (LCD)** screens that have been used for several years in portable computers are now also available for desktop use. Large screens are very convenient for digital imaging, since in addition to the image itself, the screen must display menus, tool boxes, and other information.

Computer monitors produce a video image, which consists of dots of red, blue, and green light. The dots are used to represent pixels on screen. The resolution of the monitor is the number of pixels it can display horizontally and vertically. Standard resolutions are 640 × 480, 832 × 624, 1024 × 768, and 1280 × 1024 pixels. The resolution of most monitors is adjustable. While it may sound advantageous to run a monitor at its highest resolution, in fact, the type, menus, and information boxes displayed on the screen will appear smaller at higher resolutions. That means you can fit more on your screen, but you might be straining your eyes to see the information. A 17-inch monitor at 832 × 624 pixels gives comfortably sized type and menus. People with good close-up vision may be able to work at 1024 × 768 pixels as well.

Editing Digital Images

Editing a digital image means correcting tonal values, color, detail, and image flaws. It can also mean manipulating the image by combining it with other images or applying special effects to radically modify the appearance of the image.

Image-Editing Possibilities The traditional processes of lightening, darkening, contrast control, burning, and dodging can all be performed digitally on a computer. In color images, both overall and local color balance can be controlled. Special darkroom techniques such as photomontage, Sabattier, posterization, negative image, and others can be reproduced or emulated digitally. A special strength of digital imaging is its ability to seamlessly combine two or more images into one. Not only can these techniques be performed digitally, they can be done with much greater precision and control than is possible in the traditional darkroom. A variety of digital imaging tools allows you to select specific areas of an image for treatment, with precision down to the pixel.

Special effects routines (called **filters**) in digital imaging may mimic traditional special effects or may produce new effects that are impossible to achieve traditionally. Controls over image sharpness, such as simulated motion blur or focus differences, are grouped with the special effects filters.

Once you experience the amount of control, flexibility, and visual possibilities digital image editing offers, you may find it hard to go back into a chemical darkroom. Nevertheless, currently it is difficult to achieve print output from the computer that matches the visual qualities of traditional printing materials, such as high-quality black-and-white silver papers, platinum prints, and others. However, digital imaging can be used as an intermediate stage for producing prints on traditional materials. Most nonsilver processes, for example, require an enlarged negative for contact printing, which can be created using digital methods.

Image-Editing Software The software used on a computer to perform editing operations on a digital image is called image-editing software. Adobe Photoshop® is an example of professional image-editing software. There are numerous other less expensive brands on the market, but most of them closely emulate the basic operations of Photoshop®, though they may not offer as many features.

Image-editing software in general is demanding of computing resources, such as hard disk space and RAM. The hardware requirements given by the software manufacturer are a minimum requirement, so if you will be working with large files you will want to increase your memory and storage space well above the manufacturer's requirements.

Image-Editing Tutorial The following tutorial will guide you through some of the digital editing possibilities. We will start with the tools and filters that are useful in producing straight, unmanipulated images, such as tonal and color controls, as well as basic spotting and retouching tools. The tutorial will then continue with a few of the special effects possible with digital imaging, and will also demonstrate some compositing techniques, where two or more images are combined into one. This tutorial was performed in Photoshop®, but if you are using a different image editor, you will probably find identical or similar procedures. Most image-editing programs have a number of alternate keyboard commands for menu items and tools. Because of the differences in programs, this tutorial uses the menus and tools rather than keyboard commands, but you will work faster if you learn the keyboard shortcuts that your program offers.

1. **Acquiring the image.** Your image can be from a digital camera or scanned from a traditional print. The image in this tutorial was originally taken as a 35mm slide, which was scanned on a 35mm film scanner.

2. **Opening the image.** Click on the File menu and select Open. Navigate through the Open File dialogue box until you find your file on disk. Click OK.

3. **Saving the file.** The file is probably an RGB file, but may be in TIFF, JPEG, or another format. Choose File/Save As . . . to open the Save File dialogue box, and save the file in the format recommended by your image-editing software, for example Photoshop's proprietary file format. If you want to retain the original scan or source file, you should save the file under a different name. As

Step 2: Open File Menu Choice.

you are working on the file, you should periodically choose File/Save to save your latest changes to disk.

4. **Viewing and navigating the image.**

 4a. Screen magnification: Several tools are available for changing the magnification of the image on the screen and for navigating through the image if it is bigger than your monitor screen. When the image is opened, it will normally be displayed so that the entire image is visible on screen. To magnify the image, choose the Zoom tool by clicking on it, then click on the area of the image you wish to magnify. Successive clicks will continue to magnify the image. To reduce the size of the image displayed, hold down a control key (Option on Mac, Alt in Windows) and then click with the Zoom tool. Zooming does not change the file itself, but only your view of the image.

 4b. Moving through the image: Select the Hand tool (also known as the Pan tool) by clicking on it. You can now click and drag with the mouse button to move through the image. Another method is to use the scroll bars to navigate through the image.

Step 4: The Image-editing Screen.

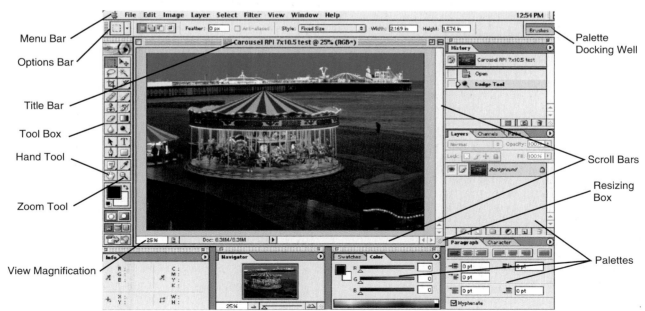

Step 5b: Choosing Transform/Rotate from the Menu Bar.

Step 5c: The Rotation Symbol just Outside the Transform "Handle." The blue line is an alignment guide.

Step 5e: Above: **Selecting the Crop Tool from the Tool Box.** Right: **The Straightened Image with the Crop Selection Box Roughly Positioned.**

Step 5f: Resizing the Crop Selection Box by Click-dragging the Handles.

5. Straightening and cropping the image. This image is slightly crooked. To straighten, perform the following steps:

5a. Drag the resizing box in the lower right corner of the image window to give some room around the image to work. Select the entire image by choosing Select All from the Select menu on the menu bar. You will see crawling dotted lines around the image indicating that it is selected.

5b. Choose Transform/Rotate from the Edit menu. Now the selection box changes to include little squares at its corners and edges. These are called **handles** and can be used to change the image inside the selection box.

5c. Move the cursor just outside one of the corner handles and you will see it change to a curved double arrow. This is the rotation symbol. Some image-editing software provides horizontal and vertical guides that you can position for alignment. The blue lines in the image are guides that we have inserted to get the subject matter straight.

5d. Click and drag with the mouse button depressed to rotate the image. In a few seconds the image will redraw in the new position. If it isn't exactly where you want it, move it again. Don't worry about the jaggy lines at this stage. These will clean up when you finalize the rotation. Hit return or double-click inside the selection box to finalize the rotation. Choose Deselect from the Select menu to clear the selection.

5e. The image is now straight, but the borders are crooked, so we will clean these up by cropping the image around the border. Choose the Crop tool from the Tool Box. Click the Clear button in the Options bar and then click-drag a box approximately where you wish to crop.

5f. The size and position of the crop selection box can now be changed using its handles to reposition corners or sides. You can also click-drag inside the box to move the whole box. When you have the box correctly positioned, hit Return or double-click inside the box to complete the crop.

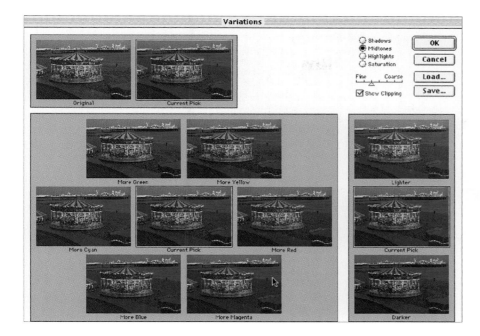

Step 6a: Above: **The Image/Adjust Menu Selection of Tonal and Color Adjustments.** Left: **The Variations Dialogue Box.**

6. Overall color and tone correction. In this step we are going to analyze and correct the overall lightness/darkness of the image, its overall color balance, and its overall contrast.

 6a. First analyze the image to see if there are noticeable image quality flaws. Look at the light values and see if they are convincingly light without losing detail. Look at the dark values and see if they are richly dark without losing detail in important areas. Look at the overall color of the image and see if it has a noticeable **color cast** toward any one particular color. For those of you who are first learning color correction, Photoshop offers a useful analysis tool called Variations, found under the Image/Adjust menus (see the illustration above). Variations shows you the effect of changing any one of the six additive and subtractive colors. It also shows you lighter and darker images, but does not address contrast. Variations will also perform the correction if you click on the image that you think has improved color, and then click OK. However, these color and tonal changes are available as separate tools that offer far more control, so it is better to use Variations only as an analysis tool and click Cancel to exit without making the changes.

 6b. Once you have determined the corrections you want to make, there are several options for making corrections. These are also found in the Image/Adjust menus. Color Balance gives a lot of flexibility in changing the overall color of the image by way of sliders, boxes, and buttons that choose whether midtones, shadows, or highlights are being altered. Adjust the values until you get the best effect. With Preview on, you can see the changes as you make them.

 6c. To change overall brightness and contrast, choose Image/Adjust/Brightness/Contrasts. . . from the menus. This is a simple dialogue box where one slider controls brightness and the other the contrast.

 6d. Between Color Balance and Brightness/Contrast you can probably get a pleasing overall appearance of the tones and colors in the image. For more precise control, however, advanced users prefer the use of Levels and/or Curves, found on the Image/Adjust menus. See the boxed section for a short introduction to the use of Levels and Curves on the next page.

Step 6b: Correcting Color Casts in the Image Using Image/Adjust/Color Balance.

Step 6c: Changing the Brightness and Contrast of the Image using Image/Adjust/Brightness/Contrast.

Levels and Curves

Levels and Curves are more precise methods for adjusting both the tonal values (brightness and contrast) and the color balance of an image. Both Levels and Curves have a Channel menu at the top of the dialogue box that allows you to choose RGB, Red, Green, or Blue. When working in the RGB channel, all colors are affected equally by changes. Individual colors can be changed by selecting their respective channels.

In the Levels box, changes are made by dragging the triangles under the tone graph (called a histogram). In this case the highlight slider has been dragged down to give brighter highlights and more contrast.

In the Curves box, changes are made by clicking and dragging on the line in the graph to change its shape. In this case, the top (highlight) end point has been dragged to the left, and the bottom (shadow) point to the right to brighten highlights, darken shadows, and increase contrast. Dragging the middle of the curve lightens or darkens midtones. Here the middle of the curve has been dragged up to lighten midtones. ■

7. Changing local areas. One of the strengths of digital image editing is the ability to work on specific areas of the image. There are tools that can be used like brushes to make changes in the image. There are also selection tools that allow you to select specific areas of the image. Only selected areas are then affected by changes.

7a. Local tools: Burning, Dodging, Sharpen, Blur. These tools are applied by "brushing" them onto the image by click-dragging with the mouse. The size and hardness of the brush can be selected in the Brush palette. The options for each tool allow you to apply the tool at 100 percent effect, or reduce the percentage so less effect is achieved with each pass of the brush. With options, you can also get special effects from some tools by choosing an application mode.

Step 7a: Dodge Tool. Lightening an area using the Dodge tool with a 65 pixel soft brush.

Step 7a: Setting Tool Effect. The Dodge tool has been set at 50% effect in the Options bar (Options palette in some software versions).

Step 7a: Setting Application Mode. Special effects can be achieved with some tools by using the application mode menu in the Options bar.

Rectangular Marquee

Oval Marquee

Lasso (freehand)

Magic Wand

Quick Mask

Step 7b: Selection Tools Available from the Tool Box.

7b. Selection tools: There are a number of selection tools available. The Rectangular Marquee tool can be used to drag selections that are rectangular. Hold down the Shift key to make a square. The Elliptical Marquee creates oval selections by dragging. Holding the Shift key down while dragging produces circles. The Lasso tool allows you to click-drag with the mouse to draw a selection freehand. The Magic Wand will select any contiguous areas with close to the same tonal values as the spot you click on. The Quick Mask tool allows you to add and subtract from a selection using the brush tools.

7c. Feathering the selection: You can soften the edges of the selection so that changes will blend into the surrounding image by "feathering" the selection. Choose Select/Feather. . . , and the dialogue box shown in the illustration below will appear. Choosing larger feathering values in pixels will cause the selection to be blended into its surroundings over a wider area.

7d. When a selection is active, any changes you make, such as painting or correcting tones or color, will only affect the selected area. This gives you control over the appearance of specific areas of the image, which would be difficult or impossible to achieve using traditional darkroom techniques.

Step 7b: Lasso Tool. Click-drag along the border of the area you wish to select. When you release the mouse button, it will complete the selection with a straight line back to your starting point.

Step 7b: Magic Wand Tool. Clicking once in the area we wished to select produced this result. The white specks inside the area did not get selected. Results with the Magic Wand can be adjusted by changing its tolerance setting in the Options palette.

Step 7c: The Select/Feather . . . Dialogue Box.

Step 7b: Quick Mask Mode. Top: Clicking on the Quick Mask icon changes any unselected area to a mask (shown here as red). The mask can be added to by painting on the image with black (which shows as red). You can subtract from the mask by painting in white. Here we are adding to the mask (i.e., subtracting from the selection) by painting with black in the lower left corner. Bottom: Once you have cleaned up and adjusted the mask, clicking on the Standard Selection icon to the left of the Quick Mask icon returns you to the crawling dashed selection line.

Step 7d: Using a Selection to Change a Local Area. Here the Brightness/Contrast menu choice has been used to increase both brightness and contrast of the selected area. Color Balance, Curves, Levels, or any other control can also be used to change the selected area without affecting the remainder of the image.

Step 8: Sharpening Using Unsharp Mask.
The first image to the right is the sharpness of the raw scan. The far right image is with Unsharp Mask set for the values in the dialogue box shown above.

8. Overall sharpness corrections. Sharpening is a procedure unique to computer image editing. By increasing the contrast between edges in the image, sharpening is able to make the image look more in focus. Care must be taken when sharpening not to overdo it, since the result may be a harsh unrealistic look, with the creation of **artifacts** (undesirable pixels not part of the original image). There are several sharpening methods in use, but the most controllable is Unsharp Masking. In spite of its contradictory-sounding name, Unsharp Masking increases the sharpness of an image. To judge the effect of sharpening, use the Zoom tool to change the view magnification so that the screen image is slightly larger than the print of it will be. For maximum screen sharpness, use view magnifications in ratios of two with 100% (e.g., 25%, 50%, 100%, 200%, etc.). Choose Filter/Sharpen/Unsharp Mask from the menu. Experiment with the settings in the Unsharp Mask dialogue box until you get a result that is acceptable.

9. Cleaning up the image. Another of the outstanding features of digital image editing is its facility at spotting and repairing image flaws, such as dust marks, scratches, and damage. The Rubber Stamp tool (also known as the Cloning tool) is what makes this possible. It picks up part of the image and paints it into another part, at a distance that you define. To clean up your image, perform the following steps:

9a. Use the Zoom tool to achieve a view magnification that gives a screen image at least two or three times the printed image size.

9b. Choose the Rubber Stamp tool from the Tool Box. In its Option palette or bar choose Normal, 100%, Aligned turned on. Hold the Option (or Alt) key down while you click near a defect in an area you wish to copy on top of the defect. Let up on the Option (Alt) key and then click-drag over the defect to "paint" it out.

9c. The Cloning tool can also be used for repairing scratches or damage and replacing missing parts of the image. Cloning is also a useful special effects tool. Parts of an image can be copied back into itself or into another image.

Step 9a: Zoom In for Cleanup.

Step 9b: Cloning Over Defects with the Rubber Stamp Tool. The crosshair is the area the tool is copying from. On the right is the same area after cleaning up with the Rubber Stamp tool.

Step 9c: Extending the Image with the Cloning Tool. This area of black at the lower left of the image was left in the rotation step. The Rubber Stamp tool is used to copy image information into the black area.

The Finished Photograph. In addition to the steps in this tutorial, many other corrections and enhancements have been performed on this im- age. Hue and saturation of the yellow/orange lights were increased. The sky was selected and color corrected separately, and so on.

© Bruce Warren.

Special Effects Digital image-editing software contains a myriad of techniques for radically altering the straight photographic image. These range from effects that mimic traditional special effects, such as sabattier, posterization, high contrast, hand painting, blur, and others, to wild effects that are only possible using the computer. Some special effects can be achieved by manipulating the controls on the Image/Adjust menu, such as curves. Others are listed on the Filter menu, and consist of routines for altering the image by distortion, mimicking artwork, adding noise, and so on. Some of these filters come with the image editor, but there are also hundreds of special effects filters available from third-party software companies. These may operate as a **plug-in** to your image-editing software, meaning that they can be accessed from within your program.

Special Effects Using Image Editing Software. Left: The unmanipulated image. Center: Use of Curves to radically change color and tone by dragging each of the channels into distorted shapes. Right: Radial Blur was chosen from the Filters menu and set for the spin effect.

All photos © Bruce Warren.

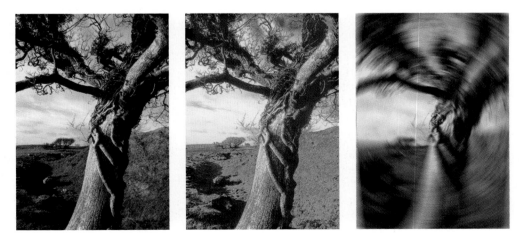

Combining Images (Composites) Another of the strengths of digital image editing is the ease with which images can be combined with each other (composited). What required laborious multiple exposure, multiple printing, collage, or montage techniques with traditional photographic materials can be accomplished easily with the selection tools and Cut and Paste commands.

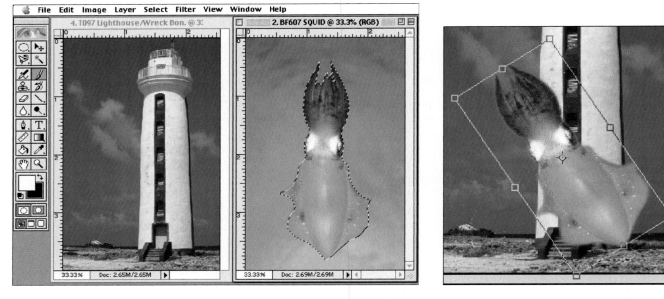

Simple Composite. On the left, we see both images open and displayed side-by-side. The squid has been selected using the Lasso and Quick Mask tools, and feathered to help it to blend with its new environment. To move it to the other image, choose Edit/Copy, then activate the lighthouse image by clicking on it and choose Edit/Paste. Some programs will allow you to simply click-drag the selection from one window to the other. Right:

Positioning and Sizing. In Photoshop, the squid is automatically pasted in as a new layer. Choose Edit/Free Transform, and the imported object will be enclosed in a box with handles with which you can resize, stretch, move, and rotate the object until you get it where you want it. Hit Return to finalize the transform.

Images © Bruce Warren.

Outputting Digital Images

Viewing a digital photographic image on a computer monitor may be a widely used method, but quality output of digital images requires that they be printed to paper. Photographs on paper are also easily viewed under a variety of conditions, and do not require a computer and monitor. The possibilities for outputting digital photographs are outlined here, along with some suggestions for improving your print output.

Output Methods A wide variety of equipment and materials are available, and your choices can heavily affect the resultant quality. The possible routes for printing digital photographs on paper include **computer printers** and **digital enlargers.**

Computer Printers Computer printers are available in several types, but the most common are inkjet, dye sublimation, and electrostatic (usually called laserjets).

Inkjet printers spray dots of ink on paper and are very suitable for printing photographs. Their advantages include good image quality and color reproduction and moderate prices. Their disadvantages include high cost per page for materials (ink and special papers). In the past, inkjet prints had poor print durability and longevity, but the latest generation of photo-quality inkjet printers used with the correct inks and papers provide print life comparable to or better than traditional photographic prints. Some service bureaus offer Iris inkjet printing, which is a superior method of printing with inks. The Iris printer has the advantage of being able to print large prints on almost any stable, flexible medium. Many photographers have their photographs printed by the Iris process on heavy, high-quality water-color papers, as well as other more exotic papers. Some desktop inkjet printers will print on a variety of papers, including water-color papers, as well.

Computer Inkjet Printer.

Dye sublimation printers give the best photographic quality for computer printers, but are expensive to purchase and have a high cost per print for materials. Many service bureaus can make dye sublimation prints for you from your digital files.

Electrostatic (laserjet) **printers** use a technology similar to that of photocopiers. They do not give very good photographic quality and are relatively expensive, especially for color. Their advantages are speed and low cost per page for materials.

Digital Enlargers Digital enlargers currently supply the highest reproduction quality photographic prints in large sizes, by printing digital files directly to traditional photographic papers. The LightJet 5000, for example, uses red, green, and blue laser beams to expose the paper directly in print sizes up to 50 inches square. These machines are very expensive and require processing facilities for traditional print materials. They can print on any light-sensitive paper that can pass through their roller system, such as type-C materials and Ilfochrome. A few labs have been successful at printing black-and-white RC papers in digital enlargers. A number of service bureaus offer prints from digital enlargers.

Techniques for Successful Printing If you are printing on your own computer printer, for example an inkjet printer, you can improve the quality of your printing output by the choices you make in materials, by testing your equipment and materials, and by the image corrections that you perform with your image-editing software.

The *printer medium* (paper) that you choose is perhaps the single most important factor in getting quality output from your printer. Most printer manufacturers market printer media under their brand names, and generally these work well with the same brand printer. You may be able to use other brands of paper in your printer, but you may have to experiment with the printer software settings and run a number of tests to determine the best settings for each paper. Several photographic paper manufacturers are now marketing inkjet papers (e.g., Kodak, Fuji, and Konica), and these have the look, surface, and weight of traditional photographic papers. Of course, the finer the paper, the more it costs.

Testing and calibration of your monitor and printer are other ways to ensure predictable quality output. To calibrate your monitor, use a calibration utility such as Adobe Gamma, or the monitor calibration utility supplied by your operating system. For testing your printer, choose a digital image with a wide range of colors and tones as a test image. You may find that your image-editing software includes a test image for printing. In addition to a photographic image, most test files also incorporate color patches and grayscale step wedges to help you determine the accuracy of your printer's color reproduction. Print out the test file, and compare the results to your monitor. The printer software controls for good printers will allow you to introduce corrections for any differences you see.

The testing that you do for your own printer will probably not apply to images that you deliver to a service bureau for output. Talk to the service bureau about controlling the quality and color of the output. The bureau may be using a color management system, such as ColorSync, and may give you profile files to make color more predictable.

Color and tonal corrections can be made with your image-editing software once you have tested and standardized your system for the output you plan, using your monitor as a fairly accurate guide to what the print output will look like. No matter how much testing and calibration you do, the monitor image will never look exactly like the printed piece, but with practice you can learn to predict results with reasonable accuracy.

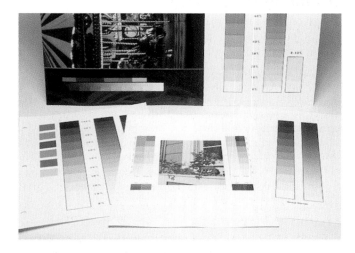

Sample Computer Printer Tests.

■ Electronic Distribution of Digital Images

One great advantage to digital photographs is that they can be transported easily in electronic form. You can record images on storage media, like magnetic or optical disks, and send them to others to view on their computer. You can also send and receive digital images over phone lines or via satellite using **modems**. If you wish to distribute your photographs electronically, the easiest ways are to put them on magnetic or CD-ROM disks or to make them available on the World Wide Web by placing them on a Web site or attaching them to e-mail.

Image Disks

Placing photographs on CD-ROM or magnetic disks is becoming an increasingly cheaper method of distributing images. Many film processing companies can put your images on disk for you, and some include a software viewer on the disk, which lets people view the images as a slide show. It is also possible to put sound and video clips on the disks, but of course the price goes up as you make the disk more complicated. This is the basis of multimedia disks, which contain images, text and sound, and are usually interactive, allowing the viewer to navigate through the contents of the disk by clicking on menu choices or graphic "buttons."

An alternative is to publish your own disks. Freeware or inexpensive shareware programs (such as QuickShow) can be included on the disk for viewing ease. Check the licensing requirements of the software to be sure that it is legal for you to include it on your disks. The disks can be magnetic, but CD-ROM is a popular choice for distributing images. You can make your own CD-ROMs by purchasing a CD recorder. These are currently reasonable in price and record on very inexpensive media. The recordable CDs are not as permanent as the professionally produced CDs, however, so if you are looking for a more permanent medium, you may want to have a CD master disk pressed by a service bureau. Permanent copies can then be produced from the master in larger quantities. One nice thing about CD-ROM disks is that they can be produced with cross-platform readability, so that your images can be viewed on either IBM-PC or Macintosh computers.

The file format you use is determined by the viewing software that you place on your disk. To conserve disk space and make image viewing quicker, small file sizes are usually desirable. These can be achieved by reducing the resolution of the image to screen resolution (e.g., 72 pixels per inch), and by using compression, such as JPEG. Be sure to include your copyright on the disk and images (see the section on Copyright Law and Digital Imaging later in this chapter).

Using the World Wide Web

The **World Wide Web** (also known as the **Internet**) has blossomed almost overnight into an amazing vehicle for communication and distribution of information, including images. To quote Deke McClelland: "The Internet may well be the most chaotic, anarchic force ever unleashed on the planet. It has no boundaries, it has no unifying purpose, it is controlled by no one, and it is owned by everyone. It's also incomprehensibly enormous, larger than any single government or business entity on the planet. . . . In terms of pure size and volume, the Web makes the great thoroughfares of the Roman empire look like a paper boy's route." In other words, what a great opportunity both to see other photographers' work and to make your own available for viewing.

Access to the Internet To get on the Internet, you will need some equipment and services. You will need a computer with a reasonably fast modem to attach to your phone line. Get the fastest modem you can afford, since it makes Web surfing much faster and more enjoyable. You will also need an **Internet service provider.** These are springing up all over, and have many payment plans depending on the number of hours you spend on the Web. They range from international giants like America Online to local services, any of which give you complete access to the World Wide Web, but which may have varying services, features, and speed of access. You will also need an Internet browser, which is the software that allows you to navigate on the Web. The current most

CD-ROM Image Disk.

© 1997 Kieffer Nature Stock.

Web browser interface.

Image courtesy of Netscape 6.

popular browsers are Netscape Communicator and Microsoft Explorer. Your Internet service provider usually supplies you with a browser, and you can also **download** (copy to your computer) other browsers from the Web.

The Internet is organized into **Web sites,** which individuals or corporations set up so that they can be contacted via the Web browser. Each site has an address, and you can access the site by typing in the address in your browser. The Web is a remarkable resource for researching photographic topics.

Setting up Your Own Web Site

You can set up your own Web site so that others can find and look at your photographs via the Web. Some Internet service providers provide personal Web sites (sometimes called Web pages) to their customers. Your Web site consists of files that you can design to contain text, graphics, and images. You can have an opening screen (called the **home page**), which tells what your Web site is about, and on that screen you can have graphic "buttons" or highlighted text (known as **links**), which when clicked on, bring other files to the screen, or allow jumps within the same file to different sections. These links can even take the viewer to other Web sites. For example, you could have an opening screen with a "contact sheet" of your images. When the viewer clicks on any image, it could open a full-screen version of the image. Other links could provide a page with biographical detail or connect the viewer to another related Web site.

You need software such as Adobe PageMill or Microsoft Front Page to design the files for your Web site. Some word processors also include the capability of producing documents for use on the Web.

Web Page Design. This is the home page for the business Glass Garden Beads. The ovals at the bottom of the page are buttons linking with other pages in the Web site. Web page design and photograph by Chris Ward. Web site owner Cathy Collison.

© Chris Ward.

Preparing Photographs for the Web

It takes time to send data over the Web, so it is important that you keep your image file sizes as small as possible. In preparing image files for the Web, you are trying to achieve a balance between the size of the file (for speedier transmission) and the quality of the image that the viewer sees on his or her monitor. The following guidelines will help you make that balance work.

Size of the images is determined by the pixel dimensions of the image, not its size in inches or its resolution, since that is how the receiving computer monitor displays them. An image of about 400 pixels high by 600 pixels wide will fill all or a good percentage of most monitors, so size your images in pixels, according to how much of the screen you want them to occupy. You should start with an image that is at least 400 × 600 pixels in size so that you can then resize it to the desired number of pixels using your image-editing software.

Color mode of the images should be 24-bit RGB initially for the first steps of image editing, color correction, and sizing. When you adjust the color and tones in the image, keep in mind that the appearance at the viewer's end will depend on his or her monitor. If you are working on a Macintosh, you will see the images brighter than someone viewing the same file on an IBM-PC. Since the highest percentage of viewers on the Web are using IBM-PC compatible computers, you may want to keep in mind that the images will be darker on their machines than on your Macintosh. Some older computers may have 8-bit monitors, rather than the 24-bit monitors most computers come with today. That means the monitor can only display 256 colors, which will reduce the reproduction quality markedly.

Once you have made the initial color and tone corrections to the file, you may want to change its color mode to **indexed color** to reduce the size of the file. Changing to indexed color also reduces the quality of the image. An 8-bit indexed color image has only 256 colors for display, but takes up about one-third the file size. Image-editing software will allow you to change the bit-depth of the image when you change to indexed color, so you could choose fewer colors as well. A 5-bit indexed color image shows only 32 colors. See the illustrations on the next page for an example of indexed color.

Choosing the file type in which to save your images depends again on the balance between size and quality. The two image file types most widely used on the Web are JPEG and GIF. JPEG provides compression, and will work with 24-bit images to produce smaller files. Since JPEG is a "lossy" compression, the choice you make of JPEG image quality affects not only the file size but also the image quality seen after decompression. Experiment with different quality levels when saving as a JPEG to see what is acceptable to you.

You will probably not want to use JPEG quality lower than medium. GIF files provide compression which is lossless, but work only with indexed color files of 8 bits or fewer.

Your choice of whether to use JPEG or GIF needs to take into account the color nature of the photograph you are sending, as well as the viewer that it is reaching. If your viewer is working with an 8-bit monitor, sending 24-bit JPEG files is wasted, since they won't see the 16 million available colors anyway. In that case the GIF file may give even higher viewing quality than the JPEG. On the other hand, if your viewers are working with 24-bit monitors and you want them to see the images at the maximum number of colors, you should send them as 24-bit RGB JPEG files and use the higher levels of JPEG quality. If you have graphics or images that contain few distinct colors and no gradations between colors, you may be better off converting them to indexed color and saving them in GIF file format. They will then display faster, and will probably appear at higher color quality level on the viewer's screen.

In any case, you should always save the original 24-bit RGB full-size color image as a master file before doing any conversions to JPEG or GIF. That way you can return to the master file (which contains all the original data) if you change your mind about size, compression, or indexed color choices.

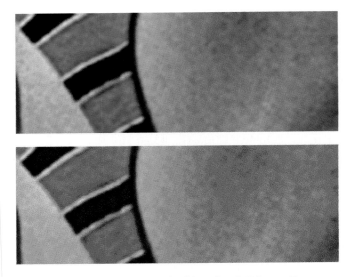

Comparison of 24-bit Color and 8-bit Indexed Color as Seen on a Computer Monitor. These are twice life-size sections of images displayed on the monitor at 100% (i.e. pixel for pixel) magnification. The millions of colors possible with 24-bit color (top) provide smoother tones, especially in the skin. Reducing the number of colors to 256 in the 8-bit indexed color image (bottom) produces coarser tonal gradations and the appearance of slightly more contrast.

© Bruce Warren.

■ Ethics and the Law in Digital Imaging

Photographers and users of photography have always had a number of ethical and legal issues with which they must deal. The primary ones are the issue of copyright, which governs the ownership and usage of creative materials, and the issues of accuracy and honesty in reporting events by photographic means. The advent of digital imaging has not really changed these overriding concerns. What it has done is to make it easier to violate the legal and ethical guidelines that have been adopted over the years.

Truth and Photography

Accurate and honest reportage with the camera has always been problematic. The adage that "a photograph never lies" has been proven false many times. Photographers and picture editors have used a myriad of techniques to mislead the viewer of a photograph. Taking a subject out of context by careful framing or cropping, for example, is a simple way of giving the wrong impression of a person or event. Choice of lighting or camera angle, or the capture of a fleeting expression, are other ways of influencing viewers' responses away from a truthful rendering of the situation. Photographers have posed their subjects to give misleading impressions. Even from the early days of photography, some enterprising propagandists have found that outright manipulation of the photographs by cutting and pasting, rephotographing, retouching, or multiple printing techniques could present a completely false view of reality. Digital image editing makes this manipulation process not only easier, but virtually undetectable in published photographs.

While people may readily accept manipulation of photographs in fine art photography or in advertising, they place the photojournalist under stricter ethical expectations. When the *National Geographic* digitally moved the pyramids of Giza so that the photograph would better fit on its vertically formatted cover, many readers were outraged by what they considered to be an untruthful ren-

Bending Reality in an Advertising Photograph. Zach Burris. In this catalog cover photograph, image-editing software was used to make summer clothing look like a frozen treat.
© Lands' End. Inc.

Copyright Law and Digital Imaging

The fact that an image is digital in nature does not change its protection under the copyright law. The creator of the image holds the copyright unless she or he releases those rights by contract or the image was created as **work for hire.** The problem with digital imaging is the ease with which it allows images to be copied and recopied with no loss of quality. The mass distribution of images electronically has also had a misleading effect on the attitudes of some users of photographs. Some of the distributed photographs are "royalty free," which means they can be reproduced without payment to the copyright holder. Others are purchased on disks or over the Web as a group of photographs called **clip art,** which means that they can be used within the guidelines of the license without further payment. With the proliferation of this means of marketing photographs, some individuals begin to feel that anything that is on the Web or on disk is fair game for usage. That is definitely not the case, and active photographers are pursuing legal means to recover damages for improper usage of their images. A recent case involving photographers Carl and Anne Purcell, for example, involved the use of a large number of their images on the Web by America Online. The court ruled in favor of the Purcells, with an undisclosed settlement.

A few inaccurate ideas that are used as justification for "borrowing" other artists' copyrighted work are floating around. Some believe that as long as the borrowed art doesn't exceed 10 percent of the final work, that it is all right to use it without permission. Another misconception is that altering the color or distorting the image in some way releases users from the necessity of getting permissions. The fact is that any identifiable use of another's work is governed by the copyright law.

A related issue to copyright infringement is the illegal use of software. Software is copyrighted and cannot be copied or used without the express consent of the owner of the copyright. Many individuals who would not dream of shoplifting a $500 leather jacket will illegally copy a $500 computer program without a qualm.

Music is also copyrighted, so if you plan to publish multimedia disks containing music, be sure to get the necessary permissions. It is especially important for those in the creative fields who would like their own copyrights to be respected to show that same respect to other copyright holders. Users of photographs should keep copyright in mind both for ethical reasons and to protect themselves from litigation.

dering of the subject in a magazine long considered a bastion of honest reportage. The discussions of what are the limits of acceptable manipulation or retouching in photojournalism or documentary photography are still lively. Many feel that any manipulation at all, even the removal of distracting unrelated background from a photograph, is not allowable for truthful reportage. The important thing is to be aware of the ethical abuses possible with digital imaging, and to tread carefully in areas where the viewer is expecting an honest representation of the subject.

Glossary

For a more comprehensive glossary of photographic terms, see our Web site at *http://www.delmar.com/photography/warren.*

aberrations Image flaws or imperfections due to lens design, causing image distortion or degradation of *image sharpness.*

additive primaries Red, blue, and green light, which when added together in various amounts can give white or any desired color of light.

ambience The light-reflecting nature of the subject environment. An environment with many light-toned, reflective surfaces has a high ambience. One with dark, light-absorbing surfaces has a low ambience. The amount of *environmental light* is influenced by the ambience.

analog readout A data display for a meter or other device that is in the form of a pointer, such as a needle, moving along a scale.

angle of view 1) For a camera lens, the angle between the lines from the lens to the ends of the diagonal of a rectangle outlining the area of the subject included on the negative, determined by the focal length of the lens and the size of the film format. 2) For a reflected-light meter, the angle between the lines from the meter receptor to the ends of the diagonal of the rectangle or the diameter of the circle outlining the area of the subject included in the meter reading. Also called angle of acceptance or field coverage.

aperture An opening, usually variable in size, located in or near a lens, that is used to control the amount of light that reaches the *photosensitive material.* See also *relative aperture.*

aperture priority An automatic *in-camera light meter* in which the aperture is set manually and the meter sets the shutter speed automatically. See also *shutter priority.*

artifact A visible defect in a *digital image,* produced by the electronic imaging process.

aspect ratio The ratio of width to length of a negative or print. A square image has an aspect ratio of 1. An 8 × 10-inch print has an aspect ratio of 0.8.

automatic diaphragm A diaphragm aperture that remains open to its maximum aperture, regardless of the f/stop setting, until the shutter is released. When the shutter is released, it stops down to the set aperture before the shutter opens and reopens to its widest aperture after the shutter closes. Used in *single-lens reflex cameras* to provide a bright viewing screen.

available light Preexisting light. This term is used most often to refer to preexisting light at a low level of *illumination.*

averaging meter A *reflected-light meter* with an angle of view of 30–45°. When used from the camera position, it covers about the same subject area as a camera equipped with a normal lens.

base 1) The support that carries a *photosensitive emulsion.* Photographic films use a transparent base; photographic prints use an opaque base, usually of paper. 2) An alkali.

base weight The thickness of the support for photographic papers. In order of increasing thickness, they are: light weight, single weight, medium weight, and double weight.

bit One binary digit. Only the numbers 0 and 1 can be represented by 1 bit.

bit depth In a *digital image,* the number of binary digits (bits) that are dedicated to representing the luminosity and color information for each pixel. A 1-bit image can only represent two tones or colors. An 8-bit image can represent 256 shades or colors. A 24-bit image can represent millions of shades or colors. Larger bit depth gives better reproduction of a continuous tone image, but produces larger files.

bleed 1) A mounting technique in which the support and the borders of the image are trimmed down to the image. Also called flush mounting. 2) In a picture layout, to butt images together with no space between them, or to run an image to the edge of the page.

blocking up of highlights Loss of tonal *separation* in the subject light-tone areas of a negative because of overexposure, an extremely contrasty subject, or overdevelopment of the film.

bounce flash See *bounce light.*

bounce light Light reflected off a white surface such as a wall or card in order to *diffuse* it.

bracketing Making several exposures of the same subject, intentionally overexposing and underexposing from an initially determined or estimated exposure.

bromide drag Streaks of uneven development resulting from bromide by-products of the development process. Agitation during development helps prevent bromide drag.

bulk film Film sold in long rolls that must be cut into strips and loaded into *cassettes* or magazines before use.

burning Increasing the exposure in a particular area of a print by blocking everything else in the print from image light and giving additional printing time to that area. Burning will darken the area when printing from a negative. Also called burn in or print in. See also *dodging, flashing.*

byte Eight binary digits (*bits*). Numbers from 0 through 255 can be represented by a 1-byte binary number.

cable release A flexible cable that allows tripping the shutter without touching the camera, reducing the possibility of camera movement during exposure.

cadmium sulfide (CdS) cell A light-sensitive electronic component of the photoconductor type, in which the resistance changes with the amount of *illuminance.* Used in some photographic *exposure meters.*

cartridge A light-tight container for strips of film, which are wound on a spool inside the cartridge. A cartridge contains a take-up reel and is inserted directly into the camera. It requires no rewinding or handling of the film itself.

cassette A light-tight container for strips of film, which are wound on a spool inside the cassette. Cassettes require a take-up spool in the camera. The film must be rewound into the cassette after use.

cathode ray tube (CRT) A vacuum tube used for viewing purposes in most computer monitors and televisions. In the tube, one or more streams of electrons are deflected across the back of the screen, which is coated with phosphors that release light when struck by the electrons.

CC filters See *color compensating filters.*

CdS *Cadmium sulfide.*

center of interest A single object or event in a photograph that is of primary interest to the viewer.

chromogenic film *Monochromatic* (black-and-white) film designed to be processed with standard color print film chemistry.

circle of confusion A disk of light that is the image of a point on the subject when the image is out of focus. The smaller the circle of confusion, the more the disk looks like a point and the sharper the image appears. *Depth of field* depends on the largest acceptable size of the circle of confusion.

clip art Drawings or photographs that are sold in groups as a collection, usually in digital form on a CD-ROM. The buyer can reproduce and publish the clip art images without further payment of fees or royalties.

closing down Reducing the *exposure* on a *photosensitive material* by changing the aperture to a smaller opening, for example from f/4 to f/5.6. This term is used loosely to mean reducing exposure by using a shorter exposure time, for example from 1/60 second to 1/125 second. Also called stop down.

cold-mounting Mounting prints with adhesives that do not set and will adhere on contact or with pressure. Cold-mounting materials come as two-sided adhesive sheets, sprays, or sheets of transfer adhesive.

color balance 1) The color of *illumination* for which a color film will give correct color rendition. Two different color balance films are generally available: *daylight balance* (5500°K) and *tungsten balance* (3200°K). 2) Often used to refer to the color of illumination, as in daylight balance illumination.

color cast In a color photograph, an unwanted tinge of one color throughout the image.

color compensating (CC) filters Filters that are manufactured in varying densities of the additive and subtractive primary colors: red, blue, green, cyan, yellow, and magenta. Designed for use in the image path to produce specific changes in the *color balance* of the light reaching the film.

color contamination A change in the color of light because of reflection from a colored surface or transmission through a colored translucent material. For example, light reflected off a green wall will take on a greenish color.

color contrast 1) The perceived brightness differences due to the relationship of adjacent colors rather than to their value. When yellow is adjacent to blue it usually appears brighter, even if the luminance of the two is the same. 2) In design, the use of color differences to add visual interest.

color contrast filter Colored *filter* used in black-and-white photography to change the tonal relationship of colored objects within the subject. A yellow filter used to darken the sky is an example of a color contrast filter.

color conversion filter A color *filter* designed to adjust the *color balance* of a light source to the suggested color balance of the film. For example, an 80A blue conversion filter would convert the illumination from tungsten bulbs for use with daylight films.

color mode In electronic imaging, the method used to represent the tones and colors of the original. The most common color modes are *grayscale*, *RGB* color, and CMYK color.

color negative film See *negative film*.

color positive film See *positive image*.

color sensitivity An indication of the sensitivity of *photosensitive materials* to various colors of light. Several categories of *emulsions* with different color sensitivities are available, such as blue-sensitive, infrared, orthochromatic, and *panchromatic*.

complementary colors Two colors of light that, when combined in equal amounts, produce white light. Red and cyan are complementary colors, as are blue and yellow and green and magenta.

compound lens A lens combining two or more *elements* to reduce *aberrations* and improve the image quality.

computer printer A printer that accepts digital information directly from a computer and produces images or text on paper or other media. Common types are *inkjet, electrostatic, and dye sublimation printers*.

conceptual art Art in which the object created is of secondary importance to the idea or concept behind its creation. Conceptual artists may produce objects that are only temporary, or may not produce an object at all but simply orchestrate an event.

content In design, refers to the apparent subject of a photograph, usually the objects that are pictured but sometimes an event or activity that is shown.

continuous tonality Describes a photographic image that can represent any increment of tone from the darkest possible tone to the lightest possible tone of the photographic material being used, as opposed to drawing, painting and other print media.

contrast In general, a difference between extremes. Used in many photographic contexts, including *lighting contrast, subject contrast, negative contrast, printing paper contrast, and print contrast*, among others. Contrast is also used in several contexts in design, such as contrasts in subject matter, mood, textures, and so on. See specific terms for definitions.

conversion filter See *color conversion filter*.

cropping Showing in a print only part of the entire image that appears in the negative or transparency. This can be done by increasing the enlargement of the image when printing or by physically cutting the print after processing.

cross lighting Light that crosses the surface of a subject at a low angle relative to the surface, used to accentuate the *texture* of the surface.

CRT See *cathode ray tube*.

darkroom A room that can be sufficiently darkened and lit with a safelight for the safe handling and processing of light-sensitive materials.

daylight balance 1) Describes film designed to give correct color rendition with daylight illumination (average direct sunlight in the middle of the day), usually defined as a standard color temperature of 5500°K. 2) Describes light sources whose color characteristics closely match that of daylight illumination, e.g. electronic flash.

dedicated flash An electronic flash that provides automatic flash exposure by coupling directly to the metering system of the camera. Since camera metering systems vary, each dedicated flash is designed for use with specific camera models.

density A measure of the ability of a material to absorb light. The higher the density, the more light a material absorbs. In silver-based *photosensitive materials*, density is created by the presence of metallic silver in the processed image.

depth of field The nearest and farthest subject distances that are acceptably sharp in the finished photograph. Depth of field changes with focused distance, lens *focal length, aperture, image magnification* in the print, and standards of acceptable *image sharpness*. See also *circle of confusion*.

detail 1) Visible *texture* or distinct *separation* of small tonal areas in a photographic negative or print. 2) A small part of a subject shown as a full-frame photograph.

diffuse Describes *illumination* that has been scattered and reaches a surface from many directions. The opposite of *specular*. See also *diffusion*.

diffusion Scattering of the rays of light either by reflection from a slightly textured surface or transmission through translucent materials. The diffusing surface effectively becomes a new light source of larger area providing non-specular light, usually called diffuse light. Diffuse light sources produce "soft-edged" shadows with a more gradual transition from lit areas to shadowed areas. See also *specular light*.

digital camera A camera that produces photographic *digital image* files directly without the use of film.

digital enlarger A device that produces images on traditional photographic papers directly from a *digital image* file. It may use laser beams or *LCDs* to expose the paper, which is then chemically processed by traditional means.

digital image A photographic image that has been digitized. See *digitize*.

digital image-processing Altering the characteristics (e.g., *color balance, contrast*, luminosity, and *sharpness*) of a *digital image* using digital image-processing software, such as Photoshop®.

digital readout A data display for a meter or other device that gives readings in direct numerical form.

digitize The procedure of breaking a photographic image into discrete areas, called pixels, and assigning numbers to the average color and luminosity of each area. The numbers can then be stored and manipulated by computer techniques. See also *pixel*.

direct viewing A viewing system in a camera that allows inspection of the image formed by the camera lens, as in a view camera. To be visible, this image must be formed on an actual surface, such as a *ground glass*.

dodging Reducing the exposure in a particular area of a print by blocking image light from that area during part of the exposure. When printing from a negative, dodging will lighten the area. Also called hold back. See also *burning*.

DOF *Depth of field*.

download To transfer digital data from a *Web site* or other remote location to your computer, placing it into RAM or onto a storage medium, such as the hard disk.

dry-mounting Strictly refers to any method for attaching a print to a support that does not use a liquid adhesive, but most often used to refer to mounting techniques that make use of a press with a heated platen and sheets of adhesive that adhere when heated.

drying down The tendency of some photographic print materials to appear darker after drying than they do when they are wet.

dye sublimation printer A *computer printer* that produces photographic quality images consisting of dyes on special papers.

EI See *exposure index*.

electromagnetic spectrum All of the forms of electromagnetic energy arranged in order of increasing *wavelength*, from gamma rays to radio waves, including the visible light spectrum.

electrostatic printer A *computer printer* that produces type and images on paper by a process of charging the paper in a pattern corresponding to the image, which attracts toner to the paper. The toner is then heated to produce a reasonably permanent image. Similar to the process used in copy machines. Usually called a laserjet printer, even though no lasers are used in the image production.

emulsion A mixture of gelatin and *silver-halide crystals* that is coated onto a film or paper base to produce a *photosensitive material*.

environmental light Light that does not reach the subject directly from a light source, but is scattered or reflected by the environment surrounding the subject or the subject itself. Environmental light may result from either pre-existing (already there) or supplementary (supplied by the photographer) sources. See also *ambience*.

equivalent The use of a photograph as a *metaphor*.

equivalent exposure settings Pairs of *aperture* and exposure *time* that yield the same *exposure* on a *photosensitive material* and, within the limits of the *reciprocity law*, the same *density*. For example, f/8 at 1/125 second and f/11 at 1/60 second are equivalent exposure settings.

exposure The total amount of light that a *photosensitive material* receives, equal to the product of the *illuminance* on the material and the amount of *time* the material is exposed to light.

exposure index A numerical measure of a *photosensitive material's sensitivity* to light. The standard system for measuring the exposure index is the ISO index, which is a combination of two older systems, the ASA index and the DIN index. In all systems, the higher the exposure index number, the more sensitive the film is to light.

exposure latitude The ability of a film to withstand overexposure or underexposure and still produce a usable image, with detail in both subject light-tone and subject dark-tone areas. The latitude for overexposure is usually greater than for underexposure. In general, slow speed films have less exposure latitude than fast films. In practice, exposure latitude also depends on the contrast of the subject being photographed—subjects with high contrast giving less exposure latitude—and the type and amount of development.

exposure meter A device used for measuring light for photographic purposes, usually called a light meter. Most exposure meters have a calculator that provides suggested camera settings for the readings obtained. See also *incident-light meter, reflected-light meter*.

exposure value (EV) A number output by some light meters that gives an indication of the level of the *luminance* or *illuminance*, relative to the exposure index. Originally devised as a simplified method of setting aperture and shutter speed with one number, exposure values are most often used now for comparison of light meter readings or for giving the sensitivity range of a light meter. The EV number is meaningless without a specified ISO.

fast Refers to: 1) *Photosensitive materials* with a high sensitivity to light. 2) Lenses with a large maximum aperture (small f-stop number). A lens with maximum aperture f/2 is faster than one of maximum aperture f/4. 3) Shutter speeds of shorter duration. 1/500 second is faster than 1/125 second.

figure-ground relationship A simple visual structure in which an object of interest or a strong visual shape (the figure) is seen against a relatively neutral surrounding (the ground). See also *negative space*.

fill light Light that illuminates the *shadow* areas of a subject.

film *Photosensitive material* consisting of a light-sensitive *emulsion* coated on a flexible transparent support.

filter 1) A sheet of glass, plastic, or gelatin placed over a lens or light source that selectively absorbs specific *wavelengths* (colors) of light. 2) A software routine that alters a *digital image* by changing its *sharpness* or producing special visual effects. May be part of the image-processing program, or may be purchased as a third-party *plug-in*.

filter factor A multiplication factor used to correct the exposure when using a *filter* on a camera. The *exposure* indicated by the meter (without the filter) is multiplied by the filter factor to produce correct exposure with the filter. Filter factors should be used when it is impractical to meter through the filter.

flare Light reflected internally in passage through a lens from the surfaces of the elements or from parts of the lens or camera body. This reflected light can spread throughout the image, reducing contrast by adding undesirable light to the dark parts of the image, or appearing as unexpected streaks and shapes of bright light in the image.

flash card A removable digital storage device in the form of electronic chips contained in a small card that can be plugged directly into *digital cameras* or readers attached to a computer.

flashing The application of white light to an area of a print before processing by using an external light source such as a small flashlight. Used to selectively blacken areas of the print.

flat Lower than normal or desired contrast when used to describe a subject, lighting, a negative, or a photograph. Gray and *soft* are terms often used in place of flat, but are not preferred since they have other meanings in the description of photographic subjects, lighting, and images.

focal length For a *simple lens* focused on an infinitely distant subject, the distance between the center of the lens and the point on the axis of sharpest focus. For a *compound lens* the focal length is measured from the rear nodal point of the lens to the point on the axis of sharpest focus. Increasing the focal length increases the *image magnification* for a given subject distance.

focal plane shutter A *shutter* that is located as close as possible to the film. Consists of a flexible curtain or a series of metal blades producing a rectangular slit that crosses the film for exposure.

fog 1) An overall layer of silver (*density*) in a negative or print due to chemical action, age, exposure to heat, and so on. 2) Undesired density on film or paper due to accidental exposure of the *photosensitive material* to light before or during development.

form The three-dimensionality of an object. Must be implied in a photograph, since depth cannot be directly perceived in a two-dimensional photograph. The representation of shadows on the surface of an object (called shading or modeling) shows its form. Form can also be implied by the distortion of lines on the surface of an object. Also called volume.

format size The size of the image produced on a film. Format size is determined by camera design and film size.

frame 1) The boundaries of a photographic image. 2) To adjust camera position or lens focal length to control which parts of a subject will be included in the image. 3) A single image on a roll of film.

f-stop number See *relative aperture*.

full-frame print A print of the entire image that appears on the negative or transparency.

gobo Any opaque object used to block unwanted light from the subject or camera lens. Black materials are normally used to prevent scattering reflected light into the environment. Also called a flag or cutter.

grade See *paper contrast*.

grain A granular texture visible under magnification in processed *silver-halide emulsions*, a result of clumping of the silver particles during processing.

grayscale In digital imaging, the *color mode* used to depict a *monochrome image* in which the tones of the original are represented as shades of neutral gray. Grayscale images are usually 8-bit images, with 256 shades of gray.

ground glass A sheet of glass with a uniformly roughened surface. It is used in some cameras to allow viewing of the image formed by the camera lens.

hair light A light used to illuminate the hair. Often placed above and slightly behind the model.

halation Unwanted *exposure* in the *emulsion* of a film that results from image light passing through the emulsion and reflecting off the backing to expose the emulsion a second time. It is called halation because of the halo effect it creates around the image of a bright light source. It can be reduced by anti-halation backings on films.

hand-held meter A light meter contained in its own integral housing, as opposed to an *in-camera meter*.

handle In digital imaging, a point on a selection marked by an icon that can be dragged to change the shape or position of the selection.

high key subject A subject with predominantly light tones and only small areas of midtones or dark tones.

highlights The light tonal areas of a subject, represented by the high-density areas in the negative and the light print values in the print. See also *specular highlight*.

hinge-mounting Use of small hinges made of rice paper or archival tape to attach a print to a support board.

home page The opening screen for a *Web site* that usually contains links to other pages within the Web site.

horizontal framing Holding a camera with a rectangular format so that the long dimension of the image is horizontal. Called landscape orientation for computer printers.

hot shoe A flash mounting bracket on a camera that contains the contacts needed to fire the electronic flash when the shutter is released.

hyperfocal distance The focused distance for a lens that provides the greatest possible *depth of field* for any given *aperture*, from half the hyperfocal distance to infinity. The hyperfocal distance is determined by formula from the *focal length* of the lens, the aperture at which it is set, and the standards of acceptable *sharpness* (the size of the *circle of confusion*).

idea book A scrapbook or file in which examples of published photographs are kept as a source of ideas or inspiration. Also called clip file, source file, or swipe file.

illuminance The amount of light falling on a surface. An *incident-light meter* measures illuminance.

illumination Light falling on a surface. The measure of this light is called the *illuminance*.

image fall-off The dimming of a lens image toward its edges as the distance from the image center increases. This effect can be reduced by careful lens design.

image magnification A measure of the size of the image on the film compared with the size of the original subject, or the size of the image on the baseboard of an enlarger compared with the size of the negative image. An image magnification of 2× indicates that the image is twice the size of the original object. An image magnification of 2× would be an image ratio of 2:1.

image resolution In digital imaging, the number of *pixels* per inch or centimeter.

image sharpness 1) A subjective description of a photographic image referring to its ability to render small *detail* and *texture* clearly and precisely. The opposite of *soft* or blurred. 2) The amount of blurring in a photographic image due to movement or poor focus adjustment. The less blur that is present, the sharper the image is. 3) In design, the use of image blurring or lack of blurring as a *visual element*.

implied line A visualized line defined by the mental connection of two or more *visual elements* that are visually attractive, similar in shape, or in close proximity to each other. The attempt to follow the direction of a subject's gaze in the photograph also creates an implied line. A moving object implies a line of travel.

implied shape A visualized shape created when *implied lines* enclose an area.

in-camera light meter A *light meter* built into the body of a camera.

incident-light meter A meter that measures the amount of light falling on the subject (*illuminance*). It is normally placed at the position of the subject and pointed back toward the camera. Also called illuminance meter.

indexed color A *digital image* in which specific colors are referenced by the number assigned to each *pixel*. In a 1-bit image a pixel can be one of only two colors. An 8-bit image has 256 color choices for each pixel. Used to reduce file size for images intended for use on the *World Wide Web*. See also *bit depth*.

inkjet printer A *computer printer* that produces images and text by spraying tiny drops of ink onto paper or other media.

intermittency effect The fact that lower *density* will result from several repeated *exposures* on a *photosensitive material* than from a single equivalent exposure. For example, four 5-second exposures would yield a lower density than one 20-second exposure would.

Internet A world-wide system of linked computers allowing communication and data file transfer from user to user. Sometimes called the Net. See also *World Wide Web*.

Internet service provider (ISP) A business that allows an individual user to connect his or her own computer to the *Internet*. Connection to the ISP can be by *modem*, cable, satellite, or other data transfer method.

interpolated resolution A method of increasing the apparent *image resolution* of a *digital image* by creating new *pixels* by *interpolation*.

interpolation In digital imaging, creating new *pixels* based on the color and luminosity of adjacent existing pixels.

ISP See *Internet service provider*.

latent image An image on a *photosensitive material* that is invisible to the naked eye. It is composed of small specks of silver reduced from silver salts by the action of light in the optical image formed by a lens. Development reduces more silver in the area of the latent image, creating a visible photographic image.

LCD *Liquid crystal display*.

lens One or more pieces of glass or transparent plastic with curved surfaces designed to produce an optical image of light. See also *compound lens, simple lens*.

lens contrast The difference between light and dark that a lens can reproduce in its image in fine subject *detail*.

lens element An individual glass or plastic component of a *compound lens*.

lens resolution The ability of a lens to produce a distinct image of closely spaced lines.

lens shade A black cylindrical or conical attachment placed on the front of a lens to prevent *flare*-producing light outside the picture area from striking the lens surface. Also called lens hood.

light balancing filter A colored *filter* designed to alter the *color balance* of light sources to match a specific film color balance. Similar to *color conversion filters*, but designed for smaller changes in the color of the light.

light meter See *exposure meter*.

lighting contrast The difference between the *illumination* supplied to (incident on) the fully lit parts of the subject and the illumination incident on the parts of the subject shaded from the direct effect of the lighting (the *shadow* areas). Sometimes given in stops, but often expressed as a *lighting ratio*. High lighting contrast is often called harsh or contrasty and low lighting contrast is called *flat*.

lighting ratio The ratio between the *illuminance* at the fully lit subject areas and the illuminance in the *shadow*. A lighting ratio of 2:1 means that twice as much illumination is being supplied to the fully lit areas as to the shadow areas (in other words, one stop difference in *incident-light meter* readings).

line A *visual element* defined by the boundary between darker and lighter tones. Lines may be straight or curved.

linear perspective The relative size in a photograph of objects at different distances from the camera. It is one of the principal indicators of depth in a photograph, the dwindling size of objects indicating greater distance from the camera. Perspective can be changed only by changing the distance from the camera to the subject.

link A graphic icon or highlighted text in a Web page that when clicked takes you to a different place in the Web page or to another Web page or *Web site*.

liquid crystal display (LCD) Electronic devices whose surfaces can be electrically induced to display patterns, including numbers, letters, and symbols. Used to display information in cameras, meters, and other photographic devices with digital readouts, as well as some computer monitors.

low key subject A subject with predominantly dark tones and only small areas of midtones or light tones.

luminance The amount of light reflected from, emitted from, or transmitted through a surface. Luminance due to reflected light is determined by the *illumination* on the surface and the *reflectance* of the surface. A *reflected-light meter* measures luminance.

main light The light that principally determines the shape and position of *shadows* and *highlights* on the subject. Also called key light.

metaphor A photograph that implies ideas unrelated to the subject matter pictured. Also called equivalent.

middle gray A neutral color of 18 percent reflectance.

modem An electronic device attached to a telephone line that allows sending or receiving digital data.

monochrome image A photographic image that reproduces the colors and tones of the subject as shades of a single color, usually a neutral gray. Also called black-and-white image.

motor drive A device incorporated in or attached to a camera that automatically advances the film after each exposure. Slower or lighter-duty motor drives are often called winders.

ND *Neutral density.*

negative contrast The difference in *density* between the areas of the negative representing the dark subject tones and those representing the light subject tones. Depends on *subject contrast*, amount of development, type of film, and film freshness.

negative film A film that, when processed, produces a *negative image* of the subject.

negative image A photographic image on film or paper that shows a reversed relationship of tones when compared with the original subject—light subject tones are represented as dark tones and dark subject tones are represented as light tones. A color negative image is also reversed in color, with subject areas represented as the complement of their original color. See also *complementary colors.*

negative space In a *figure-ground relationship*, a ground that is relatively featureless, with fairly uniform tonal values.

neutral density (ND) filter A *filter* that absorbs light without changing the color of the transmitted light. Neutral density filters are marked with their *density*; an ND 0.3 filter transmits 50 percent of the light incident on it, resulting in a one *stop* change in exposure.

normal focal length lens A lens that produces an image that most closely approximates the view and apparent *linear perspective* seen by the unaided human eye. The normal focal length changes with *format size*, being approximately the distance across the diagonal of the image formed on the film. For the 35mm camera format the normal focal length is about 50mm.

off-the-film (OTF) metering An *in-camera light meter* that meters light reflected off the film during the exposure. Off-the-film meters are useful when light may change during the exposure or when the camera meter is capable of metering and controlling flash exposure.

opening up Increasing the *exposure* on a *photosensitive material* by changing the *aperture* to a larger opening, for example, changing from f/11 to f/8. This term is also loosely used to indicate increasing the exposure by using a longer *shutter speed*, for example, changing from 1/250 second to 1/125 second.

optical resolution For digital imaging devices (*scanners, digital cameras*), the number of *pixels* per inch directly generated in the image by sensing cells in the device. See also *interpolated resolution.*

optimum exposure The *exposure* on a *photosensitive material* that yields the best quality results. In a negative, it is usually the least exposure that retains *detail* in the areas representing the dark tones of the subject. In a positive transparency or print, it is normally the exposure that gives desired tone and detail in the subject light-tone areas.

OTF *Off-the-film.*

overexposed Describes a *photosensitive material* that has received more than its *optimum exposure*. In a negative, overexposure results in excessive *density*, larger *grain*, and the possibility of *blocking up of highlights*. In a positive transparency, overexposure results in loss of light-tone *detail* and overall tones that are too light. In printing from a negative, overexposure results in print tones that are too dark.

panchromatic emulsion *Emulsion* that is sensitive to all the colors of the visible spectrum, although its degree of sensitivity to individual colors may vary somewhat from that of the eye. Most general-purpose black-and-white films are panchromatic. Panchromatic materials must be handled and processed in total darkness.

panchromatic paper A special black-and-white printing paper sensitive to all visible colors. Used for making black-and-white prints from color negatives. Since it is sensitive to any color of light, panchromatic paper must be handled and processed in total darkness or under an extremely dim dark-green *safelight*.

panning Following the motion of a subject with the camera, usually with a slow shutter speed, giving a reasonably sharp subject image against a blurred or streaked background.

paper contrast The response of a photographic printing paper to changes in *exposure*. The higher the paper contrast, the greater the tonal difference for a given range of exposure. Print contrast is given as a number, the contrast grade, which may range from 0 to 5. Grade 0 produces the least contrast and grade 5 the most. The normal contrast grade is 2.

parallax error A visual error that arises when the viewing system in a camera is in a different position than the lens that forms the image on the film, as in *viewfinder* or *twin-lens reflex* camera designs.

pattern Similar *shapes, lines, or tonal values* repeated over an area of a photograph.

PC card A solid state device in the form of a card that can be inserted directly into a computer or reading device. Primarily designed for digital data storage, but some cards may perform other functions such as *modem* operations. Formerly called PCMCIA card.

pentaprism A specially designed prism used in some camera designs to reorient a *groundglass* image so that it appears upright and correct left-to-right to the eye.

perspective See *linear perspective.*

photodiode cell A solid-state device that is sensitive to light. Used as a light-sensing cell in some photographic *light meters*. Common types are Silicon Photodiode (SPD or SBC) and Gallium Photodiode (GPD).

photogram A photographic print produced by laying objects on a *photosensitive material* and exposing it to light.

photomacrography Photography in which the image of the subject is life-size or larger on the film. Most photographers loosely include *image magnifications* as small as 1/5 life-size in this category. A less accurate but more commonly used term is macrophotography.

photomontage The combination of parts of images from two or more negatives into one print. The simplest method of making a photomontage is printing with a negative sandwich. Other methods include multiple images from different negatives printed sequentially on one sheet of printing paper, or an assembly of cut and pasted images.

photosensitive material 1) A substance that shows a visible or measurable change when exposed to light. Photosensitive compounds that undergo a chemical change when exposed to light are used for films and printing papers. *Light meters* and electronic imaging use materials that exhibit a measurable electrical change when exposed to light. 2) Often used as a general term to refer to photographic films and printing papers.

pixel Picture element. In digital imaging, refers to the small areas into which an image is divided for *digitizing*. The number of pixels determines the limits of *image resolution* for a *digital image*, with a greater number of pixels providing higher resolution. See also *digital image processing.*

plug-in A software routine that is designed to perform specific tasks within a specific application. Plug-ins are not part of the application itself, but can be accessed from the application's menus. For example, *scanner* software may be supplied as a plug-in so the scanner operation can be accessed from within an application.

polarized light Light in which the electromagnetic waves are organized so that they all vibrate in the same direction. Appears naturally in reflections from nonmetallic surfaces at an angle of about 35° to the surface.

polarizing filter A filter that allows only light waves vibrating in a specific direction to pass. Can be used to produce *polarized light* from nonpolarized light, or to block polarized light from passing by orienting the filter against the orientation of the polarized light. Also called polarizer.

positive film Film that produces a *positive image* on a transparent *base* after processing. Positive films are available in both color and black-and-white. Also called reversal, slide, or transparency film.

positive image A photographic image on film or paper that shows the same relationship of tones or colors as the original subject. Dark subject tones are reproduced as dark tones in the image and light tones appear light.

previsualize To predict the final appearance of a photograph, both in composition and tonal values, while viewing the original subject.

print contrast 1) The difference in reflective *density* (*tonal value*) between the areas representing the dark subject tones and those representing the light subject tones. 2) The degree to which a print shows a full range and *scale* of tones as demanded by the subject. Determined by how well the *paper contrast* matches the *negative contrast*. See also *flat.* 3) An indication of the number of tones the print shows between

maximum black and maximum white (the *scale*). A print with only two tones (black and white) from a subject with a full scale of tones is called a high-contrast print.

program operation An automatic *in-camera metering* system that sets both the *shutter speed* and the *aperture* based on the amount of light and a built-in program of shutter speed-aperture pairs.

push To underexpose and increase the amount of development of a film, for an apparent increase in film speed.

rangefinder An optical device for determining the distance from the camera to the subject in order to focus the lens.

reading discrimination The amount of exposure change a *light meter* is capable of distinguishing, given as a fraction of a *stop*.

reciprocity failure The failure of *equivalent exposure settings* to produce equivalent *density* on the film, requiring increased exposure to produce the expected density, and changes in development to control *contrast*. Color films may also require color filtration corrections. Reciprocity failure occurs for long exposure times or very short exposure times. The exposure times requiring reciprocity failure corrections vary from film to film.

reciprocity law A law that states that the effect of *exposure* on the film, seen as *density*, is the same regardless of the rate at which the exposure is given. One demonstration of the reciprocity law is *equivalent exposure settings*, for which the same density can be achieved with many different combinations of *aperture* and *shutter* speed. See *reciprocity failure*.

reflectance The ability of a surface to reflect light. A surface with 18 percent reflectance reflects back 18 percent of the light falling on it.

reflected-light meter A meter that measures the amount of light transmitted, emitted, or reflected by the subject (the *luminance*). Normally pointed at the subject from the direction of the camera. Also known as luminance meter.

refraction The bending of light rays as they pass from one transparent medium to another.

relative aperture A number, called the f-stop number, that is found by dividing the *focal length* of a lens by the effective diameter of its *aperture*. Also called the f-number.

repetition with variation A regularly repeated *pattern* in a photograph changed in one or more places to create a visual contrast.

representative photograph A photograph that resembles the appearance of the original subject as much as possible within the limits of the medium.

resolution See *image resolution* and *lens resolution*.

restricted-angle meter A *light meter* with an *angle of view* of 15° or less.

reticulation Wrinkling of the *emulsion* on a film due to sudden temperature changes during processing, resulting in a granular pattern in prints from the negative.

RGB color A color system that uses the *additive primaries* (red, green, and blue) to reproduce colors. Computer monitors and televisions use RGB color.

roll film A strip of *film* for several exposures rolled with protective opaque paper onto a spool. Roll films are threaded onto a removable take-up spool in the camera. Commonly available roll film sizes are 120 and 220.

Sabattier effect A partial reversal of negative or print tones achieved by exposing the *photosensitive material* to light part way through the developing step, and then continuing the development and the remaining processing steps. A thin line, known as the Mackie line, is produced along boundaries between adjoining areas of dark and light subject tones.

safelight A light providing *illumination* of the correct color for working with a specific *photosensitive material*. Blue-sensitive *emulsions* can be handled under a yellow or amber safelight. Orthochromatic emulsions can be handled under a red safelight. See also *color sensitivity*.

save To write a digital data file to disk or other storage medium.

scale 1) The number of values between two extremes. For example, the number of *luminances* between darkest and lightest in a subject; the number of *densities* between maximum and minimum in a negative; or the number of *tones* in a photographic print between the maximum and the minimum tones. 2) The actual size of an object. Objects of known and obvious size may be included to demonstrate the actual size of another object in the photograph, that is, to show its scale. Choice of lens *focal length* and point of view may sometimes create a false sense of scale for objects in a photograph.

scanner An electronic device that converts print or film images to *digital images* by analyzing color and luminosity throughout the print or film and producing *pixels*.

selenium cell A light-sensitive photovoltaic cell used in some photographic *light meters*.

sensitivity 1) The degree to which a *photosensitive material* responds to light, measured by the amount of *exposure* required to produce a given amount of *density* in the image. More sensitive (faster) materials require less exposure than less sensitive (slower) materials to produce the same amount of density. Also called the speed. 2) See *color sensitivity*.

sensitivity dyes Dyes mixed in a photosensitive *emulsion* to improve its response to specific colors of light.

separation Distinguishable *tonal* or *density* differences in an area of a photographic image that shows *detail* or *texture*.

shadow 1) In lighting, an area of the subject shielded from the direct effect of the main *illumination*. 2) In metering and printing, any subject dark-tone area or corresponding areas in negative or positive photographic images.

shape In design, a space enclosed by a *line* or lines, or defined by the outer boundaries of a *tonal value*.

sharpness See *image sharpness*.

sheet film Photographic *film* manufactured as individual sheets, one for each exposure, packed in a light-tight box. Sheet film must be loaded into a light-tight film holder or magazine for use. Sometimes called cut film.

shutter A device in a camera or lens consisting of curtains or overlapping blades designed to protect the film from exposure to the image until the shutter release is pressed.

shutter priority An automatic *in-camera light meter* in which the *shutter speed* is set manually and the meter sets the *aperture* automatically. See also *aperture priority*.

shutter speed A measure of the length of *time* a shutter remains open for an *exposure*, given in seconds or fractions of a second.

silver-halide crystals Light-sensitive crystals consisting of metallic silver in chemical compound with iodine, chlorine, or bromine. Most modern photographic materials use silver-halide crystals as the light-sensitive component.

simple lens A lens consisting of a single piece of glass. When two or more simple lenses are combined to form a *compound lens*, the component simple lenses are called lens *elements*.

single-lens reflex camera A camera design in which the image from the lens is deflected to a *ground glass* by a mirror that swings out of the way when the shutter release is operated. Many single-lens reflex cameras use a specially designed prism (a *pentaprism*) above the ground glass that shows a correctly oriented image through an eyepiece.

slave An electronic device that is connected to an electronic flash and fires it when it senses the light from a second flash.

slow Describes a film or printing paper that has a low sensitivity to light.

SLR *Single-lens reflex.*

snapshot Casually composed, quickly executed photograph made for the purpose of documenting a personal event or subject in the photographer's life.

soft 1) Describes a photographic image that is not sharp because of diffusion, lens defects, focus blur, or motion blur. 2) *Illumination* is soft when it has been *diffused* and produces shadows with graduated edges. 3) Soft is sometimes used to describe *paper contrast*, soft papers being of lower contrast than normal. 4) Variously used to indicate low *lighting contrast* or low *print contrast*, but these uses of soft are not recommended, in order to avoid confusion with definitions (1) and (2). The term *flat* is preferred to indicate low contrast.

specular highlight Visible reflection of a light source on the surface of the subject. Also called specular reflection.

specular light *Illumination* in which the light rays are traveling as if they emanated from one point or are traveling parallel. Unscattered light. A specular light source produces shadows with sharp distinct edges ("hard-edged" shadows). Specular light comes from sources that

are small in size or appear small due to their distance from the subject, or from sources with lenses or reflectors that collimate or focus the light. Direct light from the sun is an example of specular light.

specular reflection See *specular highlight*.

specularity 1) In reference to light, the quality relating to the amount of scattering in the light. Unscattered or collimated light is called specular. Scattered light is called *diffuse*. 2) In reference to reflection, the ability of a surface to reflect back a coherent image of a light source. Surfaces that are able to do so (shiny or mirror surfaces) are called specular. Ones that cannot are called dull or matte.

spot meter A *reflected-light meter* with an *angle of view* of one or two degrees, allowing very small areas of the subject to be read.

spotting The application of dyes with a fine brush to light spots or marks in a print.

stop A measure of change in *exposure*. One stop is a change in exposure by a factor of two. *Opening up* one stop means doubling the exposure. *Closing down* one stop means halving the exposure.

stopping down See *closing down*.

straight photography A style of photography in which manipulations of the photographic image are kept to a minimum for reasons of truthful documentation or as an aesthetic choice.

style In design, the distinctive way or manner in which a work of art is made. Style can be determined by choices in subject matter, materials, techniques, and visual design.

subject contrast The difference in *luminance* values in the dark-tone subject areas (the *shadows*) and the light-tone subject areas (the *highlights*). Luminance values can be read with a *reflected-light meter*.

symbolism Use of an object, *shape*, or design that represents something else, often an abstract idea or concept.

symmetry The appearance of the same arrangement of *visual elements* in mirror image in both halves of a photograph. Symmetry can be achieved horizontally, vertically, or diagonally.

synch cord *Synchronization* cord. The electrical cord that connects a flash to the camera to synchronize flash and shutter.

synchronization Timing the firing of a flash so that it reaches its maximum intensity while the shutter is open to its full extent, achieved by electrically connecting the flash to contacts in the camera. See also *X-synchronization*.

telephoto lens A lens design used to make long-focus lenses of compact size.

test strip A small piece of *photosensitive material* cut from a larger sheet, on which one or more trial exposures are made to determine the correct exposure for the full sheet of material.

texture A *pattern* of small repeated areas of *shape*, *line*, or *tone*.

thin Describes negatives that have an overall *density* that is lower than normal. This usually

results from underexposure, but can also be caused by underdevelopment.

through-the-lens (TTL) metering An *in-camera light meter* that measures the light after it has passed through the camera lens. Through-the-lens meters will provide corrected camera settings as necessary to compensate for lens changes, filters, or close-up attachments.

time In the formula for *exposure*, the amount of time the *photosensitive material* is exposed to light. In most photography, this is usually the *shutter speed*.

time exposure A longer than normal film *exposure* time, usually of one second or more.

TLR *Twin-lens reflex*.

tonal value Visual perception of the *luminance* of a specific area in a subject, or the *reflectance* of an area in a print (lightness and darkness).

tone 1) See *tonal value*. 2) To treat a processed print or film in a solution for the purpose of changing its color or protecting the image from degradation.

tone control A system of exposure and development that depends on performing *reflected-light meter* readings from specific areas of the subject and then manipulating camera settings and film development to control the tonal appearance of these areas in the final photograph.

TTL *Through-the-lens*.

tungsten balance film A color film designed to be used with illumination from studio photofloods with a color temperature of 3200°K, formerly designated as Type B films.

twin-lens reflex (TLR) camera A camera with two identical lenses. One forms the image on the film. The image from the other is deflected by a mirror to a *ground glass* for viewing.

underexposed Describes a *photosensitive material* that has received less than the *optimum exposure*. In a negative, underexposure results in loss of *detail* in the subject dark-tone areas and a loss of *negative contrast*. In printing from a negative, underexposure results in a print that is too light.

vertical framing Turning a camera with a rectangular format so that the long dimension of the image is vertical. Called portrait orientation for computer printers.

view camera A camera design allowing direct viewing of the image on a *ground glass* viewing screen. The lens and back of a view camera can be tilted or swung to alter the focus or shape of the image. View cameras are usually of large format size.

viewfinder An optical system on a camera separate from the taking lens that gives a visual approximation of the subject matter that will appear in the photographic image.

viewfinder cutoff A situation in which the *viewfinder* shows less of the subject than is recorded on the film.

visual elements In design, distinguishable features in a work of art, such as *tone*, color, *line*, *shape*, *form*, and so on. Also called design elements.

visual selection Using camera position (point of view) and lens *focal length* to alter the arrangement of *visual elements* within the frame of the *viewfinder*.

visual structure A sense of organization in a work of art that results from mental analysis of the spatial relationship of *visual elements*, the recognition of identifiable *shapes*, and the path of eye travel when viewing the photograph.

wavelength In a wave motion, the distance from peak to peak or from trough to trough. The wavelength of visible light determines its color.

Web site A digital document or set of documents residing on a computer that can be accessed through the *World Wide Web*. See also *home page*.

wide-angle lens A lens with a shorter than normal *focal length*. On 35mm cameras, wide-angle lenses range from a moderate 35mm wide-angle to extreme-wide-angle lenses that are 14mm or less in focal length. Also called short lens or short-focus lens.

work for hire Creative work (such as photography) that is done for an employer. The employer owns the copyright to any creative work done by the employee.

working life For reusable photographic chemical solutions, the amount of material that can be processed before the chemical solution is depleted. Also called working capacity.

World Wide Web The global network of computers that are connected to the Internet and can be accessed using HyperText Markup Language (HTML), a programming language that allows interaction with a remote computer via a graphical interface with icons, highlighted text, and menus activating links to allow navigation through the accessible documents. Also called the Web and often used interchangeably with Internet, though not all computers on the Internet are accessible using HTML.

X-synchronization The correct *synchronization* for use of electronic flash units.

Zone System A *tone control* system devised by Ansel Adams in which relative film *exposure* values, called zones, are labeled with Roman numerals.

zoom lens A lens with a continuously variable *focal length*, usually controlled by sliding or turning a sleeve on the lens barrel.

Bibliography

Introductory and General Photography

Craven, George M. *Object and Image: An Introduction to Photography.* Englewood Cliffs, N.J.: Prentice-Hall, 1975.

Davis, Phil. *Photography,* 7th ed. Dubuque, IA.: McGraw-Hill, 1997.

Gassan, Arnold, and A. J. Meek. *Exploring Black and White Photography,* 2d ed. Dubuque, IA.: WCB/McGraw-Hill, 1992.

Horenstein, Henry. *Black and White Photography: A Basic Manual,* 2d ed. Bulfinch Press, 1983.

London, Barbara, and Jim Stone. *A Short Course in Photography,* 4th ed. Upper Saddle River, N.J.: Prentice-Hall, 2000.

London, Barbara, and John Upton. *Photography,* 6th ed. Reading, Ma.: Addison-Wesley Publishing Co., 1997.

Swedlund, Charles. *Photography: A Handbook of History, Materials, and Processes,* 3d ed. Fort Worth, Tx.: Harcourt College Publishing, 2000.

Warren, Bruce. *Photography,* 2d ed. Albany, N.Y.: Delmar, 2002.

Darkroom Techniques

Coote, Jack H., and Keith Watson. *Ilford Monochrome Darkroom Practice: A Manual of Black-and-White Processing and Printing.* Boston: Focal Press, 1996.

Curtin, Dennis, Robin Worth, Roberta Worth, and Joe DeMaio. *The Darkroom Handbook,* 2d ed. Boston: Focal Press, 1997.

Post, George. "Shake It Up." *Darkroom Photography* (March–April 1986).

Aesthestics and Design

Arnheim, Rudolf. *Art and Visual Perception: A Psychology of the Creative Eye,* 2d ed. University of California Press, 1983.

Barrett, Terry. *Criticizing Photographs: An Introduction to Understanding Images,* 3d ed. Mountain View, Calif.: Mayfield Publishing Co., 1999.

Bayer, Jonathan. *Reading Photographs: Understanding the Aesthetics of Photography.* New York: Photographers' Gallery, Pantheon Books, 1977.

Coleman, A. D. *Light Readings,* 2d ed. Albuquerque: University of New Mexico Press, 1998.

Hill, Paul, and Thomas Cooper. *Dialogue with Photography.* Stockport: Dewi Lewis Publishing, 1998.

Lyons, Nathan, ed. *Photographers on Photography: A Critical Anthology.* Englewood Cliffs, N.J.: Prentice-Hall, 1966.

Maier, Manfred. *Basic Principles of Design.* 4 vol. New York: Van Nostrand Reinhold Co., 1978.

Naef, Weston J. *The Art of Seeing: Photographs from the Alfred Stieglitz Collection.* New York: Metropolitan Museum of Art, 1978.

Newhall, Nancy, ed. *The Daybooks of Edward Weston.* 2 vol. Millerton, N.Y.: Aperture, 1996.

Ocvirk, Otto G., Robert O. Bone, Robert E. Stinson, and Philip R. Wigg. *Art Fundamentals: Theory and Practice,* 8th ed. New York: McGraw-Hill, 1997.

Scharf, Aaron. *Art and Photography.* Baltimore: Penguin Press, 1969, rep. 1995.

Sontag, Susan. *On Photography.* N.Y.: Anchor Press, 1990.

Szarkowski, John. *Looking at Photographs.* Bulfinch Press, 1999.

———. *The Photographer's Eye.* New York: Museum of Modern Art, 1966.

Ward, John L. *The Criticism of Photography as Art: The Photographs of Jerry Uelsmann.* Gainesville, Fla.: University of Florida Press, 1970.

Zakia, Richard D. *Perception and Imaging.* New York: Butterworth-Heinemann, 1997.

History of Photography

Frizot, Michel. *New History of Photography.* Koneman, 1999.

Gassan, Arnold. *A Chronology of Photography.* Athens, Ohio: Handbook Co., 1972.

Gernsheim, Helmut, and Alison Gernsheim. *A Concise History of Photography.* 3d rev. ed. New York: Dover Publications, 1986.

Newhall, Beaumont. *The History of Photography from 1839 to the Present Day,* rev. ed. New York: New York Graphic Society, 1978.

———. *The Latent Image: The Discovery of Photography.* Garden City, N.Y.: Doubleday, 1967.

Rosenblum, Naomi. *A World History of Photography,* 3d ed. New York: Abbeville Press, 1997.

Special Techniques

Adams, Ansel. "Ansel's Intensifier." *Popular Photography* (November 1980): 116ff.

Carr, Kathleen Thormod. *Polaroid Transfers.* N.Y.: Amphoto, 1997.

Crawford, William. *The Keepers of Light: A History and Working Guide to Early Photographic Processes.* Dobbs Ferry, N.Y.: Morgan & Morgan, 1980.

Gassan, Arnold. *Handbook for Contemporary Photography,* 4th ed. Rochester, N.Y.: Light Impressions, 1977.

Keefe, Lawrence E., Jr., and Dennis Inch. *The Life of a Photograph: Archival Processing, Matting, Framing, and Storage.* Boston: Focal Press, 1984.

McCann, Michael. *Health Hazards Manual for Artists.* New York: The Lyons Press, 1994.

"Myron: Santa Fe Transfer." *Test* (Polaroid) (Fall–Winter 1990): 2. Article on Polaroid transfer.

Oberrecht, Kenn. *Home Book of Picture Framing.* Mechanicsburg, Pa.: Stackpole Books, 1998.

Pittaro, Ernest M., ed. *Photo Lab Index.* Dobbs Ferry, N.Y.: Morgan & Morgan. Updated regularly.

Rempel, Siegfried, and Wolfgang Rempel. *Health Hazards for Photographers.* New York: The Lyons Press, 1993.

Shaw, Susan. *Overexposure: Health Hazards in Photography.* New York: Allworth Press, 1991.

Stone, Jim, ed. *Darkroom Dynamics: A Guide to Creative Darkroom Techniques.* Stoneham, Mass.: Focal Press, 1985.

Vestal, David. *The Craft of Photography.* New York: Harper & Row, 1975.

Color Photography Techniques

Eastman Kodak Company. *Kodak Color Darkroom Dataguide.* Sterling Press, 1998.

Hirsch, Robert. *Exploring Color Photography,* 3d ed. New York: WCB/McGraw-Hill, 1997.

Horenstein, Henry. *Color Photography: A Working Manual.* Bulfinch Press, 1995.

Krause, Peter, and Henry Shull. *Complete Guide to Cibachrome Printing.* Tucson, Ariz.: H. P. Books, 1982.

Digital Photography

Adobe Creative Team. *Adobe Photoshop 6.0 Classroom in a Book.* San Jose, Calif.: Adobe Press, 2000.

Bouton, Gary David, Gary Kubicek, Barbara Mancuso Bouton, and Mara Zebest Nathanson. *Inside Adobe Photoshop 6.* Indianapolis, Ind.: New Riders Publishing, 2000.

Dayton, Linnea, and Jack Davis. *The Photoshop 6 Wow! Book.* Berkeley, Calif.: Peachpit Press, 2001.

Dinucci, Darcy, Maria Giudice, and Lynne Stiles. *Elements of Web Design.* San Jose, Calif.: Adobe Press, 1999.

Haynes, Barry, and Wendy Crumpler. *Photoshop 6 Artistry.* Indianapolis, Ind.: New Riders Publishing, 2001.

McClelland, Deke. *Macworld® Photoshop® 6 Bible.* New York: Hungry Minds, Inc., 2000.

Pogue, David. *Macs for Dummies,* 7th ed. New York: Hungry Minds, Inc., 2000.

Rathbone, Andy. *Windows XL for Dummies.* New York: Hungry Minds, Inc., 2000.

Stanley, Robert. *The Complete Idiot's Guide to Photoshop 6.* Que Education & Training, 2000.

Weinmann, Elaine, and Peter Lourekas. *Photoshop 6 for Windows and Macintosh (Visual Quickstart Guide Series).* Berkeley, Calif.: Peachpit Press, 2001.

Tone Control and Sensitometry

Adams, Ansel, with Robert Baker. *The Camera.* The Ansel Adams Photography Series. Rep ed. Boston: Little, Brown & Co., 1995.

———. *The Negative.* The Ansel Adams Photography Series. Rep ed. Boston: Little, Brown & Co., 1995.

———. *The Print.* The Ansel Adams Photography Series. Rep ed. Boston: Little, Brown & Co., 1995.

Dowdell, John J., III, and Richard D. Zakia. *Zone Systemizer.* Dobbs Ferry, N.Y.: Morgan & Morgan, 1973.

Gassan, Arnold. *Handbook for Contemporary Photography,* 4th ed. Rochester, N.Y.: Light Impressions, 1977.

Horenstein, Henry. *Beyond Basic Photography: A Technical Manual.* Bulfinch Press, 1993.

Sanders, Norman. *Photographic Tone Control.* Dobbs Ferry, N.Y.: Morgan & Morgan, 1977.

Sturge, John M., ed. *Neblette's Handbook of Photography and Reprography.* New York: Van Nostrand Reinhold Co., 1977.

Todd, Hollis N. *Photographic Sensitometry.* Dobbs Ferry, N.Y.: Morgan & Morgan, 1981.

Todd, Hollis N., and Richard D. Zakia. *Photographic Sensitometry: The Study of Tone Reproduction,* 2d ed. Dobbs Ferry, N.Y.: Morgan & Morgan, 1974.

White, Minor, Richard Zakia, and Peter Lorenz. *The New Zone System Manual,* 4th rev. ed. Dobbs Ferry, N.Y.: Morgan & Morgan, 1990.

Lighting Techniques

Bidner, Jenni. *The Lighting Cookbook.* New York: Amphoto, 1997.

Freeman, Michael. *The Photographer's Studio Manual.* New York: Amphoto, 1984.

Hunter, Fil, and Paul Fuqua. *Light Science & Magic.* Boston: Focal Press, 1997.

Krist, Bob. *Secrets of Lighting on Location.* New York: Amphoto, 1996.

Reznicki, Jack. *Illustration Photography.* New York: Amphoto, 1987.

———. *Studio & Commercial Photography.* Kodak Pro Working Series. Sterling Publications, 1999.

Schwarz, Ted, and Brian Stoppee. *The Photographer's Guide to Using Light.* New York: Watson-Guptil Publishers, 1986.

Zuckerman, Jim. *Techniques of Natural Light Photography.* Cincinnati, Oh.: Writers Digest Books, 1996.

Index

A page number in *italics* indicates that a photograph or an illustration appears on that page.